ICONS

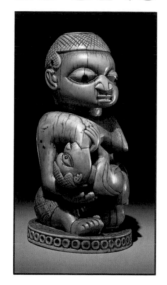

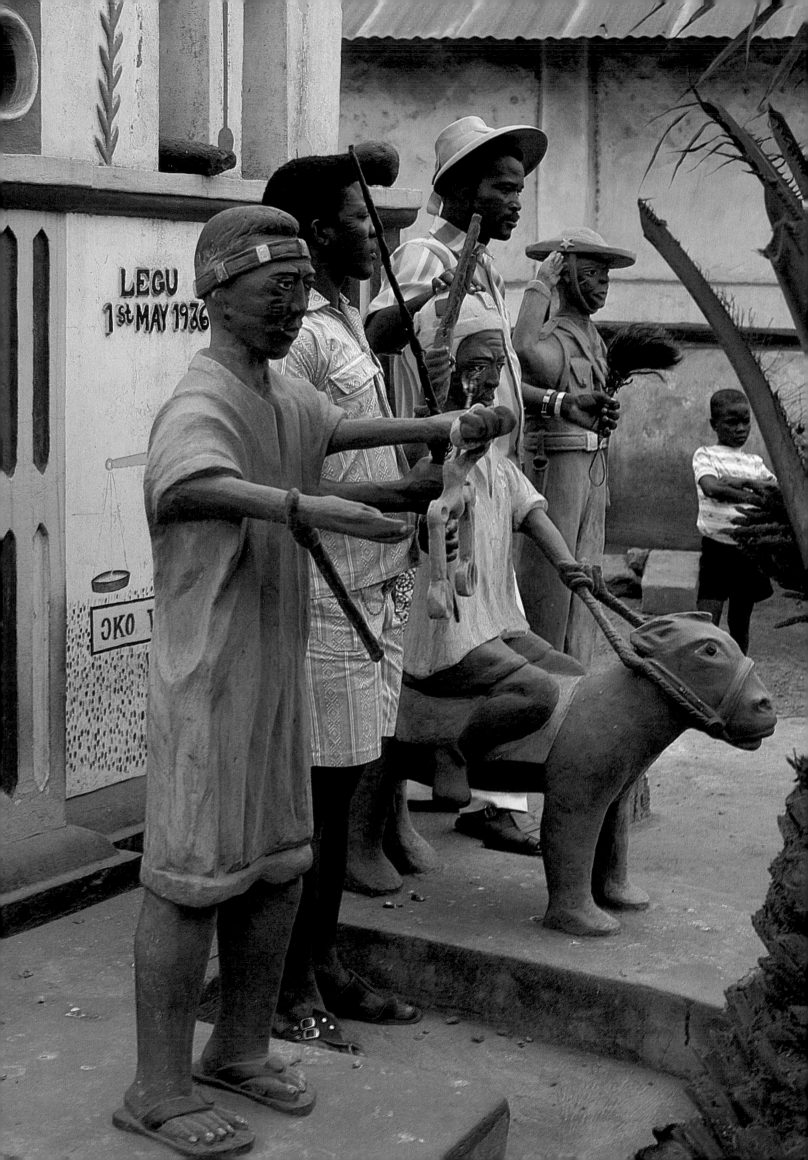

ICONS

Ideals and Power
in the Art of Africa

HERBERT M. COLE

Published for the
National Museum of African Art
by the
Smithsonian Institution Press

Washington, D.C., and London

This book is for Shelley, with appreciation and love

Published in conjunction with the exhibition
Icons: Ideals and Power in the Art of Africa
National Museum of African Art,
 Washington, D.C.
October 25, 1989–September 3, 1990

This book and the exhibition it accompanies
were supported by a generous grant from the
Special Exhibition Fund of the Smithsonian
Institution.

Library of Congress Cataloging-in-Publication Data
Cole, Herbert M.
 Icons: Ideals and power in the art of Africa.
 Catalogue of the exhibition held at the
National Museum of African Art.
 Bibliography: p.
 1. Art, Black—Africa, Sub-Saharan—
Exhibitions. 2. Art, Primitive—Africa,
Sub-Saharan—Exhibitions. 3. Blacks in
art—Exhibitions. 1. National Museum of
African Art (U.S.). 11. Title.
N7391.65.c63 1989 709.67′074′753 89-11296

ISBN 0-87474-320-6
 (Smithsonian Institution Press)
ISBN 0-87474-321-4
 (Smithsonian Institution Press: pbk.)

Acid-free paper is used in this publication.

Cover: Display sculpture, Igbo peoples, Nigeria
 (fig. 4)
Page 1: Woman and child, Yoruba peoples, Owo
 region, Nigeria (fig. 195)
Frontispiece: Shrine for an Asafo military
 organization, Fante group, Akan peoples, Ghana
 (see fig. 1 for full view)

For permission to use illustrations appearing in
this book, please correspond directly with the
owners of the reproduction rights. These
institutions and individuals are listed in the
appendix. The Smithsonian Institution Press
does not retain reproduction rights for the
illustrations or maintain a file of addresses for
photograph sources.

Designer: Christopher Jones

Contents

Foreword

The art of the world is filled with symbols, visible forms demonstrating the invisible. Through the exploration of such images in a particular civilization or society, we learn about the ideas and values that intrigued and informed a people. In the Western world, the art of medieval Europe is filled with such pictorial idioms; in the East, it is the art of Byzantium that most often comes to mind. In both instances, artists created religious miniatures, popularly known as icons, in manuscripts and small panel paintings. As art historians have pointed out, these icons were created according to a fixed representation or symbolism, and the elements of the style were spread abroad. The artists created strong characterizations reflecting different psychological responses to a particular event or idea, and yet in each depiction there is a human quality in the style that gives vitality to the symbol.

In our age of scientific technology and pragmatism, we have lost sight of the symbolic function of much of the imagery of the past. Few today know or respect the power that the Book of the Apocalypse exercised over the Spanish imagination in the eighth century, or even why this subject was expressed visually. The images of four men riding white, red, black, and pale mounts represented respectively the true Church, Christ himself; the Devil; the false Prophet; and finally Death, who turns all heretics over to sword and famine. These images symbolized not only the combative position of Christians in Spain against the powerful forces of the infidel but also offered assurance of inevitable victory and deliverance. These icons expressed ideas and ideals that were immediately clear to the faithful of medieval Spain but were as cloaked in mystery to the infidel or nonbeliever as they are today to us.

In this volume, Herbert M. Cole, an art historian of African art, explores five iconic representations from a number of diverse cultures in Africa south of the Sahara. These symbols are the couple, the woman and child, the aggressive male hunter or warrior, the rider, and the stranger. Their meanings are often multivalent—religious, social, and political—but all are expressive of ideas and values as well as power. The task that Cole set for himself was to achieve a deeper understanding of the five icons and the societies in which they functioned by analyzing the forms and the ideas underlying them. The frequency with which these depictions appear is not the issue. Rather, how each icon functioned in varying contexts and how artists conceived them through time are of paramount concern.

In 1988, as the recipient of a one-year postdoctoral Rockefeller Foundation Residency Fellowship in the Humanities at the National Museum of African Art, Dr. Cole continued his earlier research on these pervasive and persistent symbols in the art of Africa. We are deeply grateful to him for providing us with new insights into a range of extraordinary imagery. The results of his work have culminated in this publication and an exhibition of the same title. Both were supported by a generous grant from the Special Exhibition Fund of the Smithsonian Institution. The exhibition could not have been realized without the participation of many national and international museums and private collectors, who generously lent their works of art for an extended period. We are deeply grateful to each of them for their contributions. Recognition and appreciation must be given to the museum's permanent staff, especially those in the curatorial, exhibitions, and publications departments, who worked tirelessly to bring this endeavor to fruition.

Sylvia H. Williams
Director

7

Preface

The idea for this book and the exhibition it accompanies arose out of three thematic exhibitions I organized at the Los Angeles County Museum of Art between 1983 and 1985. They focused on the recurrent images of the couple, the rider, and the woman and child in African art. Taking a comparative and cross-cultural approach to these subjects, I explored the contexts, uses, and meanings of a wide variety of works from different times and places. Encouraged by the responses to the projects, I decided to add two more themes—the forceful male and the stranger—to the original three and propose a more ambitious study of what I then saw as five archetypal images. Although I have abandoned the word *archetype* in the title of the project—it is both too restrictive in its psychological implications and too universalistic for understanding art forms that occur in widely divergent situations—I am even more convinced of the importance of these iconic themes throughout the history of art in Africa.

My understanding of these icons in Africa owes much to fieldwork, especially in Nigeria and Ghana. Throughout this study, in fact, examples of Igbo and Akan uses and interpretations of the themes help give continuity and substance to subjects that threaten to become too diverse, general, and abstract. I am profoundly indebted to the many African people who have facilitated my research since 1966 and to the scholars whose work I have drawn upon.

A dual undertaking—book and exhibition—of this size owes its existence to hundreds of people. It was launched when Sylvia Williams, director of the National Museum of African Art, and Roy Sieber, associate director, embraced its basic notion in 1987, proposing me for a postdoctoral Rockefeller Foundation Residency Fellowship in the Humanities in 1988 to continue research and begin designing the exhibition and contacting possible lenders. Their faith and advice are much appreciated. I am most grateful to the Rockefeller Foundation for financial support for writing in 1989 and to

the Smithsonian Special Exhibition Fund for its generous subvention of this publication and the exhibition.

Without the generosity of private collectors and museum personnel, of course, a project like this could never be completed. I thank them all most sincerely and regret not individually naming the scores of people who so kindly gave me access to the collections under their care.

The project was guided with great sensitivity and skill by Philip Ravenhill, chief curator, and curator Andrea Nicolls most ably handled the day-to-day logistical details. I thank them both heartily for their unflagging support and hard work. Assistance from curators Bryna Freyer, Lydia Puccinelli, and Roslyn Walker is also gratefully acknowledged.

I appreciate the many contributions of the entire National Museum of African Art staff. Adding much to the success of the project were Jean Salan, assistant director; Grace Eleazer, registration; Stephen Mellor, conservation; Edward Lifschitz, education; Janice Kaplan, public affairs; Judith Luskey, photographic archives; and the members of their respective staffs, especially Veronika Jenke and Anita Jenkins. Janet Stanley, librarian, and Polly Lasker, assistant librarian, responded graciously to my numerous requests, and Jeffrey Ploskonka took many fine photographs. I appreciate the hard work of Basil Arendse and his staff in effectively mounting the exhibition. Gratitude also goes to Holly Laffoon, Cora Shores, Linda Dickerson, Dorothy Black, and especially Tujuanna Evans and Rachel M. Quynn for their various kinds of administrative and secretarial assistance.

Special thanks to Dean Trackman, editor, and Christopher Jones, graphic designer, for their skillful, sensitive work and for carefully shepherding the book through production. Thanks also to Heidi Overing for her editorial assistance and to Leo Lemaire for his help with translations.

Friends and colleagues outside Washington have also made numerous valuable con-

tributions. Field photographs have been kindly supplied by, or with the help of, the following, to whom I am most grateful: Mary Jo Arnoldi, Elizabeth Evanoff, Ekpo Eyo, Lynn Forsdale-Denny, Eberhard Fischer, Phyllis Galembo, Christraud Geary, Marilyn Houlberg, Jean-Christophe Huet, Michel Huet, Pascal James Imperato, Jean-Marie Lerat, Douglas Mazonowicz, Joseph Nevadomsky, Philip Ravenhill, Norma Rosen, Doran H. Ross, Thomas Seligman, and Jacques Soulillou. I have also benefited enormously over the past few years from discussions with colleagues, some of whom have supplied information or read parts of the manuscript. The following have been particularly helpful, sometimes saving me from egregious errors of fact or interpretation: Peggy Appiah, Mary Jo Arnoldi, Paula Ben-Amos, Marla Berns, Suzanne Blier, Donald Cosentino, Henry Drewal, Margaret Drewal, Marc Felix, Christraud Geary, Rachel Hoffman, John Mack, Anitra Nettleton, Polly Nooter, Edward Norris, Esther Pasztory, Philip Ravenhill, Doran Ross, Chris Roy, Bill Siegmann, and Judith Timyan.

My greatest debts are to Henrietta Cosentino and Shelley Cole. The former provided insightful intellectual sharpening to many ideas in the text with her highly skillful eleventh-hour editorial assistance. My wife, Shelley, gave unstinting moral, intellectual, and logistical support throughout the project. I am happy to dedicate this book to her.

Ethnic Groups and Sites

1. Akwapem (*Ghana*)
2. Asante (*Ghana*)
3. Bamana (*Mali*)
4. Bamileke (*Cameroon*)
5. Bamum (*Cameroon*)
6. Bangwa (*Cameroon*)
7. Baule (*Côte d'Ivoire*)
8. Bembe (*Congo*)
9. Boa (*Zaire*)
10. Bondoukou region (*Côte d'Ivoire, Ghana*)
11. Bozo (*Mali*)
12. Chamba (*Nigeria*)
13. Chokwe (*Angola, Zaire*)
14. Dan (*Liberia, Côte d'Ivoire*)
15. Dogon (*Mali*)
16. Edo, Benin Kingdom (*Nigeria*)
17. Ewe (*Togo, Ghana*)
18. Fang (*Cameroon, Gabon*)
19. Fante (*Ghana*)
20. Fon (*Benin*)
21. Fulani (*Niger, Mali, Nigeria, Cameroon*)
22. Gola (*Liberia, Sierra Leone*)
23. Guro (*Côte d'Ivoire*)
24. Gurunsi (*Burkina Faso, Ghana*)
25. Hemba (*Zaire*)
26. Hongwe (*Gabon*)
27. Ibibio (*Nigeria*)
28. Igala (*Nigeria*)
29. Igbo (*Nigeria*)
30. Ijo (*Nigeria*)
31. Inland Niger Delta region (*Mali*)
32. Kalabari (*Nigeria*)
33. Kissi (*Sierra Leone, Liberia, Guinea*)
34. Kongo (*Congo, Zaire, Angola*)
35. Kuba, Bushoong Kingdom (*Zaire*)
36. Kugni (*Congo*)
37. Kwele (*Congo*)
38. Lega (*Zaire*)
39. Limba (*Sierra Leone*)
40. Lobi (*Burkina Faso, Côte d'Ivoire, Ghana*)
41. Luba (*Zaire*)
42. Lulua (*Zaire*)
43. Makonde (*Tanzania, Mozambique*)
44. Mangbetu (*Zaire*)
45. Mano (*Liberia*)
46. Mbundu (*Angola*)
47. Mende (*Sierra Leone*)
48. Mossi (*Burkina Faso*)
49. Mumuye (*Nigeria*)
50. Nok style area (*Nigeria*)
51. Nupe (*Nigeria*)
52. Ogoni (*Nigeria*)
53. Pende (*Zaire*)
54. Senufo (*Côte d'Ivoire, Mali*)
55. Shankadi (*Zaire*)
56. Sherbro/Bullom (*Sierra Leone*)
57. Songo (*Angola*)
58. Suku (*Zaire*)
59. Tabwa (*Zaire*)
60. Temne (*Sierra Leone*)
61. Tiv (*Nigeria*)
62. Toma, also Loma (*Liberia*)
63. Vai (*Liberia, Sierra Leone*)
64. Vili (*Congo*)
65. Wan (*Côte d'Ivoire*)
66. We, also Guere (*Liberia, Côte d'Ivoire*)
67. Wurkun (*Nigeria*)
68. Yaka (*Zaire*)
69. Yombe (*Congo*)
70. Yoruba (*Nigeria, Benin*)

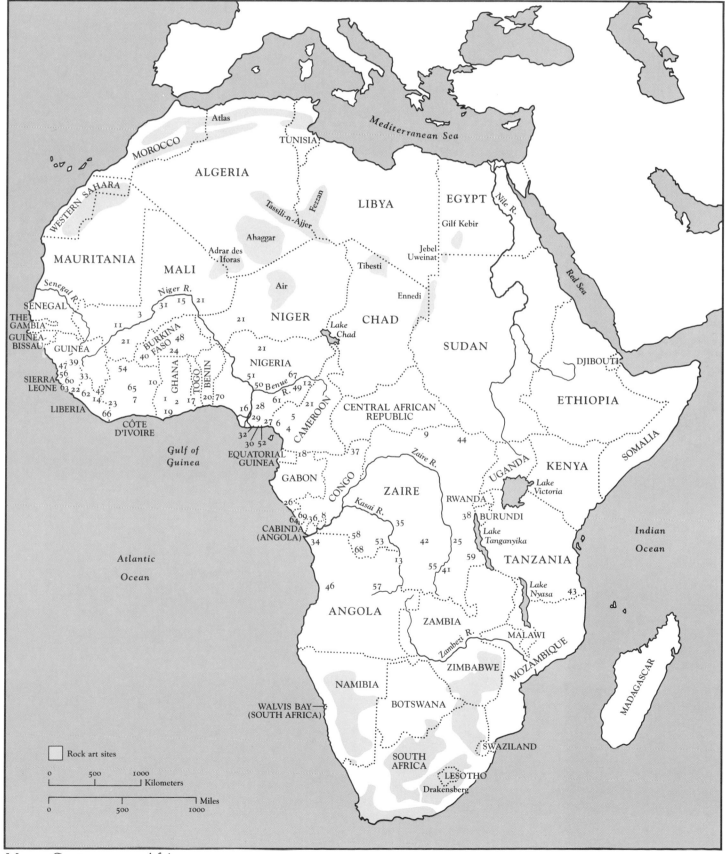

Map 1. Contemporary Africa

11

I Introduction
Icons, Ideals, and Powers

Visual representations may be called icons when they achieve compelling prominence through frequent repetition in sacred or secular arts. Icons are powerful because they encapsulate ideas and actions of central importance in human life. Five icons are the focus of this book:

> The male and female couple
> The woman and child
> The forceful male with a weapon
> The rider of horses and other animals
> The stranger or outsider

Each of these icons touches a few accessible root ideas. From the couple comes the notion of marriage, which implies family and then civilization. From the woman and child, continuity, the perpetuation of society through repopulation. From the armed male, protection from aggressors, warfare, and sustenance from the hunt. The rider, as a swift and superior male, projects leadership. Strangers stand for the stimulus of novelty from the outside.

These themes, meaningful in all cultures and in many art traditions, are widely prevalent in African art. Each has been rendered repeatedly in many societies across the continent and across the span of African history, from five or six millennia before the time of Christ to the present (fig. 1). Manifested as icons, they show some tendency toward shared universal content across cultures; at the same time they are almost as striking for the diversity of meanings they express.[1] In any case, they offer to students of African art a worthwhile point of departure, a window onto the continent. They act also as cultural prisms that can be turned this way and that to illuminate values critical to the quality of life.

The five icons proliferate not only in time and space but in a great range of materials, object types, and contexts. They appear in wood sculpture, from monumental architectural embellishments to freestanding figures and small implements; political emblems in ivory or precious metals; secular paintings on walls or signs; iron weapons and beaded display pieces; clay and ceramic shrine sculptures; multimedia assemblages used in spirit masquerades; and many other forms.

Two or more icons often coexist in the same image or group, as in a Kongo couple (fig. 2). The man may also be a forceful male. He may even be on a mount (fig. 78). The woman may also be depicted with a child. The Kongo sculptures evidently represent an African couple, yet the man's gun and clothing show influence from the European world. His image, therefore, can also be considered a "stranger" icon. Strangers are seen in the first four roles (fig. 3), although rarely as mothers with children; in fact, most of the images of strangers in this book have been chosen from the other themes. Subjects other than those expressed by these five icons are also, of course, quite common in art, often appearing alongside the ones singled out here. An Igbo display sculpture, for example, incorporates about a dozen animals along with four of the five icons (fig. 4).[2]

FIG. 1. Cement shrines for military organizations on the coast of Ghana feature forceful males, equestrians, and other images that advertise the strength, courage, and ferocity of the group.

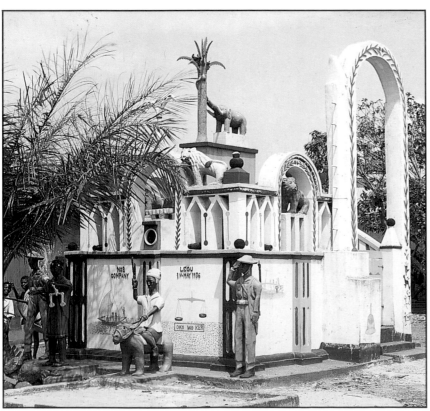

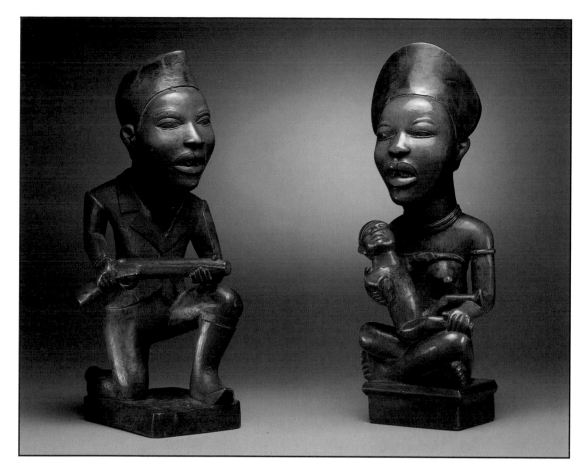

FIG. 2. Three icons are represented in this Kongo couple, carved about 1900. The male's weapon and clothing are elements from the outside world. H. 12½ in. (male), 12¾ in. (female).

Ideals and Powers

Social, political, and religious ideals are communicated in art forms and emanate from them. The five chosen icons are important in African life partly because each represents standards of thought or action. Images of male aggression or female nurture, for example, are usually idealized representations of perfect comportment (the notions vary, of course, from one people to the next). Icons may portray local models of personal beauty, family or community harmony, leadership, or ancestral wisdom. Even the ideals of the spirit world are manifested iconically. Several equestrian images, for example, represent invisible bush spirits considered swift, strong, and mobile, like human beings on horseback (fig. 146). The standards encoded in the icons are different for men and women. Ideals also change over time, as images of strangers demonstrate; ideas from the outside world have been assimilated into African culture and transformed by African sensibilities for thousands of years. The ideals, too, are about people's hopes and needs, their fears and triumphs—that is, the most vital aspects of African life.

Miniature Asante sculptures known as goldweights illustrate some ways in which

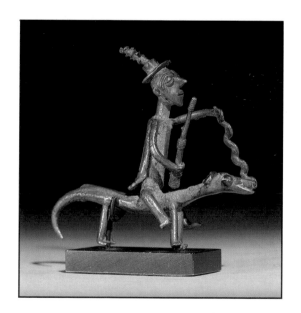

FIG. 3. This small copper alloy sculpture, a goldweight, appears to represent a stranger, perhaps someone who has ridden a horse into the forest region from the north. H. 2⅞ in.

FIG. 4. Dramatic, colorful display sculptures served as rallying points for Igbo dances. The many components are carved separately and then pieced together on a central wooden armature. H. 59 in.

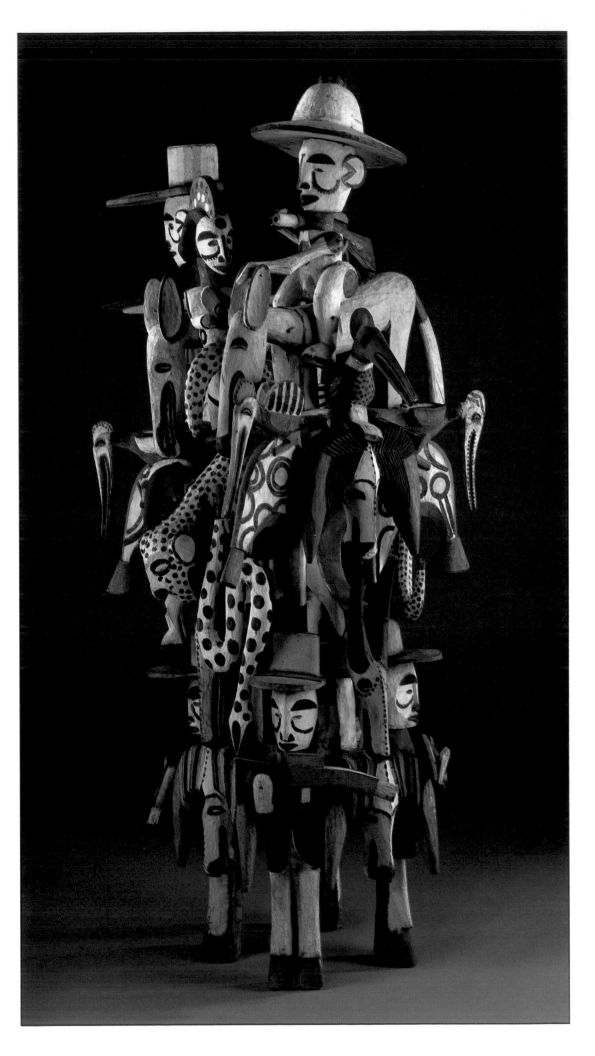

icons communicate ideals (figs. 5–7). These copper alloy castings were used as counterweights to measure specific quantities of gold. Among the hundreds of human and animal forms depicted by these weights, the five icons occur frequently. For Asante people the images often elicit maxims or proverbs that supplement the meaning of the icon itself. For example, the equestrian motif (fig. 5) is commonly associated with the saying "If the horse is crazy, the rider is not also crazy." The maxim is not so much about riding horses, which were rare in Asante culture, as it is about chieftaincy, which has long been common. The saying means that the rider (chief) is in control; the horse (people at large) can be crazy or unruly, but a good, sane chief will maintain order. Another goldweight depicts a woman carrying a basket on her head and a child on her back (fig. 6). This image evokes the proverb "It is the hardworking (ideal) woman who carries her child and a load at the same time." The standard referred to here apparently applies to mothers, but it is actually more about hard work than about maternity. A third goldweight motif, a man with a gun (fig. 7), speaks directly of the forceful male theme: "Trouble fears a great warrior."[3] Icons also address issues of power. In Asante art, the visual power of an image is often coincident with proverbs, the power of speech.

Art in Africa has as much to do with power as it does with ideals. In discussing the art of his own Igbo people of Nigeria, the great African novelist Chinua Achebe cites the proverb "Power runs in many channels" (1984, ix). Art provides diverse channels for power and ideology, for it symbolizes, invokes, and even helps generate power and authority. Military monuments and regalia aid command. A wall painting satirizes a social custom. Masquerades move people, and shrines inspire them. Art persuades, empowers, and transforms.

The military shrine, posuban, built in the Fante town of Legu on the coast of modern Ghana as the "castle" and rallying point for

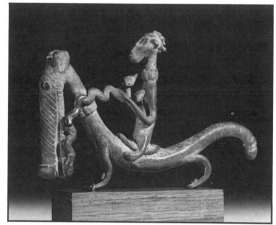

5

Asafo Company No. 2 exemplifies the channeling of powers into a single monument (frontispiece, fig. 1). Celebrating aggression and military supremacy, its foreground sculptures include an equestrian and two warrior captains—supplemented in the frontispiece photograph by proud living company members. The cement officers probably commemorate men who gave money for the building materials and the artists' fee. They permanently guard the shrine, equipped either with the mystical protection of Islam in an amulet-laden war shirt or with the firepower of European weaponry. A company's posuban typically includes sculptured motifs that boast about its strengths and belittle or threaten rival companies, often drawing on the same verbal expressions as those associated with goldweights. The lions on this posuban, for example, are direct challenges to the leopards on the posuban of Company No. 1: "A dead lion is greater than a living leopard." Vivid naturalistic sculpture, bright (imported) paint, inventive architectural motifs (derived loosely from nearby European castles), and a confident sense of superiority combine to amplify the ascribed powers of Company No. 2. An irony that leaves competitive Asafo companies undaunted is the fact that actual warfare ceased before most posuban were built. For the people, however, art is power, and companies continue to fight with it in the 1980s.[4]

FIGS. 5–7. Small metal sculptures represent a variety of subjects, including the icons. These goldweights refer to proverbs that incorporate ideas and sayings about all aspects of Akan life. H. 1^{15}/16– 3^{5}/16 in.

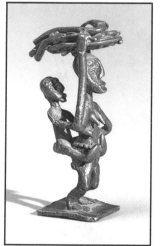

6

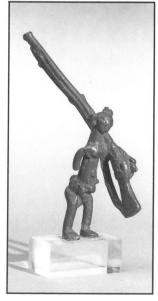

7

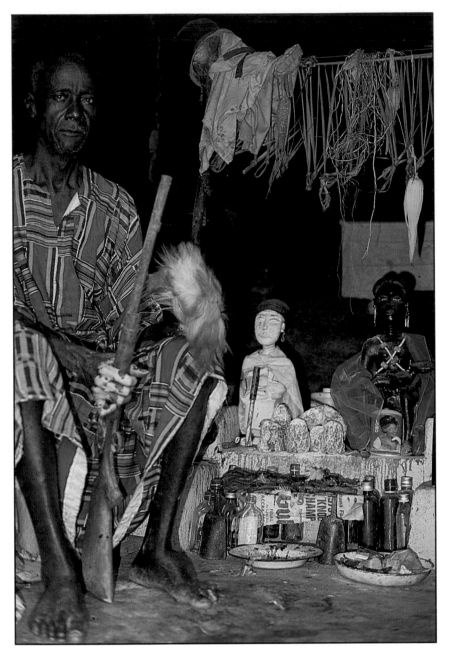

FIG. 8. A shrine to the river god Tano with two mother-and-child carvings. The priest holds a gun used symbolically against evil-working spirits.

Frames of Reference

Context. Of the many ways to examine African art, two are common.[5] The first method, which is anthropological, sees art and its meanings within its original, local context. The second examines art away from that setting, by itself or in a comparative manner; this is the usual art-historical approach. Figures 8 and 9 exemplify these distinct methods of study. In figure 8, carved wooden statues are surrounded by other ritual materials and set in a shrine attended by a priest. The whole picture implies a detailed spiritual process in which the sculptures—the river god Tano's "children"—play a relatively minor role, as if passive witnesses to the offerings, prayers, and gestures directed to Tano. Figure 9, in contrast, is an isolated maternity, a sculpture of an Asante

queen mother from modern Ghana. She might well have been made for a shrine such as that of figure 8 and could have been photographed in such a setting. Here, however, the mother-and-child sculpture takes center stage in a carefully lighted studio photograph that was taken outside of Africa. All surrounding and informing ritual props have apparently been removed, yet the lighting, colored background, and even the photograph can be seen as "ritual props" of the modern Western world. The practice of isolating a work or placing it on a pedestal in a "neutral" environment so that people may best see its artistic qualities is a recent phenomenon for the art of Africa. Both African and non-African contexts are authentic and informative, but they are obviously very different.

This contrast in contexts has further implications. The village shrine picture suggests a wealth of information about ritual processes—for example, the reasons for commissioning and including statuary. The photograph also implies other data that might be elicited from informants such as priests or worshipers. The knowledge, interests, and biases of both questioner and people questioned become part of the data gathered, yet the information provides insight into Asante beliefs and ritual activities. This kind of exploration is essentially anthropological.

The museum or studio setting is the realm of the art historian, collector, or museum visitor who may never have experienced the shrine setting and who may not be particularly interested in it. Shrine objects seen by themselves, often lacking their pigments and sacrifices (which the rains may wash off in Africa anyway) or the clothing they may have worn in their shrines, can bring other kinds of information into perspective. They may reveal, for example, the conformity or inventiveness of a specific artist, similarities and differences in style and iconography among several examples of one type, or the history of the object as revealed in its surface and wear

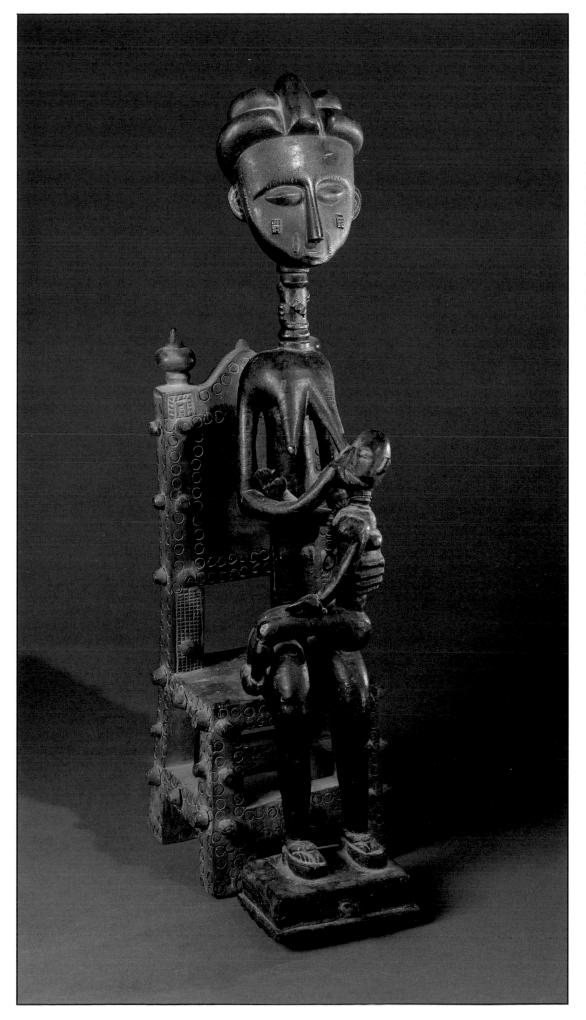

FIG. 9. The woman-and-child icon is common in the arts of the matrilineal Akan peoples of modern Ghana. This wooden version is a queen mother, almost certainly by an Asante artist. H. 22¼ in.

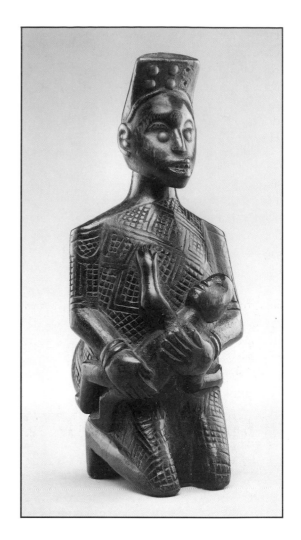

FIG. 10. This refined Kongo carving is actually a bottle. The head can be removed, revealing an opening in the neck. H. 9⅛ in.

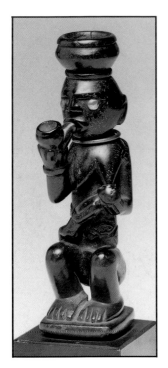

FIG. 11. A Kongo carving of a pipe-smoking woman with her child serves as a mortar, probably for grinding tobacco. H. 6⅞ in.

patterns. Cross-cultural comparisons of each icon are then possible. The analyst can contrast the royal maternity in figure 9 with a less elaborate (probably nonroyal) Asante version also of wood (fig. 86) and again with another royal variation on the theme from a different region and in a different material (fig. 172). The Vili ivory in figure 172, probably a staff finial, can in turn be compared to a mother and child fashioned as a bottle from the same general area (fig. 10) and again to other examples from nearby peoples, such as a mortar (fig. 11) or a ritual bell (fig. 173).

Anthropological data—information disclosed by contexts in Africa—deepen our understanding of the critical place of objects we call art in the lives of their creators, patrons, and viewers. Art history, on the other hand, tends to rely on having a series of objects available (and out of context) for comparative analysis. Both approaches have merits and limitations. Bringing the two together can enrich our appreciation of the images explored here, as well as increase our understanding of African culture.

Point of View. Whether anthropologists or art historians, those who document African art also reveal a great deal about their own points of view—perhaps as much as they do about the art and values of African people. Two illustrations of the same architectural sculptures from the Baham palace in Cameroon make clear the differences in point of view (figs. 12, 13). A 1925 photograph shows the ensemble on its palace façade (fig. 13). Significantly, the sculptures frame King Obemne; these carvings, along with several analogous portals on different buildings in the palace, both actually and ideologically help to support a royal structure. This particular entryway happens to include all five icons (the stranger is implied by a gun); they are part of the animated depiction of historical events and members of the royal household and entourage. Yet a European—a German missionary named Father Frank Christol—made the photograph, decided how to frame the scene, how close or distant to stand, what to include or exclude (perhaps shooing children away, for example, as inappropriate to an "image of state"). The photographer may have controlled the scene by arranging it as he did. As a participant, King Obemne contributed to the picture's composition, perhaps helping to "frame" or fix his own image in a manner analogous to the artist who created the architectural frame itself.[6]

In the late 1940s or early 1950s, another person, Raymond Lecoq, photographed one of these sculptures again in Baham (1953, 66–67). Partially broken, it was leaning up against a building, and a few pieces were missing. The sculptures were removed from their original building for unknown reasons, perhaps because of deterioration from rot or termites. One section had left Baham by the time of Lecoq's visit. Figure 12 shows what remains of the original doorway. The current owner has reunited the two separated sculptures and has reattached a mother and child to the right-hand section.

Since about 1900, when these sculptures were carved, the palace and kingdom of Ba-

FIG. 12. Architectural sculptures in the Cameroon Grassfields depict members of the royal household and entourage. Invariably they glorify the king, sometimes by referring to historical events. These are shown as displayed by the current owner (see fig. 13). H. 104 in. (left) and 100³⁄4 in. (right).

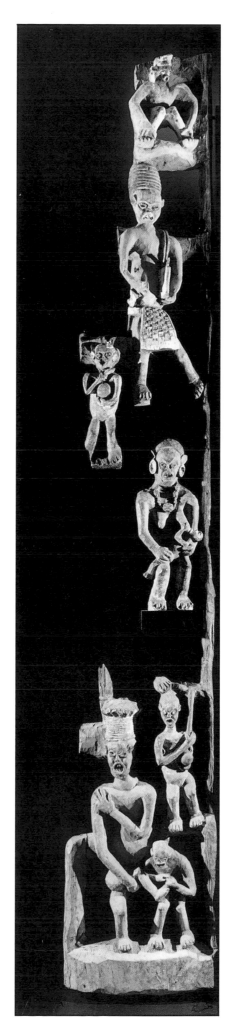
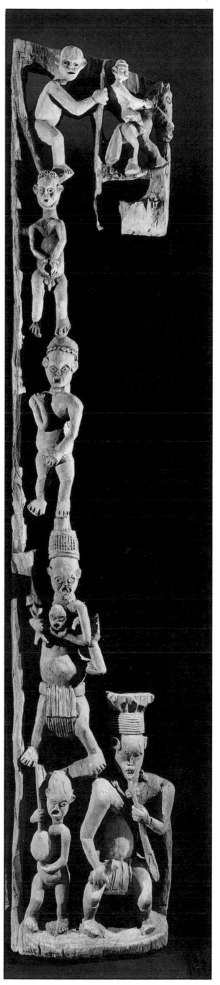

ham have undergone numerous changes. There were internal disruptions and visits from missionaries. Kingship in the Grassfields region was strongly modified first by German colonization and after World War I by the French and British. The portals, like much art once vital in African life, left Africa to enter collections in Europe and America.[7] These photographs remind us that art changes contexts and that the point of view of its observers necessarily changes at the same time. Every window onto art in Africa implies a different frame of reference. And the documentation of that art invariably affects its context, whether subtly or more directly.

Judging Quality. Like all art, that of Africa is variable in quality (most of it is less fine than the objects illustrated here). Cameroon carvers produced hundreds of architectural posts; all framed entryways or held up roofs efficiently and satisfied their patrons. Yet within this group of sculptures, qualitative distinctions can be made, hierarchical aesthetic rankings that are as important to African sensibilities as they are to our own. Two objects, one well crafted and the other poorly crafted, may be equally respected for their ritual functions. On another level they may be differentiated on the basis of their aesthetic quality. When I studied *mbari* houses among the Igbo of Nigeria, for example, the local people insisted that all such elaborate structures (fig. 14), created as sacrifices to demanding gods, were good, beautiful, and effective, implying moral, artistic, and spiritual qualities. Yet they also acknowledged that the handwork or skill of one artist was superior to that of another; they admitted that in purely visual terms one *mbari* could be seen as more beautiful than another. Igbo villagers were disinclined to make such comparisons, but when they did so, their artistic preferences were almost always the same as my own. I do not see these parallel evaluations as mere coincidence. Prior to the public unveiling of an *mbari* house, in fact, elders were invited to

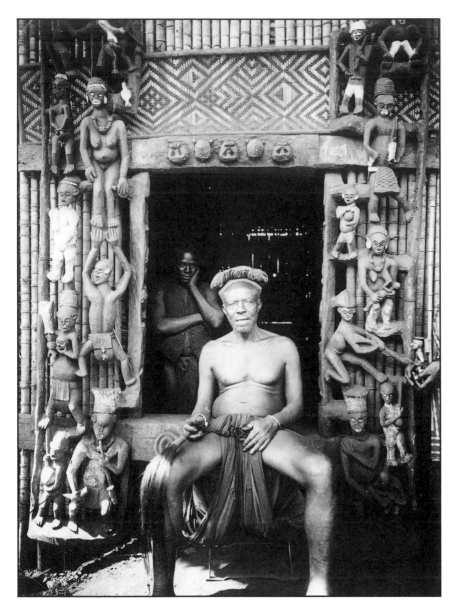

FIG. 13. The portal carvings framing the king recall the story of a king's wife who left and had a child with one of his subjects. The king in the carving (lower left) orders punishment for the lovers and has the child beheaded, thus asserting his authority.

inspect the completed monument. They ordered any sloppy or poorly made image to be redone, for its presence, people said, would offend the god for whom the *mbari* was built.

Aesthetic criteria vary from one person to another, yet in all societies some individuals stand out as major tastemakers, people who define artistic standards. In Africa, these patrons are wealthy, powerful leaders, both spiritual and temporal, for whom most of the icons on these pages were made. No doubt most of them were aware of relative artistic quality in the objects they commissioned and lived with, as are collectors and many scholars of the arts elsewhere. Research on cross-cultural aesthetics is scanty, but Thompson (1974), Vogel (1986), and my own work on *mbari* (1982) suggest that judgments by African and non-African critics tend to be similar. Possibly there are indeed some universal aesthetic standards.

Historical Dimensions

Anthropologists, art historians, and collectors have quite often treated African art as if it were the static product of an idyllic past. They consider some works to be authentic and call them "traditional," contrasting them with more contemporary art, which is deemed to be tainted by contact with other cultures. The phrase "traditional African art" helps perpetuate this unfortunate stereotyping. Moreover, writers give overwhelming (sometimes exclusive) emphasis to sculpture, especially portable wood and metal figures. Those considered rare or artistically superior have become prized commodities in the last three decades, fetching high prices on the international market. Thus sculpture has been made to appear the only viable art from Africa, which is misleading.

Neither Africans nor the history of their art is served by exclusively focusing on sculpture or by imposing an arbitrary point in time at which art ceases to be "traditional." It makes better sense to speak of "African art traditions," which include nonportable sculptures, reliefs, ceramics, two-dimensional works, and other art forms. Paintings and engravings on rock surfaces are Africa's earliest known art (fig. 15), and their present-day counterparts are emerging as some of the most important contemporary forms—often of a secular, urban, international character. Inclusion of all these forms is essential to the understanding of African art history.

All works of art are products of a specific time in history. Although most African traditions show marked continuity with the past, it is also clear that they have not stayed the same. They have evolved, often in response to stimuli from the outside. Influences leading to change have always flowed back and forth among African peoples. Technologies, products, and ideas from beyond Africa have also been assimilated over the centuries; in fact, very little African art has not been so affected. Wholesale adoption, however, is very rare; most often,

Fig. 14. *Mbari* houses are erected as sacrifices to local gods. It is important that they be striking, carefully made works of art.

artists borrow and then substantially transform these outside influences, creating art that is fundamentally African.

The persistent icon of the stranger bears witness to the importance of contact with other cultures. Even works that at first glance appear "traditional" may on close examination disclose the impact of the stranger's world. Both Igbo *mbari* houses in Nigeria and Fante *posuban* in Ghana perfectly exemplify both the outside influence and its creative transformation by local artists. *Mbari* houses have been called "traditional" because villagers made them for important local deities, such as the earth goddess. However the earliest recorded *mbari*, photographed in 1903, includes the image of a white man, a "rider" in a litter. It would seem that *mbari* artists have always actively embraced change; they have been praised for innovations showing knowledge of the outside world, such as telephone systems, an office building, uniformed nurses in a modern clinic (fig. 89), and an airplane—all present in an *mbari* erected in 1962. Two objects central to *mbari* symbolism—white china plates and flat iron rods—are both imports from Europe. We have no knowledge that *mbari* houses predate the strong late-nineteenth-century British influence.

Fante *posuban* (fig. 1) also date from the late nineteenth century; indeed their invention depended on the arrival of cement from Europe. The Asafo companies that build them are partly modeled on European military organizations, and they take great pride in their flags, uniforms, cannons, bells, trumpets, and other European-inspired (or European-made) artifacts. The culture of this part of the former Gold Coast has been subjected to constant, powerful European stimuli since the late fifteenth century, when the first traders arrived in ships and began

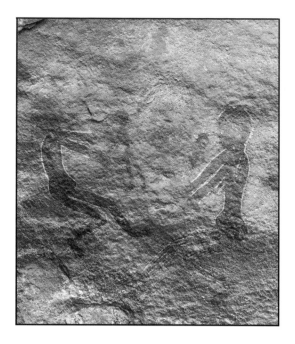

Fig. 15. Images of the five icons stretch back into prehistory, as exemplified by this rock painting of a family in the Tassili region of the Sahara.

building monumental trading forts. Nevertheless, *posuban*, like *mbari*, have wholly local motivations and an inspired, complex, intensely meaningful artistic program that is altogether West African.

Some works stand as masterpieces of local ideology. Massive Igbo *ijele*, probably the largest masks danced in West Africa, are striking examples (fig. 16). Made of European cloth and embellished with imported mirrors, *ijele* feature datable motifs, such as district officers, uniformed court messengers, and other figures with European clothing. An equestrian figure rides at the top of the mask, and the other four icons are often present. But the individual icons are not as important as the whole unified, dazzling, composite moving sculpture. The mask is a massive show of human and spiritual forces and resources.

An *ijele* mask is a multifaceted symbol of human leadership, ancestral authority, and the prolific powers of nature. Its flowered,

arboreal superstructure is a vastly expanded version of a chief's (or king's) crown (from the city-state of Onitsha[8]); thus it is a metaphor, like the king himself, for a mighty tree. The tree in turn grows out of a (largely hidden) cone of cloth that stands for a termite hill, also a metaphor for the king. More important, the termite hill is a model of nature's fecundity, since a single queen termite can produce as many as 13 million eggs per year. Termite hills, moreover, are mysterious sacred structures considered the "porch" of the underworld through which ancestors reincarnate and other spirits appear—including the *ijele* itself and other masqueraders. The tree of life "growing" upward from this mound also represents the great shade tree that embraces and shelters the people at large in its branches, and under which elders gather to advise the king. Dozens of small figures and animals, stuffed with grass or foam rubber, are perched in its benign "arms." A mother-and-child pair makes explicit the powers of nature implied in the termite hill and tree. A couple is usually there, too, along with armed males, and strangers. The equestrian sits at the top. All are protected by the spirit power of the tree and the moral guidance of the king in whose compound it grows. As if it were not enough to mediate sky, earth, and underworld, *ijele* is also anthropomorphized as a reincarnating ancestor who visits the community to bless and oversee the mortal population. Its several eyes looking in all directions are the watchful eyes of the spirit realm.

Dancing, *ijele* embodies the complex "lives" of art. It is a gift of the gods to man and a costly sacrifice by man to god. Dynamic, alive, defiant of gravity, it twirls and pulsates, projecting the powers of nature and the ideals of humankind.

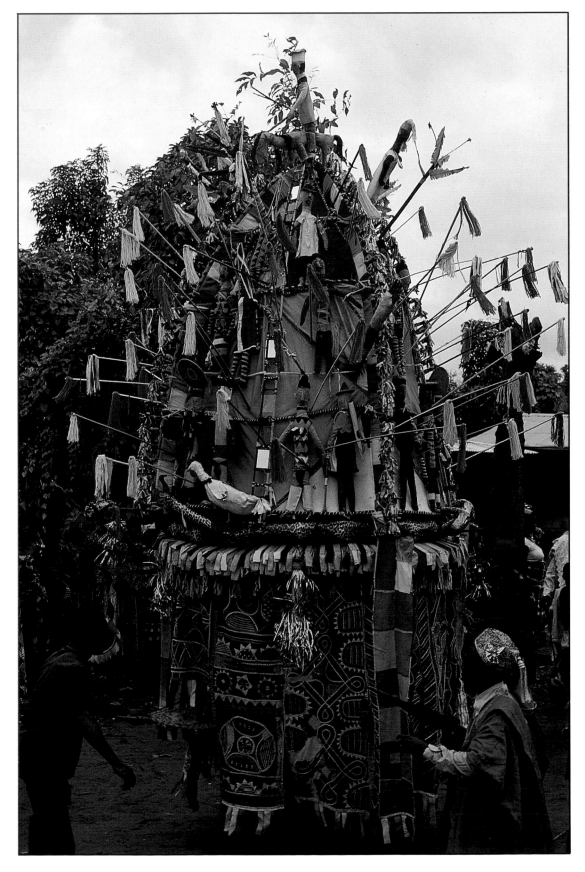

FIG. 16. The massive *ijele* mask is a rich symbolic structure that incorporates the icons and the ideals and powers embodied in them. Constructed of cloth on a wooden armature, an *ijele* is danced by an individual of great strength.

2 Useful Images
The Life of Art in Africa

A Fante chief, bedecked in rich cloth and jewelry, gestures to his people with a short sword as he is carried through the streets of his town (fig. 17). He magnetizes their attention from his commanding height, reassures them with gestures of support, entertains with the spectacle of which he is the catalyst and the crown. He is a living work of art, combining performance with visual panoply for an occasion of state.

Africans see their art in dynamic terms. About 1933, for example, a Kongo man, Nsemi Isaki, wrote about his peoples' various "fabricated charms," which include many anthropomorphic power images, *nkisi*, that are fine works of art (fig. 18).

> The *nkisi* has life; if it had not, how could it heal and help people? But the life of a *nkisi* is different from the life in people. It is such that one can damage its flesh, burn it, break it, or throw it away; but it will not bleed or cry out. Yet the magicians think that a *nkisi* possesses life because when it heals a person it sucks illness out. . . . The

nkisi has medicines, they are its strength and its hands and feet and eyes; medicines are all these.[1] (MacGaffey 1977)

Even stationary, nonanthropomorphic objects have a vital place in human society. A Chokwe chair (fig. 19) "lives" in the company of a chief, where it betokens his wealth, stature, and discerning eye for quality. Its physical structure and iconography separate the chief from the people whom he serves, elevating him above them. The chair, which incorporates three of the icons,[2] helps make the man a leader. Masks "live" more dramatically, of course, as the faces of invented spirit characters that are activated by human agents. Masked performances provide entertainment and commentary. Egungun as a whole honors ancestors, though the specific maskers in figure 20 satirize strangers—white people—whose presence, power, and imported artifacts have had a strong transformative impact on African life.

FIG. 17. During festivals, some leaders ride in palanquins. This richly dressed Fante chief gestures to his people with a symbolic sword.

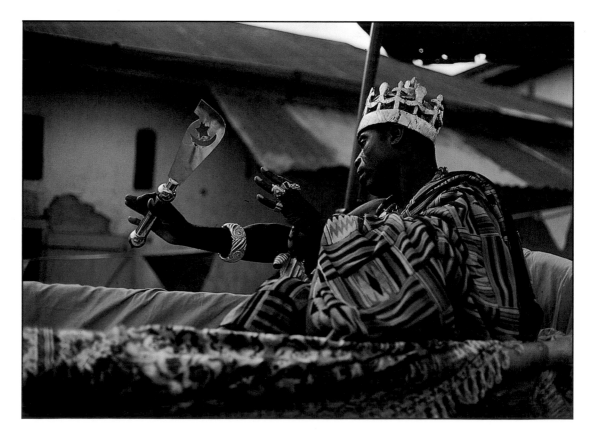

FIG. 19. Chokwe wooden chairs, though based on European prototypes, are imaginatively elaborated with carvings of actual or mythological persons central to history and ideology. H. 23 in.

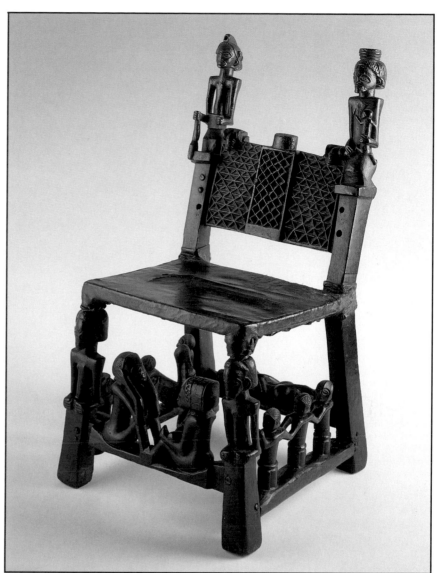

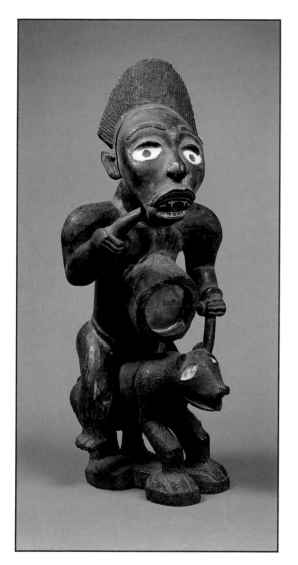

FIG. 18. This Kongo power image, *nkisi*, of wood and magical materials represents the metaphorical riding of a spirit animal, perhaps by a diviner or priest. H. 13 in.

FIG. 20. Humorous masked impersonations of an overly affectionate European couple in a Yoruba celebration for ancestors. The man writes "I love you" on the woman's face with a pen.

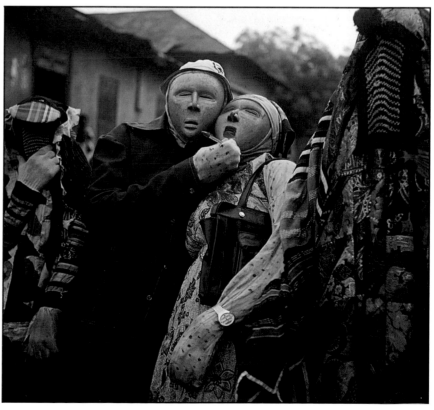

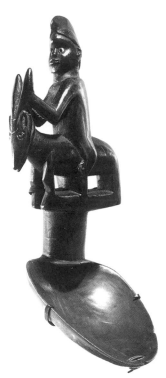

FIG. 21. Finely carved wooden spoons were undoubtedly prestige objects for Bembe people. H. 5¼ in.

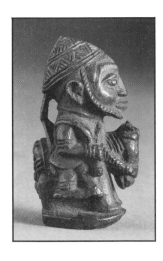

FIG. 22. Miniature ivory carvings of the Yoruba trickster god Eshu often watch over divination ceremonies. H. 2³/₁₆ in.

The Lives of Art

Art lives and works in complex ways in Africa. Although anthropologists and art historians tend to refer to the "functions" of art, that rather mechanistic term does not do justice to its vital, communicative role in culture. Its dimensions are social, political, economic, religious, psychological, and aesthetic, at least. In the daily and ceremonial round, these aspects of a given artwork all interrelate as different facets of an organic whole, though one may be dominant in a specific context or for a given observer. Thus an outsider might be most struck by the artistic character of the Fante chief's lofty dance, whereas a subchief might be intimidated by his confidence or a rival by his apparent wealth.

The social dimension is notable in art that indicates the age, affiliation, wealth, or status of its owner or user. Houses in a domestic compound, by their size, decoration, and appointment, communicate the social standing of the residents. Other objects of a social nature include household utensils and furniture, plus items of personal decoration and display: clothing, jewelry, walking sticks, pipes, and combs. A finely carved Bembe spoon (fig. 21) signals the prestige of its owner—perhaps his or her membership in an elite organization—since most Bembe people do not own embellished spoons.

Politically oriented objects, which belong to states, leaders and their advisers, help separate these offices from people at large. Numerous hand-held objects—staffs, weapons, fly whisks, long-stemmed pipes—are prerogatives of office. Furniture and architectural decoration dramatize the environment of leadership, helping to focus attention. Still other political objects can be regulators of behavior; in many cultures, for instance, masked spirits serve as police and judges. Relationships between art and leadership are elaborated below.

Most art also has economic dimensions. The artist is paid in money or in kind. Art is frequently wealth; objects are often made of valuable materials such as ivory (fig. 22), metals, or beads that were themselves actively exchanged currencies or were expensive to procure. Art serves the economy critically too when used in rituals to guarantee the food supply, whether hunted animals or harvested crops. Much art also concerns health, which affects the economy because healthy people, fields, and animals are productive and valuable. A shrine that helps cure disease or ensure the safe delivery of robust babies, for instance, contributes greatly to the economic and social order (fig. 23).

As in the case of the shrine just cited, a very large and diverse number of art objects have strong religious orientations. Two such examples are a Kongo wooden bell (fig. 173), owned by a diviner who used it to call spirits to ritual, and a tiny ivory horseman representing Eshu, the animated Yoruba trickster god (fig. 22), who in this form is believed to watch over the process of divination. A great number of the figural sculptures in Africa and in this book symbolize deities, spirits, or their messengers, while many other objects are vital to ritual process; their manifold lives are explored later in the chapter.

Although the psychological roles of art are difficult to document and prove, they are no less present. Art objects and their situations of use may arouse people to responses such as fear, devotion, guilt, or confusion that are not otherwise accessible. Consider, for example, the personal altars maintained by Igala and Igbo males for their own good fortune and success. Periodically, and certainly prior to any important undertaking, they pray and sacrifice to their personal gods at these altars, *okega* (fig. 24) or *ikenga*. A stroke of bad luck on occasion might trigger a man's anger toward his personal god; alternatively, should success exceed expectations, feelings of pride would not be unusual. Masks elicit more dramatic psychological responses. The almost exclusive use of masks in Africa by males, especially in view of recurring myths that women discovered and first danced them, suggests some interesting psychological

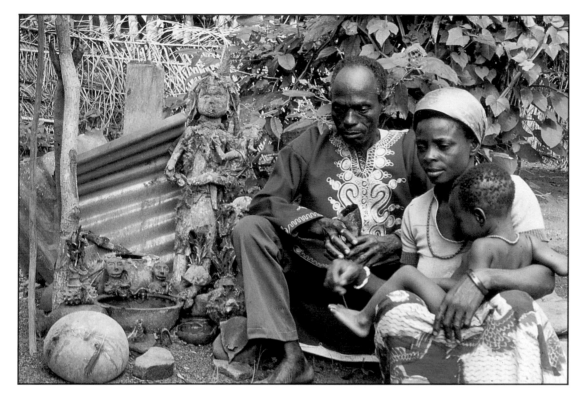

FIG. 23. This shrine was erected by the man in the picture when his young son almost died shortly after birth. It includes a mother-and-child carving, a ceramic vessel with medicinal waters, and medicinal plants.

questions. What anxieties caused men to usurp this right? What compensatory roles do women have? How do men feel when they embody female spirits? How do women respond seeing men impersonate and satirize them?

Aesthetic response too is an elusive yet important dimension, perhaps easier to grasp at a performance than in the silence of a shrine. The satirical European couple who continually embrace at Egungun festivals, striking postures both unseemly and ridiculous for their Yoruba audience, bring quick laughter (fig. 20). Finely tuned performances are appreciated everywhere on the continent; when especially fine, they elicit financial rewards. Local reactions to excellent painting and sculpture are poorly documented, but they too are certainly conditioned in part by artistic quality. A print by the artist Shilakoe (fig. 25) gains emotional impact from the poignant drawing and strong composition of the subject matter, a South African family group.

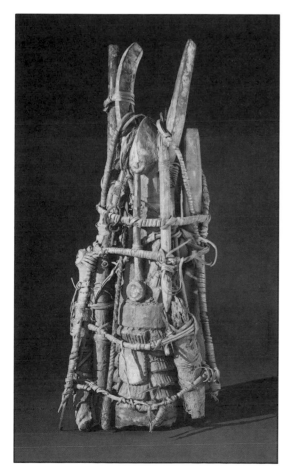

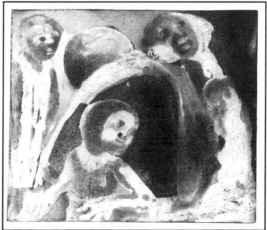

FIG. 24 (*far left*). *Okega* are shrines or altars owned by individual Igala men, who make prayers and sacrifices to them to ensure personal success. H. 24½ in.

FIG. 25. Contemporary African artists use imported materials and techniques in their works. This etching of a South African family is by Cyprian Shilakoe. 13 x 14½ in.

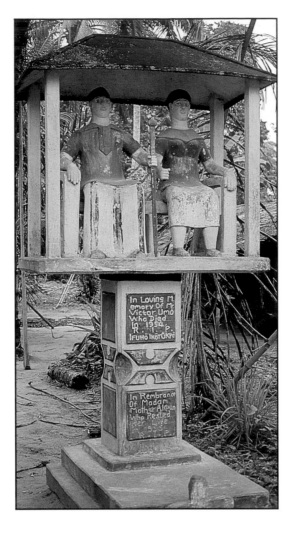

FIG. 26. The Ibibio started making cement grave memorials rather than cloth ones in the 1950s. Earlier styles in cement, like this, were generalized. Later, more naturalistic portraits began to be made (see fig. 191).

Table 1. Visibility Continuum

High Visibility/Public Display

Increasingly Secular

Increasingly Spiritual

Commercial signs (fig. 27)
Ibibio grave memorials (fig. 26)
Fante *posuban* (fig. 1)
Igbo *mbari* houses (fig. 14)
Cameroon portal sculpture (fig. 12)
Modern paintings, prints, drawings (figs. 25, 30)
Entertainment masks (fig. 20)
Regalia (jewelry, fly whisks, pipes)
Akan linguist staffs (fig. 29)
Cameroon display sculpture (fig. 82)
Yoruba palace doors (fig. 200)
Akan state swords (fig. 36)
Igbo/Igala *ikenga* (fig. 108)
Asante shrine figures (fig. 8)
Senufo/Baule divination figures (fig. 73)
Igbo deity figures (fig. 32)
Benin ancestral altars (fig. 106)
Bamana Gwan figures (fig. 115)
Chamba/Verre shrine figures (fig. 74)
Kongo *nkisi* (fig. 18)

Low Visibility/Spiritual Power

Visibility as an Index of Power

The relative visibility of an African work of art often gives viewers a clue to its charge of mystical, spiritual power. Secular, primarily socially important arts may be highly visible and accessible. In contrast, objects with great spiritual potency are normally hidden from view. This is evident, for example, in reports about divine kings. They were insulated by protective palace structures and vast ranks of counselors and servants, and when they did appear in public, it was only infrequently. On those rare occasions, clothing and regalia swathing the king created a striking collage: the art was visible, but the king's person was not (fig. 122). In fact, all art objects have relative degrees of visibility and accessibility; these can be pictured on a continuum (table 1).[3] Contrasting notions of power work at the ends of the visibility continuum, running from secular, emblematic display to spiritual, veiled instrumentality.

Modern public arts make direct, open statements intended to reach large numbers of people. In this category would be murals, signs, grave monuments (fig. 26), garden sculptures, decorated portals. Royal display pieces such as doorways and houseposts, although appearing on the surface to be different from written or pictorial advertisements, have analogous intentions: attention getting, persuasion, and propaganda. The king himself may not be accessible, but his powers can be and often are "advertised." Actual commercial signs, such as those by the artist called Middle Art, are of course prominently displayed (fig. 27). Combining as they do serial, cartoonlike drawings and written legends, his signs have special relevance to the largely literate urban audience in the bustling market city of Onitsha, Nigeria, one of the largest commercial centers in West Africa. In this painting, Middle Art, whose given name is Augustine Okoye, is showing off his talent as a graphic artist, a "sign writer."

Art housed indoors, yet on open view, is less accessible than that on public view. Fur-

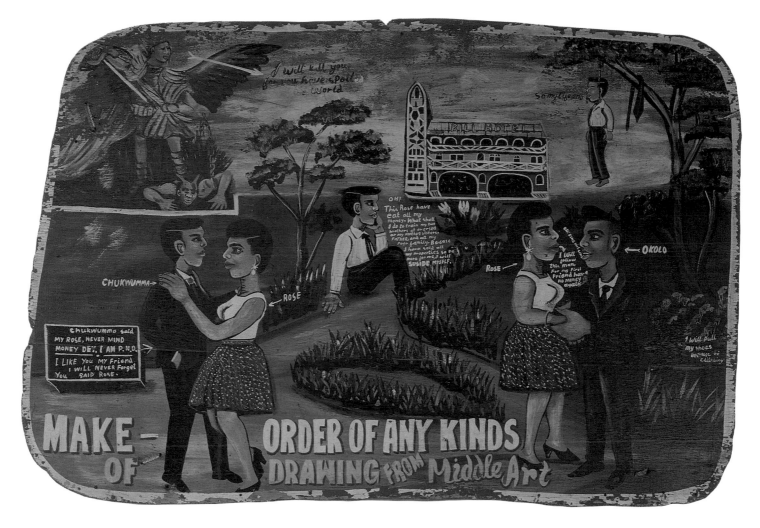

niture and nonpotent items of title regalia are examples, along with paintings, prints, and sculptures whose primary purpose is to decorate the home. All such works provide aesthetic pleasure and simultaneously make statements about social or political standing.

Still less visible—somewhere in the middle range of accessibility—are other objects that may have some spiritual or political potency calling for more restricted use. Entertaining masks are of this sort; although not powerful spirits, they are unlikely to perform often in public. Certain items of regalia such as staffs, fly whisks, pipes, and jewelry are also in this range. Examples are politically oriented staffs with ivory and gold-leafed finials, prerogatives of a Kongo chief and an Akan chief's spokesman, respectively (figs. 28, 29). In each case both the exclusive, noble materials and the motifs serve mainly emblematic purposes. The Kongo ivory female, seated upon a leopard, is probably a reference to chiefs, some of whom are women in this matrilineal society. The gold-leafed Akan linguist staff, on the other hand, signals its bearer as a chief's

counselor. Its finial prompts the proverb "The hen knows well when it is dawn but leaves it to the cock to announce," a reference to decision-making processes and gender differences. This adage comments upon the overt declarative authority of the chief (or male) and the behind-the-scenes wisdom of his counselors (or his women). The staffs, though primarily metaphorical, are carried and gestured within ceremonies, giving them some instrumentality. Neither visible, emblematic values nor those of instrumental power, of course, need be seen as mutually exclusive.

At the low end of the continuum are those things (or people) of the highest spiritual potency: sacred personages, shrine figures, ritual masks, and implements of great power, such as those used as oracles, for sociopolitical control, or in judging disputes. Rarely are these openly displayed; instead they are veiled or hidden entirely lest people mitigate their spiritual efficacy or inadvertently suffer their hazardous effects. The Kongo power figure, *nkisi*, mentioned earlier (fig. 18), is such an object. Its indwelling spirit power, believed to heal disease,

FIG. 27. Painted and written advertisements, like this sign by Augustine Okoye (known as "Middle Art"), are relatively recent phenomena associated with the rise of urbanism and increasing rates of literacy. $27^{3}/16$ x $41^{3}/4$ in.

FIG. 29. Gold-leafed wooden staffs are carried by Akan linguists, major advisers to chiefs. Staff finials like this one encode wisdom about leadership, power, and wealth. H. of full staff 66³/4 in.

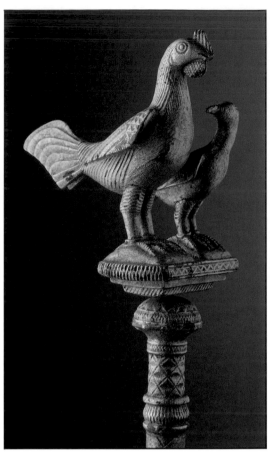

weaken an enemy, or seal a contract, had to be well protected. An instrument of such enormity must be shielded from sight and access.

Many figures now on open view in museums or books were not freely visible in Africa but were kept in small bedrooms or diviners' chambers, partly hidden with cloth, or in shrines of limited access. Monumental Bamana figures (fig. 115) were removed from their shrines only occasionally. Some terra-cotta figures from the Inland Ni-

FIG. 28. Ivory and leopards are associated with leaders. This is a finial for a Kongo chief's staff of office. H. 7¹/2 in.

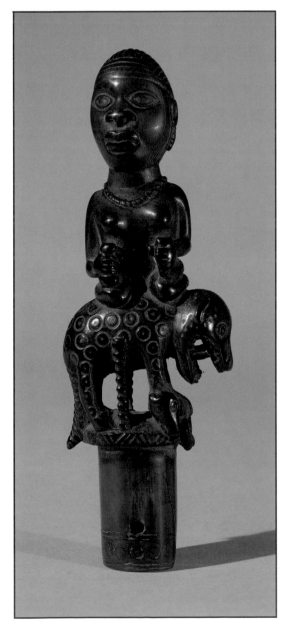

ger Delta were apparently made for interment with deceased persons; they were probably visible only for a short time. Statuary in several Cameroon kingdoms was brought out for temporary display, sometimes as centerpieces for state ceremonies, sometimes as backdrops for ritual. Even when figures are made primarily for display, as some Cameroon carvings were, their effectiveness depends in part on the fact that they are seen only infrequently.

The clay images of powerful Igbo deities that are publicly visible for several years in *mbari* houses would seem to be exceptions to the foregoing. *Mbari* figures are self-consciously artistic to remind people of the strength of the gods and the need to honor them. Yet these display figures have less artistic wood counterparts, considered more spiritually potent, that are housed in far less accessible shrines.

The visibility continuum is also useful in charting change over time. Some objects start out on the visible-display-secular part of the continuum but gain spiritual efficacy with age and use. Examples of this process are masks of the Dan, Mano, and nearby peoples of Liberia and the Ebira of Nigeria. They start life in public masquerades of low potency and become progressively elevated over time to oracles, deities, or healing spir-

its (Harley [1950] 1975; Picton 1987, 14, 17). A few become (or became)[4] so dangerous that not only are they never worn again in dances, they are also closed away in shrines, being too potent even for priests to handle. Historically these works move to a lower zone on the continuum.

An opposite movement—from less visible to more visible—has also been occurring for several decades. Many masks and other once-powerful objects have been losing their spiritual charge, becoming more secular. Masquerades once involved in social regulation may be performed today only to entertain or to lure crowds to hear the speeches of modern politicians.[5] Larger numbers of publicly visible art objects in villages and towns disclose the growing influence of outsiders, especially Europeans and Americans. These include murals, signs, cement sculptures, and other forms in materials and styles introduced within the last few generations. A repoussé aluminum relief of hunters under a tree exemplifies such modern trends (fig. 30). Expanded trade, Western education, Christianity, and the increased availability of foreign ideas and images are among the many reasons for these changes.

Dominant Roles: Spiritual Authority and Human Leadership

It is difficult to overestimate the extent to which the "life" of African art is framed by beliefs in the supernatural and connected with the exercise of leadership. A large percentage of the art discussed in this book partakes of both. Leaders invoke spiritual sanctions in their efforts to govern, and powerful deities and the personnel that represent them are also effective leaders. In fact divisions between "sacred" and "secular" life in Africa can easily be overdrawn, as divine kings attest, for they have one foot each in temporal and spiritual realms. Yet as we have seen, objects may be oriented in one or another direction, and their separation for purposes of discussion and analysis can be useful.

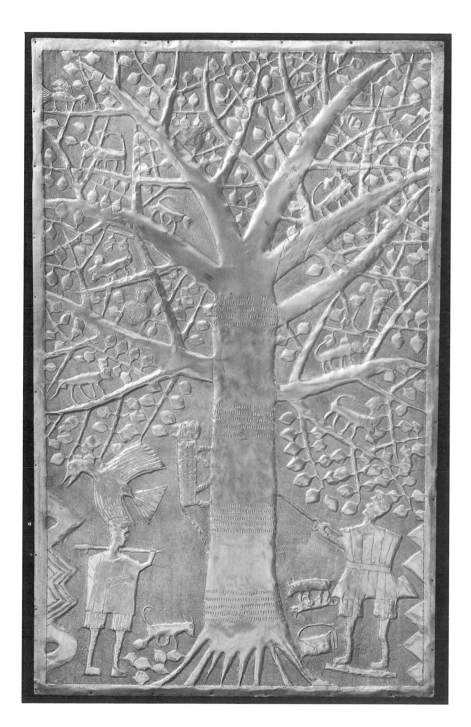

FIG. 30. The Yoruba artist Asiru Olatunde is one of several working in the town of Oshogbo, Nigeria, which under the encouragement of Europeans became a major art center in the 1960s. Asiru's panel, a hunting scene, is aluminum repoussé. 54³/4 x 34¹/4 in.

FIG. 31. Ancient sche-
matic rock art images of
human beings are found
in many parts of Africa.
These are from the now
uninhabited Tassili
region of the Sahara.

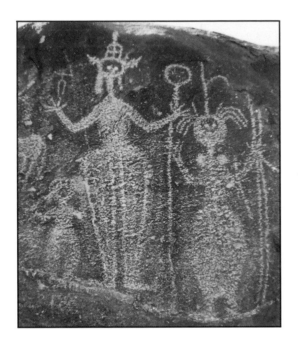

Art and the Supernatural

The visible materialization of unseen natu-
ral and supernatural forces is a basic African
impulse, as it is in most parts of the world.
Human imagery, a great deal of it realized
artistically in the five icons, is a major focus
for these powers.[6] Rarely, though, is a clay
or wood figure itself considered a god or
spirit. Rather it is a vehicle or symbol, a
tangible indication of something ineffable
that nevertheless compels belief. African art
often exists to embody spirit forces, to aug-
ment the effectiveness and emotional im-
pact of rituals, to remind people, through
visual metaphor or allusion, that they are
only in part responsible for their destiny.

Early Arts. The earliest African art tied to
supernatural belief is doubtless that found
on rock surfaces in the Sahara, followed by
paintings and engravings in the southern
and eastern parts of the continent. Al-
though the dating of rock art is problematic,
animal petroglyphs precede human imagery
and seem to have been made first in the
Late Stone Age, about the seventh and
sixth millennia B.C. By about the fifth or
fourth millennium B.C., all the icons except
the rider had appeared, although their

meanings are uncertain. Couples may refer
to primordial ancestors, but we will never
know their precise significance (fig. 31). Be-
cause hunting and gathering provided sub-
sistence in that era, however, the specialists
who interpret some rock-art imagery as re-
lating to hunting rituals are probably cor-
rect, and images of armed hunters are
common.

The earliest sculpture known, Nok terra-
cottas, was made in the latter half of the first
millennium B.C. and into the first centuries
of the Christian Era, coeval with the agri-
cultural revolution and the development of
ironwork. Two woman-and-child images,
numerous human heads and body frag-
ments, a few complete humans, including
some Janus images, and animal sculptures
are known from the Nok corpus. They are
presumed to be religious sculptures, perhaps
related to ancestral remembrance and agri-
cultural rites, but solid data on function and
meaning are almost wholly lacking.

More data, or at least plausible interpre-
tations,[7] accompany the even richer and
more artistically spectacular terra-cottas and
bronzes of the Inland Niger Delta region of
Mali, where the first four icons, and proba-
bly the fifth (stranger), are known (for ex-
ample, fig. 67). Objects dating from about
A.D. 1000 to 1500 and have been recovered
from burial mounds and ritual sanctuaries
in an area of several thousand square miles.
Funerary use suggests but does not prove
the existence of ancestor veneration. Sacri-
fices to ancestors could well have been made
at other altars containing terra-cotta im-
ages. Snake cults and other shrines in these
areas also probably addressed agricultural,
animal, and human productivity, still a ma-
jor preoccupation in the region (de Grunne
1980, 1987).

Basic Beliefs and Rituals. The essential fea-
tures of African belief systems that give rise
to so much art among agricultural peoples
are clear.[8] Basic beliefs were most likely in
place by A.D. 500 to 1000 in West Africa
and A.D. 1400 to 1600 in Central Africa.

FIG. 32. Many shrines, like this one dedicated to gods that oversee the health, fertility, and prosperity of an entire Igbo community, have large "families" of images, as if to show off the gods' success.

Generally, these include the acknowledged existence of a remote "high god" who is the original creator; this god is almost never represented in art. Numerous nearer deities and spirits, somewhat like people, are more actively worshiped in prayer and sacrifice. These anthropomorphized supernaturals are often associated with aspects of nature such as earth, forests, watercourses, and other topographical features, as well as with aspects of culture such as markets and war. They are often symbolized in works of art (fig. 32). Animals, plants, and other natural phenomena are also spiritualized, sometimes as messengers of more powerful gods. African gods and spirits are considered neither inherently good nor bad. Their actions are dependent upon the behavior of human beings, who must honor the gods, uphold their moral laws, and make periodic offerings at a shrine or altar.

There are also widespread beliefs in a kind of power or energy in human beings, nature, and many special artifacts that are artfully embellished. In the human population, ancestors, elders, chiefs, and kings have the greatest charge of potency. Since most societies are ruled largely by elders, supernatural power strongly affects political and social authority. Believing in a human cycle from birth to adulthood to elderhood to ancestorhood—and often to reincarnation—most agricultural peoples venerate ancestral spirits. Ancestors influence both their living descendants and the world of nature, especially the ground, where departed people live.

Funerary celebrations and other rites of passage are strong magnets for artistic display and performance. Ancestors are commemorated by sculpture in some regions—especially in parts of Zaire (fig. 131)—but more often they are brought into the community as spirit masquerades. These masked apparitions of the "living dead" entertain the living, who offer prayers and sacrifices to assure ancestral aid in stimulating productivity: abundant food and many children. The cleverly fabricated mother-and-child masquerader (fig. 33), danced by a man, is part of the Yoruba ancestral festival called Egungun. This icon can be seen as a sculptural, performing prayer for continuing ancestral help.

Rituals that effect the transition of young people to adult status also invoke the arts, and through them, the gods. Masquerades are again frequently employed to materialize spirits that help initiate and socialize novices during their training period (fig. 88). Sometimes masked spirits are believed to swallow youths, killing them symbolically; novices are later reborn as adults. Initiates learn that human beings wear masks and costumes to embody spirits. In some places, they learn to make and dance masks, and they perform masquerades at their "graduation" ceremonies.

FIG. 33. Most African masquerades are performed by men, even when the characters are obviously female. The mask, wooden breast plate, and child create a convincing illusion for this Yoruba spirit character.

Shrine Arts. Of all the African art made in the service of religion, shrine art is the most plentiful, and it accounts for much of the art illustrated here. African shrines vary widely in purpose, place, and form. Shrines or the altars that compose them can be personal or communal. They exist to honor and invoke ancestors, founding heroes, or spirits of the mysterious wild (usually called "bush spirits"). There are antiwitchcraft shrines, shrines for war or medicine (fig. 23) or thunder, iron, or earth, for messenger spirits consulted by diviners, for personal guardians, oracles, and many other deities.

Altars may be inside buildings or outdoors, public or obscure, simple or elaborate, at village centers and in every compound, in gardens, at crossroads, deep in forests, and on hilltops. A shrine is built wherever the gods are likely to dwell or call for sacrifice. Even some kinds of clothing, as well as amulets worn as jewelry, are in effect altars because they are material objects ordered by a spirit believed capable of exerting influence through them.

The lives of shrine objects—their histories—are as variable as the shrines that house them. A shrine sculpture may have been central in the assemblage of display and power materials representing, praising, or calling attention to a deity. It received the offerings destined for the god or stood in the background, a witness to these and other ritual activities.[9] Invariably art was more than simply decoration. Clearly, most ritual figures in Africa led active lives and were treated as vital, appreciated members of the community. They were sacrificed to or otherwise manipulated; caressed, worn, carried about, and danced; reactivated with nails, magical bundles, or applications of pigments; adorned with clothing and jewelry; and addressed with prayer, song, and gesture.

Northern Igbo shrines (fig. 32), for example, house families of deity figures that are regularly "fed"—recharged by being given sacrificial food and by being repainted and clothed. Once a year in some communities, all figures from several shrines are brought out for a festival of images. They are paraded by worshipers to the compound of the senior god and then arranged in a large semicircle. Embellished with camwood body paint and dressed up in cloth for public display, the dozen or more figures receive gifts of chalk, kola nuts, and coins (fig. 34). Libations are poured while prayers or petitions are offered. This assemblage occasions a large thanksgiving feast by devotees, who recall the year of blessings made possible by the tutelary gods represented by the carved figures.

FIG. 34. Annual festivals in some Igbo communities call for assembling wooden deity figures from all the separate shrines at the compound of the most important god. The images are dressed up and given offerings.

Art and Leadership

Many African art forms have critical connections with the exercise of leadership. These derive in part from supernatural ties, since leaders invoke spiritual aid to buttress other forms of authority. Nevertheless, the political dimensions of the art can be considered separately from the spiritual ones.

There are as many kinds of leaders in Africa as there are types of sociopolitical organization. It is in centralized states, with single kings at the apex of a pyramid of title-holders, court officials, and servants, where relationships between art and leaders are clearest. In the eighteenth and nineteenth centuries, before the imposition of colonial rule, such rulers presided in the Akan states, the Dahomey Kingdom, the Benin Kingdom, some Yoruba city-states, many Cameroon Grassfields kingdoms, the Kuba Kingdom, and elsewhere. These individuals controlled wealth and had the power to appoint officials, make war, and take human life. Gaining power from gods and dynastic ancestors, they defined morality and meted out justice, reward, and punishment. Many of these men had exclusive control of the services of artists. They ordered art, paid for it, and strongly influenced its character. Art was directed mainly to their glorification and the augmentation of royal strength in

all spheres; then, through royal offices, it worked for the benefit of the people.

At significant festivals in the realm of a paramount leader, the arts of dress, architecture, and performance work together in a number of ways. They make authority visible. They commemorate events and people. They define roles. By contrast and aggrandizement, they identify various offices in royal hierarchies. In manipulating space, these arts separate noble and royal precincts from common ones.

The annual royal festivals, or "customs," celebrated in nineteenth-century Dahomey exemplify the political lives of art in such a context. These events drew people to the capital from outlying parts of the kingdom. A tall tentlike pavilion shielded the king; the chiefs were sheltered by huge umbrellas. These, as well as large showy banners, were appliquéd with motifs referring to the greatness and invincibility of the state and its leaders, who are aggrandized by their regalia (fig. 35). The visual motifs referred to complex verbal "strong names" and praises elaborating vaunted military and other powers. Some of the banners commemorated great events, particularly glorious victories in the history of the state itself and in the lives of specific chiefs. These festivals involved lavish spectacles at fixed sites and colorful pro-

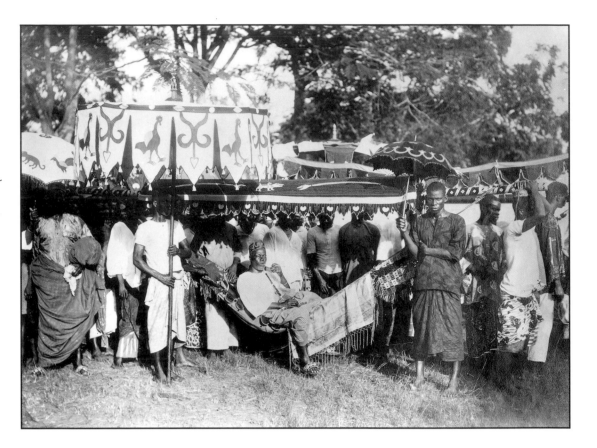

FIG. 35. Umbrellas of several kinds, litters, and cloth with appliquéd images figure prominently in the festive regalia of Dahomean chiefs.

cessions. The common people of the kingdom came to witness the might and majesty of the court and its wealth, yet the dramatic qualities of the celebration also intimidated some people and helped keep them at a certain distance. Dahomean royal treasures—some of them artworks of silver and other opulent, imported materials—were paraded on the heads of several thousand people. Some of this wealth was then given to soldiers and other loyal subjects as rewards for faithful service. "The kings and the court knew how to play on strong feelings of awe, fear, and pride by presenting themselves in splendor to the population" (Adams 1980, 31).

Overall, these festivals in Dahomey, with their declarative messages reinforcing an image of rulership already strongly stated by regalia and other forms, are parallel to the aggrandizing events recorded in Benin plaques and Cameroon architectural carvings. All of them have a passive quality in that they look back at the glories of the past or at the putative strength of leaders in the present. They are reflective arts rather than action-oriented ones.

Leaders also control art forms as active instruments of political policy, helping to effect change and create new relationships. Chiefs set art in motion to communicate among themselves and to mediate between the courts and the people. Leaders dispense art objects (or the right to them)—items of regalia to wear and hand-held implements—as identifying prerogatives of titles they have established and filled. Leaders cause judicial decisions to be executed by masqueraders; spiritual sanction and anonymity lend credibility to their actions. Weapons and staffs, by virtue of their shapes or sculptured motifs of known, conventional meaning, have been especially useful devices for communication (fig. 36). Some Akan state swords have cast gold or gold-leafed ornaments celebrating the military, financial, and spiritual strength of states and kings, along with the good character and wisdom of the latter. The messages are not simply boasts, for they are often addressed as warnings to a king's rivals. Other swords used in swearing allegiance, taking oaths of office, and purifying the souls of chiefs clearly have components of supernatural energy. Swords also provided safe conduct for Akan ambassadors in hostile territory. Each Dahomean king had many staffs with specific figurative "messages," often proverbs encoded in sculptural form; when such a staff was delivered by a messenger, its recipient was required to obey the communication. Akan linguist staffs also crystallized proverbial or emblematic statements in their carved, gold-leafed fini-

als (fig. 29), but these have little of the coercive force of Dahomean staffs. Such examples prove that art is definitely among the powers wielded by heads of state. Lesser chiefs in turn manipulated other kinds of art to inform and sometimes impel the people.

Less visible leaders in less centralized African polities also invoke works of art to further their goals and express their authority. They commission and deploy art as often as more evident leaders and according to many of the same principles. Such "smaller" leaders are also likely to use art for community welfare as much as for personal aggrandizement. The war captain who contributed funds to help build his military shrine, *posuban* (fig. 1), and the earth priest who led the building of an *mbari* house benefited large numbers of people while also advancing their own causes.

Councils of elders or associations of titled men, like war chiefs or priests, are leaders who collectively administer much of the art in their respective societies. Not only do they have some form of visible regalia, they also activate art for many purposes, including masquerades for initiation, social regulation, and commemoration and a host of religious statuary for cults exercising moral and spiritual authority. Because thousands of these leaders exercise their limited powers in many individual cultures, the art they control exists in great quantities and varieties. It is present and effective but less obviously tied to leadership than the arts of the great kingdoms.

What is clear for leaders in all African societies, regardless of sociopolitical structure, is that they are actively engaged in creating culture. Leaders cause art to be made, often dictating specific form and iconography. In conjunction with artists, chiefs and other patrons invent art. Then, in commanding its use, they have a strong hand in molding the events and the people for whom they are responsible. In short, African art has the power to move people, whether actually or figuratively.

FIG. 36. State swords are often carried at festivals by young male members of a chief's entourage. They refer to maxims that reinforce the power and wisdom of the chief and his state.

FIG. 37. Though the rider in this quite realistic Benin equestrian casting has not been positively identified, the saying "Only the king rides on horseback" (Nevadomsky n.d.) strongly suggests it is the king himself. H. 18¹/₄ in.

3 Iconic Conventions
The Ideology of Form

The distinctive appearance of works of art from Africa results from many historical and ideological factors. Each society produces objects—often several types or traditions of art[1]—that are not easily confused with those of its neighbors in style and form. These hundreds of traditions are enormously varied, but most of their artworks share one overriding characteristic: they are substantially different in form from the living creatures on which they are based.

Even a casual glance at the imagery in this book makes it clear that the exact physical likeness of humans and animals has rarely been of paramount concern to African patrons and artists. The large cast Benin equestrian (fig. 37) is rendered with precise detail and attention to nuances of texture. The caster who made the image was concerned with representing realistic feathers in the headdress, but not with "accurate," naturalistic proportions in either the rider or in his relationship to the mount. The heads of both man and beast, if judged against their living prototypes, are enormous in relation to their bodies. But this is not a man riding a horse. It is a sculpture. The point is made much more forcefully by an ancient, very schematic, tiny copper alloy horseman carrying a shield from the Inland Niger Delta region of Mali (fig. 38). It has no details at all, not even facial features. Its proportions are strongly exaggerated. Yet for viewers it evokes an image of a person on a horse quite as well as the Benin figure does. Both sculptures rely on visual conventions to key our recognition and memory of horsemen.

FIG. 38. Tiny abstract, severely economical equestrian figures in copper alloy come from excavated tombs in the Inland Delta of the Niger River. 1¹/₂ in.

Style Tendencies

African artists work within sets of formal parameters by which their art can be localized geographically, if not always chronologically.[2] In figural art, such parameters have to do with shape, size, emphasis, and the relationships of one part to another and to the whole—in short, with all visible aspects of formal structure. These qualities of a work of art, or a series of related works, are generally referred to as its "style." In characterizing figural sculpture on the African continent, it is useful to identify two distinct spectrums of style. The first is a continuum from naturalistic, or even realistic, rendering to that which is highly abstract. The second concerns postures, which range from casual and informal to idealized and formal.

Naturalistic to Abstract Spectrum. The styles of the Benin and Malian equestrians are at opposite ends of this spectrum: the one complex and volumetric, the other simple and linear. The Benin figure exemplifies one of the more realistic styles in Africa. Sculpture from the court of Benin owes much to artists' perceptions of the way people, horses (or mules or donkeys), feathers, clothing, and other things actually look. The sumptuous rendering of the horseman is characteristic of other cast copper alloy images from Benin; in this stratified culture, artistic detail is favored partly because it records minor distinctions of dress that signal rank and status. This equestrian was probably used as an altarpiece in the palace to commemorate a specific leader, most likely King Esigie, who ruled in the sixteenth century.[3]

The image from Mali, on the other hand, is done in a reductionist, nearly abstract style that is highly conventionalized. This is a conceptual image, one that captures the notion of a person riding a quadruped. The artist did not attempt either to give a naturalistic look to the anatomy and texture of the person and mount or to depict their proportions accurately. The spare, economical style of this horseman stems partly from its small size (its purpose is unknown),

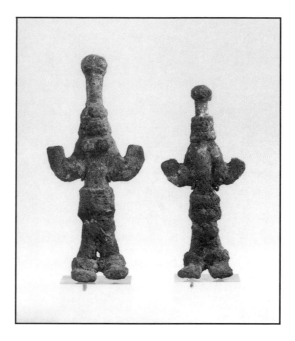

FIG. 39. This schematic, formalized couple of unknown identity in copper alloy is from the Inland Niger Delta region. H. 3½ in. (female) and 3 in. (male).

FIG. 40. Wooden shrine figures in highly conventionalized styles are characteristic of several northern Nigerian peoples. H. 17½ in. (left) and 15½ in. (right).

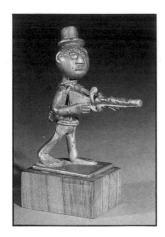

FIG. 41. Armed hunters or warriors, posed informally, are fairly common subjects in the vast corpus of miniature Akan goldweights. H. 2³⁄₈ in.

FIG. 42. Secular Dan castings, five or six times the size of Akan goldweights, show considerable detail. They are often informally posed. H. 8 in.

FIG. 43. Court scenes and images of chiefs tend to be more formally posed than people in everyday activities. This is a goldweight. H. 2 in.

which makes detail hard to render.

Many other images from nearly all time periods are highly stylized. Compare, for example, an ancient copper alloy couple (c. A.D. 900–1500) from Mali (fig. 39) with a relatively recent pair of wooden shrine figures from the Wurkun people of northern Nigeria (fig. 40). Both threaten to become unrecognizably abstract because of the simplification and schematization of body parts and facial features.

Two-dimensional imagery also spans the spectrum. Early rock engravings and paintings range from naturalistic, detailed, and lifelike to rigidly simplified and schematic (fig. 31). The painting and graphic arts that have proliferated over the last several decades likewise cover a broad range of styles, although strong illusionistic influences from Europe and America—descriptive conventions such as foreshortening, perspective, and shading—have increased naturalistic

tendencies. The works showing these traits are almost entirely secular.

Informal to Formal Spectrum. Figural images also range in posture or position from casual, informal, and lifelike, on the one hand, to stiff, frontal, and formalized on the other. The Benin equestrian just discussed, like most art from the Benin court, is at once relatively naturalistic and strongly formal. Dogon art, which ranges from naturalistic (fig. 65) to schematic (fig. 64), is usually quite formal. This range of postures may be observed even within a single genre, as in Akan goldweights or Igbo *mbari* houses. Some goldweights, those depicting people in casual pursuits, have a rather lifelike quality, as if the artists, being free of the stock imagery of royal courts and shrines, had license to evoke the realities of daily existence creatively. Men poised to shoot (fig. 41) or women going about their daily chores with

children tied at their backs (fig. 6) are good examples of this informal genre. Secular Dan castings (fig. 42) are also often casual and lifelike. Other goldweights, however, depict personages and scenes that are more rigid and idealized. They speak of hierarchy and imposed order—in figure 43 a chief is elevated on a chair of royal prerogative. This is a miniature counterpart of the dignified queen-mother figure discussed earlier (fig. 9), an even better example of formality in posture. In *mbari* houses there are many sculptures depicting informal scenes and postures (fig. 89). These tend to be situated in secondary positions—for instance, on the back side of the house or in a separate gallery.[4] Icons of deities, on the other hand, are usually stiff and idealized (fig. 79), and they usually appear at the center of the most accessible side of the monument.

Two-dimensional renderings tend to be on the informal end of the scale. Rock paintings, even when schematic, often capture informal postures and gestures (fig. 15). Painted icons are rarely found in ritual or other formal contexts;[5] however, they occur commonly in the work of twentieth-century

artists such as Djilatendo and the early glass painters of Senegal (fig. 44). Typically, figures painted by these artists are not only naturalistic but also informal. Here, too, the influence of European imagery is evident.

For most iconic images made more than thirty or forty years ago, the tendency is toward idealized formality (fig. 45). Formal, canonic styles are characterized by prevailing frontality (profile in the case of riders), immobility, symmetry, conventionalized positions of weapons and children, indeterminate or youthful adult indications of age, and generalized human features. Sculpture is preponderantly rigid and balanced along the vertical axis; human proportions are interpreted freely, with great emphasis given to the head. Some canonic traditions are richly detailed (for example, Benin, Kongo), while others suppress detail, lending scale to sculptures that are sometimes actually small (for example, Dogon, Lega). Expressed negatively, this art does not show people in natural or casual poses, nor does it catch action in mid-stride. It avoids lifelike asymmetry, realistic proportions, and the subtleties of age, mood, and personality.

FIG. 44. Senegalese artists paint formal and informal scenes on glass panes. The image is applied to one side of the pane and viewed from the other. The couple shown here seem to be at ease in their prosperous colonial setting. 13 x 18⅞ in.

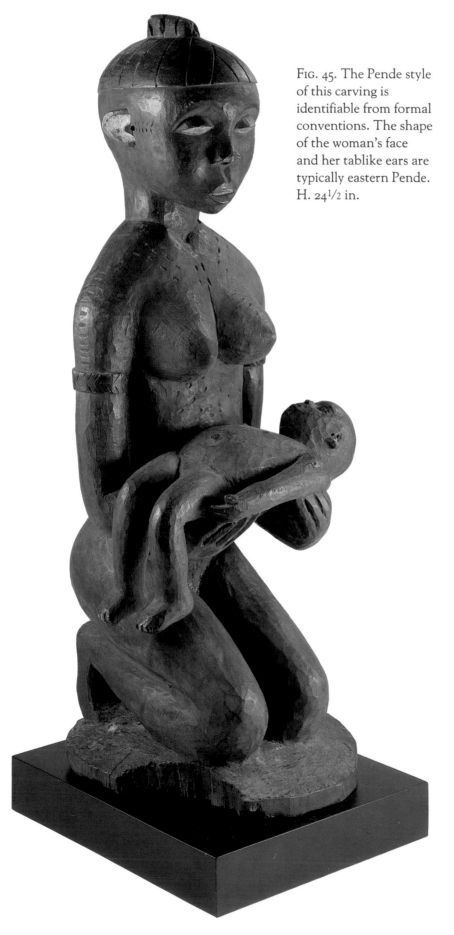

FIG. 45. The Pende style
of this carving is
identifiable from formal
conventions. The shape
of the woman's face
and her tablike ears are
typically eastern Pende.
H. 24½ in.

The Ideology of Form

African peoples make a distinction between
the ideal and the real, between the happen-
ings of legendary or mythical time and the
lived events of chronological time. In short,
they see art as different from life, however
much their art may draw upon and evoke
the realities of life. This becomes clear by
comparing prevailing African concepts of
portraiture with Western ones. Photography
and other literal, descriptive systems in
painting and sculpture are common in the
Western world, but this has usually not
been the case in African figural arts except
under strong European influence. (The ex-
ceptional naturalism of ancient Ife [fig. 68],
is an anomaly in this respect and also
surely not the result of European stimulus.)
Most African representations are neither
imitative portraits of actual people nor
reportorial scenes based on artists' direct
observation.

Many African peoples make "portrait"
images, but with few exceptions, these are
generalized renderings. They are recogniz-
able to their audiences not because of idio-
syncratic facial likenesses but because they
are designated as portraits and named for
real people. They may be personalized by
having the subject's facial markings (scars or
tattoos) and perhaps hairstyle. Mostly, how-
ever, they are portraits because people say
they are and know whom they represent.
Some cultures actually forbid the making of
recognizable portraits of any sort, believing
them to be offenses against gods or spirits.
The Owerri Igbo, for instance, believe that
creating a true likeness of someone in an
mbari house will cause his or her death.

The majority of images are not intended
to represent living people. Gods, spirits, and
ancestors are not thought of as having spe-
cific features, such as an aquiline nose or
projecting ears, or, in some cases, as having
bodies at all. They are of concern to living
people because of their many powers and
responsibilities. Physical likeness seems irrel-
evant to the salient qualities of spirit beings.
These qualities are not really visible, but

they are nevertheless concretized in visual representations.

The dichotomy between the ideal and the real is strongly evidenced in Dogon art. The idealized, improbable appearance world of Dogon art and myth is far different from actual everyday life.[6] Myths, for example, speak of orderly house and village plans that cannot be found in real communities, just as most figural sculpture, in its distortions and simplifications, is far removed from its apparently human models. Both myths and sculptures are conceptualizations. Douglas (1975, 128–30) sees the "world of appearances under the control of Nommo [mythical progenitors]." She notes that "formal judgments, curses and blessings," as efficacious rites, belong to Nommo, whereas the tangible world belongs to the Fox, the oracular animal. Dogon sculpture also apparently belongs to the world of Nommo, for it seems largely to depict them in their multiple guises as mythical progenitors who handed down eternal truths (fig. 46, 64, 65). These received truths are in actuality quite different from the reality of life itself (as interpreted by the Fox). This very contrast, however, provides a key to understanding the canonic, idealized character of imagery among the Dogon and many other African peoples.

Most traditions of shrine sculpture, like those of the Dogon, have been tied to conservative ideals maintained from early times by repetition. Analogous climates of image making arise out of political ideologies, which are most evident in African kingdoms. Although historical change can be observed in these traditions, it has been incremental and slow until recently. The icons are commissioned to support value systems espoused by patron leaders, who do not normally welcome experimentation and innovation.[7] The genres are relatively closed, repetitive, and self-perpetuating.

Thus formal qualities have often hardened into conventions that, being spiritually or politically appropriate, occur with very minor changes over and over again,

like the rituals themselves. Indeed, a significant aspect of the efficacy of art is its expected familiarity. Artists look to the familiar sculptures of previous generations and are more influenced by these models than by living people.[8] The icons, therefore, tend not to imitate the observable realities of African life, with its flux, irrationality, and inconsistency. Instead, they speak of order, immutability, and inner realities, which are suggested by visual conventions.

Ideological Disproportion. In contrast to life forms, African sculptures and paintings quite often exaggerate one part or more of the body. The head is normally disproportionately large. Next in emphasis, particularly in relation to the legs, is the torso; legs are often disproportionately short.[9] Much ancient rock art and the earliest sculpture known from sub-Saharan regions, Nok terra-cottas (c. 500 B.C.–A.D. 200), have proportions that greatly exaggerate head size. The same is true in the thirteenth- to fifteenth-century art of Ife, which is otherwise very naturalistic (fig. 68). Recent fieldwork documents this emphasis on the head as reflecting a belief in its value as "leader," the seat of intelligence, identity, will, the force or breath of life. The torso, with stomach, heart, and other organs, is next most esteemed and emphasized; it is

FIG. 46. Abstractly rendered images of Dogon couples are quite common. This is a heddle pulley, part of a man's loom. H. 8½ in.

FIG. 47. An amusing, whimsical equestrian puppet from Mali, certainly carved by a man with a sense of humor. The rider, with his exaggerated long, sharp nose, is probably a caricature of a European. H. 13¾ in.

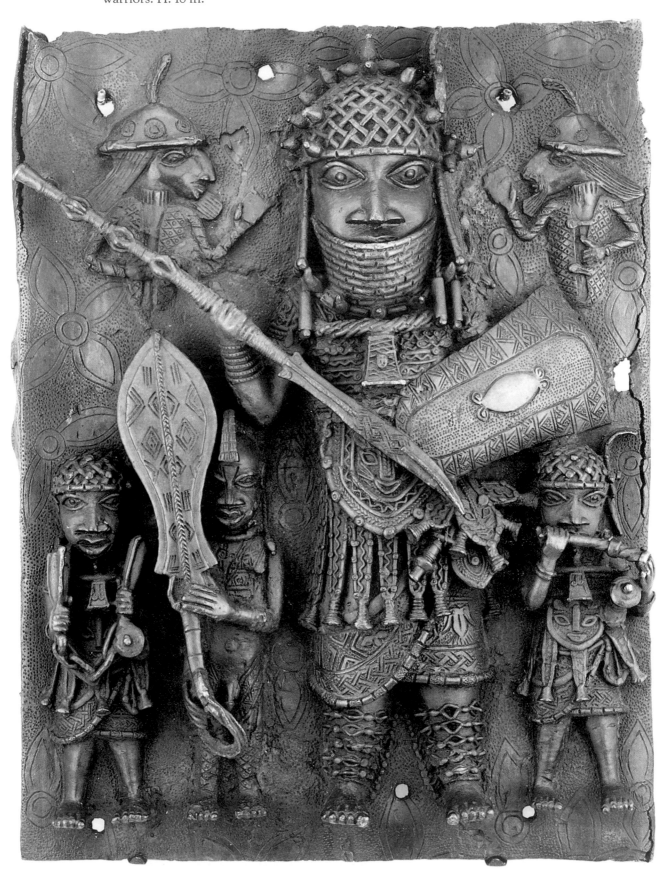

Fig. 48. A cast copper alloy architectural plaque from the Benin Kingdom. Portuguese strangers are depicted in lower relief and far smaller than Benin warriors. H. 18 in.

the locus of sustaining digestive and reproductive powers. Legs may be neglected sculpturally.

Reasons for differently scaled body segments among the Igbo were dramatized for me by an Igbo priest's responses to questions about the proportions of a formal seated goddess in an *mbari* house (fig. 79). Her enlarged head extends upward to dramatize the massive, elaborate hairstyle formerly worn by wealthy titled women. Neck and torso are elongated "to show her dignity, her stature," said the priest. When I pointed out her short legs, the man quipped, "Ah, but the legs are not what you put your eyes into," as if to say they make her complete but they are unimportant to her overall visual and ideological impact.

Equestrians and group compositions show disproportions of a different sort. Human beings often dominate their mounts, which are less important culturally despite greater actual size (fig. 47). Subsidiary human beings in multifigure groups, as in Benin plaques, are rendered smaller than the focal dignitary whom they flank, because such a leader, often considered "larger than life," is ideologically the most important (fig. 48). Similar gradings of size and scale are found in Akan, Dahomean, Yoruba, Urhobo, Kalabari Ijo (fig. 107), and Cameroon Grassfields renderings of multiple figures. All these are cultures that have pyramidal sociopolitical structures.

Many prehistoric rock paintings and engravings also show variable scales of representation. In some cases, human figures have diminutive mounts or massive weapons or enlarged genitalia (fig. 49). In others, the humans are proportionately small in comparison with large game animals or cattle, which were probably dramatized in thought and therefore in art because of their crucial role in subsistence or ritual.

Formal Conventions. Still other sorts of formal conventions stem from regional ideas and ideologies. The origins and reasons for many of these are lost to history, but some

rationales survive. Elongated, ringed necks, for example, are widely distributed across the landscape of African art (fig. 50). The prevalence of this trait reflects the great admiration many African peoples have for long necks, especially in women, and for neck rings, ridges, or lines, which are thought to betoken beauty, prosperity, and good health. The fact that no real woman looks like the sculpture of her region is irrelevant given the distinction between the idealism of art and the reality of life.[10]

Many local preferences also manifest themselves in art, helping create distinctive ethnic styles. Mothers among the Asante and other Akan groups, for example, sometimes flattened their babies' heads because slightly elongated foreheads were appreciated as beautiful; Asante and related Akan

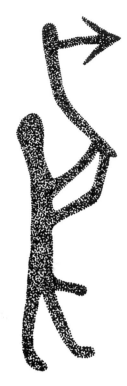

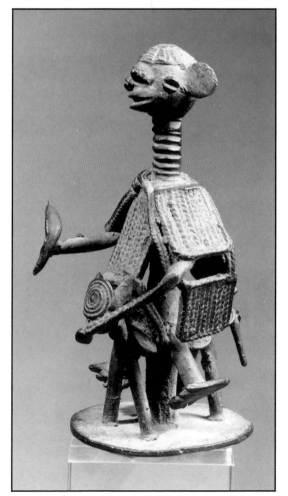

FIG. 49. All artists are selective, stressing some aspects of their subjects while neglecting others. The creator of this rock image, which is only a few inches high, chose to emphasize the relationship between male sexuality and aggression.

FIG. 50. The ridged neck is one of many formal conventions of this stylized rider casting, probably made in northern Nigeria by the Tiv. H. 6 in.

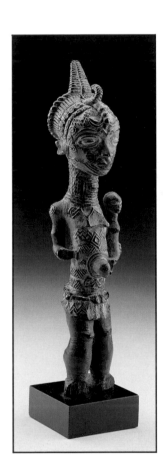

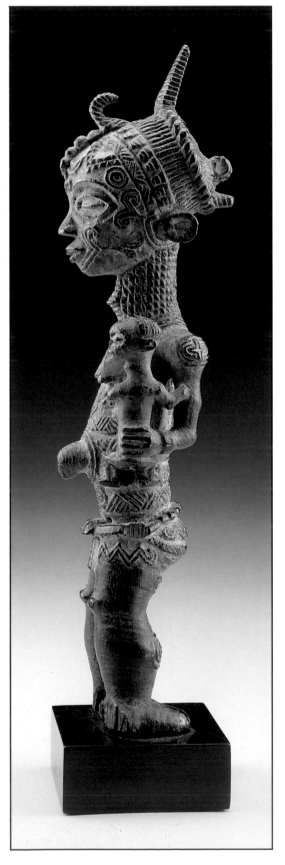

FIG. 51. Body decorations such as scarifications, tattoos, and fine hairstyles, as in this Bena Lulua maternity carving, are usually considered signs of beauty and cultured, adult status. H. 12 in.

figural styles show distended foreheads and disk-shaped heads.[11] In Baule carvings, prominent bulging calves reflect the Baule people's esteem for highly developed calf muscles, which refer to strength and a person's capacity for hard work (fig. 204; Ravenhill 1980, 8).

Similar emphasis in Baule art and elsewhere is given to scarification (or tattoo) patterns and elaborated hairstyles, which are far more than simply matters of fashion. They mark bearers as appropriately socialized, civilized members of the community. Finely dressed hair marks a socially responsible, educated person; particular styles are often age- and status-specific. Permanent body marks are generally acquired as part of the initiation process that turns children into adults. In many sculptural traditions, these emphatically visible social indicators are more exaggerated than on actual people, as if to telegraph their prominence in local concepts of a beautiful, cultivated, and moral person. Bena Lulua carvings make this point clearly. They show large keloidal scars raised to exceptionally high relief, whereas the people themselves had tattoos rather than keloids (fig. 51). The maternity sculpture in figure 51 also has a highly exaggerated navel hernia; many African peoples consider hernias beautiful.

The extent to which dress is shown in African art is highly variable. Although modesty forbids the display of genitalia in real life, sculptured human figures—especially shrine images—are often depicted nude and with visible genitalia. It should be noted that some images, although created with genitalia, are intended to be clothed in their African setting; however, many are left unclothed. This is neither immodesty nor a preoccupation with sexual matters but rather a need for human beings in art, as canonic models, to be mature, complete, and thus ideal. A clue to the ideology of these depictions comes perhaps from a Thonga proverb: "To bear children is wealth, to dress oneself is [nothing but] colors" (Finnegan 1970, 396). It is as if the po-

tential for procreation must be proclaimed publicly in images of gods or ancestors despite codes of modesty among the people themselves.

From the foregoing it should be clear that style and iconography in Africa are informed—given form and shape—by the ideology of culture. Style is the result of many factors: the sociopolitical structure and belief system; the type, context, and use of the iconic object; the identity of the being represented. The geography and history of the makers and of the art tradition itself also come into play, although these factors are elusive and difficult to assess.[12] One conclusion, however, is inescapable: African art is not a duplication of anatomy. Overwhelmingly, it is an interpretation of multiple realities. Just as myth and ritual encode ideas and actions perpetuated from an undisclosed antiquity, so are these icons quite often compressed, idealized visual statements. They are more akin to poetry than to ordinary speech.

Artists

Although objects made in the same area tend to have a recognizable style or appearance, it is usually harder to discern the individual "hand" or style of the artist. Unlike Western artists, who strive for personal expression, African artists have traditionally been at the service of a communal ideology. Though inventive geniuses do exist, most art is not characterized by idiosyncratic style, for artists are more skilled copyists than innovators. Their work is fashioned with slight variations on the models inherited from forebears. Most artists are not concerned with creative invention; their mission is to transmit the enduring values of an inherited tradition. They hold clear visions of intended results, with little left to chance.

Both men and women make art, usually of different sorts. Men, as sculptors and smiths, are responsible for most ritual arts. Because men fashion magical ingredients and execute sacrificial animals, the lower

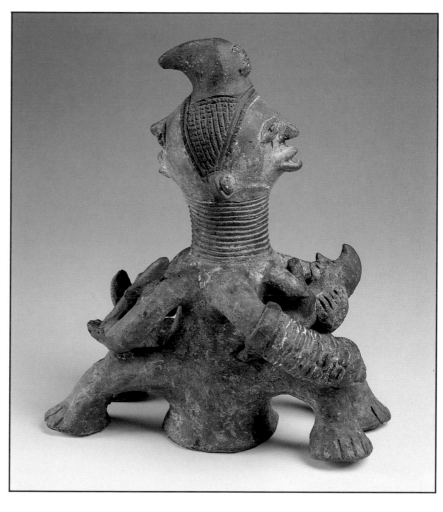

zone of the visibility continuum (table 1, p. 28), contains male products. Women's arts, in contrast, often embellish surfaces such as the human body, sculpture, and walls, and their work belongs mainly to the upper zone of the visibility continuum. Women are potters, calabash decorators, painters, and often basket makers. Their arts stress envelopes and containers, usually of soft materials. In contrast, men work with more durable materials (except for some terracotta sculpture made by women [fig. 52]). Hard, sharp, pointed weapons and tools are only made by men.[13] Both men and women can be weavers, although not usually in the same textile traditions. In recent decades, men have embraced secular, two-dimensional arts both for commercial purposes and for "art's sake" and exhibition.

FIG. 52. Janus spirit figures of terra-cotta embellished the shrines of doctors, diviners, and priests in northeastern Igboland (see fig. 23). H. 12 in.

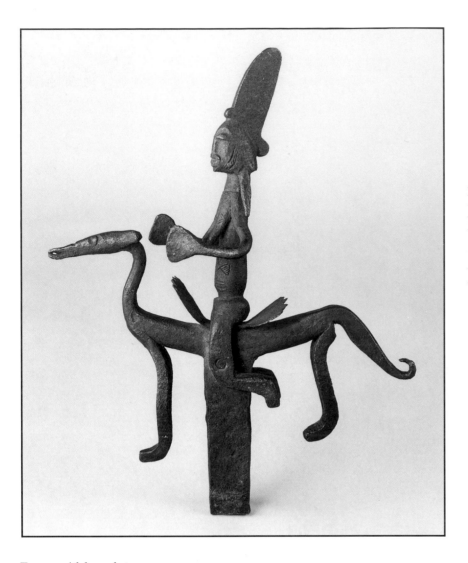

These works include glass painting, sign-boards, murals, and vehicle decoration, as well as framed canvases and graphics.

Most artists in Africa are well-trained, part-time specialists. The recruitment and training of artists varies widely on the continent. Some are born into families of artists and have little freedom to choose a life's work. Others make art because it pleases them or because they are talented and want to supplement their income. A number of artists are trained within apprenticeship systems that are more or less formally constituted, but others learn carving or painting techniques by informal observation and practice. Those involved in metal casting or forging receive specialized training. Blacksmith descent groups of the Western Sudan (among the Dogon, Bamana, Senufo, and others) guard the mysterious secrets of earth and fire required for forging iron. This privileged knowledge, which enables them to create essential tools, weapons, and sculpture for shrines, earns them special respect, fear, and power in the eyes of farmers from other groups (fig. 53).

Materials

Materials are bearers of values. Most raw materials chosen by artists are meaningful. Wood, for example, may come from trees inhabited by spirits; masks or figures made from such wood have spiritual dimensions. The medicinal ingredients used to construct Kongo power images have wounding or healing or transforming capacities. Lustrous gold is precious, while ivory connotes the strength and endurance of elephants. White chalk is cool and pure in some places where red pigments stand for blood and danger. The use of varied ingredients, then, helps articulate the relationship between form and meaning in African art, although it would be a mistake to say that all materials are always symbolic. European red cloth, prestige indigo and white tie-dyed cloth, eagle feathers, leopard skins and teeth, and elephant-tusk trumpets in the reception chamber of a powerful Igbo chief all bear messages; most viewers are sensitive to the sometimes elaborate codes of meaning with which these substances are endowed (fig. 55).

Wood, as the overwhelmingly dominant material for art in Africa, is used for all kinds of objects. Some African peoples distinguish between masculine and feminine trees, carving specific objects from each.[14] Male woods, such as African oak, are hard, strong, and termite resistant. They are used when durability is desired and heavy weight is not a deterrent. In parts of Nigeria (at least), male woods are carved into shrine figures, architectural elements, furniture, and implements. Several mask types and other lightweight, portable objects are carved from woods considered female. Often, whether the tree is male or female, its indwelling spirit must be placated by sacrifice before it is felled and carved.

A host of other substances are also used to make or embellish art. Some materials come from specific, often hazardous parts of the natural environment, such as river-banks, forests, or termite hills, or from wild animals; others derive from man-made

sources (for example, glass and nails). Because they are accorded medicinal capabilities, harmful potential, and other power-working qualities, they must be carefully organized and controlled.

Riverain and termite-hill clays have special uses in art and ritual by virtue of their spirit associations. Termite clay, an explicit symbol of proliferation among the Igbo (see p. 22), is used to make figures in *mbari* houses, built to promote fertility in the land and people. Clays are often the province of women, who are responsible for pottery everywhere and terra-cotta (baked clay) in some areas (fig. 52). Female creativity in clay can be linked with the primordial, mysterious creativity accorded women in many African mythologies. In these mythologies, they are named as the original creators or discoverers of masks and other ritual apparatus.[15] By some female transgression of correct behavior, so the male-transmitted myths say, men were obliged to take over these enterprises; thereafter, women were barred from them forever. Such myths seem to acknowledge women's exclusive creative role as mothers and perhaps reveal male jealousy toward women. Edo women who fashion images and ceramic vessels for shrines dedicated to Olokun, a god of creativity (fig. 54), use spiritually charged river clays, as if to recapitulate god's original act and their own god-given creative power.[16]

Many power materials have what may be called "signature elements" that are directed to specific ends or stand for certain qualities (Rubin 1974, 10). Thus snakeskins may signify transformation. Porcupine quills are weapons in the aggressive masculine masks of the Bamana and Senufo. Bird beaks and feathers, various antelope horns, snail shells and so forth—all key elements in survival—are also exploited for art. Leopard pelts, claws, and teeth evoke the nobility, ferociousness, beauty, and mystical aura of the animal; when transferred to leadership contexts, these elements, like elephant tusks, project multifaceted powers (fig. 55). A number of these materials appear in both instru-

mental and display contexts, but it is unusual for strong power substances, such as ivory or metals, to have democratic usage. Rare, exclusive, expensive materials have ideological weight by virtue of these elitist qualities, in addition to their other associations.

The rarity, color, luster, and virtual permanence of various cast copper alloys (mainly brass and bronze) have particular power associations in several areas. In Bamum (Cameroon Grassfields) brass is called "red iron" (Geary 1988a, 111). There and in Benin the color of polished brass is likened to blood and is thus threatening. Its shiny surface is considered frightening; copper alloy objects are thought to be spiritually charged, as well as beautiful (Ben-Amos 1980, 15). These metals, in addition to gold, silver, and ivory, are rare and expensive. Of-

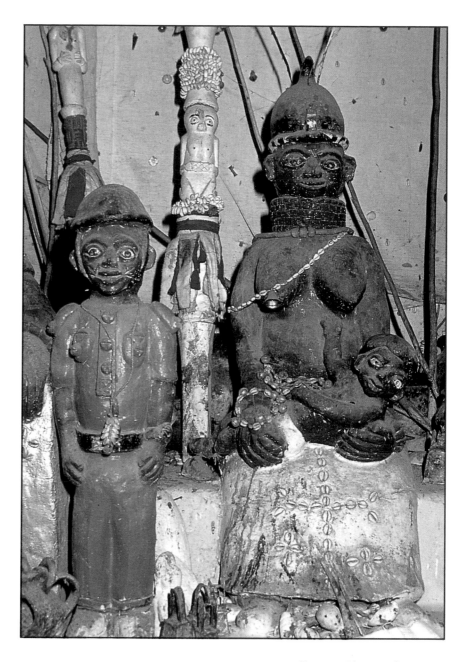

FIG. 54. Shrines for Olokun, god of the sea, wealth, health, childbirth, and creativity in Benin, often include mother-and-child images. Beautiful women and children are sent into this world by Olokun.

FIG. 55. The reception room and regalia of this important Igbo chief mix heirloom ritual symbols—elephant-tusk trumpets and skulls of sacrificed animals—with more recent artifacts of imported materials.

instance, they too were appliquéd to numerous items in several regions. Many materials, such as beads and metals, once served as trade currencies and continue to have high monetary value. Their inherent worth and their frequent origins in the outside world bring status to objects made from them (and to their owners); these exotic materials are overt declarations of worldliness. Most cement monuments, like Fante *posuban* (fig. 1) and the now widely dispersed funerary sculptures of West Africa (figs. 26, 191), are quintessential display pieces. These have added prestige in local eyes because they are painted with European enamels. Glittering, showy, valuable materials also embellish a large number of performance pieces such as Malian puppets (fig. 119) and masks (fig. 16), as well as the ceremonial dress of important onlookers.

A beaded Yoruba showpiece from the early part of this century epitomizes the integration of material, iconography, form, and meaning (fig. 56). Thousands of richly colored beads, sewn on a stiff cloth armature, constitute the entire surface of the sculpture. Crowns and other beaded regalia have served Yoruba kings (and other leaders such as diviners) since ancient times, for they are clearly reproduced in Ife images (fig. 68). The twentieth-century sculpture in figure 56 was apparently commissioned by the king of Ikerre and given by him to a British envoy. An aggrandized version of a king's conical beaded crown, it condenses notions of royal display. A royal wife or queen mother, with a child at her back, surmounts a tall cone. The cone extends upward from an ancestral face (or mask), as if supported by it. Several devices—symmetry, formality, differentiated scales of human figures, the exaggerated size of the woman's head and breasts, the sumptuous beadwork—all work together to project ideology. The royal woman and the ancestors, the sculpture suggests, are surrounded and protected by servants and armed warriors. Like the beaded crown, it acts to assure the continuity of kingship.

ten considered noble, their use for art, their ownership, and their visibility have been correspondingly restricted.

Display-oriented art forms, whether or not wood, are often enhanced with special substances that add to their visibility, sumptuousness, and meaning. Various colored pigments, beads, bells, cloth, mirrors, porcelain plates, metal appliqué, and shells are among these. When glistening, highly colored glass beads became available in nineteenth-century trade with Europe, for

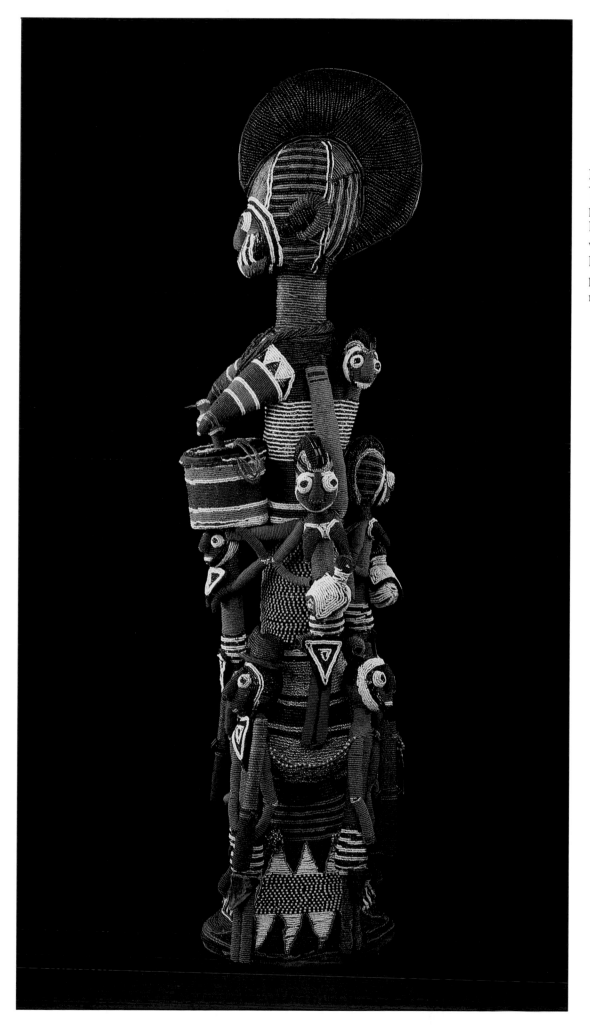

FIG. 56. This large Yoruba beaded display piece, which resembles a king's crown, features a woman with a child on her back. She is supported by several armed men. H. 41 3/4 in.

4 Two as One
The Male and Female Couple

FIG. 57. This pair of male and female carvings from the Tabwa of Zaire are representations of revered ancestors. H. 18¹/₂ in. (male) and 18¹/₄ in. (female).

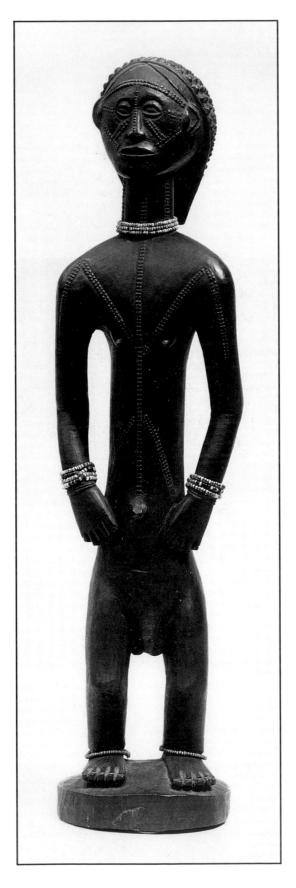
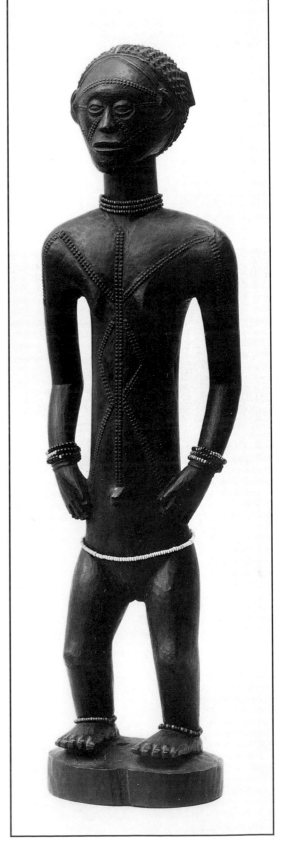

Images of the male-female dyad have a great range of identifications: married couples, otherworld lovers, mythical progenitors, community founders, twins, ancestors, and a host of other gods and spirits. Behind such labels lie rich constellations of meaning that account for the existence of painted, sculptured, and danced representations of couples in Africa. These help people understand themselves, the world, and the paradox: two are one.

Sculptured Couples

The most common sculptures of couples are two freestanding figures conceived as a unit; they are normally identical in style and pose and nearly so in size (fig. 57). Sculptures are made in a variety of materials: ivory (fig. 22), iron (fig. 53), copper alloy (fig. 58), and terra-cotta, although most are wood. Their sizes vary from a few inches to over six feet, signaling many different contexts and uses. Standing figures, the most common, are distributed everywhere sculpture is made; seated couples are less frequently seen, but they are not rare. Frontality, symmetry, and reduced detail lend to most a formal, canonic quality, a sense of rigid monumentality whatever their actual size. There are also more informally posed images, however, such as the goldwight couple who share one chair and appear to be conversing (fig. 59).

Most couple figures were created for shrines and represent nature spirits and other tutelaries. Occasionally, couples embody the spirits of ancestors—for instance, the conventionalized pair of supports on a Zimba stool (fig. 60; see also fig. 131).[1] Ancestor figures are almost never recognizable portraits of individuals; they are generalized according to canons of local style—idealized, not personalized—and named as often for families as for specific people. Like images of gods and spirits, ancestor figures have a sculptured formalism that reinforces the stable, enduring nature of supernatural beings in African belief.

Postures of ceremonious dignity are widespread in African codes of self-presentation,

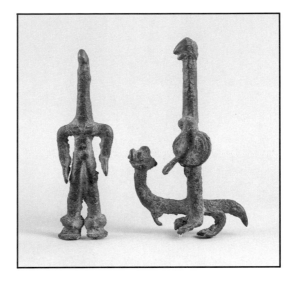

FIG. 58. Cast copper alloy couples, like many Inland Niger Delta images recovered in archaeological digs, were originally interred as funerary offerings. H. 3⁵/₁₆ in. (female) and 3¹/₂ in. (male).

as can be seen from the history of photography on the continent. When sitting or standing for a portrait, people insist on being dressed well and posed firmly, frontally, and symmetrically. Even today, most African people staunchly resist candid, casual photography in favor of the formal portrait (fig. 61).

Cross-Cultural Ideological Values

One couple is portable and cast in enduring brass (fig. 62). Another is stationary and made of sun-dried clay, which the rain will melt after several years (fig. 63). The first comes from the Yoruba peoples in southwestern Nigeria. The second was modeled by Igbo artists, also from Nigeria, 250 miles to the east. A comparison of these couples and the ideas they engender demonstrates some of the complexities of the couple theme in African systems of thought.

The brass male and female sculptures, known as *edan*, represent founders of a community. They are sacred emblems of membership in the Ogboni (or Oshugbo) society, a Yoruba organization with powerful political and judicial functions. Ogboni membership includes the senior chiefs of the town and its most important women. Meeting at a lodge called "The House of the Spirits of the Earth," members are responsible for upholding the original spiritual sanctions gov-

FIG. 59. The couple forming this Akan goldweight appear to be conversing with one another. They are seated on an old village chair. H. 2¹/₄ in.

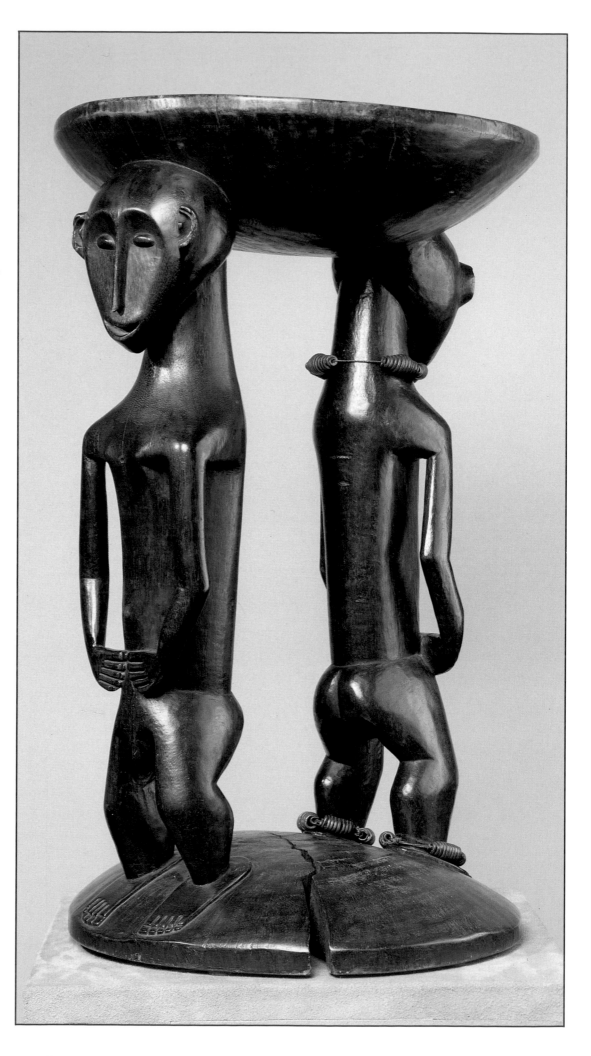

FIG. 60. Carved wooden caryatid stools, like this example from the Zimba peoples of Zaire, imply that the sitter is being supported by the personages represented—in this case, probably ancestors. H. 15 in.

erning human society. Ogboni sets the standard for human behavior, adjudicates violations, such as the spilling of blood, and holds kings to account. Its emblems, owned by each Ogboni lodge and by every member, crystallize the highest and deepest of Yoruba values. Each member receives a pair of *edan* to signal induction into Ogboni.

The *edan* images are made by the lost-wax casting process. First modeled in wax on an iron spike, they are covered with fine and then coarser layers of clay. After the wax has been melted and drained off, the clay serves as a mold, providing a space into which molten metal is poured; the mold must be broken to yield the casting.[2] Although the figures are cast separately, they are made at the same time and subsequently joined by a chain because they represent the founding, primordial couple, Yoruba counterparts of Adam and Eve. The set of *edan* in figure 62 is probably of nineteenth-century manufacture.

The clay couple, about half life-size and more colorful and modern in appearance than the *edan*, was made in an *mbari* house in 1962. The male figure that looks like a white man is in fact Amadioha, the Igbo god of thunder. The other figure is identified as his wife. Amadioha wears prestigious imported clothing, associated with high status and thus high titles. His wife's mirror-studded headdress and densely painted arabesques also indicate elevated stature, but her attire is less modern than that of her husband. Amadioha's fair skin, according to Igbo people, stems in part from his association with the brilliant whiteness of lightening and in part from the fact that all gods are given light skin in *mbari* to honor them. This couple is modeled on the side of an *mbari* house dedicated principally to the earth goddess Ala, sometimes also considered Amadioha's wife or consort (although she is not the wife depicted here). Amadioha's stature as a god is confirmed by his ritual staff, drinking horn, and bag decorated with bells, but particularly by the iron bar that elevates his, and his wife's, feet

Nº 47. CONGO BELGE. — *Caporal clairon et sa femme*

FIG. 61. A Congolese couple were photographed for this postcard in a formal pose typical of the early colonial period. The uniform and dress, of course, are Belgian imports.

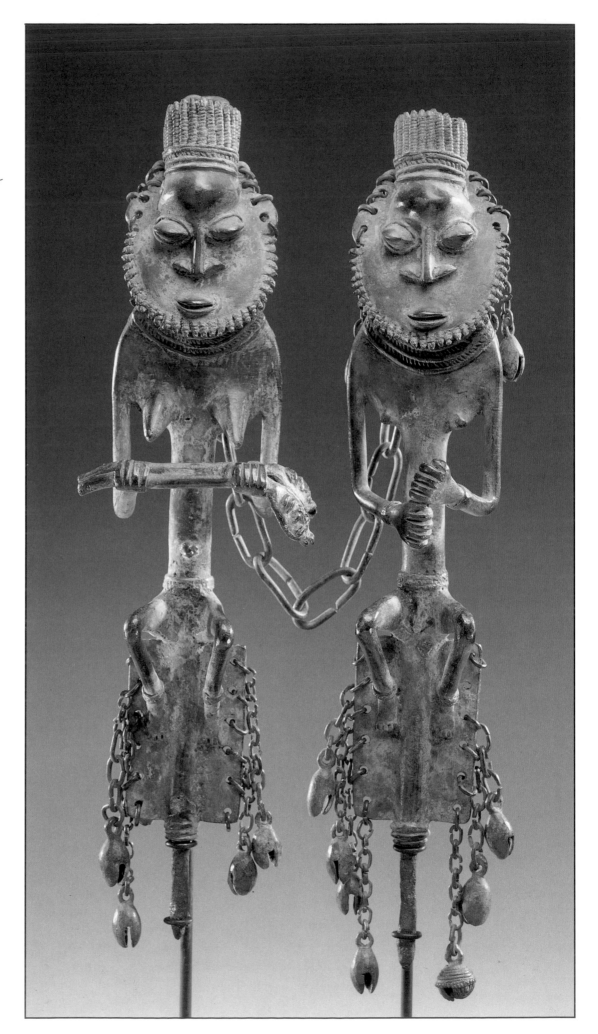

FIG. 62. The couple constituting *edan* Ogboni castings represent the founders of a community. H. 9¾ in.

above the profane ground. Although Amadioha is a centuries-old Igbo deity, his sun helmet, necktie, walking shorts, kneesocks, and shoes are evidence of the cultural influence of Europe.

An entire community pledges to erect this elaborate monument to Ala; each large *mbari* is an enormous, explicit sacrifice of human energy, time, and money. The two figures illustrated here were made by different artists—as is evident from the styles of the facial features—but this fact is unimportant to the local people. To them *mbari* figures are modeled not by human beings at all, but by spirits. Indeed, the workers responsible for the *mbari* are considered spirits. Symbolically killed as they enter the fenced enclosure that hides construction, the men and women chosen for the god's work live apart from their families for a while to signal their new status. The *mbari* figures themselves are also considered spirits, both because they, like the people, are children of Ala and because they are modeled from spiritually charged clay dug from deep within huge numinous termite hills, from whose "doors" humans are believed to reincarnate.[3]

As a couple, the *edan* pair are more important than Amadioha and his wife. The former are coequal founders of a town. In contrast, Igbo religious thought gives no importance to the wife shown with Amadioha; Amadioha, in fact, is often depicted by himself.[4] Surely, though, the artists were aware of the social importance of marriage and felt it appropriate to show the thunder god in a married state. So in making *mbari* figures, it seems, the artists took the creative prerogative given them by the *mbari* tradition to fill the large niche available with two figures rather than one.

The *mbari* figures embodied the artistic and social ideals of their culture in 1962. Then (as it is today), the larger and more visually impressive an *mbari* house, the more effective it was as a statement of the community's spiritual and financial offerings to its gods. A prestigiously attired deity

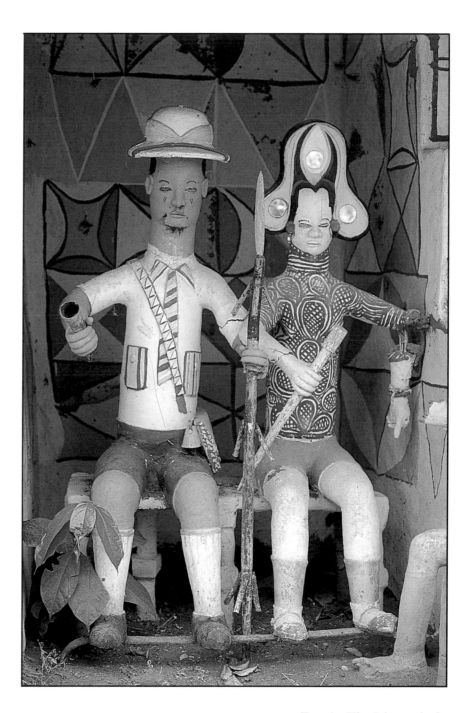

FIG. 63. The Igbo god of thunder, Amadioha, sits with his wife in an *mbari* house dedicated to the earth goddess, Ala. H. about 40 in.

with a classic, conservatively dressed wife contributed measurably to that commitment. In this couple, the community acknowledged the spiritual power of thunder, one of nature's most dramatic mysteries. The god should be well pleased.

The contrast between Amadioha's modern attire and his wife's more old-fashioned female dress probably also has psychological implications. This *mbari* was made in a rural, agricultural village at a time when "modern" women were often associated with the fast, loose life of cities. By contrasting the styles of dress, the older male artists seem to have been saying, "Keep our women at home, dressed and painted the old way, not with rouge and lipstick. It is all right for men to be modern, but women should maintain the ways of their mothers."[5]

The Yoruba castings, artistically elaborated far beyond ritual necessity, also speak of ideals. To be effective for ritual purposes, *edan* Ogboni need be no more than simple shafts surmounted by heads. The *edan* illustrated here are among the finest known; they were probably made for a wealthy, demanding patron, and certainly by a master artist. These fully detailed male and female examples, embellished with bells from their headdresses and basal flanges, both show meaningful gestures. The male displays the ritual thumbs-hidden, left-fist-over-right Ogboni greeting. The female holds two miniature *edan*—visually punned as twin children—in a female gesture of gift giving. Ogboni and Yoruba ideals, respectively, are expressed in these acitivities.

Despite the mandatory real-life modesty of Yoruba people, genitals on *edan* figures are depicted graphically; they are not covered and are sometimes exaggerated. This emphasis accords with the completeness expected of founding couples, making explicit their sexual nature and thus their childbearing potential. It is notable that Ogboni initiates and members are all nude at induction rituals (H. Drewal 1989).

The puzzling Ogboni saying "Two Ogboni become three" would seem to refer to the creation of family by having children. Marriage, family, and finally society would all appear to be the third element referred to in the saying.[6] The three are possible only in a moral, ritually sanctioned climate overseen and promulgated by the Ogboni society. The balanced Ogboni couple, linked by a chain as if to represent the social institution of marriage, stands at the foundation of Yoruba culture.

In many ways, *edan* and *mbari* couples could hardly be more different. The *edan*, an elegant set of matched, durable castings, have survived since the nineteenth century, possibly earlier. *Edan* and larger pairs are essential to Ogboni ritual and thought. The *mbari* couple, made of clay much more recently, no longer exists except in photographs, having returned to the earth, a sacrifice to the earth goddess. Amadioha is important in *mbari* and is normally present, but he is not focal, being only one of forty or more figures. The *edan* signal membership in a small, elite secret society. The *mbari* images, in contrast, recall a truly communal effort. Amadioha, although dressed in contemporary style, is a clay manifestation of eternal meteorological and biological processes—thunder, lightening, rain, and fertilizing maleness. The *edan* are sacred emblems about historical or even mythical beginnings. *Edan* are largely private and personal; an *mbari* is a self-consciously aesthetic public display.

As different as they are, however, both couples argue for the importance of art in their respective societies. Although the two sets of images were not created primarily as works of art, their effectiveness as cultural expressions, as artifacts, has everything to do with their being well-made, exemplary, locally approved, and affecting works of art. The sculptured couples are more than symbols, more than just expressions of ideas. They incarnate ideology, both in ritual process and artistic form. Yoruba and Igbo people understand these images, of course, without having them explained.

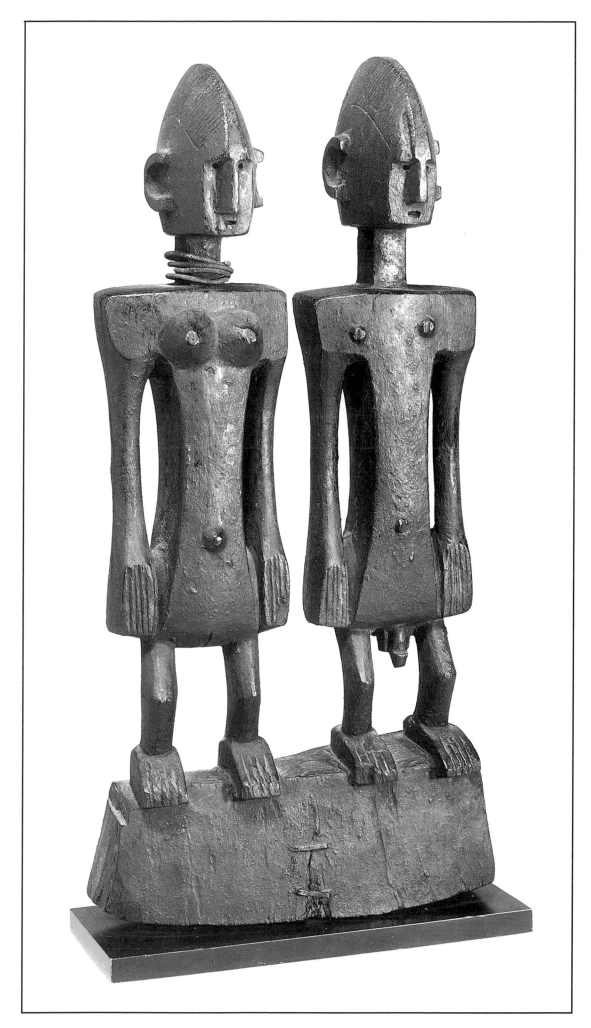

FIG. 64. The precise iden-
tity of Dogon couples is
rarely known, although
most are believed to
represent Nommo,
mythical or primordial
ancestors. H. 20¼ in.

Fig. 65. Life-size human figures, like this naturalistic Dogon hermaphrodite wood carving from Mali, are unusual in African art. H. 82⅞ in.

Sex and Gender

The concepts of sex and gender are related but different. Sex refers to physical characteristics distinguishing male and female and to the physical act of intercourse that underlies and precedes humans as social beings with language and civilization. Gender, on the other hand, refers to cultural definitions and roles of males and females, deriving in part from anatomical differences but often transcending them. The biological fact that only women bear and nurse children leads to gender-associated ideas about nurture. Both men and women can be nurturing; however, to say "women are nurturers" is a statement primarily about gender. The same is true of the declaration that "men are aggressive," for of course women too can be aggressive. Neither nurture nor aggression are uniquely sexual characteristics. The fact that in Africa most potters are women and most carvers are men speaks of gender roles, not sexual ones. Women can carve and men can make pottery, and they do in the Western world, where divisions of labor are less gender-specific. In Africa, however, most gender roles for adults are strictly defined.

A comparison of the *edan* and *mbari* couples shows that images of males and females incorporate ideas of both sex and gender. The *edan* graphically show male and female sex organs, and the female holds symbolic children. The *mbari* images are less explicit; they imply sexuality by various gender-related attributes such as clothing, hat, hairstyle, and objects held in hands.

These two couple images also demonstrate the extent to which artistic interpretations of the human couple can vary. No two individuals hold exactly the same beliefs about what it is to be human, much less male or female. It follows that the beliefs and practices of specific groups of people (such as the Yoruba or the Igbo) at specific times and places will give rise to numerous variations on the depiction of the couple. A potentially infinite range of formal choices is usually held in check by the strength of the local art traditions within which artists

work—that is, the local style—as well as by the functional requirements of the art forms being created. For couples, like other African icons, there are great varieties of local use and meaning.

Creation: Primordial Couples

Not all people have a creation myth, and even fewer have an original human pair memorialized in visual art; first causes are not of widespread concern in African ontologies (Donald Cosentino, pers. com., June 1988). Relatively few images exist, therefore, that can be confidently discussed as counterparts of the biblical Adam and Eve. More examples are known from Zaire than from West Africa.[7] While *edan* and other paired sculptures made for Yoruba Ogboni members and chapters certainly are primordial couples, or at the least founders of a community, no elaborate mythology records their origins and destinies.

Dogon mythology, however, speaks of several couples as original progenitors. Dogon creation legends, and those of other Mande and related peoples (for example, the Bamana and Senufo), tell of primordial seeds or opposite-sex twins who sprang from the same egg. These primordial twin beings, called Nommo among the Dogon, are "archetypes of the future men" (Dieterlin 1957, 126).

Many images of couples populate Dogon art. They are found on posts of men's houses (fig. 188), in shrines as carvings of various sizes, both linked (fig. 64) and freestanding, and on door locks and heddle pulleys (fig. 46). They even appear as small but meaningful additions to an important type of mask (*kanaga*). Though solid evidence is slender, most writers on Dogon art have interpreted these couples to be Nommo.[8]

Androgynous images, both single and Janus, also proliferate in Dogon art and may well be compressed representations of primordial Nommo couples. Androgyny and bisexuality[9] are associated with presocial states of being: infancy and childhood. The Dogon practice both male and female cir-

FIG. 66. This ornate cast copper alloy cylinder was excavated at Igbo-Ukwu in southeastern Nigeria. It shows a couple that may represent primordial ancestors. Only the female is visible here. H. 10½ in.

cumcision and believe that these operations remove the female element from males and vice versa. In doing so they create wholly male or wholly female people who will thereby be prepared to assume adult roles without the sexual and gender ambiguities of childhood. Androgynous, Janus, and bisexual sculptures (fig. 65) may thus refer to ideas of precultural, primordial beings, "children" (perhaps twins) who preceded civilized institutions as they are now known.

A remarkable couple that may also be primordial appears on a bronze openwork object—called a potstand—excavated from Igbo-Ukwu in Nigeria (fig. 66). Dated to the tenth century A.D., it is among the earliest cast copper alloy sculptures known from the sub-Saharan region. Male and female figures stand naked (except for the man's loincloth) on opposite sides of its delicate cylindrical form. Facing outward and away from one another, the two halves of this ancient Igbo couple are separated by the air of the cylinder and connected by the tendrils of its open structure, possibly stylized yam vines. Theirs is a distant kind of unity, without

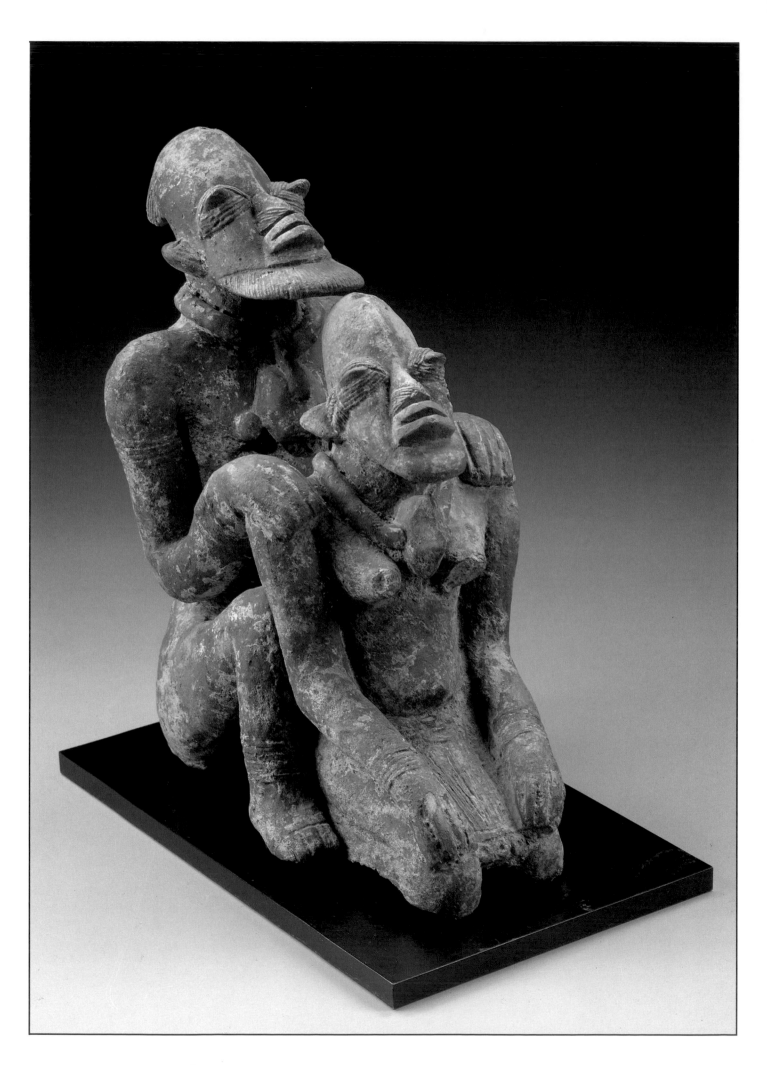

intimacy or expressed affection.

An origin myth told by the Igbo people of Nri, who have occupied the Igbo-Ukwu site for many centuries, may help explain this imagery. When Eri, the first Nri king of primordial times, was hungry, God (Chukwu) instructed him to behead his senior son and daughter and to bury the heads, as if planting a crop. From them grew the two types of yams, now prestige foods in the Igbo diet, that are associated with males and females. The deaths of the first Nri Igbo couple, then, introduced agriculture. From death sprang the yams that nourish life. Are the couple depicted on the Igbo-Ukwu potstand meant to call to mind the first Nri people who are still brought to life in myth? There is no way to be certain.[10]

Male-Female Affection in Ancient Sculptures

Two other archaeological couples, both executed as single units, project the kind of physical bond of emotional intimacy uncommon in more recent art until well into the twentieth century. Both are classic, characteristic renderings epitomizing the styles of their specific epochs and regions, and both lack explanatory information. The terra-cotta sculpture (fig. 67) was recovered near Djenné, Mali, in the Inland Niger Delta region, and dates from within the first four or five centuries after A.D. 1000. Although it is not known whom the figures represent, they are likely elite rather than common people because of the jewelry worn on necks, wrists, and ankles. They are unusually posed: the larger male figure sits behind the kneeling female as if to protect her.

The cast bronze couple (fig. 68) dates to between the twelfth and fifteenth centuries and is believed to depict a divine king and queen of ancient Ife, the spiritual capital city of the Yoruba peoples of southwestern Nigeria. Yoruba mythology cites Ife as the place where dry land first appeared at the beginning of time and as the home of the first king. Ife origin myths, however, do not record the emergence of a first couple. Both

FIG. 68. A copper alloy casting of a king and queen from ancient Ife, excavated in 1957, is unusual for its naturalism and intimate pose. H. 11¼ in.

king and queen wear beaded garments and crowns analogous to those still reserved for Yoruba monarchs. Like other Ife art, this couple is remarkable for its fleshy naturalism—for example, the slightly pudgy belly of the male and the subtle modeling of the female's head (the man's head, missing in the excavated group, is a modern reconstruction). We note neither age nor blemish; commonly in Africa all ordinary and royal people are idealized as eternally young adults. Ife sculpture is no exception in this, although its tendency toward what seem to be naturalistic, individualized portraits of specific persons is highly unusual in African art before the most recent decades. Another unusual aspect of the sculpture is the intertwining of upper and lower limbs. The position of the male's left leg is not possible anatomically; why it was rendered in this manner has never been explained, though it does of course reinforce the closeness stated by the interlaced arms.

Ife and Djenné heads in these and other sculptures are disproportionately large, but clearly their size corresponds to inner and cultural realities rather than to anatomy. When revered individuals are commemorated, lifelike head-to-body proportions are sidestepped in the interest of ideological statement. If we examine the Ife and Djenné couples closely, we see that several other formal devices support this point. All body parts are simplified and less detailed than in life, increasing the vital monumentality of the art. Eyes and other facial features are enlarged and dramatized to similar expressive ends. The compositions of both groups include strong, simple double masses, articulated as separate yet linked in tension. The subtle unifying rhythms created by the artists do not necessarily follow the "facts" of men and women standing or seated in these positions. The artists' choices were surely deliberate and in our view successful. Their creativity must be acknowledged, not taken for granted; other artists setting out to render men and women similarly posed would achieve quite different results.

Intimate Couples

Artistic and public expressions of love and physical intimacy are rare in Africa, and images of human sexuality are rarer still. Among the hundreds of ethnic groups producing visual art, only a handful show intercourse (figs. 69, 70). Several renderings, such as the example on the top of a Kongo whistle, show couples in rather chaste positions that nonetheless make the activity clear. Almost never expressly erotic or titillating, sexual depictions are usually celebrations of conjugal love—that union of male and female responsible for the creation of children and thus a family.[11]

The few overt sexual scenes, as in Yaka masks from Zaire or Igbo *mbari* houses, are socializing devices calculated to dramatize either acceptable or unacceptable behavior, particularly for adolescents. These are subjects treated during the initiation process, when boys and girls are trained for responsible adulthood. Bourgeois (1982, 47) indicates that one purpose of Yaka initiation masks themselves, as well as their sometimes dramatically sexual imagery, is to foster and protect the fertility of male initiates. Men and women of many cultures also sing bawdy songs mocking and satirizing the opposite sex, and sexuality is frequently mimed in dance and sometimes in masked performance.

The single best-known "couple" masquerade in sub-Saharan Africa, the Bamana Chi Wara, includes dancing that plays upon motions of human sexual intercourse, even though the masked characters are mythical antelopes (fig. 71). Chi Wara is performed to embellish and support agricultural rituals and competitions. Fruitfulness is a major theme in dances that metaphorically combine human, animal, and agricultural processes and realms (Imperato 1970). People and animals are often interchanged symbolically in African thought, corroborated in this case by the "human" position of the baby antelope on its mother's back.

Fig. 70. Sexually explicit goldweights are uncommon. H. 1¾ in.

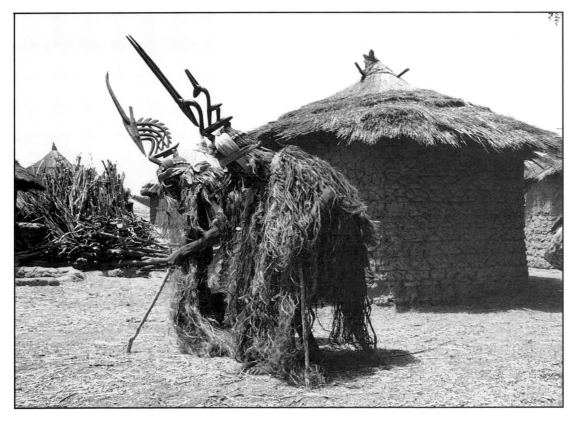

Fig. 71. Chi Wara dances are still performed by the Bamana peoples in Mali (although this 1971 photograph was posed).

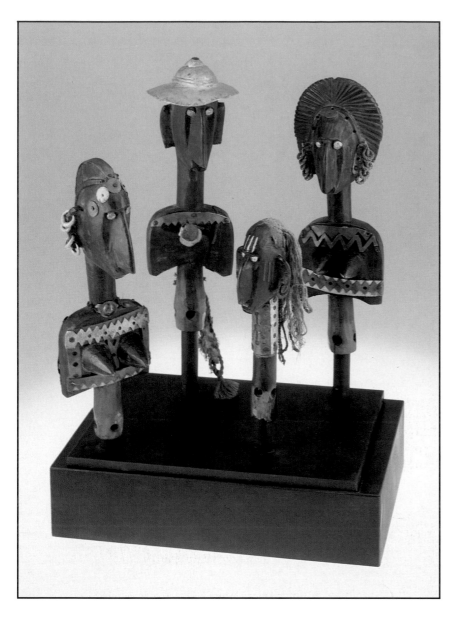

FIG. 72. These small puppets from Mali represent a man in a pith helmet, his two wives, and a long-haired water spirit. H. 6–8 in.

Marriage and Gender Roles

Images of couples, even when they represent spirits or ancestors, refer to the primary social institution of marriage. In Africa this union is less an expression of romantic love between a man and a woman than a sociopolitical alliance between corporate kin groups, or lineages, that entails reciprocal rights and obligations. Among these is bride price, a contract requiring the husband and his people to compensate the bride's family for its loss, the woman who is given away. Child betrothal has been common (as in past generations in Europe), and African marriage may involve relatively little companionship between partners. This is not to say that mutual love and friendship are lacking, but that Western notions of "togetherness," the frequent sharing of activities, are not generally characteristic. Married partners seldom eat together, for

example, and many sleep in separate rooms or houses.

The principal end of marriage is the propagation of children, who expand the family work force, add stature to the lineage, and provide descendants to guarantee the continuity of the family name (Mair [1953] 1969, xii). The social ideal for most African men is a polygamous marriage. This prestigious situation, however, is realized by relatively few men (today, usually less than one in ten), and multiple wives are rarely represented in the arts (fig. 72). Usually men and women are rendered as a balanced unit, with equal emphasis given to each partner.

Although a symmetry of men and women is often evident in art and perhaps represents a cultural ideal, this is by no means always the social reality. In Africa, as elsewhere, male and female roles are asymmetrical; African society is male dominated. As a rule, men have more overt political, judicial, ritual, and social authority.[12] They are oriented to the public realm beyond the household. Women often have a good deal of social and economic power—occasionally more than their men—and in some cases they have political authority as well. Women more typically associate with the domestic sphere because of their prevailing roles in childrearing and food preparation.

Men and women are socialized differently. Shortly after infants begin to walk, gender-determined tasks begin. Girls grow into women by associating with women and learning from them in the domestic arena. But a boy has to "break away from his mother and establish his maleness as a thing apart" (Rosaldo 1974, 25). Whereas women gain their status in the home, men must win adult stature outside, first through ordeals of initiation and later as farmers, hunters, warriors, and traders. Ranking and role differentiation are more clearly aspects of the male realm. Women have fewer specialized positions, in part because of their demanding domestic concerns. The roots of asymmetrical relationships between the sexes are seen in these respective socializations to

public and domestic spheres. It is thus not surprising that the ideological base of culture in most of Africa provides justification for greater stress on the male half of the couple in art.

Gender roles among Mande people of Mali and nearby areas are particularly illuminating as explained by Bird and Kendall (1987, 14–15). The Mande recognize a tension between the individual and the group, expressed in concepts roughly translated as "father-childness," *fadenya*, and "mother-childness," *badenya*. Father-childness is a centrifugal quality associated with "competition and self-promotion—anything tending to spin the actor out of his established social force field." Mother-childness is centripetal, encompassing "submission to authority, stability, cooperation." Adventurous, heroic, individualistic deeds and consequent elevated status are obviously of the former realm. Security and collective values cleave to the latter, as they do to the hearth and household. These are complementary spheres of dynamic interaction and equally necessary for the existence and perpetuation of society. When either a forceful male or an equestrian forms a couple with a woman and child, the makers and users of that double image would seem to be evoking these roles precisely (figs. 2, 58).

Chiefs, kings, and religious specialists are much more often men, though these men draw upon the more covert, sacred power and support of the female population. When male figures in the couple group are shown subtly dominant in size or posture, as in the Dogon couple (fig. 64), or with more obviously superior size, as in Bijogo, Lobi, and ancient Djenné couples (fig. 67), we may suppose (without certainty, however) that sociopolitical realities are being expressed.

The equal size and emphasis of male and female in *edan* Ogboni seem to reflect the extent to which the sexes in Yoruba society are truly reciprocal and equal. In Ogboni funerals, for example, male and female leaders must emerge simultaneously from their

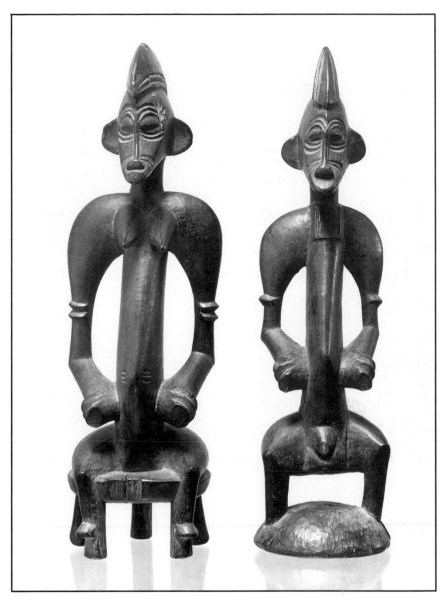

respective compounds and walk together to the funeral site (Marilyn Houlberg, pers. com., 1988). Even though more Yoruba men than women hold positions of political authority, the sexes are balanced in ritual power and leadership; males are ascendant in some cases, females in others.[13]

Occasionally, the female half of a sculptured African couple is larger than the male, as in many hundreds of small Senufo pairs (fig. 73). These show a seated female equal to or greater in height than her standing male partner. Such differences are not at all accidental. A simple explanation would be that because the Senufo are matrilineal, women are accorded greater respect than men by the male artists responsible for these images. Were this reason enough, however, we should expect analogous formal asymmetry in the art of other matrilineal peoples. This does not often occur. In fact, a number of patrilineal societies also render females

FIG. 73. Paired male and female images like these are standard equipment in the shrines of Senufo diviners. The figures represent unseen bush spirits. H. 9⅝ in. (female) and 9 9/16 in. (male).

taller, and other peoples with matrilineal, patrilineal, or dual descent show the male as dominant. These diversities throw us back onto specific data. In this case, we have Glaze's (1981, 1986) detailed work on Senufo gender dialectics to draw upon.

Senufo male-female interaction is formalized in two basic institutions, Poro and Sandogo. Poro is the male organization responsible for initiation, education, masquerades, and many facets of sociopolitical life. Its female counterpart, Sandogo, protects the purity of matrilineages and sponsors divination that seeks to maintain good relationships between villagers and a hierarchy of supernatural beings. More important still, Ancient Mother, the female aspect of the creator deity, is considered head of the male Poro organization and the most important spiritual force for justice and against major crimes. The dominance of this legendary ancestress in Senufo ideology—along with the power and prominence of women in general—must therefore give rise to the greater scale and emphasis on female halves of many sculptured couples.

Senufo couples of varied size and materials fulfill many roles. The most numerous small carvings, from five to ten inches in height, live in diviners' small consulting houses. The figures materialize otherwise invisible bush spirits that cause disease and misfortune and that, when appropriately appeased, provide cures or redress. Many other West African peoples—for example, the Baule, Guro, Lobi, Akan, Dogon, and Mossi—make images of analogous spirits of the wild. Larger Senufo figures may embody oracle spirits or generalized ancestors. Glaze indicates that carved and cast couples of whatever size allude to the primordial couple, twins, and idealized males and females such as a married pair, as well as to the Poro and Sandogo associations (1981, 67). On a deeper level, all Senufo couples, and probably most others from Africa, embody the dynamic, reciprocal interaction of male and female as one of the primary dualistic unities in biological life and in culture.

Male and Female: Binary Oppositions

The human couple is a paradoxical unity in both life and art. United as one, it is the elemental force igniting sexuality and reproduction to maintain the species. As two, it is the equally elemental fact of opposition and reciprocity. Matched pairs of sculptures carved or cast at the same time for a unitary purpose are simultaneously two and one. A semiabstract Chamba/Verre shrine carving cleverly expresses this idea: the torsos and heads of male and female figures rise above a single pelvic area and a single pair of legs (fig. 74). Whatever deep meaning may lie behind this humorous interpretation has not been reported, but such images have been found in shrines addressing several distinct problems: disease, snake bites, and marital difficulties such as childlessness and impotence. The carvings are commonly hidden in pots that are in shrines located at the outskirts of villages (Richard Fardon, pers. com., 1989).

Artistic renderings of couples are part of a broad structural dialectic found everywhere. Dualities are often articulated in African belief systems and implied in art, where they serve as explanatory models. Maleness is understood in relation to femaleness, hot to cold, night to day. In many African systems of thought, the unified world is composed of dual oppositions: the bush on the one hand, lawless, unpredictable, mysterious, and the village on the other, passive, calm, law-abiding, associated with order and civilization. Often these opposites are also gender-linked. Sometimes the bush is associated with male attributes and the village with female ones; in other cultures or circumstances, the linkage is reversed. Dualistic systems such as these compress practical and philosophical notions associated with gender, morality, time, space, cosmology, and transformation. Interpretations vary, and the literature elaborates many versions, including those of the Tabwa of southwestern Zaire, the Fang of Gabon, the Igbo of Nigeria, the Senufo and Baule of Côte d'Ivoire, and the Bamana and Dogon of Mali.[14]

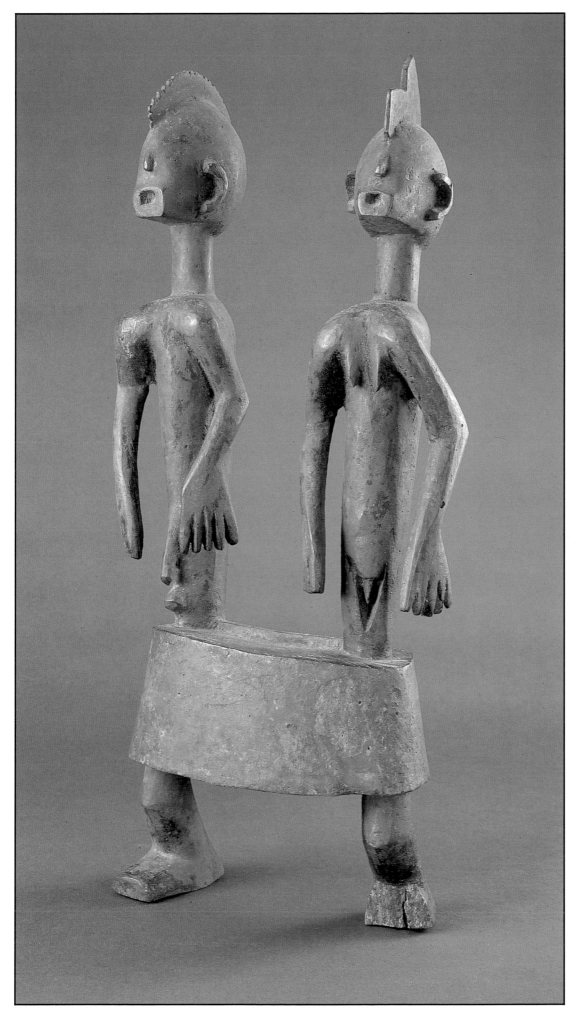

FIG. 74. The notion of a human couple as simultaneously two and one is well-expressed in this shrine carving from the Chamba or Verre peoples of northern Nigeria. H. 21 in.

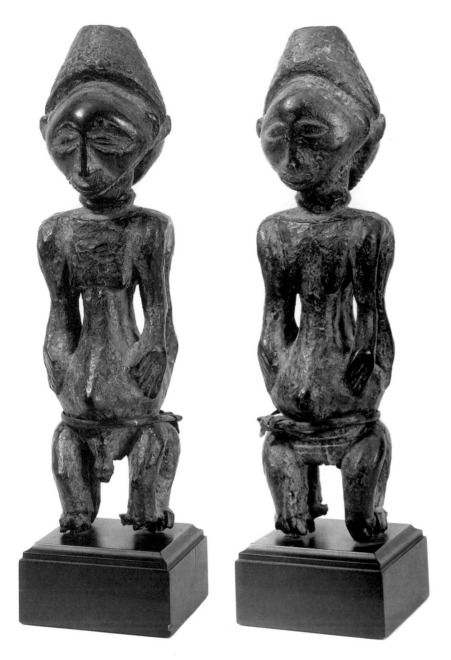

Fig. 75. Janus images express the "two as one" idea, as in this shrine carving from the Hemba of Zaire. Both sides of the figure are shown here. H. 12½ in.

the European-American world between handedness and morality.) These *mulalambo* lines, at their beginnings and endings, refer as well to other paired elements. In the human body, the head (wisdom, intelligence, leadership, and maleness) contrasts with the loins (fertility, lack of restraint, and femaleness). In the geography of Tabwa belief based on myth, spirit-inhabited caverns are found at the upper and lower ends of the watershed, representing life-to-death (natural death) and death-to-life (dreams, reincarnation) transformations. The serpent Nfwimina mediates between wet and dry seasons, as well as between the transformation of the "raw" wild animals of the hunt into the "cooked" food of civilization.

A principal function of ritual, and thus an implicit role of ritual art, is to mediate these interpenetrating realms, resolving the conflicts that inevitably arise between them and thereby fostering harmony and balance. Certainly much of the thought behind paired images and the ritual activity in which they are employed refer more or less implicitly to such dialectics. Variations in form among sculptured couples would seem to bear this out. In addition to freestanding and linked male-female groups, several versions of Janus imagery exist, from androgynous single figures among the Dogon to quite separate male and female figures sharing a single torso, as in an Igbo terra-cotta (fig. 52). Hemba *kabeja* Janus images (fig. 75) fall between, as do several related Luba and Tabwa Janus figures used in divination processes mediating between a person's past and his future, one of the dialectics addressed in such sculpture.

Hemba *kabeja* images are receptacles of power used by family heads to mediate between spirit and human realms. The figures recall mythical deformed children, born with two heads and doubled limbs, offered as scapegoats to keep evil spirits at bay. Sacrifices activate *kabeja*'s spirit energies for many purposes, including general protection, the curing of disease, and aiding in human fertility.

The degree of complexity possible in such dualistic systems is manifest in Tabwa art and philosophy (carefully interpreted in Roberts 1986).[15] The Tabwa conceive of a line called *mulalambo* that marks the bilateral symmetry of the universe and its parts. They represent *mulalambo* in body scarification and figurative arts with a broken vertical line bisecting the torso (fig. 57). An actual north-south watershed in the Tabwa region is seen as a topographical manifestion of this line. It is further expressed in a mythical serpent, Nfwimina, who connects earth and sky. Body midlines separate—and mediate—the right side, with associations of east, birth, and males, and the left side, with associations of west, death, and female. (Similar oppositions underlying the words *dextrous* and *sinister*, from the Latin words for *right* and *left*, indicate perceived links in

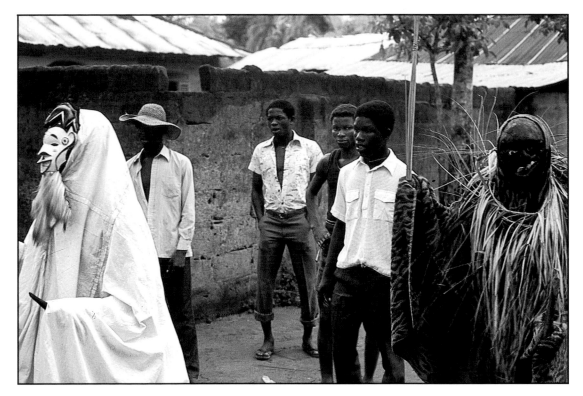

FIG. 76. Light and dark Igbo Okoroshi maskers represent the reciprocity of female and male, among many other dualistic oppositions.

Couples in Performance Arts

Performance arts are especially revealing arenas for the expression of dramatic oppositions. Images of the male and female that tend toward formal rigidity in shrine sculptures become animated as fuller personalities in masquerade and puppet performances. Here the tensions of reciprocating, living relationships are literally played out in dramas that approach, but stylize and concentrate, the complexities of life. Couples, whether explicit or implied, human or animal, are frequently foreground characters in masquerades. Masked couples allude to overarching polarities of the sort found in Tabwa and other systems of dualistic thought. Masquerades quite often feature somewhat stereotypical paired characters, particularly beautiful women who dance opposite male "beasts," either humanoid or zoomorphic. Two masquerade couples—in addition to the Chi Wara cited above (fig. 71)—exemplify the vitality of a genre widely performed in West and Central Africa.

Igbo Okoroshi masquerades, enacted during the rainy season, feature dozens of male and female spirits that encourage and celebrate agricultural and human productivity, coming out to bless both the ripening yam crop and pregnant women. Refined, delicately featured white masks are paired with oversized, exaggerated, brutal, dark masculine masks in what is one of Africa's most clear-cut beauty-beast dyads. The two mask types normally dance on alternate days; it is unusual to see both at the same time (fig. 76). Their linked opposition is clear and richly textured in the minds of many masquerade participants and onlookers, corresponding closely to many of the dualistic unities noted. At one level, for example, they are understood to represent benign "female" white clouds and threatening, dark "male" rain clouds. Similarly, light female characters dance gracefully on sunny days, whereas the pounding, aggressive male maskers dance rain or shine, day or night. Their potentially destructive behavior, like that of occasional torrential rains in this season, is balanced by the creative, pretty dances and the nurturance of normal rainfall. The light maskers wear white cloth; they stand for the cool order and peace of the village in contrast to the hot mystery and danger of the "dark" bush, signified by circlets of palm leaves.

Yet the dyadic opposition breaks down as we move closer to specific masquerade characters. Although all white masks are locally classified as feminine and all dark ones as masculine, two white spirits have both male and female traits, and several dark spirits have women's names. The several dozen masked characters that appear each season in any one community range—in a conceptual sense—from nearly pure white to heavily saturated black; most fall between those extremes as varied shades of gray. The

FIG. 77. Senior female
(left) and senior male
Goli spirit masqueraders
of the Wan peoples,
Côte d'Ivoire.

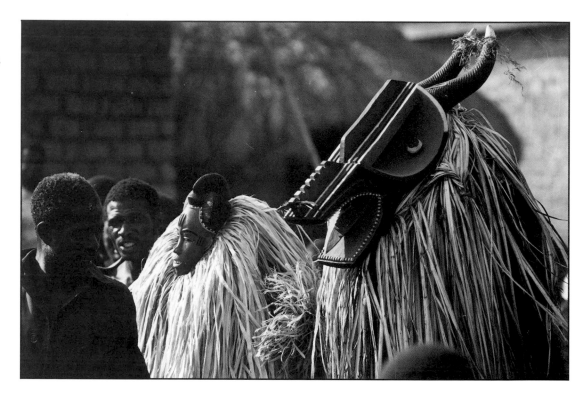

white-black contrast becomes misleadingly simple as we examine the allusive names of some of the many spirit personalities, moving from light to dark: Delicate, Sprouting, Sugarcane, Basket, Paddle, Superficial Laughter, Rumors Fly, Glutton, Husband-Hater, Jealousy, Vulture, Slow Poison, Elephant, and Killer.[16] In general, form and meaning are correlated, following a continuum. The more symmetrical and delicate the features of an Okoroshi mask, the more benign its character. The more grotesque and misshapen the features, the more powerful and aggressive are the associated behaviors. This spectrum of personalities acknowledges the nuances of the human and natural worlds while more overtly "playing" in the complex psychological arena of male-female relationships.

In contrast to the Igbo Okoroshi masquerade with its dozens of spirits, the Goli masquerade of the Wan people of Côte d'Ivoire involves only three dancers. A junior male, a senior male, and a senior female dance at the funerals of respected men (fig. 77). Together, the three masked person-

alities compose a richly expressive tableau (as analyzed in Ravenhill 1988).[17] Like the Igbo, the Wan insist that these spirits are neither human nor animal, although references to each, in masks and performance, clarify Wan divisions between wild (bush) and domestic (village) realms, as well as oppositions between youthfulness and maturity and between men and women. Both male masks manifest animal traits. The junior male, a nervous, boisterous but domestic goat, contrasts with the senior male, a composite wild animal (antelope and crocodile) that suggests both fearful, aggressive qualities and protective ones. The youthful male stands for force without wisdom. The elder male represents the fully socialized adult characteristics of physical, ritual, and intellectual power. The mask colors and the animal skirts worn by each reinforce and extend these associations. The young goat is black and dirty, a loner. The senior bush animal is in part red, linked with blood, aggression, heat, and danger. An elder, this spirit is also linked with man's social nature, with the corporate identity of human soci-

ety. The one female has pretty humanoid facial features. Her bleached bark fiber cape signals many "white" associations: purity, beauty, coolness, and water. This spirit represents womanhood and life-giving beauty. She only comes out to dance, however, at the funeral celebration of a man who had grandchildren.

Her appearance on this occasion of death makes it clear that men and women are equally necessary to the fulfillment of the social ideal of a large family. The destruction caused by death is reversed by two weeks of lavish funerary feasting, masquerading, and festivity that reestablish order. Ancestors are summoned to these ceremonies, which create another ancestor. Death can thus be purposeful because the ancestors celebrated at these performances are the ultimate guarantors of life. This Wan masquerade has but three characters. Yet an understanding of their allusions and interactions reveals the extent to which, by constructing new, synthetic, expressive realities, a masquerade simultaneously comments upon and enriches fundamental categories and activities of life (see Ravenhill 1988).

Couples and Procreation

A marriage without children typically does not last long in Africa. Proof of a woman's fertility, either by pregnancy or more often by the birth (and even survival) of a child, is necessary for sustaining the marriage. The mother-and-child theme is therefore as important in African life and thought as that of marriage. Cultural equations of the two find visual expression in images of couples in which the female half is a woman and child (fig. 78).[18] The exceptional, sculpturally complex Yoruba shrine carvings shown in figure 78 are rich in content and allusion. Probably made as votive gifts for Eshu, the trickster deity,[19] the couple would remind devotees of Eshu's instigating role in human sexuality, fertility, procreation, and marriage. The horse carries an armed hunter-warrior and a small alert figure in the saddle, either his servant or his child. Yet

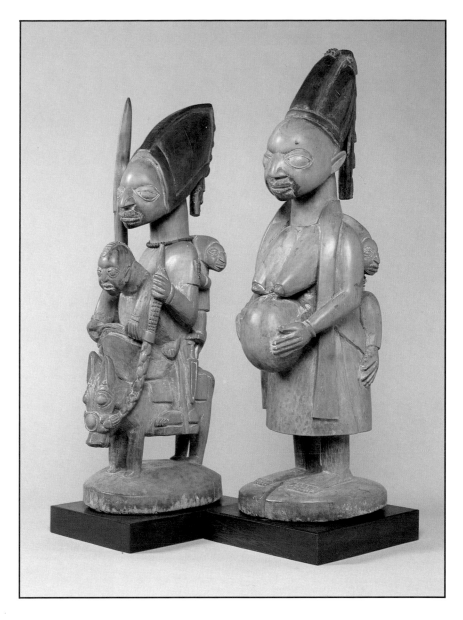

the notion of family is more clearly stated in the female image, for she carries at least one child.

The woman stands erect. In the frontal view she is holding a bowl against her torso. Or, is she grasping her own pregnant abdomen? That the sculptor probably intended both interpretations—a deliberate visual pun—is more evident in the side view. The artist has played with the notion of woman as container; her pot-shaped womb is the ultimate source of her power and of the future of her family.[20] The fetal child contained within, and held as if a gift at her front, is balanced by the alert young child tied to its mother's back. Given by her lineage to her husband's, a woman enters marriage as a gift. By having children, she herself becomes the giver.[21] The African couple, then, exists primarily to create this gift for themselves and for the lineage.

FIG. 78. Large Yoruba shrine figures, probably for the trickster god Eshu, incorporate four of the icons examined here and also allude to the idea of family. H. 27½ in. (male) and 29 in. (female).

5 Maternity and Abundance
The Woman and Child

No male occupation, however exalted, can compensate for the unique ability of the female to conceive, bear, and nurse the young of the species.

—Joan Bamberger (1974, 279)

Ala is the earth goddess and great mother of the Owerri Igbo people. She is the mother of all, an awesome natural phenomenon that stands for the prodigious abundance of life. Fertilized by rain from Amadioha, the thunder god, Ala brings forth all plants, animals, and human beings. An *mbari* house is given as a sacrifice to appease her displeasure at human folly or occasionally in thanks for her bounty. In *mbari* houses built to honor and "crown" her, as people put it, Queen Ala is shown as a wealthy older woman of high title with her feet raised above the ground on a sacrificial iron bar. She is flanked by her children. In physical presence, as in thought, Ala is larger than life (fig. 79).

The unveiling of an *mbari* is a celebration of Ala's abundance. Like the members of the community, the figures in the *mbari* are considered to be her children. Larger *mbari* houses feature rich tableaux of local life with as many as a hundred or more figures, including humans, animals, and prominent local gods in all manner of pursuits. All are modeled in fertility-associated clay from termite mounds, whose queens are amazingly prolific. Both the ritual processes of the *mbari*'s creation and the art of the completed monument serve to regenerate the community; both are repetitions of cosmogony. The world is reborn for Ala. In return, she is expected to promote fertility in the land and people.

Not all African cultures conceptualize earth as mother, and few others are known to represent her in anthropomorphic sculpture. In many regions, however, images of women and children also signify far more than biological motherhood. These are often referred to as "fertility figures," an accurate if misleading phrase that tells only part of a story sometimes very rich in metaphor and allusion. In fact, unless we have solid local data, we can never be certain how broad or narrow the implications of an image are.

Strong evidence that the theme of woman with child (or children) represents something greater than biological meaning comes from a Djenné terra-cotta dated to between the twelfth and fourteenth centuries (fig. 80). Two diminutive people clamber up the woman's torso, but they do not seem to be children. Like the woman, both wear necklaces, bracelets, anklets, and loincloths; one is bearded and thus certainly not a child. Although information is lacking, this ancient figure would appear to be a "mother of society"—perhaps a deity, perhaps a legendary or founding ancestor.[1]

All these designations are apt in the case of several large Senufo woman-and-child carvings representing Ancient Mother (fig.

FIG. 79. The Igbo earth deity, Ala, is shown with two of her children in an *mbari* house. The *mbari* is erected by community members—also considered Ala's children. Ala, modeled in termite-hill clay, is nearly six feet high.

81). This older "mother of the village" is also considered head of the male Poro organization (Glaze 1981). Her image is displayed in Poro activities not so much to teach about actual maternity but to demonstrate that under her tutelage, Poro graduates have been "nursed . . . with the milk of knowledge, [as] she redelivers them as initiates, complete human beings" (Bochet in Vogel 1981, 45–47). Associations such as Poro inculcate novices with practical knowledge of sexuality along with deeper ideas about the social process. These teachings are revealed by myths and initiatory rituals. The abstracted, "larva-like" appearance of the child in the Senufo sculpture—a symbol, not a real baby—is cited as a clue to the nonliteral character of the carving; "beyond superficial reality there exists hidden, esoteric meaning" (ibid.). Having undergone twenty-one years of training within Poro, initiates, represented by a child in the image, are of course not children any more than Ancient Mother is a terrestrial, flesh-and-blood woman.

In a number of African societies Great Mothers, whether of mythology, among the gods, or in real life, are at the height of their awesome power after menopause, when their actual childbearing days are over. As experienced elders, they are capable of turning their accumulated but hidden reserves of life force against the community or of using their strength and wisdom for its prosperity. These mothers are revered and feared, and they demand to be honored. Among the Yoruba, such women are lauded as "the gods of society" and "owners of the world" (H. Drewal and M. Drewal 1983, xv). Babalola speaks of sacrifices for the gods as metaphorical food for the mothers during an epidemic, explaining that "all these mothers are the owners of all these gods" (quoted in ibid., 8). Clearly, many Yoruba and other images refer to older women, and broader, more cosmological or intellectual meanings are intended even when some are explicit depictions of a baby suckling its mother's breast.

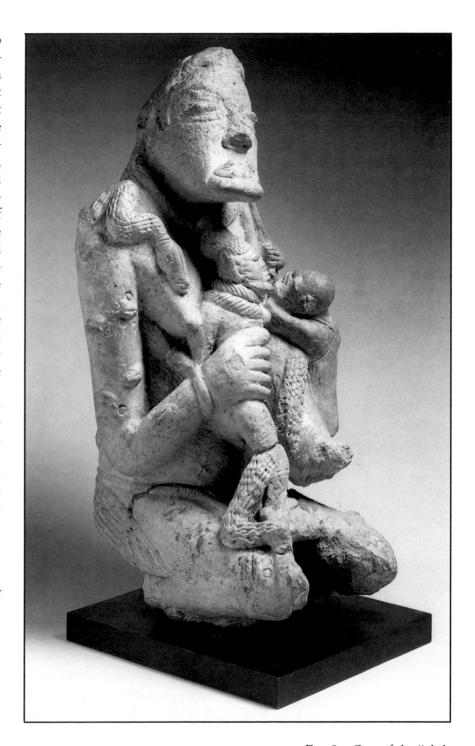

FIG. 80. One of the "children" with this woman is bearded, suggesting that the terra-cotta image represents a metaphorical mother rather than a biological one. H. 15¹/₈ in.

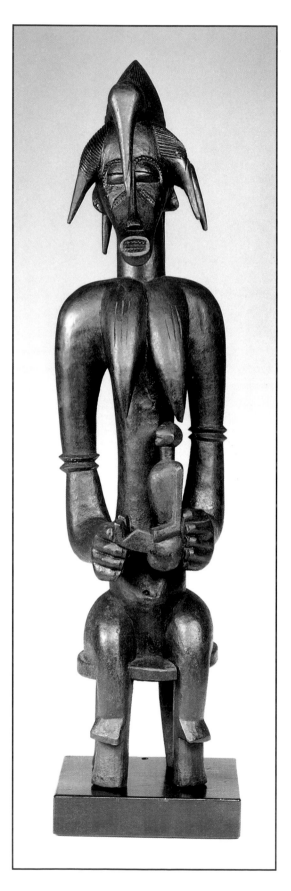

FIG. 81. The Ancient Mother among the Senufo peoples is responsible for "giving birth" to all male initiates when they finish their twenty-one-year initiation cycle. H. 36¾ in.

Royal Mothers

Royal examples of the maternity theme are known from several Akan and Cameroon Grassfields kingdoms. In addition to the notions of motherhood just discussed, they express others reflecting regal origin. Some are queen mothers, relatives of the king (not always his actual mother) whose office is ritually powerful. Queen mothers have roles in kings' installations. They are advisers to kings on women's affairs and are honorary mothers of the kingdom. And of course they are mothers of their own children. The Asante woman and child illustrated in chapter 1 (fig. 9) shows a queen mother, identified by her royal chair and the footstool that elevates her sandaled feet off the profane ground. This image probably came from a shrine, either one for Tano, the river deity, or an ancestral stool room in a royal palace. The figure may be a child or messenger of Tano, or it may commemorate a specific queen mother.

The original contexts of Cameroon royal maternities are better known (fig. 82). Many were found among ensembles of statuary—kings, royal ancestors, nobles, court retainers, and their women—that are sometimes brought out for large public palace ceremonies. They provide a focusing display, an entourage reiterating the glory of the state, that complements the ceremonies. Sculptural groups show off the wealth of a court and the discerning artistic patronage of a king and his predecessors. They show off the grandeur of royal office and the historical and present strength of the kingdom. The figures are often called royal ancestors, but they are not the focus of an ancestral cult per se, and the extent to which they were ritually potent is not known.

An especially dynamic woman-and-child image from the Bamileke could be a queen mother or a royal wife (fig. 82). Information on its specific identity is lacking. The carver, a man named Kwayep, and the approximate date of the image, however, are known. "In all probability, the figure was carved to commemorate the birth of King N'Jike's first

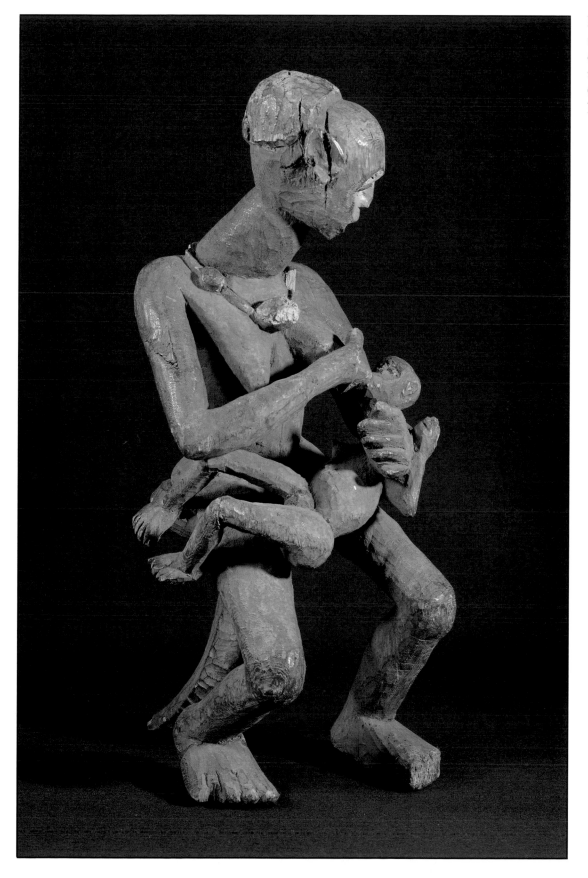

FIG. 82. A royal woman and child in an especially dynamic style. It is from the Bamileke area of the Cameroon Grassfields. H. 25³/₄ in.

FIG. 84. This Fon casting of a woman and child might have surmounted a staff for ancestor commemoration, *asen*, or it might have been a secular display piece owned by a wealthy person. H. 7 in.

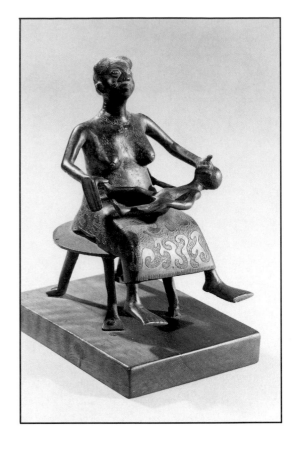

child soon after 1912 when he began to reign" (Vogel and N'Diaye 1985, 141). Commemoration was a primary motivation for all Grassfields statuary, though this maternity figure may have had other uses and meanings as well.

A royal stool (fig. 83), also from Cameroon, shows ten maternity images rhythmically disposed as supports between the base and the seat. Caryatid stools, each carved from a single block of wood, are fairly common chiefly attributes in this area, but few others rival this example of the carver's art. Each compact, rounded figure bursts with energy. The forms are set off by charged open spaces and alternating higher and lower positions. Such stools elevate leaders above the people. Royals and chiefs must sit on stools, whereas by unwritten law, ordi-

FIG. 83. Stools were royal prerogatives in Cameroon Grassfields kingdoms. H. 21¼ in.

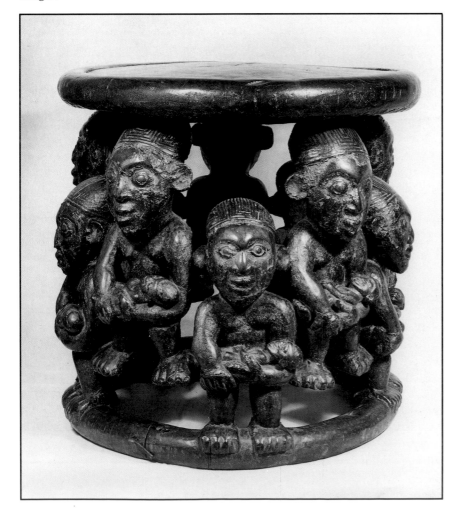

nary people may not. In this case, metaphorical support for the chief is provided by several royal women, who are perhaps intended to recall in a general way his wives or noble ancestors.

Even though ancestral presence and support is implicit in many woman-and-child groups, relatively few are intended to depict named deceased persons. "Ancestor images" are considerably rarer than early writing on African art would have us believe, despite the wide distribution of ancestor veneration on the continent (see Siroto 1976). Only one maternity figure included here, as far as we know, may have been involved in ancestor worship, and then only indirectly (fig. 84). This small cast brass figure probably decorated the top of an *asen*, a Fon ancestral altar from the Republic of Benin (formerly Dahomey). The figurative tops of *asen*, however, do not depict the deceased, nor are they named for them. Rather, they are scenes that refer to proverbs, allegories, or deeds with which ancestors are associated (Bay 1985). When sacrifices are made to the family or royal dead in shrines where *asen* are kept, these scenes are general reminders of ancestral power rather than direct symbols of people who once lived.

A memorial terra-cotta of a royal woman with twins from the Akan of Ghana was

created after the woman—perhaps a queen mother—or her husband had died (fig. 85). Akan terra-cottas, like those in Cameroon, often appeared as members of an entourage. As part of the funerary rites of important royals, they were displayed as if sitting in state. Sometimes the figures were also paraded through the streets of the town.[2] In such celebrations, this figure would have commemorated the woman's life either in its own right if it were her funeral, or if her husband's, as the honorary mother of the kingdom. The terra-cottas were later placed in or near the royal cemetery. Yet the ancestral spirit of the woman—or for that matter any important Akan person—was believed to reside not in any figurative image but in a specific stool, which was ritually blackened with sacrificial offerings. Ancestor cults for royal and nonroyal Akan were focused on "stool rooms," where these symbols were housed. Terra-cottas are memorials somewhat analogous to the grave markers common for centuries in Western culture and increasingly widespread in Africa. They are not worshiped, but they are held in a certain reverence. Many are considered portraits, although they are generic rather than imitative likenesses (as discussed in chapter 3).

An Asante maternity figure, carved by the Ghanaian artist Kwaku Bempah (d. 1936), was probably made as a shrine figure, though not necessarily a royal one (fig. 86). Other woman-and-child images were created for shrines patronized by royals; the shrine in figure 8, for example, has a sculpture of a queen mother. Queen mother maternities were also made for secular popular-music groups, which were not associated with courts (fig. 87). Royal imagery of this sort proliferated from about 1920 to 1940, in part because of the catalytic patronage of the British anthropologist Robert S. Rattray, who commissioned many figures from several sculptors. It was his idea for artists to carve specific members of a chief's court and entourage—including queen mothers—as groups (Ross 1984, 34). He

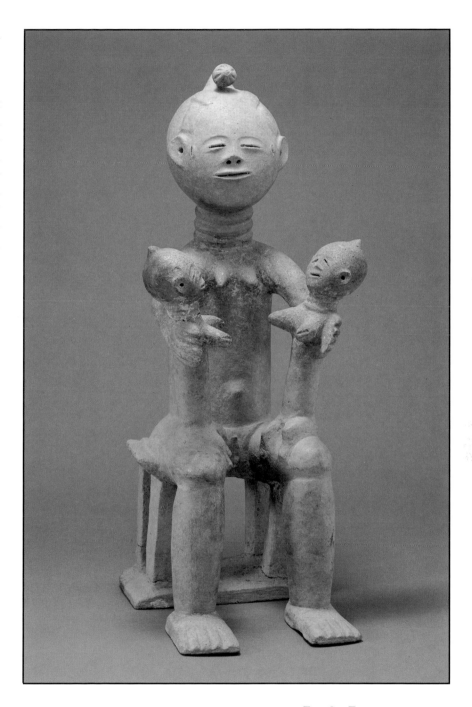

made it possible for two Asante artists, Bempah and one of his sons, to go to London for the 1924 British Empire Exhibition in Wembley, where they carved as part of the exhibition (ibid., 30). Rattray's influence thus increased both the repertory and visibility of skillful, innovative artists, including another son of Bempah, the prolific Osei Bonsu (1900–1977). When Bempah went to

FIG. 85. Funerary terracotta images were made as royal memorials by several Akan peoples of southern Ghana. This mother of twins is Fante. H. 18 1/4 in.

FIG. 86. Kwaku Bempah, father of Osei Bonsu (see fig. 87), carved this dynamic woman and child, probably for use in a shrine. H. 17³/4 in.

FIG. 87. Osei Bonsu, who died in 1977 at the age of 77, was a prolific carver for three Asante kings and hundreds of other patrons, including the British anthropologist Robert Rattray. H. 18³/4 in.

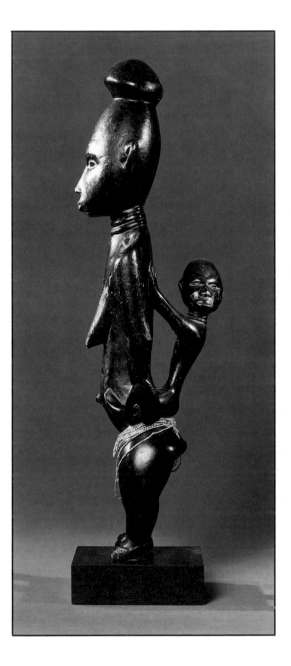

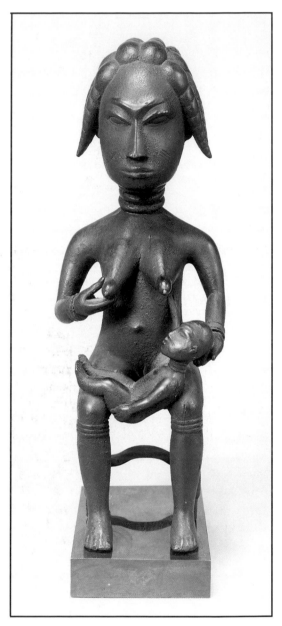

England, Bonsu remained at home carving royal and other commissions.

Between 1925 and 1940, Osei Bonsu carved most of the secular sculptures displayed in groups by popular bands. Bonsu's mother and child in figure 87, seated on a cut-down version of a European chair, was more than likely carved for such an ensemble. Bonsu's commissioned works were both traditional and highly innovative. They spanned the range of possibilities: sculptures actively used in shrines and as regalia

(crowns, sword handles, linguist staffs), objects for secular Asante needs, presentation pieces given as gifts to retiring colonial officers and foreign dignitaries, and outright tourist pieces (see Ross 1984). Such a spectrum reminds us that strangers such as Rattray sometimes have had a positive, generative effect on artistic production and that artists, like others, are concerned about economic well-being as well as creativity. They will carve for anyone who pays them well.

Womanhood and Initiation

A woman's destiny is to create children. Preparation for this role, and for the marriage that enables it, is a crucial part of girls' education in Africa. In some cultures, this occurs informally as part of the daily socialization process whereby girls learn to do as their mothers do. In others—for example, among the Mende, Temne, Senufo, and others in Sierra Leone, Liberia, and Côte d'Ivoire—the training of girls and their initiation into womanhood is accomplished formally by women's associations (often called secret societies) such as Sande and Sandogo. Typically, pubescent girls are taken outside the village to a "bush school," where they are taught by older women, usually officials of the association.[3]

The training period is a time for physical and psychological conditioning, for "fattening," and for learning of all kinds.[4] Initiation rites may begin with scarification or clitoridectomy. Decorative scars make a young woman attractive to men and symbolically more receptive for motherhood. Clitoridectomy in some areas is an explicit metaphor for the position, pain, process, and place of childbirth (MacCormack 1982a, 121).[5] Fattening betokens beauty, pride, prosperity, and health, all linked with fecundity and women's social power as producers and reproducers. Relative corpulence has been shown to increase female fertility and enhance the chances of survival of both mothers and their infants (MacCormack 1982a, 122, 124, 126).

Masks worn by officials of the Sande and Sandogo societies during the central rites of the initiation process represent several ideals of womanhood (fig. 88): finely dressed hair, a long neck with ridges or folds, glistening black skin, and children, the quintessential emblems of motherhood. The ample lower torso of this mask, broadened to accommodate the wearer's head, also implies pregnancy. Masks like this do not represent initiates. Rather, they refer generically to women's powers; they are worn by leaders who have already proven themselves by giving birth to several children.

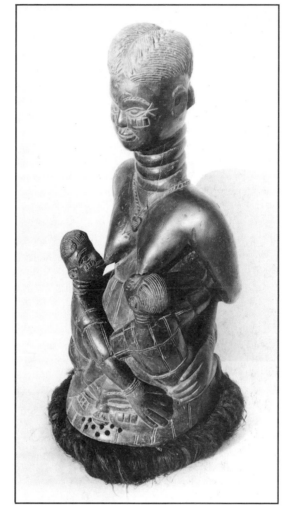

FIG. 88. Temne masks are often danced by women. This one, a woman with several children, is a statement about the benefits of a large family and about the ideals of feminine beauty. H. 26³/₁₆ in.

Celebrations of passage to productive womanhood may also involve the temporary elevation of the initiates to the status of revered leaders, as among the Urhobo of southern Nigeria. There may be lavish gift giving and self-beautification. Marriageable girls parade through town markets wearing valuable jewelry and textiles. Prayers are intoned for them at local shrines to ensure their health and to keep jealous, malevolent spirits away (Foss 1979). The principal visible marker of this transitional stage in an Urhobo girl's life is her brilliant body dyed with red camwood, which symbolizes blood (of circumcision, menstruation, childbirth) and the potential power and peril of her imminent status as a childbearing woman

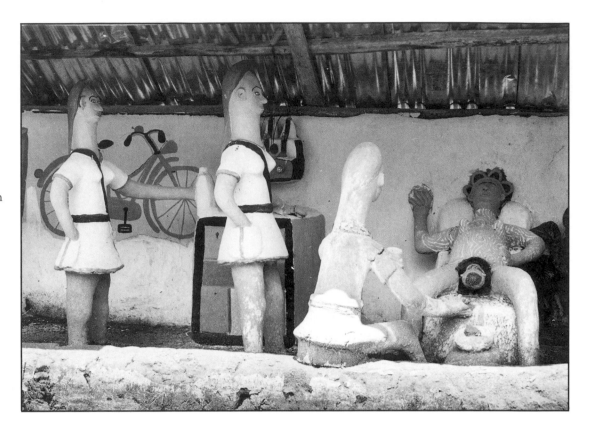

FIG. 89. Representations of actual childbirth, as in this illusionistic scene of a maternity clinic created for an *mbari* house, are infrequently seen in the arts of Africa.

(ibid.). In other regions, girls paint themselves with white clays, signifying among other things symbolic death or purity associated with childbirth. Everywhere, some visual marker heralds their changing or newly acquired status.

This initiation period is parallel to that of birthing, when a woman enters the dangerous zone between nature and culture. Baule women giving birth are said to have "gone to a place between life and death" (Judith Timyan, pers. com., 1988), a reference both to their psychic and physical states and to the fact that the event takes place in the ambivalent zone between the ordered confines of the village and the threatening bush. The pain, blood, and hazards of birth pull a woman toward unpredictable nature.

Childbirth, Productivity, and Health

Scenes of childbirth rarely occur in visual art. Yaka masks and Nkanu panels for initiation houses show them (see Bourgeois 1984); both figure in boys' puberty rites, when explicit instruction is given in sexuality and related subjects. Birth scenes on Chokwe chair rungs and in Igbo *mbari* houses appear among other glimpses of village life (fig. 89). Occasional Yoruba palace doors and Gelede mask superstructures show childbirth, again as vignettes of everyday activity. Apart from doors, each of these genres incorporates iconographic references to many crucial phases and activities of life, and each is in its own way encyclopedic, for other sexual, sacred, political, and everyday themes are included. In *mbari* and Gelede, at least, many of the graphic sexual scenes are found amusing, as well as instructive, because they are outside the acceptable range of general discussion. Childbirth, in particular, is beyond direct male experience in most areas.

A great many spiritual agencies are invoked to promote healthy childbirth, and most woman-and-child imagery is created to these ends, at least indirectly. The overwhelming desirability of children to all African peoples helps focus energy on the fecundity of marriage. Demands for children—or at least perceived needs—exceed the supply in most agricultural societies (Levine 1983, 50). The good health of both partners is important, but it is especially so for the woman. If no child comes of the union or if an infant dies, the wife is usually considered at fault (Mair [1953] 1969, 4). Infertility and other problems with conception and successful birth also send one or both married partners to shrines, which are the contexts of most maternity imagery depicted here. A childless marriage rarely lasts, and men and women alike will try anything to avert it—including divorce.

Very high rates of infant mortality contribute to the emphasis on childbirth in Af-

FIG. 90. Mother-and-child images were sometimes commissioned by childless Baule men to represent their "spirit lovers." A man would offer sacrifices and prayers to this spirit in an effort to resolve his problems. H. 26 in.

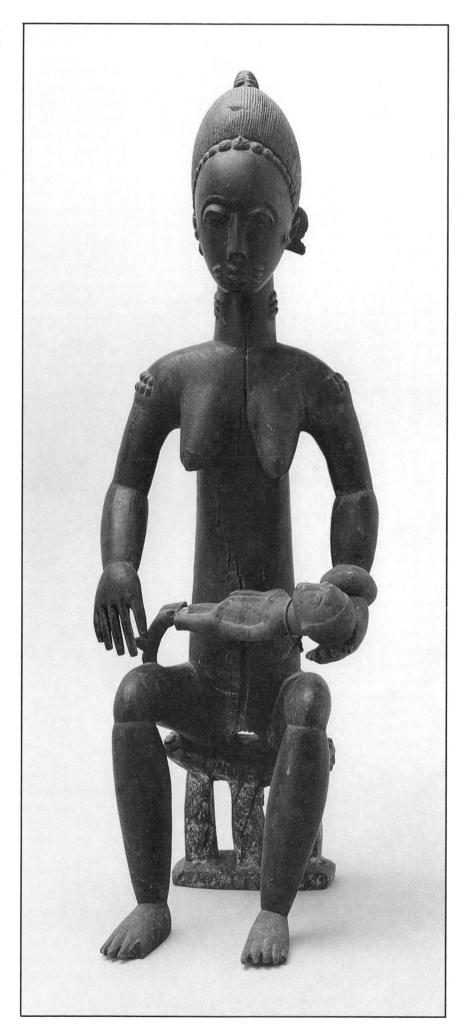

rica and indirectly to the existence of woman-and-child sculpture. In many areas a generation or two ago, less than half the pregnancies yielded surviving children. Shrine images of healthy nursing mothers can only be reassuring to a woman advised by a diviner to seek supernatural help for her infant's sickness. Sacrifices and other petitions to spirits deemed responsible for disease are made to, or adjacent to, woman-and-child carvings symbolizing these supernaturals.[6]

Many Baule woman-and-child carvings (fig. 90) owe their existence to a man's difficulties in life, often but not exclusively having to do with his wife or children. A man might face problems finding or keeping a wife or having children by his wife, or he might experience financial or other misfortune. Such individuals, divination often reveals, are being troubled by their "otherworld spirit lover," who desires more time and attention, including presents (sacrifices). The diviner determines that an image—a woman either with or without a child—should be made of this spirit. The man must feed it regularly, devote one specific night per week to this lover (rather than sleep with his real wife), and otherwise answer its demands. Thus placated, the otherworld spirit should stop disturbing the man, whose life will then improve.[7]

The need for children has social and political dimensions that help account for rituals in which maternity imagery is employed. The biological dependency expressed by a nursing-mother image is later reversed. Just as ancestors depend on the prayers and libations of their living kinfolk, parents depend on their children to provide appropriately impressive burial ceremonies. The more children a person has, the higher his or her status is in this life, the more prestigious the funerary rituals will be, and the more influence he or she will exert as an ancestor. Chiefs and kings with many wives and literally dozens of children are making statements that are implied in royal woman-and-child imagery.

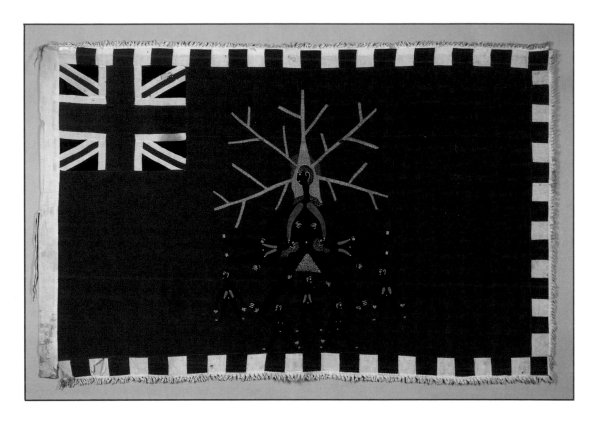

Women with Several Children: Metaphors of Prosperity

Large families—many children—bring joy and a sense of success and prestige, feelings of self-esteem, to both parents. Children are also economic assets; they provide needed help in the fields or with the herds, and they add stature to the lineage. More than anything, these factors explain polygamy. Images of women with several children celebrate multiple successive births and thus the desirable condition of sustained female fertility (fig. 91). An Igbo river goddess known for her success in helping women have many children is shown in *mbari* houses with four children clambering over her. It may be this sort of goddess who is depicted in Djenné terra-cottas with multiple "children" (fig. 80).[8]

Men and women with large families, when celebrated in Akan funerals, are likened to okra with its profusion of seeds: "Mother the okra, full of the seeds of many issue, and proven" (Finnegan 1970, 155). Similarly, pregnant Dogon women are lik-

ened to ears of millet beginning to swell with their hundreds of kernels (Griaule 1965, 141). Analogous visual metaphors of abundance show the numerical strength, and thus the power, of a Fante military company on one of its flags (fig. 91). Likewise, Akan linguist staffs show the chief or king as a mother hen, sheltering and disciplining her many chicks, the people at large. A large kingdom, like a large family, is prosperous and powerful.

Most African masquerades celebrate childbirth and children somewhat indirectly by honoring ancestors and various influential deities (fig. 33). In the Epa (or Epa-Elefon) masquerades of the Ekiti Yoruba kingdoms, however, mask names and iconography, as well as performance, are quite frequently addressed specifically to ideas about children.[9] Dozens of Epa masks display different mother-with-children tableaux above fixed, fierce-faced helmets that fit over wearers' heads (fig. 92). These masks have names such as Mother with Children, Owner of Many Children, Children Cover

FIG. 92. Epa masks often represent fertile women with one child or more. They signify Yoruba preoccupations with children and large families. H. 39 in.

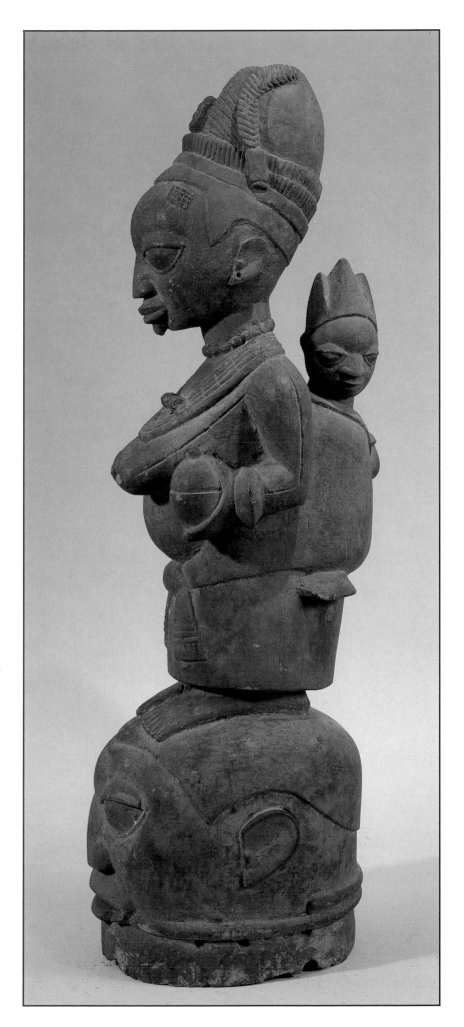

Me (like a protecting cloth), Children are Honorable to Have, Bringer of Children, Mother of Twins, Nursing Mother, and many others that verbally reinforce varied sculptural interpretations. Epa masks honor deities known to help women bear children. These gods are petitioned by women at masking festivals and at specific community shrines with gifts, prayers, dances, and songs. Two songs include lyrics that directly relate to the kind of mask in figure 92: "The spirit which came from heaven and earth . . . to grant that I may carry a baby on my back"; and, "Plump, plump children, I carry plump children on my back" (Ojo 1978, 461). Although warfare and other topics are also featured in Epa, fertility and childbirth—especially concerns about having many children and therefore large families—are major, focal subjects in this masking cult.

Twins and Multiple Births

Twins and their mothers, an important subsection of the woman-and-child theme, are celebrated in many works of art (fig. 93). Twin and other multiple births are more common in Africa than in other parts of the world,[10] and in much of the continent they are honored. Senufo and Dogon images of women with two children allude to Nommo, mythical primordial twins (see p. 61). The miracle of twin birth may have established the original male and female couple in some areas, and everywhere it calls for special ritual precaution. As mystical double souls, twins receive gifts, uncommon foods, and protective charms. Several groups that honor twins also create images to memorialize them or to house their souls when they die. Twin images, *ibeji*, are well known among the Yoruba, who have the highest incidence of twin births in Africa.[11]

Two mother-and-twin images included here are symmetrical on the vertical axis, giving balanced emphasis to each child (figs. 85, 93). The multiple doubled rhythms of these groups, building upon and echoing the woman's limbs, breasts, and facial fea-

FIG. 93. The Dogon peoples, like many others, revere twin births and accord twin children elevated status. This wooden image was undoubtedly made for a shrine. H. 15½ in.

tures, lend to such sculptures a firm stability that seems more honorific than lifelike. The extra burdens and difficulties brought on by the arrival of twins would seem to foster insecurities that would throw a household off balance. Certainly the mother and both children (often prematurely born) are weaker than in single deliveries, requiring extra attention to increase the survival chances of all three. Strictly symmetrical renderings, like cool serenity, would appear to be pious hopes or prayers rather than accurate reflections of life in the twins' household. Alternatively, the mother who successfully raises twin babies is doubly praised; the Fante terra-cotta mother-and-twins group was created to commemorate a royal woman (fig. 85). We may suppose its dignity and sense of equanimity are appropriate recollections of her fruitful life. Overall, it is not surprising that exceptional mothers and their twin children receive unusual attention in both art and life.

Images of African Childhood

Woman-and-child imagery conveys only some of the reality of African childhood. Physical and emotional intimacy are expressed on occasion but by no means always. The subjects are handled ambivalently, as if to reflect ambivalence on the part of African mothers. Sometimes mother-and-child figures suggest an intimate physical bond—for example, when infants are seen tied to their mothers' backs as virtual extensions of their bodies. The sculpture of a serene mother seated cross-legged on a bench or pillow is a created, idealized image. In real life, a mother is likely to offer a breast while engaged in quite another activity. Small children sleep with their mothers and accompany them to the farm or dance. A mother's interactions with her child are far more casual than formal mother-and-child imagery would suggest (fig. 94). Moreover it is rare for a baby to be shown with the proportions and body conformations of an actual infant. Seldom is the child given any real personality (or sex-

FIG. 94. A Cameroon Grassfields royal mother nurses her child in this photograph by the late Paul Gebauer, a missionary.

FIG. 95. A small simplified, quite abstract Dogon carving of a woman and child. H. 7¼ in.

ual identity), nor is the mother.

The iconic formalism of maternity imagery also conveys a sense of emotional distance and aloofness of mother to child. There is little sense of intimacy between them. Carvings rarely show the mother looking down at her baby. She is usually detached, even impassive. This may reflect the fragility of life in Africa—the very high rates of infant mortality—and the consequent reluctance of women to attach themselves to infants who might die. It is equally likely, however, that the maternity group's ritualistic nature and its use in shrines account for the formality of the genre. The sense of psychological distance is reminiscent of Christian Madonna-and-child icons, which serve analogous ritual purposes.

Like the Christian Madonna, many African woman-and-child images depict deities (figs. 79, 81). These are often unseen, impersonal bush or other nature spirits with which people do not really want close emotional ties. Unlike Christianity's (apparently) loving God, some unruly bush spirits, considered nasty and ugly, are only reluctantly acknowledged and attended.[12] These rationales for the emotional distance be-

tween mother and baby are only speculative. Geluwe (1978, 148) further suggests, "The absence of emotional expression to some extent accentuates the transcendent detachment of mind which shows . . . a symbol of fertility itself rather than any particular mother."

Mothers' Poses and Children's Positions

A selection of mother-and-child images does show something about the early life of children, including their growth away from full dependence on their mothers. When we closely examine the poses in these groups, differences in mother-child relationships emerge. Carvers and casters have been sensitive to different ages and degrees of independence in their images of children and to the postures of both child and mother. Mothers commonly sit, stand, or kneel. The latter position conveys the same expressive meanings in most African cultures as it does in our own: submission, prayer, and reverence. Since kneeling and nursing at the same time are uncomfortable and thus unusual, this posture most likely is votive in nature rather than a translation from a common nursing position in real life (fig. 95).

The two most common positions for a sculptured child are supine on the mother's lap, whether or not nursing (fig. 90), and tied to her back. Nursing babies, especially when shown as very small, imply the total dependency of an infant's early months. Children on women's backs, though perhaps young, are slightly removed from their source of nourishment. In this carrying position, too, the mother is free to pursue nearly all the demands made on her. She can and does move around almost as if the child were not there at all. Some back-carried babies are shown nearly merging with their mothers' torsos, exemplifying the Wolof proverb "A mother's back is the baby's medicine" (Judith Timyan, pers. com., 1988). Others stand away, almost as if supporting themselves (fig. 86). Children in the

FIG. 96. Cast copper
alloy images among the
Dan, like this actively
posed woman and child,
were prestige objects
owned by wealthy men.
H. 8 in.

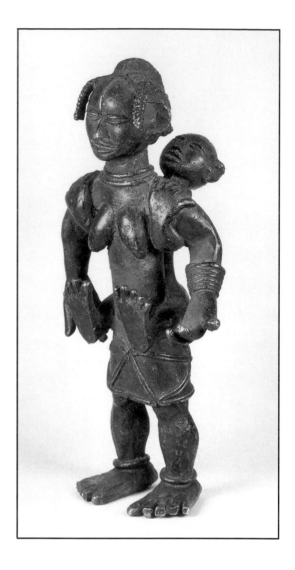

latter instance may be shown as fairly large
(figs. 86, 96) and, in some cases, quite active.

The woman and child shown in figure 96
is a secular work made for a chief to display
on important occasions (Fischer and Him-
melheber 1984, 143). The Dan sculptor who
modeled it used several devices to activate
space and imply movement. Hand gestures
break symmetry. The woman leans forward
and the child backward. The mother's and
the child's arms and legs, with enlarged
hands and feet, project outward. The size
and independence of this child remind us
that children are nursed and carried by
their mothers in many areas until about the
age of three, long after they can walk and
talk.

Children in the front or back position,
common in life itself, appear in almost all
images. A significant number of sculptures
show a child in both places (fig. 88), suggest-
ing the extent to which females are occupied
with childbearing, care, and nurture in their
productive years. These images imply that
since the child of two or three has less of a
need for milk and constant attention, he or
she can be moved to mother's back to make
way for a newborn infant.

Children are also shown in other posi-
tions, such as on the hip. Babies are often
carried this way in daily life; this is a realisti-
cally rendered active pose. In carvings, these
children are animated, as they may also be
on the back (fig. 97). Far less common in
sculpture is the child held up in front of its
mother. Two versions of this unusual pos-
ture are illustrated here. The first, a finely
balanced carving of unknown use, is from
southern Africa (fig. 98), and the second is a
small Lobi carving (fig. 99). Lobi artists, like
few others, have shown the varieties of
mother-and-child positions (see Meyer 1981).
Notably, these small Lobi images almost in-
variably depict bush spirits considered any-
thing but human. The explicit presence of
well-observed humanistic subjects, here and
elsewhere, indicates the extent to which
ideas of the sacred are modeled on readily
available human themes.

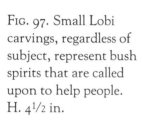

FIG. 97. Small Lobi
carvings, regardless of
subject, represent bush
spirits that are called
upon to help people.
H. 4½ in.

Maternity Imagery
in the Lower Congo

Noble, aloof, serene, and beautiful, a
Yombe woman and child radiates quiet
power (fig. 100). The Yombe are one among
several Kongo groups famous for wood and
ivory mother-and-child carvings, which
served a variety of ritual and political pur-
poses. Detailed documentation on the lives
of these images is often unavailable. We
have no information whatever, for example,
for an image from the nearby Vili peoples
(fig. 101). The standing mother holds her
daughter, also standing, by the arms. The
child in this case is partially grown, perhaps
a young teenager. More than likely this was
a shrine image, but beyond that we can only
guess. In the case of the seated Yombe ma-
ternity, on the other hand, we are fortunate
to have a field report from a missionary, Leo
Bittremieux, on a nearly identical maternity
carved by the same artist. Bittremieux
writes that the figure belonged to a great
diviner. The diviner said that "the statue
represented his 'mother,' from whom he
claimed to have acquired his exceptional di-

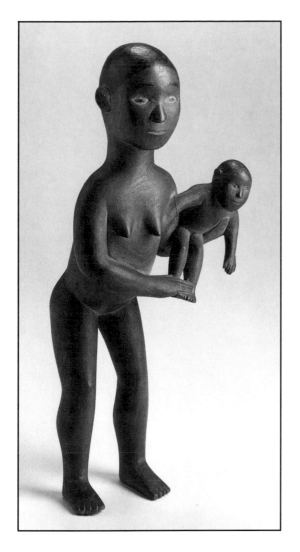

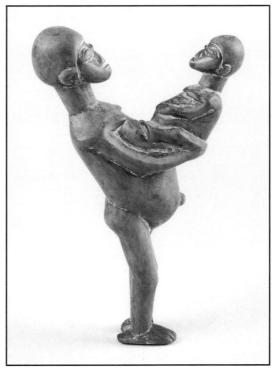

FIG. 98. A dramatically posed woman-and-child group from southern Africa. Its place of origin and use are uncertain. H. 12³/₄ in.

FIG. 99. The variety of positions for the child in African carvings—especially among the Lobi—reflects the variety of positions adopted in life. H. 6 in.

vinatory powers and the power to fertilize seed" (Geluwe 1978). The diviner carried his figure "in a baby carrier made of cotton," suggesting both that his "mother" became his "child" and that his explanation is clearly in the realm of metaphor (ibid.). The data suggest that the "mother" is in fact the amalgamated supernatural powers of both male fertilization and female fecundity, though lodged in a female form. Perhaps, as Zuesse (1979, 51) puts it in another context, this is because "women are the divine in the sphere of human society. Though one sex, they are the source of both." Bittremieux observed the diviner's figure being used in rituals, and he later collected it.

According to Bittremieux, the figure is called *phemba*, "the white," a Kikongo word referring to the white earth (kaolin) or chalk that is a symbol of fecundity in this region and elsewhere. Bittremieux later supplemented his explanation of *phemba* to include its derivation from *kivemba*, a verb meaning "broadcast" or "eject" the "seeds of children." Therefore, "*phemba* is she who ejects potential children who gather in a

man or woman, the future father or mother" (Geluwe 1978). The metaphysical creative force composed of male and female elements is apparently the fertility principle embodied here. It would seem to be impersonal, even cosmic. Indeed, nothing indicates that the woman portrayed in this carving is a specific individual. Considerable evidence suggests that she represents perfect womankind in a broad, even archetypal, sense.

The Yombe are matrilineal, tracing descent through the female line and, in terms of origins and history, granting women considerable power. Kongo societies were once powerful kingdoms that vested leadership in nobles, who are well recalled by this woman's royal demeanor and personal decoration. She is shown wearing the woven pineapple fiber cap of a dignitary and a leader's armlets and bracelets. The imported brass tacks embellishing her forehead and a necklace of glass beads are also indications of wealth and prestige. Her beauty, idealized and dramatized by an enlarged head, is set off by detailed accents that increase physical

FIG. 101. This is a rare
example of a woman with
an older child rather
than an infant. The
carving is attributed to
the Vili people of the
Kongo group. H. 9½ in.

FIG. 100. Congo styles
are refined and relatively
naturalistic. The digni-
fied woman depicted in
this carving is a Yombe
royal. H. 10⅛ in.

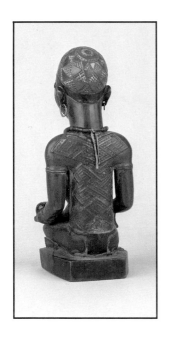

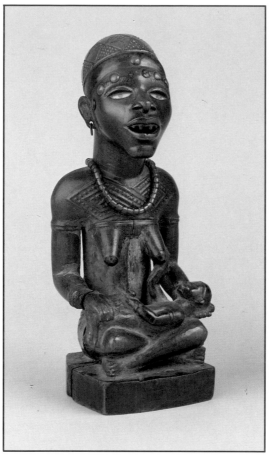

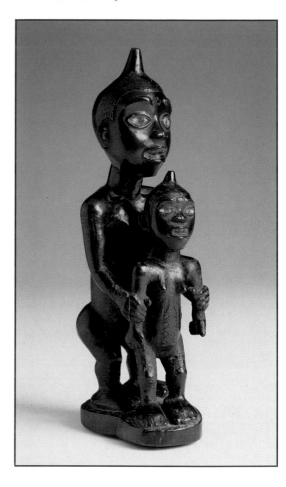

perfection in the eyes of Yombe people: finely chipped teeth, eyes resonant with in-set glass, elegant rectangular "endless knot" keloidal chest and back scarifications, and a breast-binding cord. Above all she is an aristocrat, proud, impassive, and majestic.

Yoruba diviners, when ordering their cups for palm nuts from sculptors, favor those depicting a woman with one child or more (fig. 102). One such diviner, also a sage ana-lyst of his own art and culture, identifies the women holding these cups as containers themselves. He further indicates that the cup is given to a diviner by his mother or wife (M. Drewal and H. Drewal 1983, 67). Margaret Drewal elaborates upon this idea, calling ritual containers "a primary symbol for female power" (1989, 320).[13] Though more implicit, such symbolism is present among other West and Central African peo-ples, including, for example, the Lobi and Gurunsi (northern Ghana and southern Burkina Faso), Dogon (Mali), Igbo (Nigeria), and probably Luba (Zaire).[14] The child ren-dered in works of art with its mother is the revelation of the most profound female se-cret and power, graphic proof of the conti-nuity of the race.

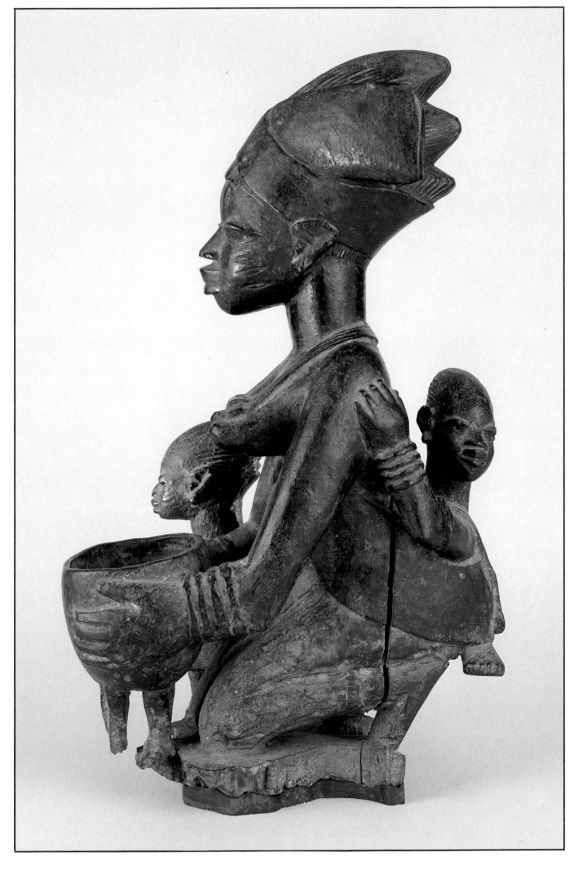

6 Hunters, Warriors, and Heroes
The Forceful Male

FIG. 103. This fine copper alloy casting of a hunter carrying an antelope, from southern Nigeria, has a monumental scale that belies its modest height of 14 inches.

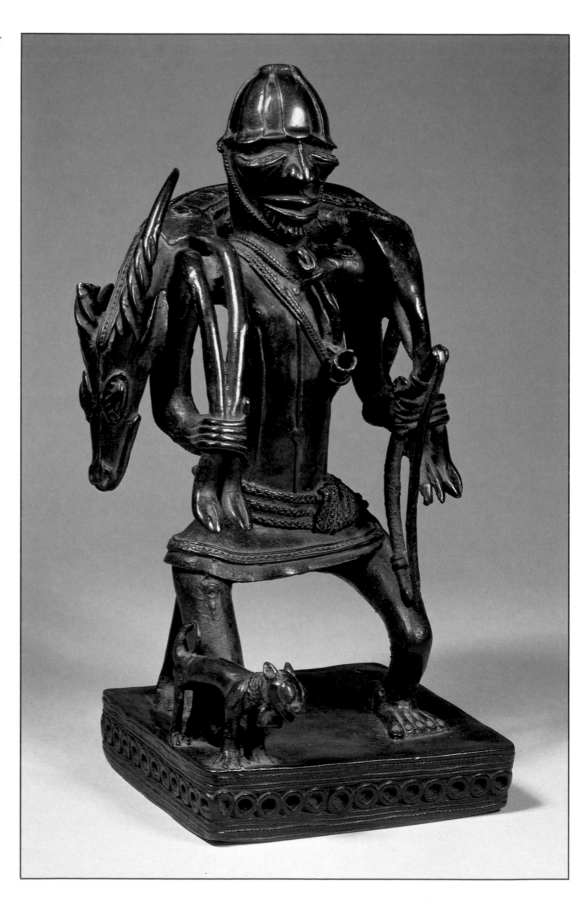

"For the man hunting, for the woman procreation." This simple expression of male-female opposition in Ndembu society in Zambia establishes the social model accepted as fundamental in much of Africa (Turner 1957, 27). Whereas female power derives from the giving of life, male power derives from the taking of it. Woman's power is internal and hidden, like her reproductive organs. Man's is external, like his genitalia and like the weapons he carries forth from the village to realms of conflict or danger. Like women giving birth, men must leave the cool order of the village to interact with the wilder world of nature.

In art, males are sometimes shown bearing their trophies—animals or human heads—just as women carry babies. A famous cast copper alloy hunter, for example, shoulders a large horned antelope and grasps its bound legs in each hand (fig. 103). Standing firmly on widely spaced legs and carrying a bow in his left hand and a quiver strapped across his chest, the hunter is posed as if returning triumphantly from the hunt to feed and support his people. Beside him stands his dog. This unusual, confidently modeled figure, perhaps dating from the fifteenth or sixteenth century, is believed to have been collected in Benin City in 1897.[1]

The life of a hunter or warrior is fraught with risk, for in an instant he may become the hunted. Danger is inherent in the acts of aggression these men must perforce commit, as it is in the weapons they wield. Their violent clash is with the hot mystery of blood, whether animal or human. Warriors and hunters traffic with capricious forces that must be manipulated with esoteric knowledge. For this they arm themselves not only with weapons but also with supernatural protection—charms and special clothing (figs. 104, 105). Similarly, magical medicines must be used to cool their victims and purify the killers before either may enter the domestic sphere. The more ferocious the animal sought—leopard, elephant, or human—the stronger must be the ritual

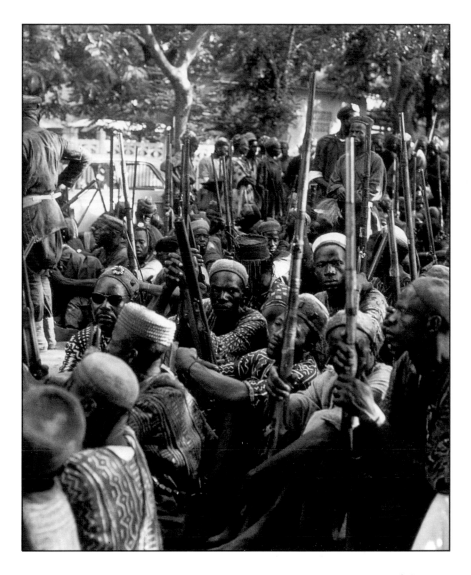

preparation. The greater the prize, the greater the glory.

The forceful men of African art are not ordinary unglamorous villagers caught in the tedious daily struggle for survival. Rather, they are heroes who command the spiritual, mental, and physical energy to master every challenge. They exist in the realm of what the Bamana call "father-childness" (fadenya, see p. 67), where men spin out of the controlled, secure world to do exceptional deeds and make a lasting name. And they are leaders, for leadership derives from power.

A unique standing terra-cotta warrior-hunter from the Inland Niger Delta is undoubtedly such a person of exceptional merit (fig. 105). Finely dressed, with heavy stone-pendant jewelry on his upper arms, a necklace, and crossed bandoliers, this stately man carries a quiver on his back and a dagger strapped to his arm. His hairstyle and facial scarification perhaps identify his office, status, and cultural affiliation—now lost to us.

FIG. 104. Most of the Bamana hunters in this photograph wear ritually prepared shirts. The motifs on the shirts protect the hunters from natural and supernatural dangers.

FIG. 105. A stately terra-cotta warrior-hunter from the Inland Niger Delta region of Mali. It probably represents a leader, perhaps an ancestor or other deity. H. 24⅜ in.

The Head as Emblem and Trophy

The head is honored above other parts of the body in Africa. It is the locus of destiny and divinely bestowed energy. It controls intelligence, will, and, ultimately, a person's success in the world. The interchangeability of words for head and chief in many African languages, as in English, reinforces leadership metaphors; it is the head that leads a person in life, just as sociopolitical direction rests in the king as head of state. In the Benin Kingdom, palace altars were dedicated to the head of the living king, as well as to the heads of dynastic ancestors and queen mothers. Rituals and many human sacrifices were necessary to maintain their spiritual efficacy. Shrines displayed a large number of cast brass heads, mainly those commemorating kings and queen mothers, although some represented trophies of war (fig. 106; Ben-Amos 1980, 18).

Heads in many West African cultures were highly charged symbols of leadership, vitality, and braggadocio. Some Akan warriors carried several severed heads into battle; these were doubtless highly intimidating to enemy warriors in the fighting at close quarters characteristic of much African warfare as recently as a hundred years ago. Heads or mandibles of sacrificial victims or opponents in war were carried in victory dances to celebrate the superiority of the warrior.

Actual heads were displayed on drums, trumpets, and elsewhere and were added to the shrines of war gods among Cameroon, Fon, Akan, and other peoples. Trophy heads—translated into gold castings—adorn important state swords and ancestral stools among the Asante. Among the Kalabari Ijo, commemorative ancestral screens called *duein fubara*, "foreheads of the dead," memorialize trophy heads in two ways. Either the central chief holds a head in his left hand and a knife in his right or small heads are placed along the bottom edge (fig. 107).

Young men in several southern Nigerian areas (among many others) aspired above all to be great warriors, an ambition achieved

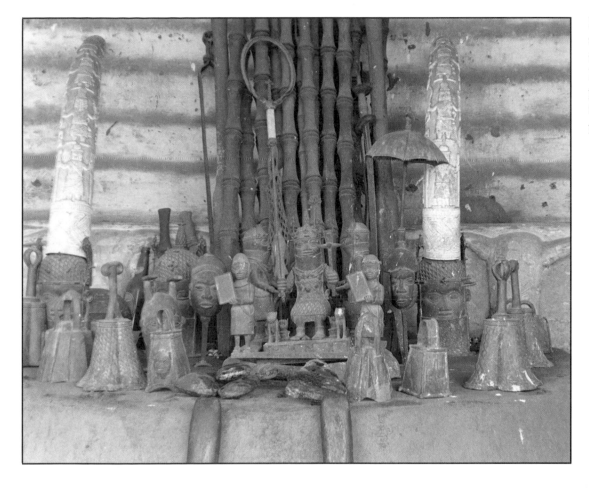

FIG. 106. Assemblages of royal materials, sculptures, and symbols of leadership and spiritual power characterize altars in the Benin king's palace.

by taking an enemy head in battle. Annang and other Cross River boys' initiations featured mock headhunting, along with learning martial arts, military strategy, and the use of firearms (Salmons 1985, 60). Much precolonial warfare involved hand-to-hand combat with machetes and knives rather than firearms. Elevation to prominent leadership positions, sometimes even membership in elite men's associations, depended on success as a warrior. Among many peoples, taking a head and sacrificing a slave were the paths to personal achievement and its public recognition. The hunted or sacrificed victim is mystically transmuted through ritual consecration into food and drink; the victim's powers were thereby assimilated by the victor (Harter 1971).

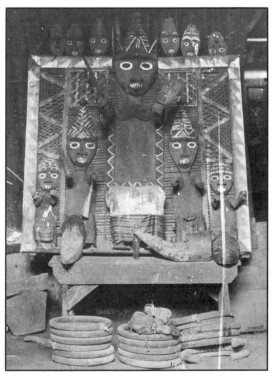

FIG. 107. Some Kalabari screens that commemorate ancestors feature trophy-head and knife symbolism. Widespread in West Africa, such symbolism indicates men of great power and accomplishment.

FIG. 108. *Ikenga*, Igbo shrines for personal success, are quintessential symbols of the forceful-male ethos in Africa. H. 21¹/₂ in.

monish the spirit. Especially pious men make small daily food offerings to their *ikenga* and pray to the creator god, local nature spirits, and their ancestors. *Ikenga* are associated with the right arm, the arm of action, with which men brandish knives in these wood carvings. The left hand holds a trophy head, sometimes shown upside down and small, as if to emphasize the humiliation of the victim. Most *ikenga* have horns sprouting from the man's head. Here, as in so much of Africa, horns embody force; they often contain magical power materials, either actually or implicitly. Horns are the principal weapons of animals, converted by man into metaphorical emblems of physical and mystical strength. The horns on *ikenga* are associated with those of rams, which are noted for their stoicism as well as for their irrepressible ferocity when aroused to action. These qualities are appropriate, of course, to successful warriors or others of marked accomplishment.

The idea that personal accomplishment claims the help of family—living and dead—and the gods is institutionalized in *ikenga*. Apart from warfare and headhunting (which ceased in the first decade of the twentieth century when the Igbo were subdued by the British), the typical Igbo path to high status was through accomplished yam farming. Wealth from farming made possible the accumulation of prestigious titles and many wives. The large resulting family, as well as progressively more exclusive titles, assured the man of a lavish burial and a respected place among his ancestors. Although *ikenga* were a democratic shrine art, maintained in much of Igboland (and among several neighboring peoples[2]) by all adult men, some *ikenga* are far more elaborate than others. The most impressive ones were commissioned by highly successful individuals—usually leaders—and occasionally by whole communities to glorify and increase their collective strength.

A closely related, extraordinary shrine carving from the southern Igala seems to embody these notions of collective support

Headhunters and Executioners

Among the hundreds of male-with-weapon images, certain types are identifiable by their specific iconography. The most striking of these is the man who wields a knife and carries a human head. This subtype of the forceful-male icon is fairly limited geographically; most examples come from the forest regions between Ghana and Cameroon. Two precise roles are portrayed: headhunter and executioner.

The greatest number of idealized headhunter images comes from the once-warlike Igbo peoples of southeastern Nigeria. The figures serve as shrines called *ikenga* (fig. 108). These are kept by adult males to assure their personal achievement; they bring spiritual energy to the drive for success. Men sacrifice to their shrines before going to war or undertaking any crucial event. If their goals are achieved, they thank *ikenga* with more offerings. Should they fail, they ad-

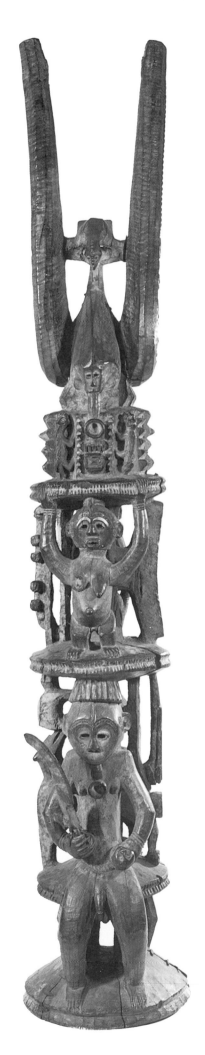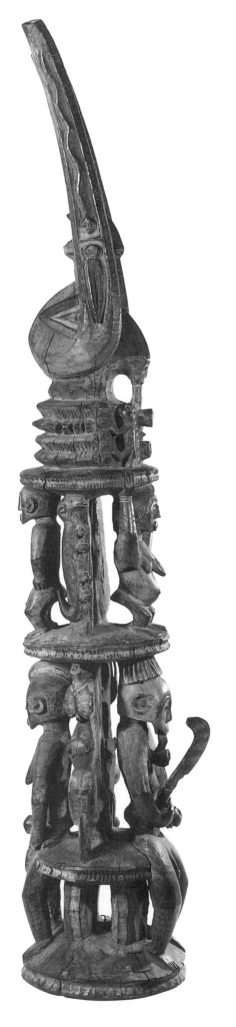

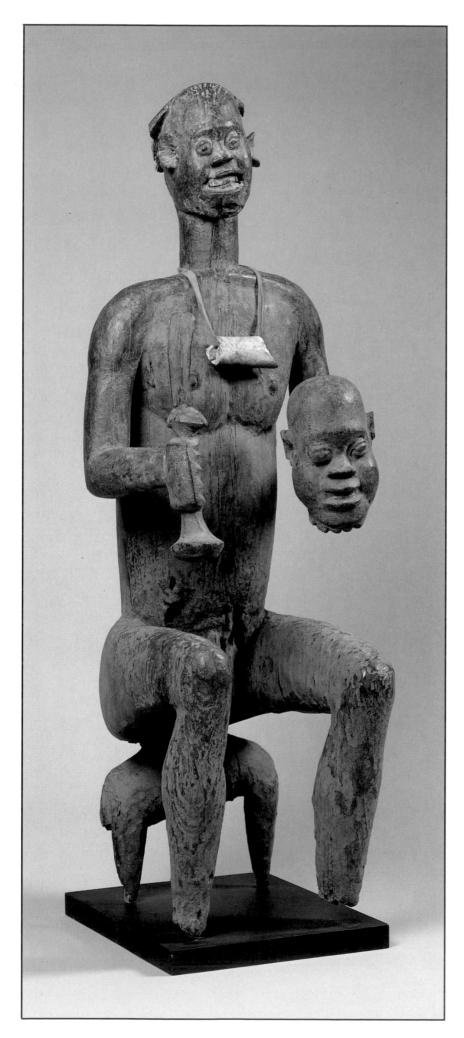

FIG. 110. Knife and trophy-head symbols are fairly common in the Cameroon Grassfields, as exemplified by this maliciously grinning "big man" or chief. H. 45½ in.

and power (fig. 109). Northern neighbors of the Igbo, the Igala created images called *okega*, similar in name and type to *ikenga*. Most are small, individually owned single figures (fig. 24), like the Igbo image just discussed. The three-level, aggrandized Igala shrine shown in figure 109 is unique in its complexity and monumental size. At the top, establishing the image type, is a horned head (in this case, it is smoking a pipe). Below, where the body of the seated personage would ordinarily be, is a two-tiered network of subsidiary figures that probably represents an entire support system. On the bottom tier are a knife-wielding male and his wife, who is holding a child. (Two indecipherable emblems separate the two figures.) On the central tier appear smaller figures of a male and a female and a board for a game involving the capture of an opponent's pieces, perhaps a metaphor for conquest. The entire structure is composed of caryatid stools of the kind reserved for distinguished men of the highest title, the only sort of person who could ever own such an elaborate *okega*. Yet it is more probable that this shrine served an entire community. Apart from the long knife wielded by the male on the lowest tier, this six-foot, openwork sculpture was carved from a single block of wood, a tour de force in size and complexity.

A work with analogous iconography, also a large unitary carving, commemorates a Cameroon Grassfields warrior, or "big man," from the Esu (or Bafum-Katse) chiefdom who is returning from victory (fig. 110). Although the figure is not an *ikenga* and no horns are present, the symbolism of the knife and trophy head is the same. The theme is common in Cameroon art; it also appears as one of the dozen or so figures on the houseposts discussed in the first chapter (see fig. 12).

Although no definitive documentation exists, this piece probably represents a headhunter.[3] As in Igboland, heroic Grassfields men equate headhunting with military conquest and, on a more conceptual level, with all kinds of power and success. The disem-

bodied heads in these images probably also imply the mystic augmentation of the vital powers of the hunter and his people through cannibalism. The ritual ingestion of human flesh, though not nearly as widespread as earlier stereotypes once maintained, nevertheless has a documented place in the history of African warfare. Almost everywhere, war has involved the use of magical charms, spells, and substances. Eating the enemy means assimilating his vital essence, his life force. It increases the magical—and thus the effective physical—powers of the conqueror (Kasfir 1988a, 91). "You love the war; is not the head of a man your nourishment?" is the oath ascribed to a particular Bamum warrior (Geary 1988a, 105).

The gleefully alert facial expressions of the Cameroon warrior and the disembodied head are unusual, for emotional expression, apart from a kind of generic dignity common to most iconic imagery, is quite rare in African art. Harter, who reads the man's visage as "joyful and menacing," believes the figure may have been carved by a nineteenth-century sculptor known for "the terrifying appearance he gave to his figures" (in Vogel 1981, 192). This interpretation is plausible, for although the two heads have comparable expressions, that of the man is clearly more dramatic. Its rather grim effect is achieved not only by the slight tilt of the head but by an inlaid carved ivory tooth plate that draws attention to the open, smiling mouth. Inlays of this sort are very rare. Another feature of this work, shared with most *ikenga*, is the explicit depiction of male genitalia, which are commonly visible even when there is clothing on the lower body. Such a practice is sometimes most graphic in African art—for example, in rock engravings (fig. 49)—and it reminds us of analogies made by Africans themselves between sexual aggression and other forms of male power.

Since owners of these images—including Igbo and Igala men—were themselves not necessarily headhunters, the iconography is clearly also conventional and metaphorical.

The knife is thus the swift cut of decisive action. The head refers to accomplishment, whether battles won or a peace successfully negotiated without bloodshed. An Akan goldweight less than two inches in height is a symbol of this sort; it shows a royal figure holding both a head and a sword (fig. 43). The chief or king is shown seated on an kind of chair known as an *akonkromfi*, an Asante adaptation of seventeenth-century European models. This image is explicitly about royal power. It indicates the king's prerogative to take human life, an act that preserves order in the society and increases the mystical and imperial powers of the state.

A number of other small figures with similar iconography are no less metaphorical, but they refer to the actual practice of execution. In the Asante, Dahomey, Yoruba, and Benin kingdoms, criminals, captives, witches, sorcerers, misfits, and others were executed as sacrifices by the order of kings and the priests who served them. A small number of figures of executioners, each holding a knife and a head, were made for Akan and Fon shrines.[4]

A Fon executioner figure from Dahomey is remarkable for its unusual pose (fig. 111). The executioner is carved with his left foot on the headless victim's torso; he conveys a sense of glory in his legitimized violence. Fon executioners were eunuchs, slaves consecrated to the king's service. Medicines investing them with special powers were inserted in the scalp beneath tufts of hair on an otherwise shaved head, publicly announcing their office (Pemberton in Vogel 1981, 85). In Dahomey, such men were dedicated to the god of iron, Gu.

Gu is the *vodun* (god) who eats flesh and drinks blood, yet his destructive work is culturally legitimated. His devotees—the warrior, the hunter and those who use the knives, hoes, and axes forged by the blacksmith—are persons whose acts of violence are necessary for the existence of the culture. (ibid.)

FIG. 111. This unusual carving shows a Fon executioner not only with the head of his victim but with his foot on the decapitated body. H. 8³/4 in.

FIG. 112. This engraving
shows in detail a
hunter's regalia and
equipment, which are
usually greatly simplified
in carvings.

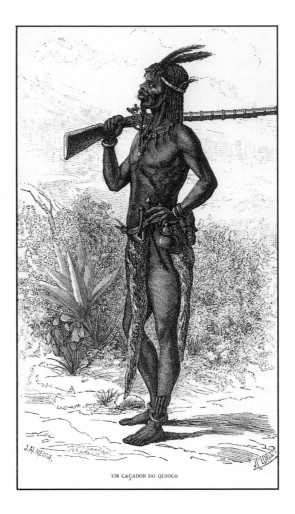

UM CAÇADOR DO QUIOCO

Hunters, Warriors, and Kings

Though the role of chief combines with that
of warrior in several West African king-
doms, it is more often linked with that of
hunter in Central Africa. (Hunters there, as
elsewhere, are also warriors, to be sure.) The
importance of hunters in the culture and art
of Zaire correlates with a broadly distrib-
uted mythology that tells of founding he-
roes who were both strangers and great
hunters. Successful hunters (fig. 112) win
great prestige among many peoples of Zaire,
which for many centuries has had an abun-
dance of game animals in the forests, river
valleys, uplands, and savanna.

Whether the high social and political sta-
tus of hunters precedes or stems from myths
and legends of founding heroes who were
great hunters is not always clear. The
Chokwe subsist primarily by farming and

herding, for example, and yet hunting has
ritual and cosmological significance arising
from origin myths featuring Chibunda
Ilunga (fig. 113), a legendary hunter, hero,
and leader. Chibunda Ilunga, or a mythical
forebear, established the Lunda Empire by
marrying the daughter of a Lunda chief.
The stratified political system of the
Chokwe derives from that of the Lunda
Empire (de Heusch 1982).

It is significant that Chibunda Ilunga, a
Luba man, is a stranger to the Chokwe peo-
ple among whom he settled. Leadership
gains impetus in deriving from the foreign
"other." Whether this hero is an actual late-
sixteenth-century person or a mythical per-
sonage is a complex issue. In either case, he
is an outsider and a culture-bearer.[5]

Chibunda Ilunga's existence as a central
figure in myths about the struggles and ex-
ploits of primordial hunter-chiefs who intro-
duced advanced cultural institutions makes
him a prime subject for Chokwe leadership
arts. Images of Chibunda Ilunga are well
documented in the late nineteenth century,
although some were probably carved earlier.
These sculptures are therefore thoroughly
"traditional" in style and iconography.[6] In-
deed, de Heusch (1982) shows how the
transformative concepts represented by the
mythology of this hero underlie the very
traditions by which the Chokwe and Lunda
are now known to us. Much of the iconog-
raphy of their leadership arts depends upon
this one critical figure.

The details in Chokwe artistic interpreta-
tions of Chibunda Ilunga vary somewhat
from one image to the next, as do myths
each time they are told (figs. 113, 114). The
chief depicted in figure 114 is bearded. He
has two small persons seated on his head-
dress and another standing at his left heel.
This is the more complex of the two wooden
figures illustrated here, as well as the finer
one aesthetically. It was probably carved
earlier by a great (but unknown) master art-
ist. Both images show the hero holding two
implements, a wanderer's (or stranger's) staff
and the weapon that establishes the

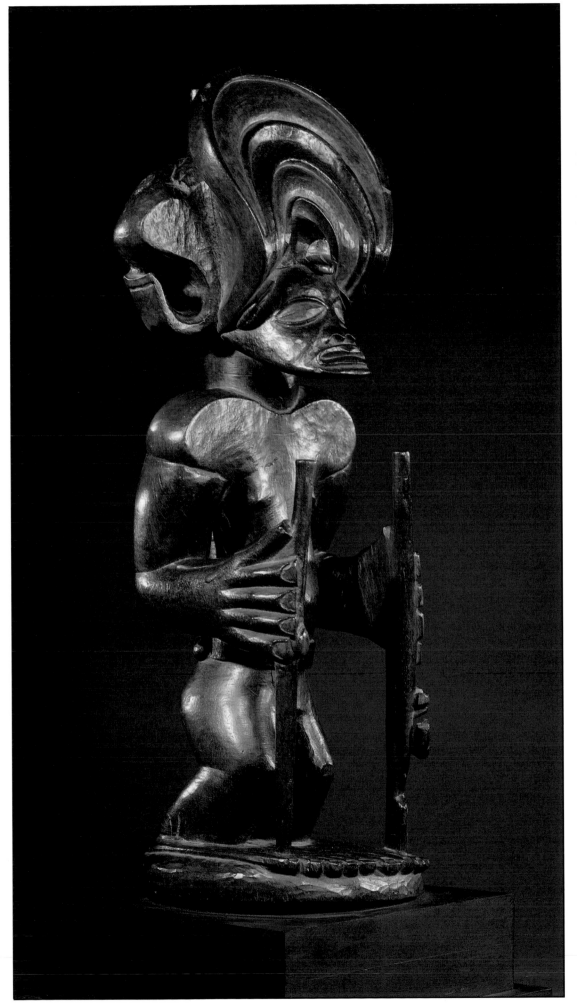

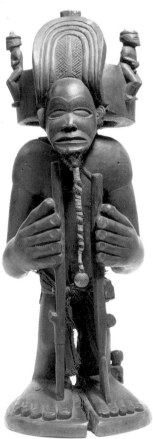

FIG. 113. The culture hero Chibunda Ilunga is shown as a great hunter in many carvings of him. H. 15⁵/₁₆ in.

FIG. 114. This version of Chibunda Ilunga is more elaborate than that in figure 113. His long beard is reminiscent of the hunter's in figure 112. H. 15¼ in.

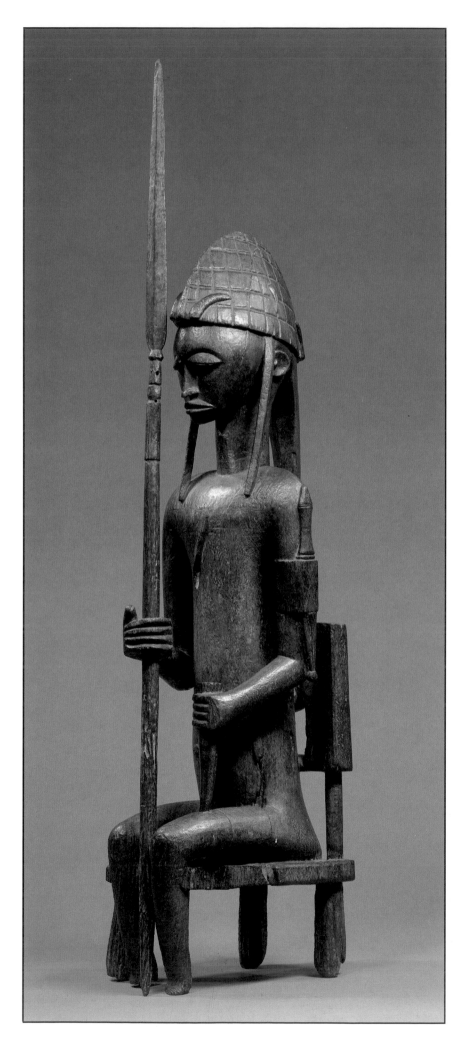

hunter's profession and status. The elaborate swirling headdresses are signs of elevated chieftaincy. The images attached to the one (in other versions, the attachments are medicine horns) are normally invisible helper spirits, indicating the hero's command of divine aid in hunting and leadership. Shoulder bags identify the carvings as hunters rather than warriors, and greatly enlarged hands and feet emphasize physical strength and endurance (Vansina 1984, 103). The long beard stands for the wisdom of elders and ancestors. The complexity of origin myths, however, is not even hinted at in these sculptures. Yet without the cultural foundation of myth, there could be no such figures, for myths are critical in explaining their attributes.[7]

The art itself is not in any way narrative, as most African art is not. Rather, it serves a mnemonic function, calling forth mental associations. Wise Chokwe informants have shared knowledge of leaders' regalia and other traits—and their meanings—along with myths; the two types of information are combined in their testimonies. The process is similar to our recollection of the biblical story of David and Goliath by simply seeing Michelangelo's marble statue of David with a sling in his hand. Much more is told in the myth of David's heroic exploits than is physically stated in his image.

Impressive statues of Bamana hunter-chiefs from Mali are interpreted in a similar manner. Like many of the figures discussed here, the seated Bamana male was created as part of an ensemble (fig. 115). With a similarly commanding, nearly life-size woman and child (fig. 116)—and thus also forming a couple—it was the principal focus of a sculptural group and its sponsoring cult, called Gwan. Other figures were companions of the central couple, adding weight and grandeur to the ensemble while expanding its iconographic richness.

The man carries a spear and a horn. Small horns are carved in relief on his headdress and a daggerlike knife is strapped to his left arm. All these insignia refer to physi-

cal and supernatural power and protection. The hat with added amulets (in this case, horns) signals hunters and other "persons of knowledge"—those who knew how to tap supernatural sources for the benefit of their people (or if sorcerers, sometimes to their detriment[8]). Ezra (1986, 33) provides an especially telling discussion of the long spear, which closely resembles nineteenth-century and earlier iron-bladed "weapons of distinction."

> Today such spears are still handed down from generation to generation, as relics of heroic ancestors. They are emblems of village chiefs and family heads, and are presented to newly circumcised boys in order to protect them with the dual powers of iron and ancestral knowledge during their period of vulnerability.

Together these insignia make this seated male into far more than an ordinary hunter.

The names of the two central figures, Gwantigi for the male and Gwandusu for the woman and child, summarize the attributes of revered leaders in this sector of Bamana culture. *Tigi* means "master" or "owner"; other male figures are called "great lion" and "ruler." *Dusu* means "soul, heart, passion, character, courage, and anger." *Gwan*, the name of the cult, also means "hot, hard, and difficult." Together the figures represent exceptional values: "extraordinary strength, ardent courage, intense compassion and conviction, and the ability to accomplish great deeds" (Ezra 1986, 30). Although the Gwan institution that commissions, enshrines, displays, and sacrifices to these images has fertility and childbirth as primary purposes, it has more general concerns as well: promoting temporal and spiritual authority, maintaining harmonious relations between the sexes, initiating youth, and fostering knowledge and wisdom. Intelligent leadership and the wise control of supernatural powers are ascribed particularly to hunters, who are the heroes of Bamana and other Mande epics, as they are of Chokwe and other Zairian myths.

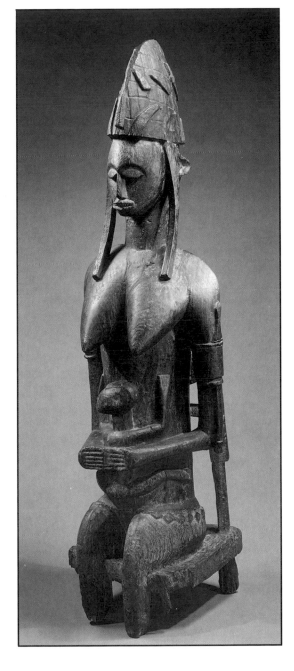

Fig. 116. Woman-and-child carvings like this one form couples with male figures (see fig. 115). Both the female and the male refer to the great powers of Bamana gods. The pair are the primary figures in a shrine ensemble. H. 48⅝ in.

FIG. 117. Although actual warfare is a thing of the past, it is recalled in powerful masquerades that are still performed in Dan villages. War spirits are accompanied by revered armed warriors.

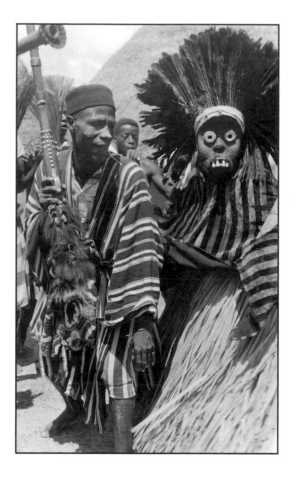

FIG. 118. Dark-masked Igbo spirits are all more or less aggressive. They chase people, and the more powerful among them have armed attendants.

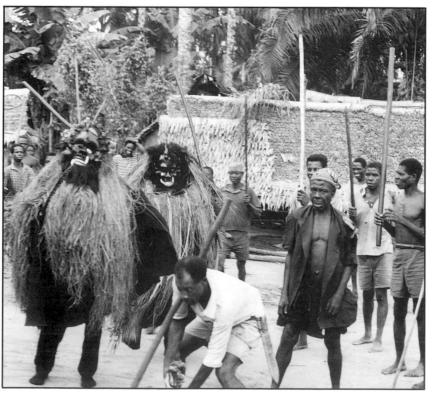

Aggression in the Performing Arts

In the performing arts, forceful-male imagery comes alive. Processions, masquerades, rituals, puppet theater, and the activities of warrior groups are dynamic arenas for the aggressive male. In fact, performed depictions of this icon are more widespread than sculptural and painted ones.

Many pastoral peoples in eastern and southern Africa have little in the way of painting and sculpture, yet they glorify warriors as works of art. Youthful warriors celebrate the strength and beauty of their bodies with elaborate personal decoration. They carry weapons almost as extensions of their arms. In everyday life, as in ritual, warrior groups are fond of proud, often aggressive posturing in a self-consciously artistic manner. Elsewhere, particularly in agricultural societies, masquerades are frequently the major forum for the dramatization of forceful or aggressive male behavior.

Probably every African group that dances masks has at least one powerful, weapon-wielding male spirit. Among the Dan and related peoples of the Côte d'Ivoire-Liberia border area, there are many such characters.[9] They range from fairly mild-mannered maskers who chase the audience for entertainment to strong spirits who have the power to take human life. These masks are not representations of bush spirits; rather, they are manifestations of them, brought to life with human help. One is Bugle, a war spirit (fig. 117). In earlier times, maskers of this type prepared men for war, blessing and leading them. A war masker recorded in 1960 carried an ancient Neolithic axe blade for magical protection. As in earlier times of warfare, the masked spirit was accompanied by the area's most celebrated warrior, who carried a musket studded with brass tacks and laden with charms. The masquerader's dance involved constant, often abrupt motion, and he continually looked in all directions, as if for enemies.

Before the imposition of colonial rule early in the twentieth century, executive and judicial positions were occasionally held

by masked spirits. This was especially true among peoples with decentralized political systems. In such polities, the human agent within the costume operated with full anonymity in the name of a major deity. Powerful masked spirits of this sort, feared by villagers, were strong deterrent and punitive regulators of behavior. The masks were often large grotesque, semihuman heads with bold, thrusting shapes, huge toothy maws, and multiple horns. Wood, cloth, or fiber masks, garments, and many substances attached to garments were considered medicinal charms. Mask, costume, and medicines localized the impersonal powers of the spirit. In turn, the spirit's powers were broadcast from the animated masker, who moved with nonhuman strides or glided and spoke in eerie, otherworldly tones, if at all (fig. 118). Some such spirits had supporters to direct and even restrain them; others operated alone, often at night. These maskers had many specific duties, including levying fines, arresting witches or criminals, punishing lesser lawbreakers, settling disputes, and administering poison ordeals (a form of lie detection).

If shrines are repositories for power, aggressive masks are enactments of it (Kasfir 1988b, 5, 7). Whereas a shrine depends on people coming to it, a masker is mobile and fast acting and can seek its object out. The masker is enveloped with magical substances seen as instrumental, even fatal. Power thus embodied in the masker exists as a living, moving agent. In some cases, too, a god's power "rides" the masker, fusing with him as a horseman fuses with his mount. Though this sort of spirit possession does not necessitate a mask, it is particularly awesome and authoritative when it combines with the visual drama of masquerade.

The attributes of hunters, warriors, and heroes are also celebrated in the secular puppet theater of Mali (Arnoldi 1983). Bamana, Bozo, and other peoples construct daytime dramas around, and sometimes physically on, the backs of feared animals, such as the bush buffalo, called *sigi* (fig. 119).

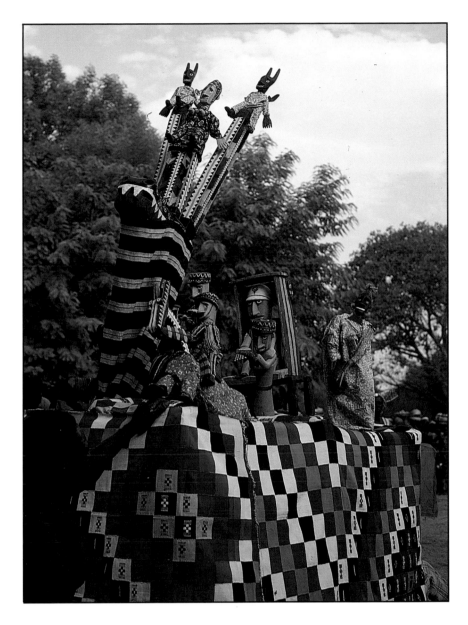

A broad range of social issues are enacted in these performances. Hunters and warriors appear in the foreground of many, dramatizing at least implicitly the qualities of "father-childness," *fadenya*, discussed earlier. The words of one *sigi* song are: "Bellow, strolling solitary buffalo. Bellow, you are in the hands of men." Members of a local audience interpreted the song in two ways. It refers both to the alienation from his kin of the man seeking heroic stature and to the rivalry "which exists between bush animals and men in their role as hunters" (Arnoldi 1983, 152). The song was seen as praise for hunters. The entire puppet ensemble of figure 119, an innovative creation featuring President Musa Traore of Mali and his entourage, was an expression of these concepts when it was introduced in 1968. The age grade responsible for it continued to be credited in the late 1970s, when it was still being played (ibid., 142–43).

FIG. 119. Puppet dramas are played out on the backs of bush animals, in this case a buffalo. Here, the president of Mali is accompanied by an entourage that includes an armed policeman and a rider.

FIG. 120. Benin chiefs
gesture their support of
the divine king or his an-
cestors by twirling their
mystically charged cere-
monial swords in the air.

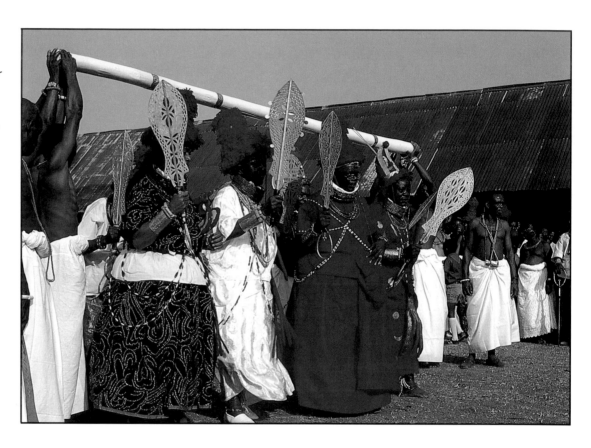

Statecraft and Force

Divine kingship, especially in Benin and among the Kuba of Zaire, is a show of force. In a Benin ritual that glorifies the king, loyal subchiefs twirl ceremonial swords aloft (fig. 120). Weapons and gestures alike contribute to strengthening the king's head and his other powers. Military might is stated constantly in the regalia, ritual, and arts of both kingdoms. Benin weapons—and the men who wield them—are amplified and spiritualized by the strength of dynastic ancestors (the swords normally reside on ancestral altars) and by the mystique of sacred iron and brass.

The relative continuity of Benin royal imagery over several hundred years, from the fifteenth to the nineteenth century, is seen in repeated military iconography not only in depictions of various titleholders, chiefs, and soldiers but in images of the divine king himself. The actual strength or military sagacity—or their lack—of a living king is not to be read in the corpus of Benin royal arts. Viewed cumulatively, the representations seem to be repetitive, propagandistic statements akin to political image making. The king is aggressive, dominant, invincible.

Kuba royal arts are analogous in several ways. The succession of kings' portrait figures, called *ndop*, is similarly propagandistic (fig. 121). Each king holds the same ancient short sword introduced by the founder of the dynasty in the seventeenth century; he is rendered as an eternally youthful and idealized being. Sitting solidly on a simple throne, each radiates an enduring sense of continuity with earlier and later holders of the office.

Kuba *ndop* figures, unlike much Benin art, are not displayed openly inside or outside the palace. The sculptures are said by the Kuba to be portraits that were carved from life in the presence of their subjects (Vansina 1972, 44). Yet apart from the carved symbol of each reign and the relative corpulence of the king figure illustrated here

(fig. 121), the images are not individualized in any way. They are generic commemorations.

Ndop are housed and cared for by royal wives when the king is away. During installation rites, a new ruler is isolated with the image of his predecessor to absorb his divine life force. Until early in the twentieth century, when the visiting researcher Emil Torday was given three royal statues for safekeeping (they are now in the British Museum in London), *ndop* of past kings were kept in the palace as memorials. They were not, however, the focus of rites for royal ancestors (see Vansina 1972).

Two major differences between Kuba and Benin royal art are the greater subtlety of the former and the constant repetition of militarism in the latter. Among the Kuba, apart from *ndop*, there are no multifigure groups, no elaborate figurative altars, no profusion of ritual implements adorned with royals. On the other hand, decorative arts—sophisticated textiles, dress, and prestige objects embellished with geometric patterns—flourish. Many masks are also produced. On ceremonial occasions the king is laden with rich symbolic regalia, including a weapon for each hand (fig. 122). The sumptuousness of this assemblage contrasts with *ndop* figures, which are restrained and sober in comparison. Military force and opulence are understated in the statue, overstated in the actual king.

Although no precise features distinguish the royal art of Benin and Kuba from leadership art elsewhere in West and Central Africa, the art of those two kingdoms nevertheless communicates greater intensity, richness, and restrictiveness than the art of peoples lacking divine kingship. Style consistency over several centuries in both kingdoms also signals the unusual strength and continuity of the central authority vested in these divine rulers.

In leadership art, high-ranking individuals are often set apart from those of lesser status by the materials and objects—including weapons and staffs—that they

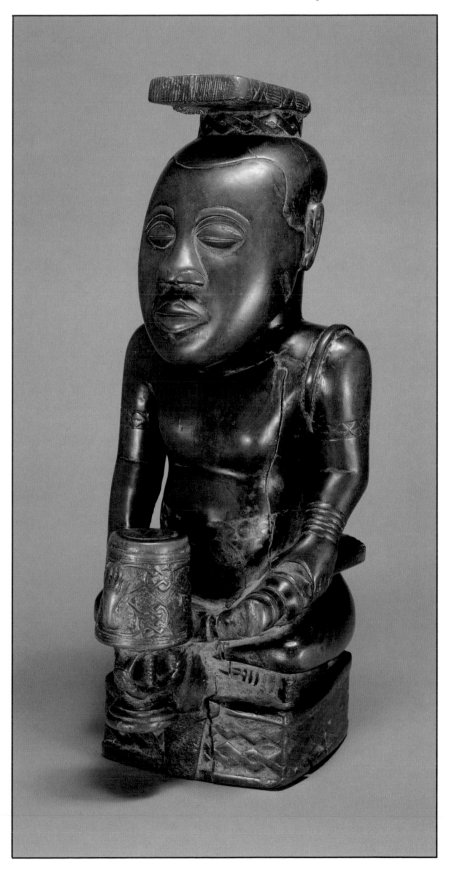

FIG. 122. Kot a-Mbweeky III, a divine Kuba king, seated in state. He is holding a sword in one hand and a lance in the other.

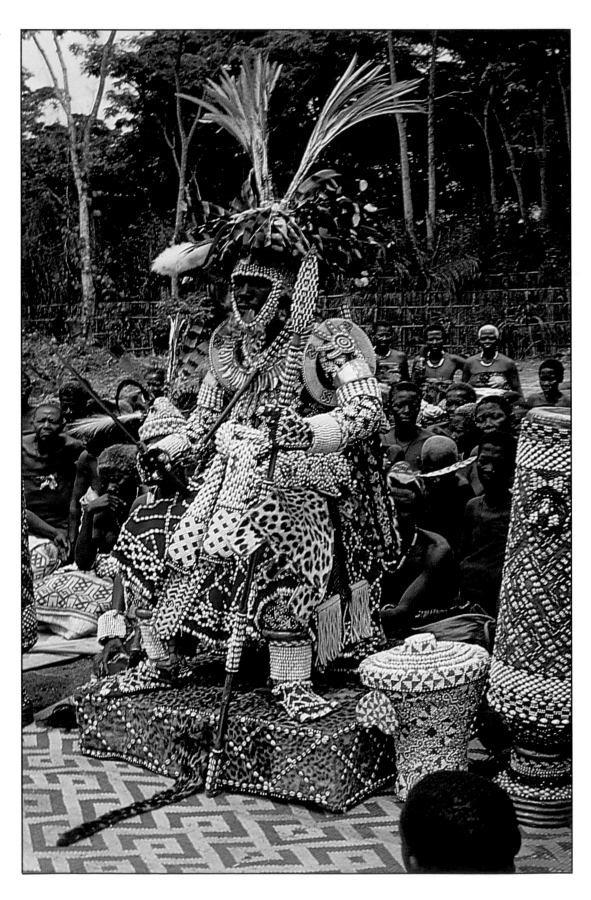

FIG. 123. This Akan staff top in gold leaf over wood shows an ill-prepared hunter being attacked by the leopard he sought to shoot. H. of full staff 60 in.

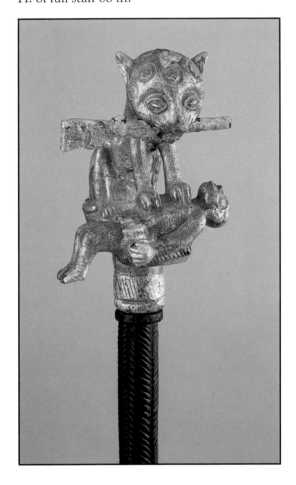

FIG. 124. Asante gold-weight with the same motif as in figure 123. H. 2⁵/₁₆ in.

command. Copper alloy objects in Benin were the privilege only of those granted the right to use them by a king. The king reserved ivory for himself alone. Among the Akan of Ghana—an area rich in goldfields and long called the Gold Coast—gold was a royal prerogative in art and regalia (although before about 1900 it was widely used as currency at all levels of society). Gold-leafed staffs, commissioned by chiefs and owned by states as part of the royal treasury, were lent out to chiefs' counselors, called linguists.

One fanciful staff image depicts the hunter as a rare negative example, as one who is vanquished by the animal he seeks to kill (fig. 123); in this case, the leopard has also stolen the hunter's gun! The same theme appears in many goldweights owned by royals and nonroyals alike. Most show an earlier phase of the apocryphal action; in figure 124, the leopard attacks the hunter, who has not yet lost his weapon. An English translation of the associated proverb is "It is better not to have fired at all than to fire and only wound the leopard." This motif—both visual and verbal—is an admonition to anyone unsuited to his job, whether because of incompetence or the lack of forethought, appropriate material, or spiritual support. In the context of state-craft, where the linguist operates, the proverb has relevance to anyone whose challenge to the chief, or to the state itself, either has been or might be inadequate. The motif and its proverb also speak about the judicious use of power, whether or not royal, implying that the king himself would not go hunting—or anywhere else—ill-prepared.

There is nothing inherently royal about either hunters or the use of proverbs or power in Akan life. But by using gold leaf over the carved wooden finial and placing the staff in the hands of a major royal adviser and spokesman, the Akan elevate both the hunter and the emblematic expression of his shortcomings. The staff adds to the king's ability to separate himself and his court from rivals or challengers, implying that they will never be capable of mounting an effective campaign against him. Such principles of elevation and contrast are often used by African leaders, particularly in the weapons carried by them and shown in works of art.

FIG. 125. A group of tongue-as-blade adzes from several peoples of Zaire. H. 10–14 in.

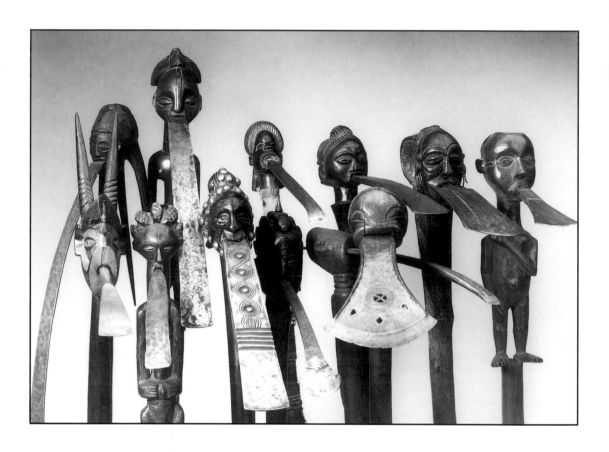

FIG. 126. A rock art image of a man hunting or threatening with a stone-bladed weapon, Tassili region, Algeria.

The Iconography of Weapons and Metallurgy

The practical and symbolic values of weapons in African life are frequently dramatized in works of art, particularly when weapons appear in contexts of ritual and political display. As ceremonial objects, they are elevated beyond technological utility to become emblems of myth, history, authority, and spiritual power (figs. 36, 120). The compressed and varied ideological statements made by these implements give them greater force than is lodged in a mere cutting tool. Superior status is expressed in their artistic aggrandizement—the openwork blades of Akan or Benin ceremonial swords, for instance, or handles too fragile or ornamental to be comfortably grasped (fig. 36).

Spears, knives, adzes, axes, and other weapons and tools are broadly distributed items of chiefly regalia in most parts of West Africa and Zaire. Adzes or axes with sculptured heads, and sometimes bodies, often have blades serving as tongues (fig. 125). These status symbols belong to chiefs, warriors, diviners, or healers, who frequently carry them on the left shoulder. They are also found among weapon collections in chiefs' treasuries, where they have great value as heirlooms. Tongue-as-blade anthropomorphic ceremonial weapons have such a wide distribution, from the Tiv of Nigeria to numerous peoples of Zaire, that they are probably an ancient form. Perhaps future research will link them with the Bantu migrations that populated Zaire.[10]

The symbolic uses and meanings of tongue-bladed adzes in Zaire—where they are concentrated—vary from one ethnic group to another. Among the Mbuun, they are associated with ancestors and possession of the land. Among the Mbala, they symbolize a chief's capacity to unify his people (Biebuyck 1985, 137, 163). Unadorned adzes are the principal tools of sculptors; elaborated examples are owned by numerous specialists in the art of ritual or political power.

FIG. 127. Yoruba ceremonial weapon of cast copper alloy. The handle is in the form of a dignitary, perhaps an Ogun priest, since this weapon is associated with the cult of Ogun, god of iron. H. 18¼ in.

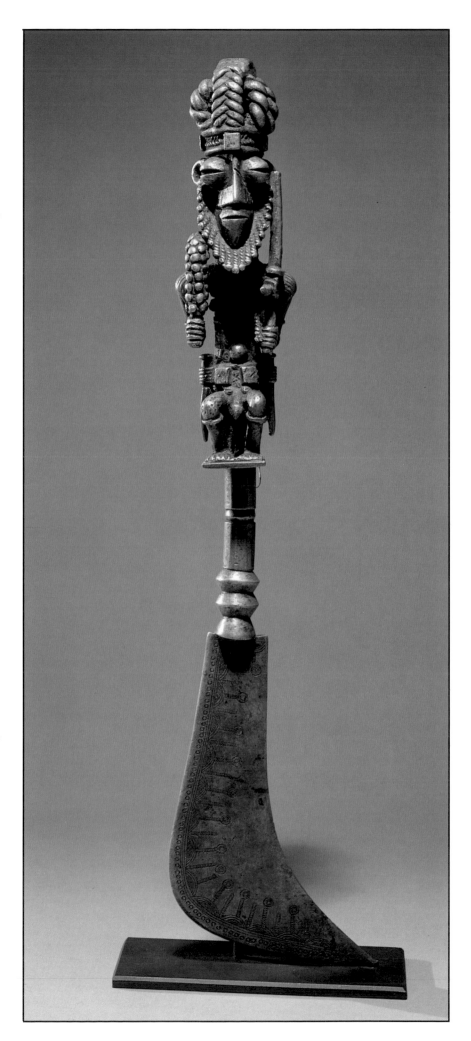

A metaphorical link between these powers of leadership and those of commanding speech is strongly suggested by the use of tongues as blades. The words of leaders, like weapons and the metal of which they are made, are authoritative. Wise speech is a sharp tool.

Another now-symbolic weapon is the kind of ancient stone axe widely found in West African shrines. Among the Yoruba and nearby peoples, these ground stone blades, actually made in the late Stone Age (c. 10,000 B.C.–1,000 B.C.), are believed to be "lightening celts" sent to earth by the god of thunder and lightening.[11] They survive as symbols and also remind us of other premetal weapons shown extensively in Saharan and other rock art. The stately hunter-warrior in figure 126 brandishes a hafted stone axe or club. The spear and the bow and arrow are other common Stone Age weapons. Stone tools were rendered obsolete by the slow but pervasive introduction of iron implements, which simultaneously helped promote the agricultural revolution. That they survive in ritual attests both to the primacy accorded weapons in African thought and to the need to invest contemporary action with allusions to the remote, even mythic, past.

The mystical transformation of ore into metal has long been a hazardous art. It is spiritually sanctioned, as is the fashioning of utensils from these materials. Smelting furnace and forge alike invoke extraordinary heat and energy and thus danger. Furnace and forge are sacred, fertile places where earth is mysteriously transformed to metal. Their creative potential, parallel to women's procreative powers, is sometimes manifest in female symbols—breasts and vagina—in otherwise all male arenas (Herbert 1984, 40). Weapons and tools are ambiguous; they have the power to create and destroy. They make civilization possible and constantly threaten it.

In ancient times, the knowledge and working of metals came to be vested in specialized families, classes, or castes, which

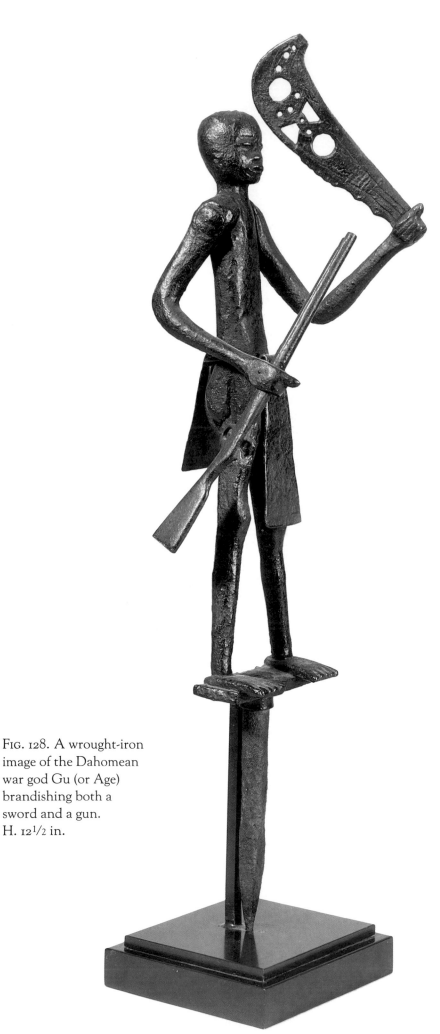

FIG. 128. A wrought-iron image of the Dahomean war god Gu (or Age) brandishing both a sword and a gun. H. 12½ in.

guarded their occupational secrets. Access to metal is access to power. Because power in the wrong hands is dangerous, metal must be controlled either by its owners—blacksmiths and casters—or by the leaders of the larger society.

Blacksmiths in the Western Sudan are particularly powerful. Creation myths among the Bamana and Dogon peoples identify primordial smiths as creative culture-bearers. Their invention of iron tools underlies productive cultivation, just as their earlier spear and arrow points and more recent firearms make hunting and warfare more efficient. Smiths among the Bamana have especially potent charges of life force, *nyama*, and thus links with divinity and esoteric knowledge, enabling them to be doctors, circumcisers, diviners, and peacemakers. Like the heat and metal they manipulate, smiths are anomalous in the eyes of the numerically dominant farmers among whom they live yet with whom they may not intermarry. Throughout sub-Saharan Africa, smiths are both respected and feared for their exceptional powers and knowledge.[12]

Several forest peoples honor the power of metal through cults of the god of iron and war, known by the Yoruba and Edo as Ogun and by the Fon as Gu. Ogun, who drinks blood, is a restless, hot-tempered god of violence and overt male sexuality. In Yoruba creation stories, Ogun's machete cleared paths for other gods; this tool is perhaps recalled in the fine cast brass figurative ceremonial weapons held by Ogun priests (fig. 127). Fon creation myths may account for the openwork sword, *gubasa*, held aloft by an iron image of Gu (or Age,[13] a related deity who is the patron of hunters and bush animals) (fig. 128). "When the creator came to earth he held Gu in his hand in the form of a *gubasa* and with it he cleared the forests, and taught men how to build houses and till the soil" (Barnes and Ben-Amos 1983, 10). Ogun and Gu are worshiped by blacksmiths, carvers, warriors, and hunters, as well as others who use tools and weapons.

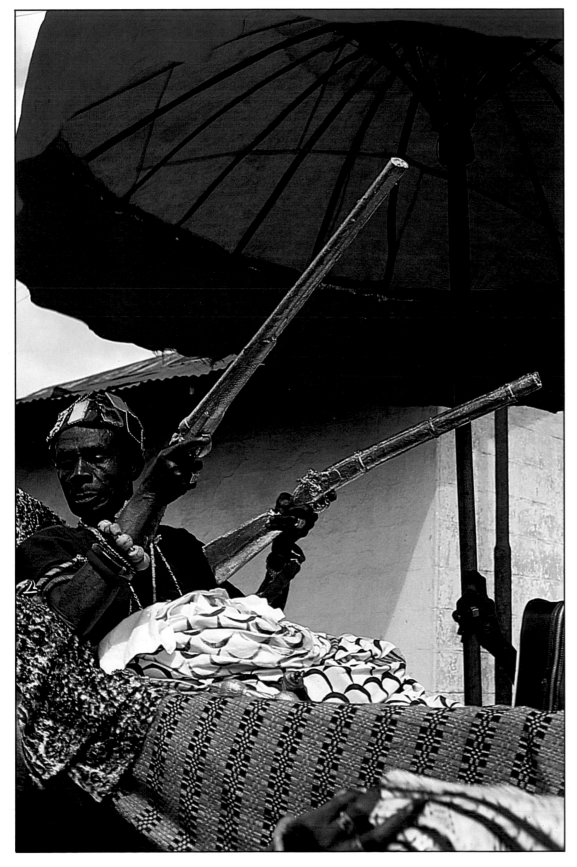

FIG. 130. Akan gold-weight of a man smoking a pipe and carrying a weapon in each hand and a powder keg on his head. H. 2³/₁₆ in.

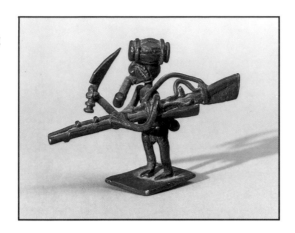

When correctly approached, these gods are beneficent, but their destructive potential is ever present.

Weapons of many kinds are treated as heirloom relics, and some are vested with divinely energized powers of their own. This metaphysical value is evident in the war gods' weapons, in the way spears are used in Bamana initiation, and in the anthropomorphizing of adzes of Central Africa. Benin ritual swords, *ada*, express ancestral power (Ben-Amos 1980, 15). The most elevated Asante state swords had names and ascribed personalities; they thus had a kind of independent, animated existence that transcended the roles and powers of their human bearers. These and other ceremonial weapons represent a merger of public display and spiritual powers, the latter originating in restricted sacred sources. The heat and generative energy of the forge imbues metal with dangerous essences that are then embodied in the implements controlled by leaders and other elite specialists. Man has actively used weapons to form and maintain political institutions.

A number of forceful-male icons are shown carrying two or more weapons, just as the Kuba king wields a sword in one hand and a spear in the other (fig. 122). Indeed sometimes male forcefulness is intentionally redundant by virtue of "weapon overload."[14] In such cases the weapons have a cumulative symbolic meaning. An Akan chief, for example, carries a gold rifle in one

hand and a silver one in the other (fig. 129). That neither gun fires—both are wooden replicas covered with noble gold and silver leaf—matters not at all in this doubled expression of political and military might, appropriate for an annual festival that shows off the strength of the state. The doubling of weapons is apt for the shrine figure of the war god Gu (fig. 128). The image exactly fits the words of one Fon informant: "When a man goes to war what does he take? He takes the sword, he takes the gun" (Herskovits 1938, 107). An even more overloaded hunter, cast as an Akan goldweight, carries a rifle longer than he is tall, a dagger poised for action, and a powder keg balanced on his head (fig. 130).

The Ideology of Force

A Hemba figure with two weapons (fig. 131) is both an ancestor figure and a warrior-hunter—perhaps a war leader and principal military adviser to a Hemba chief. Such figures were made for cults of ancestor veneration and preserved in funerary houses or chiefs' houses. Though the Hemba termed them portraits, facial features are not individualized. The images recall the glory of the warriors who were the clan founders, as well as the more recent dead.

All the important features of the forceful-male theme can be seen in this Hemba ancestor. As extensions of his arms, his weapons refer to courageous physical action; they also symbolize the prevailing masculine ethos, the aggressive impulse to venture outward to the dangers of warfare or hunting. Implicitly this icon refers both to life-taking powers and to the mystical wells of protective and life-sustaining forces in metal and the forge. It also alludes to the potency of blood, in death, to regenerate the ultimate sources of life: the ancestors and the gods. In being ritualized, the hero is also depersonalized. Instead of being an individual person, the forceful-male icon is a kind of visual panegyric, the province more of heroic ideology than real flesh-and-blood people.

FIG. 131. A Hemba ancestor figure in wood holding a weapon in each hand. H. 31½ in.

7 Riders of Power
The Mounted Leader

A mounted horseman fuses human intelligence with animal strength, creating an awesome presence far greater than the sum of its parts. The strength of this unit is daunting enough when the horse stands still, but when catalyzed by motion and speed, it unleashes superhuman power (fig. 132). It is no wonder that all over the world, equestrian images have glorified the lives of emperors, heroes, and warriors—even if they never rode horses! So it is in West Africa, where equestrian imagery began before the dawn of the Christian Era and continues today.

The superiority of riders—both physically and figuratively—identifies them as aggrandized, affluent, forceful males. The mounted man generally outranks the unmounted. He is faster, richer, higher, more visually and psychologically impressive, and thus in a more commanding position from which to lead.

Animal Mounts in Art

Horses are the primary animals ridden in African art, but by no means are they the only ones. A great many other animals appear in rider imagery. Camels, which were introduced by the Romans and used in the trans-Saharan trade, are depicted with riders in rock paintings and engravings in several locations (fig. 133).[1] There are sculptures showing people riding elephants, antelopes, oxen, crocodiles, tortoises, leopards, and lions. The rider-of-power theme extends as well to the palanquins and hammocks in which important people are carried. The theme has also come to involve bicycles, motorcycles, and other modern vehicles (fig. 134).[2] Some vehicles have even been invented for African terrain (figs. 135, 136). Many images depict the riding of animals that are not ridden in real life or of animals that are themselves imaginary; these renderings draw creatively on belief,

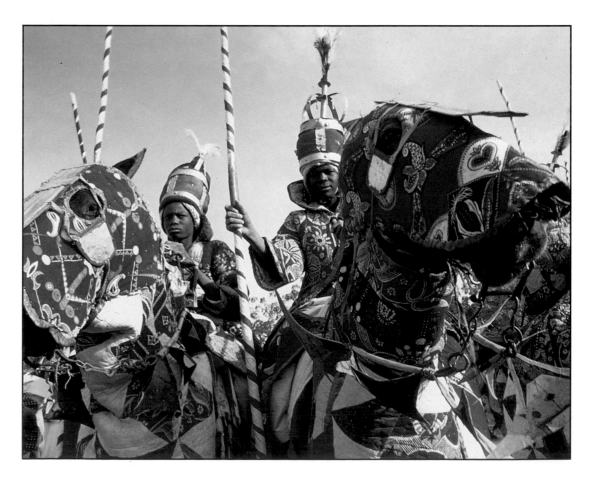

FIG. 132. Hausa riders and their horses wear protective garments in a state celebration, northern Nigeria.

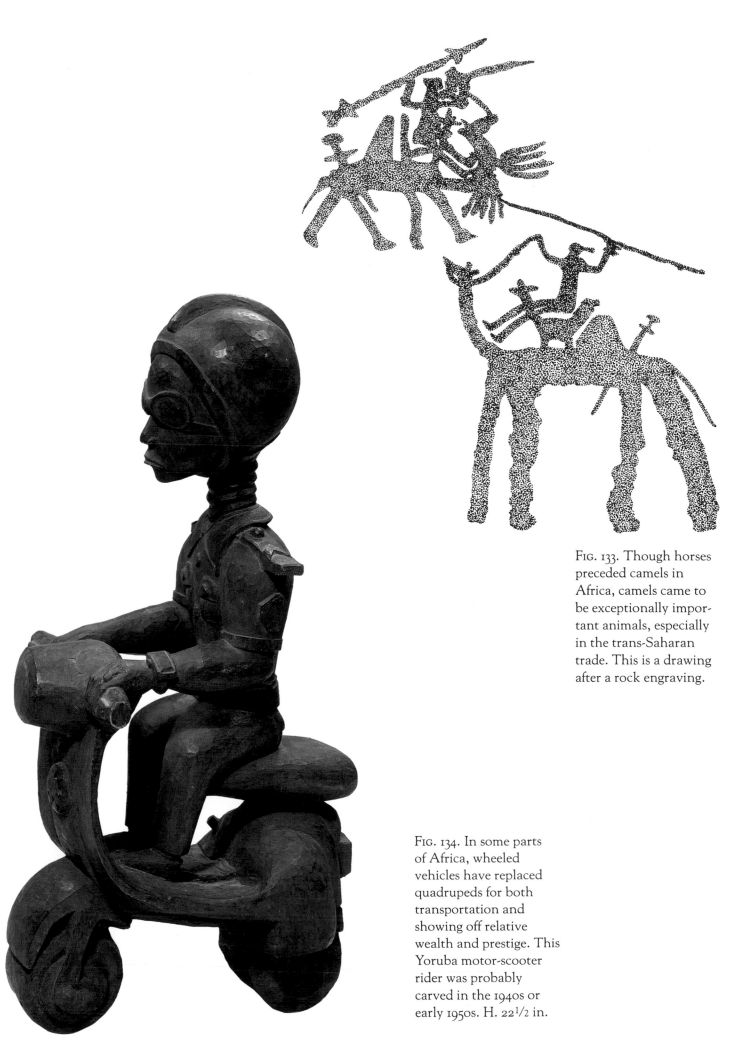

FIG. 133. Though horses preceded camels in Africa, camels came to be exceptionally important animals, especially in the trans-Saharan trade. This is a drawing after a rock engraving.

FIG. 134. In some parts of Africa, wheeled vehicles have replaced quadrupeds for both transportation and showing off relative wealth and prestige. This Yoruba motor-scooter rider was probably carved in the 1940s or early 1950s. H. 22½ in.

FIG. 135. A 1908 letter in the collection of the Smithsonian Institution ascribes the invention of this unicycle to a Scandinavian missionary. He adapted a "bath chair" for use on the hilly, narrow pathways of the Lower Congo region (now Zaire).

FIG. 136. This Kongo wood carving recalls the scene in figure 135. It appears to satirize the white missionary. H. 11⅝ in.

a

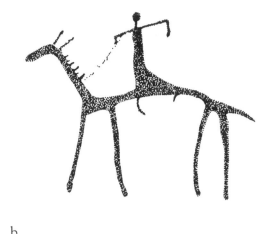

b

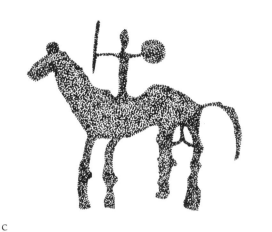

c

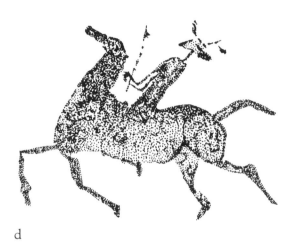

d

FIG. 137. Several rock art versions of equestrians from different sites in the Sahara and the Drakensberg Mountains in southern Africa. (Drawings not to scale.)

ritual, dream, myth, and even fantasy. In some cases, the rider figures are spirits, and the "horses" they ride are really their human devotees. Still, the horse and its relatives, the mule and the donkey, dominate the theme of riding in African art.

Horses, donkeys, and oxen preceded camels in the Sahara as beasts of burden. Horses were introduced in the second millennium B.C.; it was the horse, not the camel, that opened trans-Saharan trade and travel. Chariots drawn by horses, noted by Herodotus in the fifth century B.C., still charge across rock walls in the Sahara. Engraved and painted horses with riders, created somewhat later and more broadly distributed, further attest to the early prestige or utility of the equestrian unit (fig. 137).

The earliest evidence that horses were ridden in forest regions south of the Sahara comes in the form of a small bronze equestrian unearthed at Igbo-Ukwu in southeast Nigeria (fig. 138). It dates to the tenth century A.D. Like the openwork potstand discussed in chapter 4 (fig. 66), this well-cast image was part of the sumptuous regalia be-

longing to a priest-leader of the ancient Nri Igbo people, whose descendents still occupy the site of these archaeological finds. Horses do not survive well in Igboland because of the deadly sleeping sickness borne by tsetse flies. For this reason, they have not been ridden for practical purposes nor have they been brought into forest areas in large numbers. This early sculpture, however, suggests that some have been imported for a long time. Even today the Igbo people attach great prestige to the ceremonial riding and killing of a horse, activities required for the taking of a costly "horse title." It is possible that the Igbo-Ukwu equestrian refers to this prestigious title.

Horses were for several centuries carriers of foreign products and thus important agents of change. The many riders engraved and painted on rock surfaces—though their riders can rarely be identified—remind us that strangers have come to tropical Africa since ancient times. The first strangers traveled across the Sahara and southward into forest areas, and more recently they came from across the seas.

FIG. 138. A small tenth-century copper alloy equestrian figure from Igbo-Ukwu, Nigeria. The rider's facial scarification is similar to that observed on elderly Igbo people in the 1980s. H. 6³/₁₆ in.

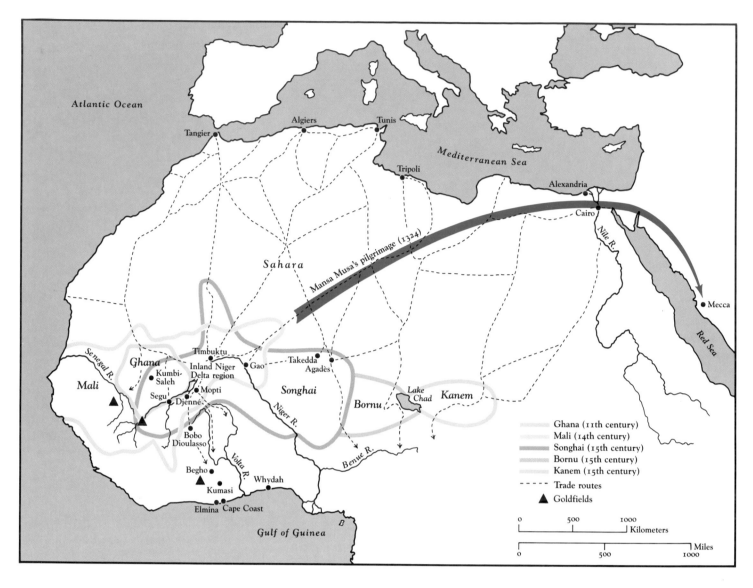

Map 2. West African Empires c. 1000–1500

Horsemen in the Western Sudan

Horses survive well in the (tsetse-fly-free) savanna and Niger River flood plain of the Western Sudan and apparently have done so since about A.D. 1000. At approximately this time, according to written and scientifically derived records, horses and horsemen were certainly present in the region. Terracotta and copper alloy equestrians have been recovered archaeologically from Djenné and other sites in the vast Inland Niger Delta. Their dates (by thermoluminescence) fall between A.D. 1000 and 1600 but are concentrated in the period from A.D. 1240 to 1460, roughly coeval with the expansion and apogee of the Mali and Songhai empires (de Grunne 1987, 20). The chronicles of Muslim explorers and travelers also provide written evidence for both horse and camel riding in the region, beginning in the tenth century. Writing of the ancient empire of Ghana about 1050, for example, al-Bakri reports that ten gold-bedecked horses were kept ready for the king. In addi-

tion to royal riding, several medieval West African empires also relied on vast ranks of cavalry. Al-'Umari reports, for instance, that the military strength of the Mali Empire (c. 1200–1400) depended in part on ten thousand horsemen (Law 1980, 13). Horses were being bred and raised in the Western Sudan by the fourteenth or fifteenth century, but the best ones were still being imported in large numbers and at considerable expense from the Arab Mediterranean. They were paid for in slaves.

Among the largest and most impressive of the archaeological finds is a small group of mounted terra-cotta dignitaries from Djenné or sites nearby (fig. 139). In figure 139, the rider wears a helmet, arm and leg bangles, and a decorated garment. He carries a large quiver strapped to his back and a short knife on his left arm. Both he and his mount—dressed in a fancy collar, a necklace of bells, and a bridle—strike rigid, noble poses as if at a review. This straight-legged, formal stance is preferred for equestrian

icons, which serve to support and project the image of heroic leadership. An especially large and majestic Dogon equestrian in wood (fig. 140) has not been dated, but it is related in stance, style, and iconography to figure 139. In all likelihood, this piece was once the focus of an important shrine. Since the Dogon have also continued to carve horsemen well into the twentieth century, this icon has nearly one thousand years of continuity in Mali.

The identity of both ancient terra-cotta horsemen and more recent Dogon versions in wood and the exact uses of these images remain matters of speculation. De Grunne (1987, 20) sees the terra-cottas as gods of the early inhabitants of the region. He notes the sacrifice and ritual burial of horses in royal tombs and thinks that equestrian statues were a means of obtaining help from the deities. It is equally plausible, however, that horsemen commemorate respected deceased leaders, perhaps cavalry chiefs, rather than gods.

Alternatively, they could be mythical ancestors made in human form. Ezra (1988, 40) proposes that Dogon equestrians could represent "invaders or emissaries of distant kingdoms." This possibility is consistent with the image of the rider as warrior, chief, god, or mythical hero. Whoever is specifically depicted, most writers believe these riders are wealthy leaders by virtue of the cost and prestige value of horses and the high status conferred upon their owners.

Some Dogon equestrians are certainly to be associated with a supreme officeholder, the *hogon*. During a *hogon*'s death rites, his corpse is bound upright on a horse's back and then carried in this position for a brief promenade (Desplagnes 1907, 332). A few of the numerous Dogon brass rings with riders depict this scene exactly (fig. 141).[3]

The *hogon* is a semidivine leader of great wisdom who acts as a peacekeeper and judge. He also wields spiritual power by virtue of his experience, his proximity to the ancestors, and his death-rebirth initiation as head of the cult of Lebe. This transform-

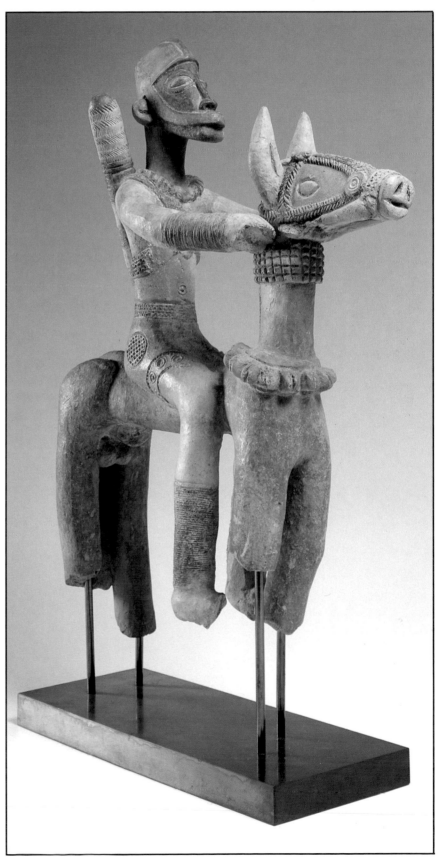

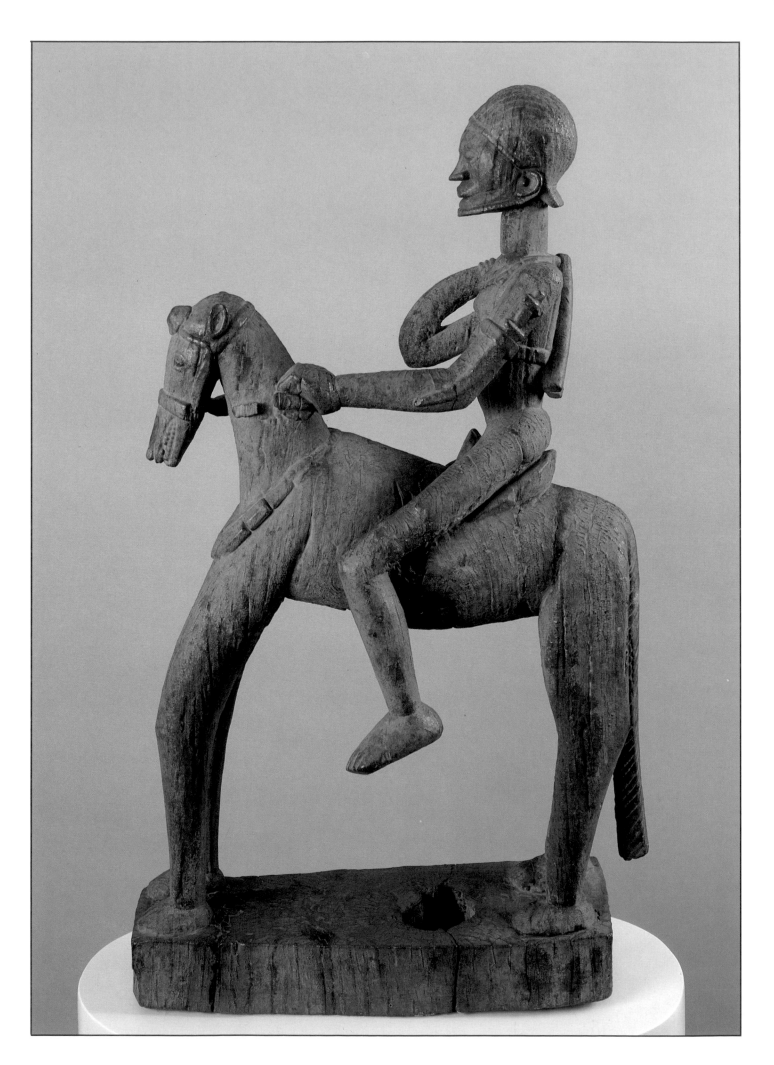

Fig. 140 (*facing page*).
This Dogon sculpture
is one of the largest
wooden equestrians
known. H. 36 in.

ing initiation fuses the person of a *hogon* with Lebe Serou, a primordial ancestor incarnated as a snake, symbol of rebirth. Lebe cults address the fertility and regeneration of Dogon people and their agricultural lands. The importance of the *hogon* in Dogon life makes him, or his mythical prototype, a prime candidate not only for ring sculptures but for larger shrine images.

There are other Malian ring sculptures, copper alloy miniatures, and small terracottas of riders that probably do not depict *hogons* (fig. 142), because they have been recovered from sites well beyond Dogon territory. Since Songhai and other medieval states maintained large cavalries, rings and other small equestrians may be associated with these men. In the absence of any data, it is logical to relate larger rider statuary to leaders, smaller versions to the troops. Possibly the numerous small images were amulets, as many small copper alloy sculptures are today among several peoples of the Western Sudan.

Many small images are more animated than the large horsemen, in part because spears or shields break out of the stable, grounded composition made by the horses' stiff, straight legs (fig. 143). The group of smaller horsemen includes a number of amazingly tiny bronzes about an inch high (fig. 38). They may be precursors of more elaborate miniature riders made further south by Akan peoples (in the forest region) from about 1600 to 1900 and used as goldweights (figs. 3, 5).[4] The archaeological pieces from Mali were recovered from tombs, where they apparently figured as votive grave offerings (and originally, perhaps, as amulets).

Iron Horsemen

Iron horsemen—and very rarely, women (fig. 53)—are made by Dogon, Bamana, and other smiths of the Western Sudan (fig. 144). These equestrians convey the awesome power lodged in the metal itself, as well as the power vested in the blacksmith and the related professions of hunter, warrior, and

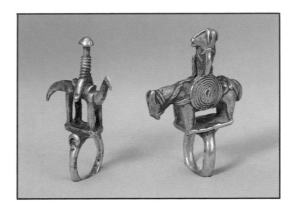

Fig. 141. Two Dogon rings of cast copper alloy. The bound person (right) in all likelihood represents a deceased important priest and dignitary called a *hogon*, and the other abstract figure may as well. H. 2$^{1}/_{2}$ in. (left) and 2$^{11}/_{16}$ in. (right).

sorcerer. Some iron staffs (both with and without rider imagery) have been documented on Bamana ancestor shrines. One staff, for example, was placed over the tomb of a village founder known as a great warrior (Ezra 1986, 9). Iron staffs also embellish the altars and groves of Bamana initiation societies (ibid., 10). McNaughton (1988, 122) documents varied uses for iron equestrian images, which are sometimes called "iron horse masters" because of the political and military potency of horsemen in this area. Of the Bamana blacksmith's many prod-

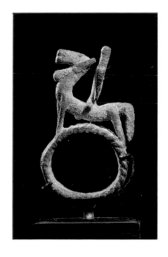

Fig. 142. A copper alloy ring excavated from an unspecified site in the Inland Niger Delta region of Mali. H. 1$^{3}/_{4}$ in.

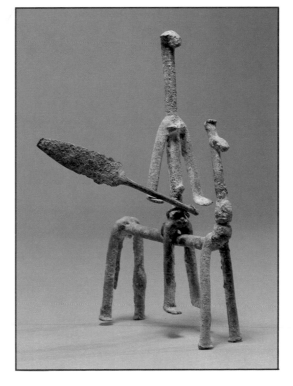

Fig. 143. An excavated copper alloy equestrian rendered in an abstract, economical form. H. 6$^{1}/_{4}$ in.

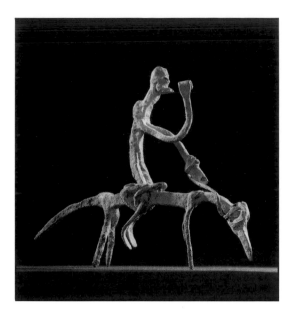

FIG. 144. A Dogon wrought-iron equestrian in a fluid style. H. 4½ in.

Riders in Modern Mali

Equestrian statuary and other modern versions of the theme continue to enliven the arts of Mali. Today the president of the country rides in a limousine in the streets of Bamako, the capital city. An amusing yet admiring image of this scene is part of a secular puppet tableau in a rural Bamana village (fig. 119). Here the president is accompanied by mounted guides and armed guards, as he is in Bamako. A recent glass painting, made in Bamako by the transplanted Senegalese artist Djiby Seck, tells the story of the reluctant donkey, well known in Malian folklore (fig. 145). Inspired by an earlier painting of the same subject by the late Gora M'Bengue, Seck has created a dynamic new interpretation. A griot (hired praise-singer) is being thrown by his donkey as he and others—also toppled by the donkey—arrive at a village to sing for a wedding. The donkey protests, according to the artist, because its rider was drumming too loudly and causing a ruckus. Griots are often considered impolite (Mary Jo Arnoldi, pers. com., 1989).

ucts, figurative iron objects are considered the most difficult to make, in part because iron is hard, in part because the pieces are full of vital spiritual energy (*nyama*), and in part because they are charms with varied powers depending upon the material and verbal formulas of which they are composed. When used actively and sacrificed to, iron staffs continue to gain and radiate power, the power to protect, cure, fight, honor, lead, and repel. McNaughton (1988, 120) cites one instance when a villager held up an iron equestrian with its back in the direction of an invading enemy while another person held a spear. "In this way they would avoid war," McNaughton was told.

FIG. 145. "Griots being thrown by a reluctant donkey" is the subject of this animated glass painting by the young Wolof artist Djiby Seck, who works in Bamako, Mali. 12¾ x 19 in.

Optional Shrine Art

Equestrian images in several media are made and used by the Senufo people, who live south of the Dogon and Bamana. Horse-and-rider figures of various sizes are found among diviners' and other priests' shrine implements and statuary. These shrines usually feature a male-and-female couple. An equestrian (fig. 146) may replace the standing male as half of the pair, or it may supplement the group. The rider is always optional, a sign of the shrine owner's affluence (Glaze 1981, 72); a display of prestigious artworks enhances his or her professional reputation and draws more clients. Owning a sculpture of a horseman, like owning a horse itself, signals wealth and status and thus greater than ordinary power.

Inside Senufo shrines, equestrian images join carved or cast couples, bracelets with humanoid or animal motifs, rings, and other small cast amulets. All these objects belong to the realm of bush spirits. In this context, the horseman assumes a characteristically dominant place, visually and otherwise. Called "power owner," *fanhafolo*, the equestrian is considered an especially strong, fast, aggressive leader among the spirits (Glaze 1981, 70). Most Senufo horsemen carry a weapon at the ready, whereas standing male sculptures rarely do. The rider may also wear a war hat and a protective Islamic amulet around his neck.

When used in the forest and savanna areas of West Africa, amulets suggest influence from the north, from the Sahel and beyond, where, for West Africa, both Islam and horses originated. Real Islamic amulets (rather than carved replicas, as on the Senufo rider) draw upon the mystical efficacy of texts from the Koran. The writing is combined with other magical ingredients and encased within pouches. These charms have long been sought by non-Islamic peoples for their power. For example, an early-nineteenth-century mounted royal Asante captain, or caboceer, equipped for war is shown in a drawing published by Joseph Dupuis ([1824] 1966) (fig. 147). Both man and

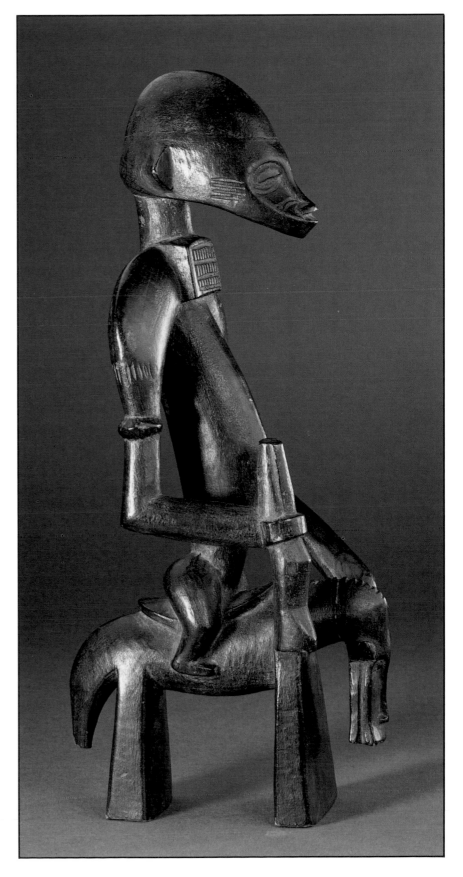

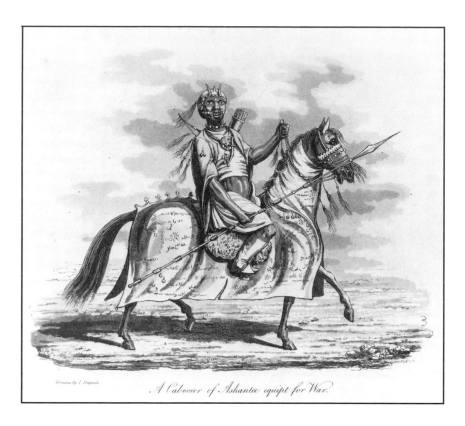

A Caboceer of Ashantee equipt for War.

FIG. 147. This 1824 engraving shows an armed Asante war captain and his horse. Both are protected by Muslim charms, including the Arabic writing on the horse's cloak.

FIG. 148. An equestrian, presumably from an Ewe shrine, with several modern features: pieced-together construction, articulated arms, and bright enamel pigments. H. 27⁵/16 in.

horse wear an assortment of charms. Protective writing in Arabic covers much of the horse's cloak, which also has some attached amulets similar to those worn by the rider on his upper arms and chest. The rider's hat features two small horns analogous to the medicine-filled horns on Bamana and other sculptures made farther north.

Although horses may always have inspired respect in the Senufo, it was during the late nineteenth century, when they brought Muslim crusaders, that horses became fearful bearers of power. The Senufo had had some experience with Islam, its charms, and horses through traders or warfare before this period, but Islam had not threatened their way of life. By the early years of the twentieth century, a number of Senufo subgroups had embraced Islam, thanks to conversions set in motion by the late-nineteenth-century military campaigns of the aggressive Muslim leader Samory. His soldiers and cavalry laid waste to several Senufo and other groups in his version of the holy war, or *jihad*. Samory's depredations were facilitated by his use of horses. The full meaning of equestrian "power owners" in Senufo religious thought and artistic creativity owes much to these belligerent Muslim strangers from the north. So however optional an equestrian may be in a Senufo shrine, its presence is very meaningful—all the more so if it bears signs of being a Muslim horseman.

The way shrine figures are decorated, of course, is also an option of the owner. In recent decades, among people with access to imported oil paints, the embellishment of shrine statuary with bright pigments has often been considered a boost to the status of the shrine and its custodian. This interest in modern European products undoubtedly accounts for the dramatic coloring of an Ewe rider and fanciful pink horse (fig. 148); in this case, the horse's legs have been fitted with "modern" wheels made from spools— presumably to facilitate movement!

Equestrians are also featured in many practical implements used by ritual special-

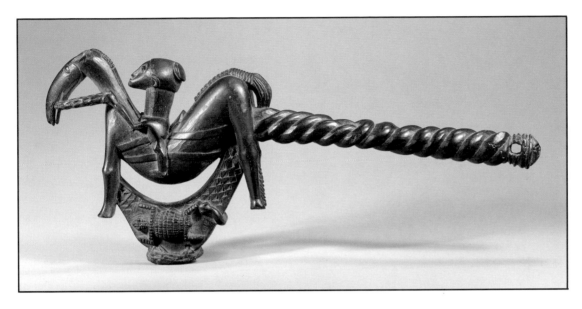

FIG. 149. A Baule
diviner's gong beater
with a rather fancifully
conceived equestrian.
H. 9⅞ in.

ists. A gong beater featuring an imaginatively conceived swaybacked horse with rider comes from the Baule of Côte d'Ivoire (fig. 149). The Baule live within the forested tsetse-fly zone, where horses rarely survived and were not well known. Several images of men on horses, however, attest to some knowledge of the animal in this region. Diviners own wooden mallets with which they hit iron gongs to summon spirits. These spirits are thought to mount their human partners, who go into a trance; at times a diviner may be called the "horse of a spirit." Such spirit riding may be echoed in the subject matter of this diviner's mallet (Judith Timyan, pers. com., 1988). The immoderate, rather random actions of possessed persons, like those of horses run wild, however, have not been incorporated in this subdued, stable image. Possession may account for the fact that the animal shown here is only vaguely horselike; a spirit's "horse" is of course not a real one. This interpretation may also apply to the animal with a standing rider (fig. 150). The origin of the sculpture is unknown, but it may be from a northern Nigerian people. The identities of both the rather fancifully rendered quadruped and the rider are not clear; perhaps they were carved with deliberate anonymity, as spirits.⁵

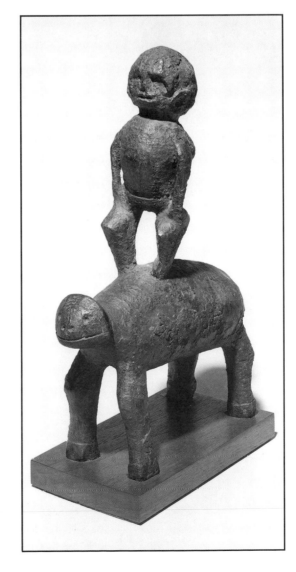

FIG. 150. Both mounts
and riders are occasionally rendered
so schematically or
abstractly that their
identities are obscured.
This puzzling image is
probably from northern
Nigeria. 9½ in.

FIG. 151. Diviner's or priest's antelope-horn whistle from the Lower Congo area. The standing rider could not have been observed from life. H. 7½ in.

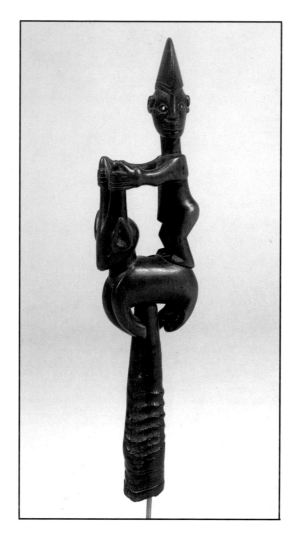

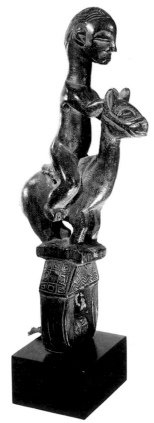

FIG. 152. Large Guro heddle pulley with equestrian motif. H. 11⅞ in.

imply a hierarchy that situates those who have them in a higher social and economic position than those who have equally useful but unembellished or poorly embellished implements. Whistles (fig. 151), spoons (fig. 21), combs, pipes, staffs, various containers, musical instruments, and weapons fall within this broad category of useful prestige objects; all have been rendered with riders.

Guro artists, when called upon to fashion heddle pulleys for looms, occasionally choose the equestrian motif (fig. 152). Pulleys require no decoration at all to fulfill their function. Given the great variety of sculptured Guro pulleys in existence, we can hypothesize with some certainty that artists repeatedly seek out new motifs. These are introduced in part because artists want to avoid the boredom of executing dozens of near-identical forms and in part because weavers themselves want unique pulleys. Virtuoso heddle pulleys—like this large equestrian—may also be a form of advertising for a sculptor's skill in executing private objects, since looms are often in visible public places (Philip Ravenhill, pers. com., 1989). It may be misleading to ascribe deep cultural significance to the equestrian motif in this instance or extraordinary status to its original owner. The weaver may simply have been a good friend of a gifted sculptor, who made it as a special present. Yet the possibility also exists, as Siroto (1979, 288–89) suggests, that the motif was chosen—with the help of a diviner—as a tutelary spirit to stave off the evil intentions of rival weavers.

The rider is also a favored icon in Yoruba religious arts. It is considered an appropriate way to praise both the gods and those who worship and minister to them. A great number of Yoruba diviners' cups, called *agere* Ifa, employ horse-and-rider imagery (fig. 153). The possession of such an elaborate container is again optional, as are its motifs. Woman-and-child images are slightly favored, but motivations for the choice of subject are variable. In some cases, the diviner ordered a specific kind of bowl from a

Prestige Objects

Equestrian figures are often used as motifs on objects that connote the high stature, wealth, and discriminating taste of their owners. The Baule gong beater in figure 149 is in the large category of useful prestige objects, found among nearly all peoples across the continent. An iron gong can be beaten with a simple stick, so an embellished mallet immediately signals its owner's regard for finer things. Although the iconography of this beater suggests a spiritual component, many others of the same type, despite use in ritual contexts, are elaborated without any spirit-related imagery. Here again we are in the realm of "owner's option," or voluntary patronage, as in the case of Senufo equestrians in shrines. Decorated utilitarian objects

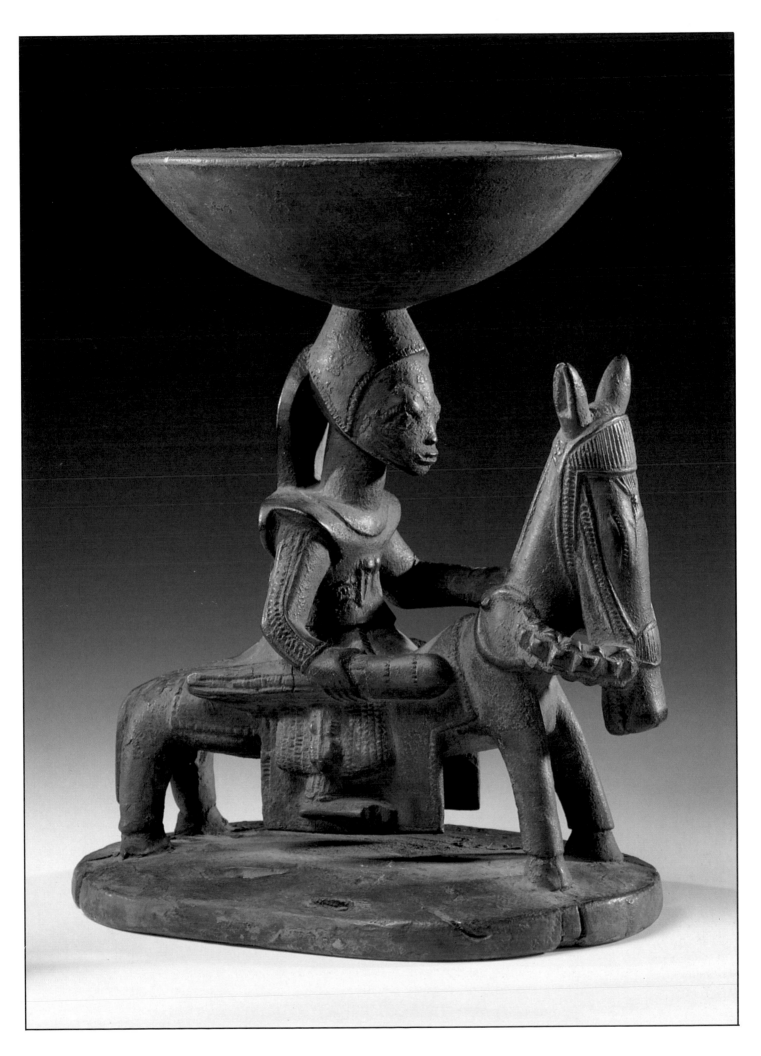

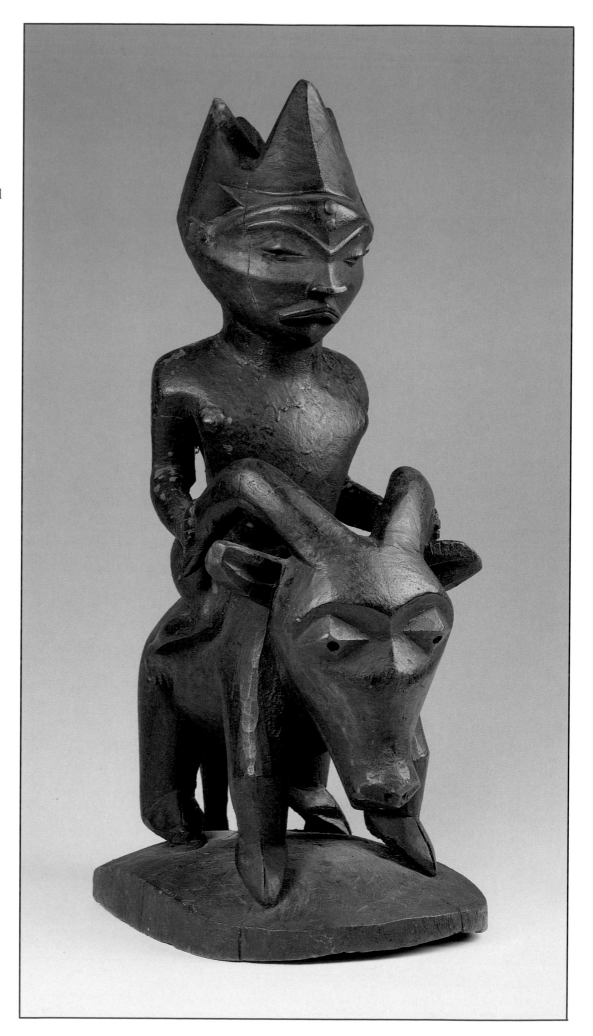

FIG. 154. A carving of a
Pende rider on a horned
animal, perhaps an ox.
H. 22¼ in.

carver. Alternatively, the patron was a diviner's client who wanted to thank the ritualist for an auspicious consultation (Fagg and Pemberton 1982, 82). Possibly the buyer chose a bowl from a group of completed ones. (Sometimes art objects in Africa are stockpiled, especially those that are in considerable demand and are not too expensive.[6]) Prestigious riders aggrandize many common practical objects, often more than other carved motifs do. The quality of the carving also helps account for the prestige bestowed upon the object's owner.

The Ifa cup in figure 153 is surely the work of a master artist. His genius is in the creative emphasis and simplification of the anatomy of the horse (or mule or donkey), as well as in the integration of the rider within the overall conception. Horse, rider, and cup merge to form one expressive unit. The horse's long low-slung body, which might be seen as distortion by those who expect ana-tomical accuracy, is essential to the unified impact of this sculpture. It provides a firm base for the cup balanced on the rider's head.

The precise identification of animals ridden in African sculpture can be difficult because artists have not always paid close attention to anatomical traits, those that separate mule from horse, for example, or horse from donkey. When a quadruped sports horns, however, quite a different animal has entered the picture. In the case of figure 154, both riders and mounts are well documented in eighteenth- and nineteenth-century Angola and Zaire. Half-caste merchants, called *pombieros* in Portuguese, rode oxen or bullocks on trading missions that carried them many hundreds of miles inland from the coast (fig. 155). Pende and Songo artists accurately observed these memorable strangers who traversed their homelands.

FIG. 155. A photograph, taken about 1870, of a trader or farmer mounted on a bovine. Cattle were used in some areas for transportation. Horses were rare in Central Africa.

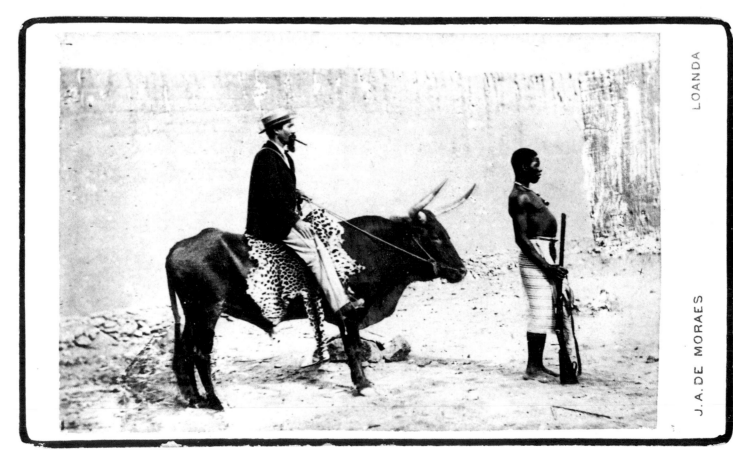

LOANDA

J. A. DE MORAES

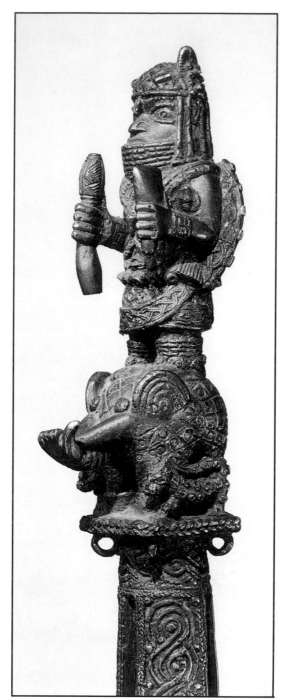

FIG. 156. A metaphorical figure of a dominant king of Benin on the back of an elephant. The image surmounts a copper alloy rattle-staff used in ancestor worship. H. of full staff 64 in.

ity and sometimes in their references to extraordinary powers. A Benin king, ruler of men and animals, is shown riding, or at least standing upon, an elephant (fig. 156). This ability, it would seem, stems from the king's divinity, the importance of animal metaphors in Benin culture, and notions of the king's dominance over all creatures.

Images of what seem to be fantasy riding are mysterious and problematic for the student of African art, since they emerge from belief systems not always well understood. Certainly, to paraphrase the anthropologist Lévi-Strauss, animals are good to think about, to believe in, and to ride. Trance, dream, divination, sorcery, and death are all extraordinary states of being that may involve human-to-animal (or vice versa) communication or transformation. These processes involve mystical traffic between human and animal realms that are beyond the grasp of rational comprehension or explanation but are no less firm in many systems of belief. Several West African peoples visualize witches as people transformed into birds, for example. Elsewhere, exceptional people become leopards or perhaps elephants at death, or even while alive under auspicious circumstances. These transformations cannot be described as "metaphorical," for in Africa they exist. People believe they happen.

How do we account for images of riders on unusual animals, those not ridden in normal life? Carvings of people riding leopards (fig. 28) and lions may refer to the possibility of supernatural travel.[7] A Luba Shankadi neckrest depicting an antelope rider cannot be dismissed merely as an imaginative artistic solution for preserving the elegant shape of a royal hairstyle (fig. 157). Its owner might have had a mystical identification with the spirits of antelopes, perhaps as protectors. A Kongo antelope-horn whistle surmounted by an antelope rider was owned by a religious specialist or chief who belonged to an *nkisi* cult (fig. 151). Some whistles are hunting charms, so perhaps this one depicts the dominance of

Metaphorical Riders

Leopards, lions, and antelopes may be ridden in dreams, folktales, myths, and the imagination, but they are not physically mounted by human beings in ordinary life. African elephants are not ridden either, although in the late nineteenth and early twentieth centuries, King Leopold of Belgium did experiment with harnessing elephants for work in the northeastern Belgian Congo (Doran Ross, pers. com., 1988). Yet we encounter images of people riding all these animals, along with tortoises, goats, chameleons, crocodiles, ostriches, and a few that can best be described as "quadrupeds." These artworks are exceptional in their rar-

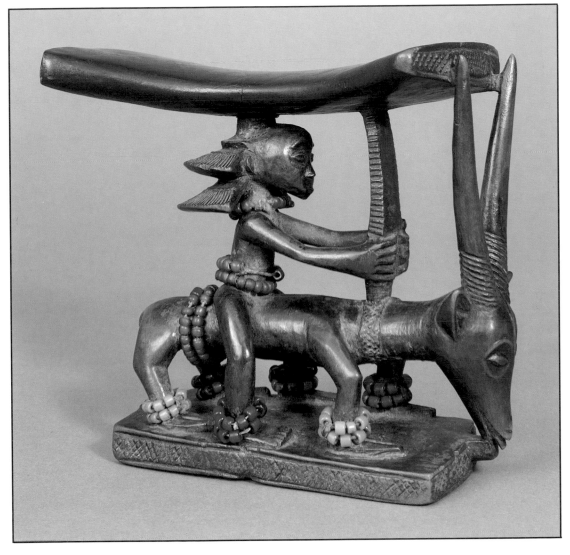

FIG. 157. A rare Luba Shankadi neckrest depicting a rider on an antelope, possibly a reference to spirit possession or divination. Antelope horns are common containers of spirit power in Luba ritual (Polly Nooter, pers. com., 1989). H. 6¼ in.

hunter over antelope. A modern Senufo rider (fig. 158), called a "cowboy," sits astride a chameleon in a small aluminum sculpture of the kind made recently for diviners' shrines (Ellen Elsas, pers. com., 1989). This is a bush spirit in contemporary guise, an updated version of the more common equestrian "power owner" (fig. 146). Though many such animal riders are spiritually significant, others are not necessarily so. Igbo *mbari* houses contain images of riders on goats and ostriches that are imaginative solutions by competitive artists. These animals have no religious implications.

Because rider motifs represent ideas of support, sometimes mystical in nature, rid-

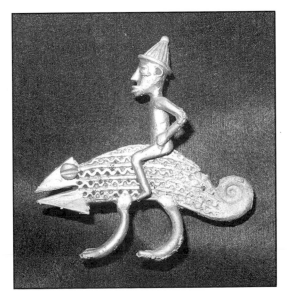

FIG. 158. Modern Senufo cast aluminum rider on a chameleon. The makers and owners of such images refer to them as "cowboys." H. 4⅞ in.

ing and sitting are closely aligned concepts. This discussion, therefore, must at least touch upon stools providing either zoomorphic or anthropomorphic support for the sitter. Such caryatid stools are widely if unevenly distributed on the continent.[8] The few examples illustrated here dramatize the similarity between riding and sitting, especially for higher classes (fig. 83). Most artistic stools and neckrests were originally carved for high-ranking people. A Kongo chief's ivory staff finial that depicts a noble woman seated on a leopard exemplifies this genre well (fig. 28). Holding an object in each hand, the woman squats or kneels sideways on the back of a lively looking leopard with an open mouth. This "mount" is not carved as if it were only a stool; the leopard is animated, signaled by its grasping of a snake in its forepaws. Although leaders sit on leopardskins in many parts of Africa, this image takes that notion much further. Yet in this case we cannot determine whether or not the Kongo artist or patron intended metaphorical riding (or sitting). The leopard might have had a spiritual dimension beyond the more usual reference to leadership and dominating power. The many leopard stools owned by Cameroon leaders attest to spiritual and power relationships between the animal and the person and to their interchangeability.

Stools provide leaders with physical, spatial elevation. These notions of superiority are further reinforced by carved animal supports that add symbolic, sometimes metaphysical meaning. Often they are beautiful, powerful creatures such as elephants, lions, and pythons, in addition to leopards. Noble animals are fitting supports for elite stool owners. Human caryatids also occur; they may be ancestors, court nobles, retainers, or slaves (see Flam 1971). In any case, the supporting figure or animal joins the leader's retinue, contributing to his or her aggrandizement.

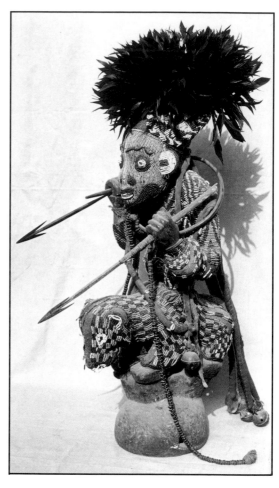

A War Chief Rides a Leopard

An icon from the Bamum Kingdom of Cameroon compresses many of the meanings of riders illustrated and discussed here.[9] A quintessential rider of power is portrayed on the richly beaded headcrest of the war chief, *tu panka* (fig. 159). The war chief, appointed by the Bamum king for a three-year term, derives his title from an episode in nineteenth-century Bamum warfare. Meaning "head of the people of the barrier," *tu panka* refers to the human barrier formed by retainers to protect the beleaguered King Mbuembue in a battle. They enabled the king, and Bamum, to emerge victorious and capture enemy heads in the process. On coming to power, King Mbuembue's first words were that he would "set the borders of the kingdom with blood and black iron" (Geary 1988a, 110), an expression of his im-

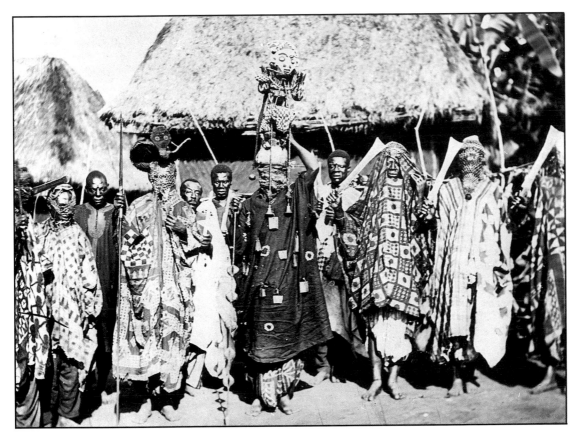

FIG. 160. Photograph, taken about 1912, of the installation of a Bamum war chief, who is wearing his beaded headdress. Members of his inner circle gesture with weapons.

perialistic military ambitions.

A new war chief acquires the headdress during elaborate installation rites and wears it in a procession through the royal dance ground (fig. 160). His face is veiled. Medicine, bells, and amulets hang from his garment. He carries a sword and an iron staff with bells attached. He has lost his former identity to become a "timeless ideal warrior" for three years (ibid., III). The human figure riding a leopard on the crest and holding a spear tipped in (black) iron in each hand represents the *tu panka* who wears the crest. The large sculpture is almost completely covered with European beads and is topped with the tuft of black feathers worn by warriors. Cowrie shells and small European-made bells are also attached to it. The imported materials constitute wealth. Leopards in Cameroon, as elsewhere, are metaphors for speed, ferocity, beauty, and leadership; they are often considered chiefs in their bush world, kings that are superior

to other animals. The beaded war chief, however, dominates the leopard he rides, fusing with it to create a still more powerful military force, a force of animal aggression and great speed. The actual war chief has medicines and amulets to buttress his position, as well as the support of Bamum ancestral land. This support is evident in the name of the actual headcrest, *tu mola*, which means "head of the chief of the land" (ibid., 109).

Multiple, crisscrossing statements about history and power coalesce in both the headcrest by itself and in the larger entity of the war chief wearing it. In performance, the entire rich construction "rides" the head of the human leader, who in turn dominates the hundred or more warriors of his entourage. To all this is added another significant fact: the crest is almost certainly the work of strangers, artists from defeated former enemies of Bamum who were resettled to serve the king and his court (Geary 1988a, III).

8 Ambiguous Aliens
The Stranger in African Art History

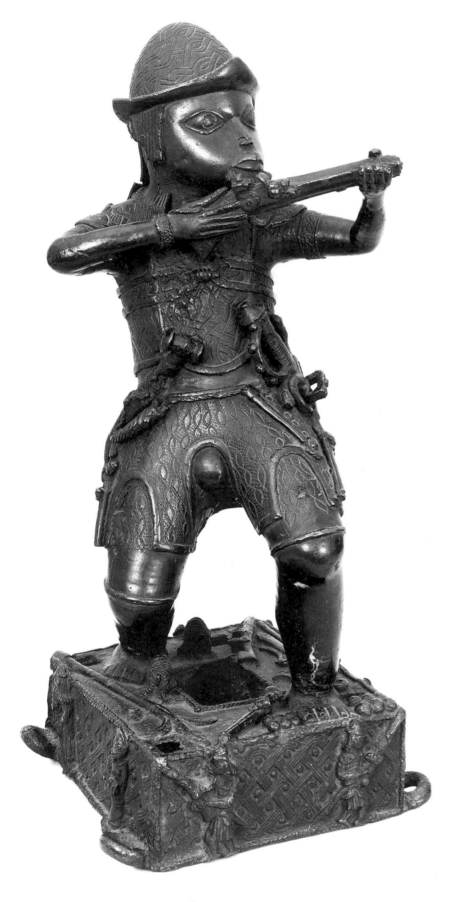

Strangers in any society are anomalous. Sufficiently inside to be identified, to affect and be affected by the host culture, they are defined nevertheless as outsiders who are to some degree alien. Thus neighboring Africans who speak different languages are strangers to one another, and white people, or even Africans from another part of the continent, are obviously greater strangers. From ancient times until the present, African art has recorded these encounters in a multitude of ways. There are many explicit images of outsiders, like a sixteenth-century Portuguese soldier shown with straight hair, an obviously non-African uniform, and a gun (fig. 161). The ideas, technologies, materials, styles, and motifs of outsiders have also been incorporated into art, often with modifications. These influences are often complex and difficult to document with certainty, but they are no less important.

The larger the cultural gap between host and stranger—that is, the more strange an outsider seems—the more visible his status as stranger. Contiguous peoples—each often considering the other odd and barbaric—continually influence one another, but the resulting changes may be barely noticeable, either in life or in art, to Western observers (and perhaps to the peoples themselves). Africans from a greater distance—for example, Muslims from the Sahel who entered forest regions to trade—have a more evident presence, and so does their cultural baggage. Whites and their effects are most easily discerned.

FIG. 161. Cast copper alloy shrine figure from Benin, Nigeria, of a Portuguese soldier in sixteenth- or seventeenth-century dress. The image may be of later manufacture. H. 17 in.

Identifying the Stranger in Art

It is often hard to identify figures of strangers in African art. There are two kinds of difficulty. Most objects—whether ancient, archaeological, or more recent—come to us with no data on meaning or context. More modern works, on the other hand, may have misleading appearances. Rock arts undoubtedly include hundreds of images of outsiders—enemies in warfare, for example—but we rarely know who the two fighting groups are. A remarkably facile, amusing caricature of a human being could well be a stranger (fig. 162). The exaggerated, distorted features of this walking man probably characterized him as an alien— bizarre looking and barbaric acting. Such stereotypical labels are quite often given the "other," the person whose looks, customs, and language are at variance with those of the observer. In this respect Africans are no less ethnocentric than other peoples of the world. Like so many, most African groups define themselves as "The People," the only ones whose habits of mind and action are "true and correct."[1] All others are considered strangers.

Potentially misleading images include those that appear to be outsiders but that actually depict local gods or people. Thus, in an *mbari* house, Amadioha, the Igbo god of thunder, wears prestigious European clothes and has pink skin. But he is not a white man. Pink or white faces do not automatically signal intentions to represent whites, or indeed to caricature foreigners, as earlier scholars thought; nor do European clothes. On the basis of their clothing, our first inclination might be to identify some seated Guro shrine figures (from Côte d'Ivoire) as white people (fig. 163). Yet in all probability they depict not strangers but local bush spirits with harmful or helpful potential. Such images are ordered by a member of a Zu (or Zuzu) cult on a diviner's direction. Zu spirits appear in dreams; they can protect against witchcraft, for example, and they can heal. They often demand food offerings and send other requests through

the carved figures, which are considered messengers or intermediaries to the human world. Some of these images are kept close to their owner's bed, as their proximity is considered beneficial (Fischer and Homberger 1985, 19).[2]

The style of this Guro carving suggests that the artist has consciously "modernized" his figures both by posing them somewhat informally and by breaking away from the stylized bodies of earlier modes in favor of rounder, fleshier, more lifelike forms. A Guro artist working fifty years earlier would not have been able to model his work on European images or pictures in such naturalistic styles or with such realistic detailing, nor at that time would the clothes and

FIG. 162. This fluid rock drawing may well be a caricature of a stranger.

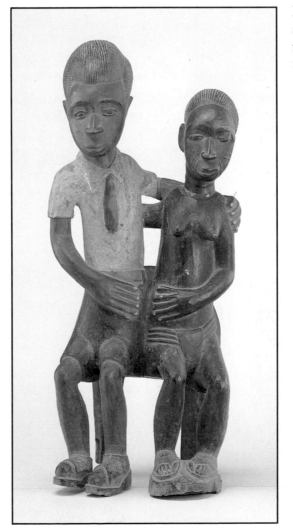

FIG. 163. Despite their appearance, Guro shrine figures are depictions of nature spirits. H. 18 in.

Fig. 164. Soldiers dressed
in European-style
uniforms and carrying
imported weapons are
often made as guards for
shrines. Sometimes they
represent spirits. This is
an Ewe image from
coastal Togo. H. 28³/₄ in.

other possessions of urban Africans or Europeans have been seen as so desirable. In this case, both foreign clothing and the modified sculptural style are useful in dating the image to between the 1930s and 1950s.

The Guro example reiterates the need for field documentation in determining the precise identity of any sculptured image, for otherwise appearances may deceive. We do not know, for example, whether strangers are depicted in the aggressive male and rider images believed to have come from an Ewe shrine (figs. 164, 148). The style, dress, and enameled polychrome surface of both figures indicate strong outside influence, but the individuals (or spirits) represented may be locals, not foreigners. The entire corpus of "colon" or "colonial" sculptures needs careful re-examination, for relatively few actually depict European outsiders.[3] Like sixteenth- and seventeenth-century Benin images of Portuguese, however, some strangers are recognizable as such even without field documentation.

Early Strangers: Pre-Fifteenth Century

It appears that changes in the arts have been continuous from earliest times (fig. 162). Of course it is difficult to account for major historical shifts in remote periods for which actual processes of introduction, as well as accommodations to the new "alien other," are hard or impossible to document. There is no way to know precisely how the smelting and forging of iron tools and weapons migrated southward from northern Africa or the Nile valley, for instance. These things did happen, however, and we can be certain that the arts were affected.[4] The proliferation of metal tools facilitated early woodworking, even if the carvings themselves have long since disappeared. We can postulate also that the first warrior with iron-bladed weapons was a stranger to his enemy with stone-tipped arrows or lances. Rock drawings record something of the distribution of ironworking technology, but the authorship and dating of rock arts is so problematic that we usually cannot interpret them very well.[5]

About the first millennium B.C., plant domestication and the subsequent spread of agriculture were accompanied by ironworking in sub-Saharan regions. Neither settled agriculture nor ironworking seems to have been an African invention. Both revolutions have much to do with visual art. It is evident, for example, that most African sculpture is made and used by agricultural peoples, that the proliferation of types and quantities of sculptured objects depends upon a settled existence, and that the greater speed gained from working with iron tools helps account for the tens of thousands of art objects in existence, including iron ones.

Similarly, the introduction of horses and camels in sub-Saharan West Africa—doubtless first ridden south by aliens, ancestors of the Berber and Tuareg peoples—affected much more than just artistic subject matter. Beasts of burden made possible, or at least hastened, the diffusion of new ideas, technologies, and artifacts, all of which contributed to the late-first-millennium development of Africa's early empires.[6] Ancient Ghana in the Western Sudan, Songhai in central West Africa, and Kanem in the Lake Chad basin to the east are all reported to have had camels and horses for trade and to help implement military policy. The capitals of all three empires developed another common feature—twin cities. Indigenous people lived with an Islamized king in one, and nearby was a city of Muslim traders, holy men, and scholars. Islam was partially absorbed into all three empires at different times and rates, but it was never fully assimilated. Al-Bakri, writing in A.D. 1068 of the twin capitals of ancient Ghana, says, "The one inhabited by the Muslims is very large and includes twelve mosques," whereas "the city of the king is surrounded with huts, massive trees and woodland, which serves as residence for the magicians of the nation in charge of the religious cult; it is there that they have placed their idols and the tombs

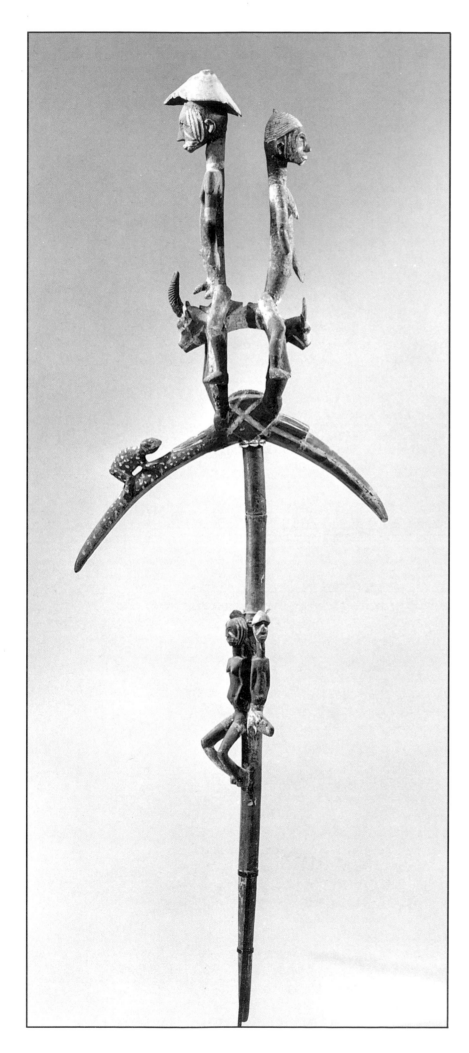

FIG. 165. Wooden staffs incorporating images of bush spirits were displayed at farming competitions among the Gurunsi peoples of Burkina Faso. H. of full staff 59 in.

of their sovereigns" (quoted in Prussin 1986, 111). By the eleventh century, Islam was a forceful sub-Saharan presence, destined to press further south into the forest region and later to the coast.

Both Islam and sub-Saharan trade became established as major institutions with profound if often indirect impact on visual art and architecture. Both in turn owe some of their effectiveness to camels in crossing the Sahara and then to horses in the Sahel and savanna further south. Gold and slaves were taken north across the desert, where they were traded for the horses, salt, copper, and luxury goods desired by the increasingly elaborate courts of African kings. Muslims, traders, and horsemen—sometimes all three combined in the same person—were certainly strangers when they first appeared in West African villages south of these and later empires. Warriors invading on horseback, then establishing new leadership, became a pattern of political and religious conquest and rule remembered by many savanna peoples. In some cases Islam stamped out indigenous religious practices, but usually it coexisted with local cults.

A Gurunsi staff featuring a couple seated upon an imaginative double-headed "horse" was created to honor champion cultivators (fig. 165). It may evoke the memory of invasion by armed horsemen in the fifteenth century (though the object is probably of nineteenth or twentieth century manufacture) and thus the conflict between Islam and local religions.[7] Some Gurunsi were amalgamated into what became the Mossi Empire, while other groups resisted the conquerors by using their superior magical powers against them. The staff would seem to represent the triumph of local medicines and bush spirits, some of which have taken over the mounts of unsuccessful (perhaps Muslim) cavalry; the spirits attached to the staff guarantee rich harvests as well as many healthy children in the coming year. These are the petitions made by young men's dances with such staffs in empty agricultural fields following harvest.

The mystical powers of Arabic writing and other magical graphic signs, plus a host of charms, have been embraced by a number of forest region and savanna animists in designs for protective clothing, in architecture, and in several other ornamental contexts. The Senufo equestrian discussed earlier (fig. 146), wears what is probably an Islamic amulet. Similarly, the Arabic writing (or pseudowriting) and charms worn by the Asante captain in Dupuis's engraving (fig. 147) represent the penetration of both Islam and horses into southern forest regions. Like the Senufo and Asante, many Guinea Coast peoples have not themselves adopted Islam, yet for many centuries they have accommodated its traders, holy men, scribes, doctors, and charm makers and other craftsmen. Some of these specialists undoubtedly accompanied Muslim Dyula traders, whose fourteenth-century presence is documented in Begho, immediately north of the Akan forest area in what is now Ghana.

It has long been recognized that Asante *kuduo*—cast brass vessels used in royal ritual and political contexts—incorporate panels of pseudo-Arabic writing and medallions that derive from fourteenth-century Mamluk vessels. Some of these Islamic containers, transported from Egypt across the Sahara and then south, are still used in northern Akan shrines (Silverman 1983, 12). Prussin's (1986) fine study of the impact of Islamic design and thought in West Africa (including Asante, Dahomey, Yoruba, and other peoples who have not adopted Islam) refers mostly to forms documented well after the 1470s, yet many of these were undoubtedly carried southward during the two or three centuries before that date, when trans-Saharan trade still supplied African leaders in the Sudan with luxury goods.

Sometime between about A.D. 900 and 1100, two other technologies, both critical to all subsequent visual arts, developed their sub-Saharan forms. The two are weaving and lost-wax casting of copper alloys, documented in West Africa about the turn of the millennium. Woven and cast goods were certainly known before A.D. 1000, but examples had to be imported across the Sahara until the technologies were developed by West African peoples to meet local needs. Exactly when and how they got to the Western Sudan is uncertain, but most scholars believe that these technologies were not invented there. The tenth-century Igbo-Ukwu equestrian (fig. 138) is the earliest dated copper alloy casting known to have been made south of the Sahara. Many bronze and brass castings from the Inland Niger Delta, recovered illegally and therefore lacking dates, may well have been made in the same general period, for most of the terra-cottas apparently found with them are dated (by thermoluminescence) between A.D. 1000 and 1600. Narrow-strip textiles of the eleventh century, possibly woven in West Africa, have been recovered in the Bandiagara cliffs of Mali in what is now Dogon country. Islamic weavers are broadly distributed in the Western Sudan, but just how and when weaving got established is also not yet known.

Horses, trade, craft specialization, agriculture, and warfare, along with the forces of Islam, were factors in the consolidation of the medieval empires of the West African Sahel and savanna. Strangers were variously concerned with all these. Northern and southern Manding peoples combined to form the nucleus of Mali, the empire that succeeded ancient Ghana and reached its height between the thirteenth and fifteenth centuries. Located further south and west of ancient Ghana, Mali included most of the Inland Niger Delta. Niani, the Mali capital, has not yet been found. Other cities, such as Gao, Timbuktu, and Djenné, grew to prominence in this period because of Islam's hold on trade, its religious fervor, and its political and military leadership. The Songhai Empire grew independent of Mali in the late fourteenth century, becoming powerful in the fifteenth century under Sonni 'Ali. Continuing craft specialization supplied the material needs of increasingly complex soci-

FIG. 166. This unique terra-cotta figure with straight hair is interpreted as an image of a stranger to the Inland Niger Delta area of Mali, where the figure was made. H. 18¾ in.

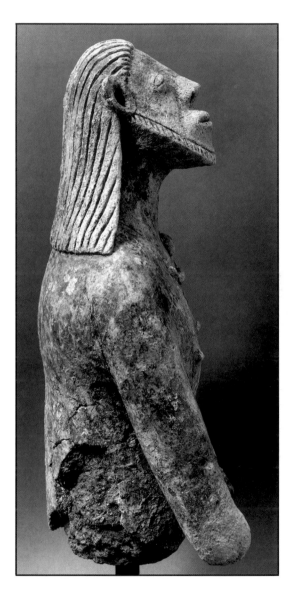

eties: blacksmiths and casters provided the weapons, agricultural tools, and votive images; goldsmiths the regalia; leatherworkers the horse trappings; architects and builders the mosques and fortifications; weavers and embroiderers the clothing; ceramicists the pots and terra-cotta sculptures; learned doctors the Koranic charms and other amulets.

We do not know precisely how metal, terra-cotta, and wood Inland Niger Delta sculptures supported these polities and expressed their values, but an important role is likely, especially among non-Islamized peoples. The straight, flowing hair depicted on a unique terra-cotta sculpture may identify its wearer as a stranger from the north (fig. 166). Based on his research in the region, de Grunne maintains that most terra-cotta images represent gods, some of them deified founding ancestors (fig. 67), of the Bozo, Soninke, and other inhabitants of the area. It is not impossible, of course, that a stranger was also a founder. Probably made by blacksmiths or their ceramicist wives, the enshrined statuary was focal in sacrificial rites (de Grunne 1987, 19).

1470–1600: Early European Impact

A new era began with Portuguese explorations along the extensive coasts of Africa, and the encounters that ensued left their mark on art. In voyages made possible by new ships that could sail close to the wind, as well as by perfected navigational aids, the Portuguese set out in search of gold, which they had heard originated south of the great desert. Early voyages were also motivated by high European prices for spices, silks, and other Oriental luxuries and hence the desire to find an alternative route by sea to their source. Red cloth and various beads, not to mention weapons and tools, were obtained from the Portuguese, and hats and other elements of elaborate Benin dress, regalia, and ritual also owe something to their influence.

For the first several decades after initial contact with the Guinea Coast in the 1460s and early 1470s, the Portuguese held a monopoly on trade and missionary activity. In 1482 they built (with the permission of Fante chiefs) the first of several trading forts, São Jorge at Elmina, on what was to become the Gold Coast (later modern Ghana). "Naturally, the Africans found the new arrivals, with their white skins, long hair, and funny-looking ships, profoundly strange" (Boahen 1971, 310). Yet friendly relationships also existed between the Portuguese and the kings and courts of both Benin and Kongo.

Cordial relations at this time—plus arms, ammunition, military help, and gifts to the king and others—disposed the Edo of Benin

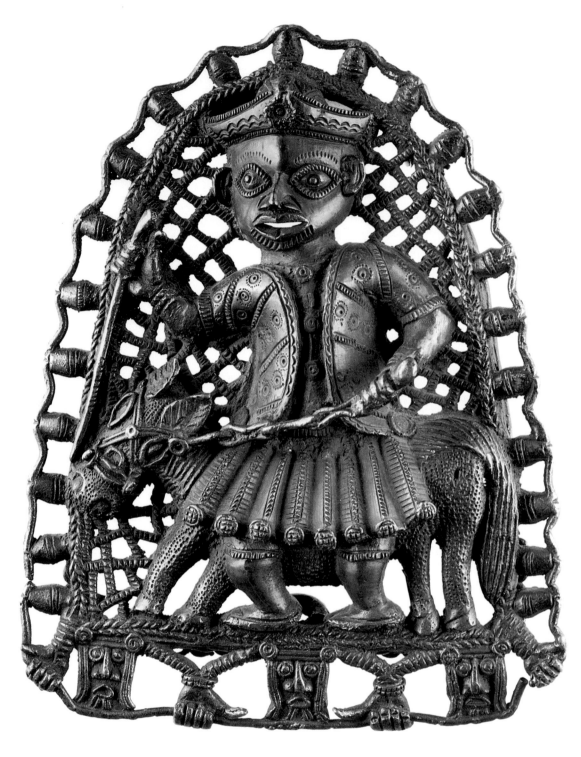

FIG. 167. The Portuguese were often depicted in the royal art of Benin. Because the Portuguese brought riches from across the sea, they were seen as messengers of the sea god Olokun. H. 8 in.

kindly toward the Portuguese, as evidenced in numerous images of their soldiers and traders in sixteenth-century Benin arts (figs. 48, 161). A pendant of a Portuguese rider standing beside his mount reminds us that in 1505 the king of Portugal gave his Benin counterpart a caparisoned horse (fig. 167; Ryder 1969, 41). The gesture of the man's closed fist with projecting thumb (plus the four others at the pendant's lower edge) refers to "the gathering up of riches" that the people of Benin link with both the Portuguese and Olokun, god of the sea, creativity, and wealth (Ben-Amos 1980, 57; Freyer 1987, 57). It is probably the association of Portuguese strangers—who came across the waters—with Olokun that accounts for the frequent appearance of these Europeans in Benin court arts.

The arts of Benin also absorbed other sorts outside influence, from obvious depictions of foreign artifacts to less direct, less provable effects in the realm of form and style. The influx of copper alloy trade goods enabled casters to create hundreds of works, for example, including over nine hundred architectural plaques (fig. 48). Possibly, too, the rectangular format of these plaques was inspired by Portuguese books or engravings.[8]

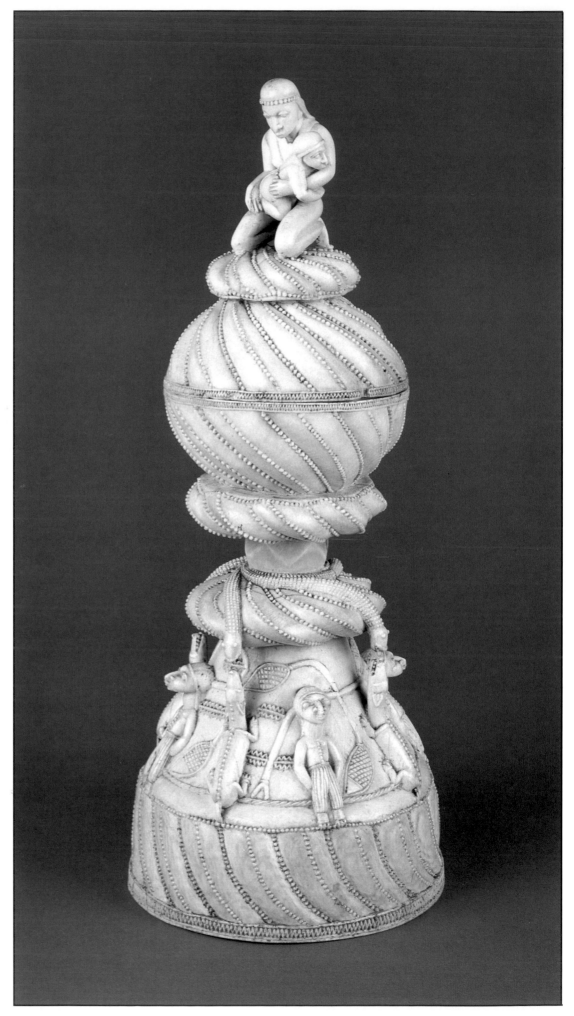

FIG. 168. Refined ivory sculptures were created by African artists for European patrons in the sixteenth and seventeenth centuries. This saltcellar depicts a woman and child in a unique pose. H. 13¼ in.

Afro-Portuguese Ivories. Ivory was one of the most appreciated commodities among early African items brought to Europe. The Portuguese also learned early on that African artists in some areas were consummate ivory carvers, so over two hundred painstakingly intricate objects were commissioned from artists from two areas, Benin and Sierra Leone.[9] These include several dozen lidded vessels, called saltcellars, over a hundred decorated elephant-tusk trumpets, and a few dozen spoons and forks. Nearly all, like the saltcellar shown here (fig. 168), are virtuoso carvings that combine African and Renaissance styles and subjects in ways that occur only in this limited corpus. Virtually all were made expressly for European collections during the hundred-year period following 1490.

The saltcellar in figure 168 is one of several in related styles made by Sapi carvers, ancestors of the Bulom, Temne, and Kissi peoples of coastal Sierra Leone. The heads on it are very close in style to soapstone carvings made by the same peoples. The sculpture is composed of six spiraled, zoned, curved surfaces with beaded subdivisions; a plainer band has four humans and four dogs with heads raised toward four serpents hanging down from the bulging shape above. The piece is surmounted by an unusual woman-and-child carving.[10] The child's position in its mother's arms is unique; the child faces to the side, kneeling between the mother's legs. Woman-and-child images are of course common in both African and Renaissance European art, but never in such a posture, the meaning of which is unknown. Nor can we interpret the snakes, dogs, and figures below. It is not even certain whether the artist intended the human beings to be Africans or Europeans.

The entire work is skillfully executed in meticulous detail, with graceful shapes and sensitive proportions. This saltcellar, like the other Afro-Portuguese carvings, is a hybrid artwork made by Africans for strangers. It was influenced by covered cups or chalices from Europe, not Africa. An export art of considerable beauty, it is also a historical anomaly with meanings that are almost entirely lost.

Christian Legacies in the Lower Kongo. The same Portuguese who imported ivories also exported Christianity and several of its sacred sculptures and ideas, which were in turn modified by another group of African artists. The "conversion" of Kongo kings and family members in the early sixteenth century, plus the partial adoption of Christianity in the Kongo Kingdom, set in motion an artistic interchange both subtle and far-reaching, sometimes easy to document, often quite difficult.

Naturally, Kongo peoples regarded Europeans from their own perspectives:

> They [whites] looked like albinos, who were venerated as water spirits; they came from the sea which, with other stretches of water, constituted the ideal barrier between this and the other world; they spoke a strange language, as *kimpassi* cult initiates did, and they brought rich gifts unknown in "this" world. (Hilton 1985, 50)

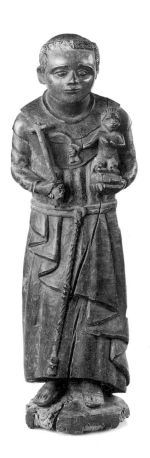

FIG. 169. A Kongo version of St. Anthony that is based on a sculpture brought to Africa by the Portuguese, probably in the sixteenth century. H. 20 in.

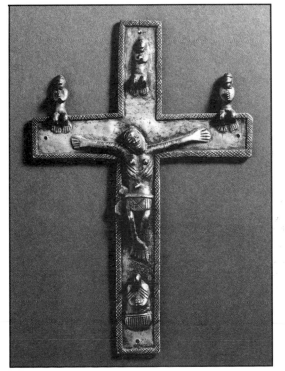

FIG. 170. Crucifixes were first a feature in Kongo versions of Christianity and then later were used as authority symbols by chiefs. They were locally cast of copper alloy in open molds. H. 10⅝ in.

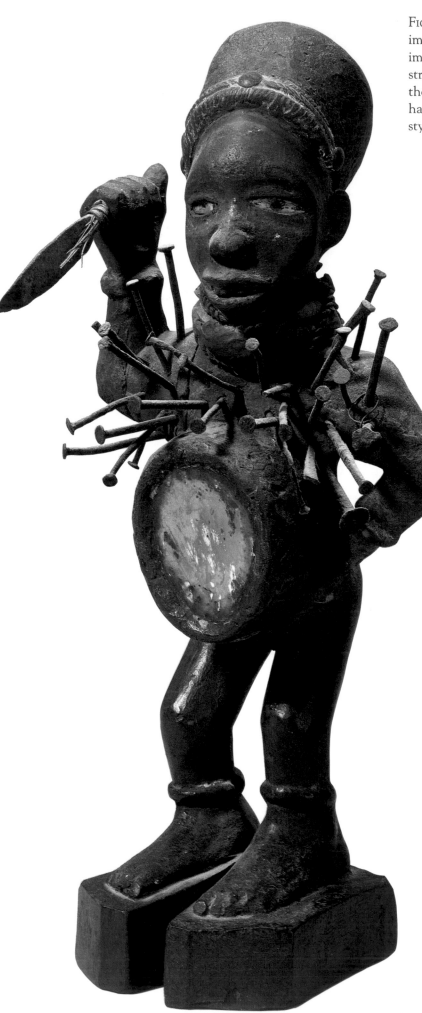

FIG. 171. Kongo power images, *nkisi*, betray the impact of European strangers in some of their materials and perhaps in their poses and styles. H. 12½ in.

Having sent lavish, quite miraculous gifts, the king of Portugal was called *nzambi mpungu*, which the Portuguese translated as "lord of the world" but in the Kongo language actually means "highest spiritual authority" (ibid.). The first Kongo king to be baptized took João as his name, that of the Portuguese king, but the new João and his six titleholders, secluded within a new, partly finished stone enclosure (a church), probably saw this as initiation to a powerful new cult, authenticated by ancient and new spiritual authorities.[11] The new initiates, prompted by the Portuguese, gathered the existing power images, *nkisi*, and burned them, as if to make way for new ones. According to a 1591 report, "the king sent him [the Kongo king] priests, ornaments for the churches, crosses, images, and everything else necessary for such service." These included implements for altars, pictures of saints, medals, and banners (Lopes and Pigafetta [1881] 1970, 71, 74).

Imported Christian sculpture was modified by local artists (fig. 169). Christianity was clearly Africanized (Thornton 1983, 63), both materially and ideologically, for Catholic priests were called *nganga*, as were (and are) non-Christian diviners and religious specialists. All Catholic paraphernalia (for example, cross, rosary, church) were called *nkisi*, translated as "holy" in that context but as "fetish," charm, or power substance in others. Christianity indeed became the official religion in Kongo, a version for a time acceptable in Rome, yet very different from European orthodoxy in its amalgamation with preexisting Kongo rituals, ideas, and objects. Christianity expanded nominally in the early seventeenth century, but without changing basic Kongo belief systems, which embraced—as charms, *nkisi*—the same crucifixes and statues of saints that European Catholics used (figs. 169, 170). These images were changed in Kongo-made versions, as if to signal transformed meanings in blended religious practices. Kongo-made crucifixes, for example, came to be leaders' status and power symbols, especially

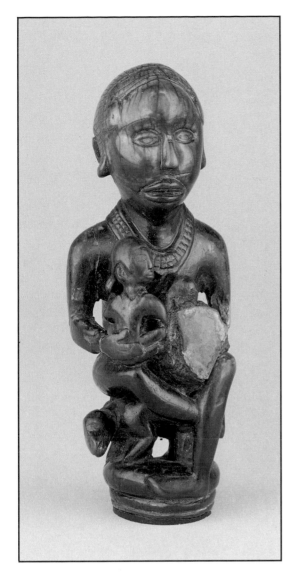

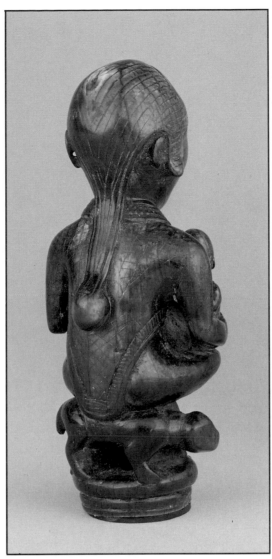

FIG. 172. A carved ivory staff finial of a person (perhaps a male chief) and child sitting upon a leopard. The European coat and the mirror both indicate outside influence. H. 5¼ in.

useful in judicial situations. Indigenous earth and sky spirit cults continued to be administered by their own priests, *nganga*, who were far more numerous than Christian priests. The latter were dominated by and principally served royals and their towns. They also evangelized widely, often conflicting with local "superstitious" cults and destroying the cults' *nkisi*. Then, between 1640 and 1660, a series of natural and human disasters led to a revival of indigenous beliefs and practices and subsequently to an erosion of the Christian presence in the Kongo region (Hilton 1985, 196–97). Without question, however, some Christian ideas had been grafted on to local rituals and their supporting material forms, including works of art.

Thus many *nkisi* made between the eighteenth and twentieth centuries, when local beliefs and ritual had been reasserted and Christianity largely discredited, still bear witness to Christian and other strangers' legacies. *Nkisi nkondi*, the "hunter" images

characterized by glass- or mirror-faced containers of magical ingredients, as well as by nails or blades, owe aspects of their forms and functions to outside influences (figs. 18, 171). The materials themselves are assimilated elements: mirror, glass, iron nails, blades. Although European reliquaries had glass fronts and Christ's limbs were nailed at the crucifixion, the Kongo charms incorporating glass or nails, used to remind an *nkisi* spirit of its work, only distantly echo these practices and may not derive from them (fig. 172). It is similarly difficult to prove that the relative naturalism of much Kongo sculpture may in part derive from images brought to Africa by the Portuguese or that some examples of the woman-and-child icon may be similarly inspired, although a number of scholars have considered such influences likely (fig. 173).[12]

A Kongo steatite *ntadi* figure that combines Kongo dress (a chief's cap, *mpu*, and wrapper) with European forms (frock coat and container) is an appropriate grave

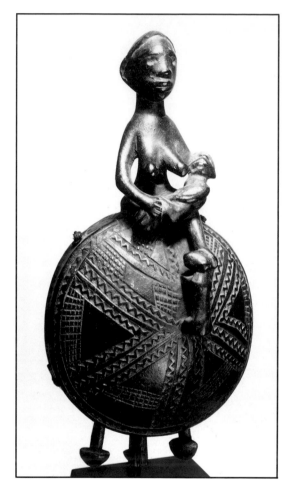

marker since from early times Kongo burial cults have blended indigenous and Christian practices (fig. 174). The figures are simultaneously otherworldly equivalents of revered deceased persons and *alter egos* who watch over them, according to MacGaffey (quoted in Thompson and Cornet 1981, 97). Cornet dates them back only to the nineteenth century; he believes the idea for such monuments may have come from European models, since foreigners' cemeteries existed far earlier than that time in the region where the stone sculptures are found (ibid., 216).

Trade goods desired by most Central Africans in the early decades of contact included silk, brassware, horses, beads, manillas, handkerchiefs, and wine, followed somewhat later by guns and powder, spirits, tobacco, and many varieties of cloth. Euro-

peans received gold, copper, dried fish, sugar, pepper, ivory, and by 1500, some slaves. Not until about the middle of the sixteenth century did traffic in human beings become dominant, and until that time (and afterward in many areas) it was the Africans who dictated the terms of trade (Boahen 1971, 311). By then, too, the Portuguese monopoly was broken by Dutch, English, and French merchants, as well as by Danes, Swedes, and traders from Brandenburg. By the mid-seventeenth century, Europeans principally demanded slaves, so lucrative was this devastating commerce. By then, African kings, nobles, and wealthy traders had become so "addicted to the European goods, especially to spirits, tobacco, guns and gunpowder, they had no choice but to sell their fellow men to obtain them" (ibid., 318).

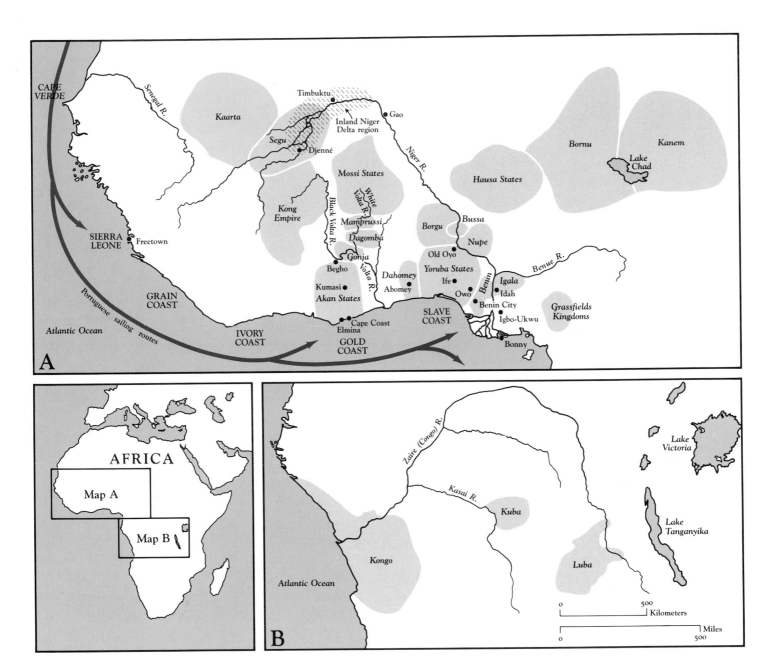

A map with labels including:

CAPE VERDE, Senegal R., Timbuktu, Inland Niger Delta region, Gao, Kaarta, Segu, Djenné, Niger R., Mossi States, Bornu, Kanem, Lake Chad, Hausa States, Kong Empire, Black Volta R., White Volta R., Mamprussi, Borgu, Bussa, SIERRA LEONE, Freetown, Dagomba, Nupe, Benue R., Gonja, Old Oyo, Begho, Volta R., Yoruba States, Dahomey, Ife, Benin, Igala, GRAIN COAST, Kumasi, Abomey, Owo, Idah, Grassfields Kingdoms, Akan States, Benin City, Atlantic Ocean, Portuguese sailing routes, Cape Coast, SLAVE COAST, Igbo-Ukwu, IVORY COAST, Elmina, GOLD COAST, Bonny, A

AFRICA, Map A, Map B

Zaïre (Congo) R., Lake Victoria, Kasai R., Kuba, Lake Tanganyika, Kongo, Luba, Atlantic Ocean, B

0 500 Kilometers, 0 500 Miles

1600–1900: The Expanding European Presence

Between early European contacts with coastal Africa around the turn of the sixteenth century and the imposition of colonial rule around the turn of the twentieth, an astonishing quantity and variety of European influences were experienced by West and Central African societies. The slave trade contributed indirectly to the very formation of culture in many places, as it had earlier in the Kongo and Benin kingdoms. Dahomey, Akan (Asante and Fante), and Niger Delta arts, for example, are all thoroughly conditioned by responses to experiences with strangers and by creative adaptations of their ideas and artifacts. European goods were enormously appealing to the big men, chiefs, and kings on or near the coast who served as middlemen in the

Atlantic trade. The warfare that provided most slaves to African sellers was clearly stimulated by this trade. Until the nineteenth century in most areas, Europeans themselves were confined to the coastal zones, although their products and other subtler influences filtered upcountry many hundreds of miles. Beginning about 1800, Europeans moved inland to trade, evangelize, and eventually subjugate.

African art shows the influence of these strangers in innumerable ways. Categories of impact, often overlapping, include new materials and modified surfaces, imported objects, assimilated motifs, borrowed artists and technologies, and the changing arts of dress.

Map 3. West and Central African States c. 1650–1850

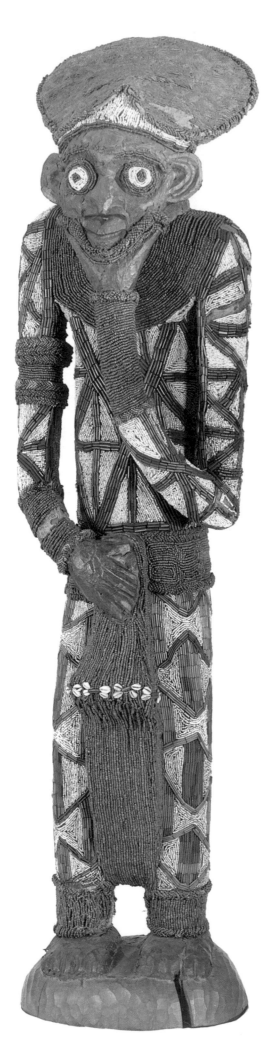

FIG. 175. The European beads and sheet metal appliqué (face and feet) on this royal figure from the Bamum Kingdom in Cameroon show the impact of outside materials on prestige art forms. H. 63 in.

New Materials and Modified Surfaces. We have seen that Kongo and other artists and priests modified religious carvings with additions of glass, porcelain, nails, and blades, these elements all adding meaning to an image while reflecting some dimension of ritual use. Some of the items, especially mirrors and pieces of china or porcelain, are applied to surfaces in several parts of Africa, creating rich mosaic effects that normally denote wealth and prestige.[13] The same is true of beads and cowrie shells, widely employed to adorn sculptures, especially those associated with royalty in Cameroon, Yoruba, and Kuba societies (figs. 159, 175). Appliqué sheet metals, particularly brass and occasionally tin, silver, and gold, adorn figures and masks in several areas (so-called Kota reliquary figures in Gabon; Cameroon Grassfields figures, headdresses, and masks; Marka, Mende, Temne, and related cultures' Bondo society masks). Stools, chairs, and staffs among the Akan and in Dahomey are dressed up with sheet-metal appliqué, as are heads in Benin. Brass upholstery tacks adorn wooden statuary and furniture among several peoples of Zaire and West Africa (fig. 100). Every occurrence of these embellishments signals European influence. Yet surface additions also manifest a specifically African use of materials.

Africans frequently dismantled imports to reuse their components according to their own creative vision. Thus Kota, Hongwe, and other peoples of Gabon cut up brass containers and flattened wire to obtain the brass sheets and strips applied to reliquary and weapon-handle surfaces (Siroto 1968, 86). Likewise, Akan weavers unraveled rich imported silks and other cloth to reweave the thread in their own patterns and styles. These inventive works transform raw materials that happen to have originated in Europe, but the forms are not in any way borrowed. Rather, they are absolutely African and will always be celebrated as such.

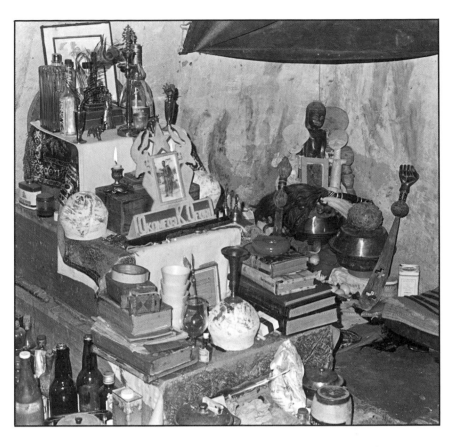

Imported Objects. Textiles and brass containers have been two of the most desirable, enduring imports, undoubtedly brought in before A.D. 1000 in trans-Saharan trade and continuing as trade goods for several centuries after the center of commercial gravity shifted to the Atlantic. Both fabrics and containers came in myriad types and sizes. Some, like the brass pans essential in many Akan shrines (fig. 176), were used as imported. Most were creatively reused by African artists. Textiles had countless roles, especially in ritual and royal contexts. Cloth was sacrificed to many deities. It still appears as "decoration" in shrines and as

FIG. 176. An Asante shrine to the river god Tano includes numerous imported objects such as books, candlesticks, bottles, photographs, and a crucifix. Imported brass pans contain various materials considered the essence of the god.

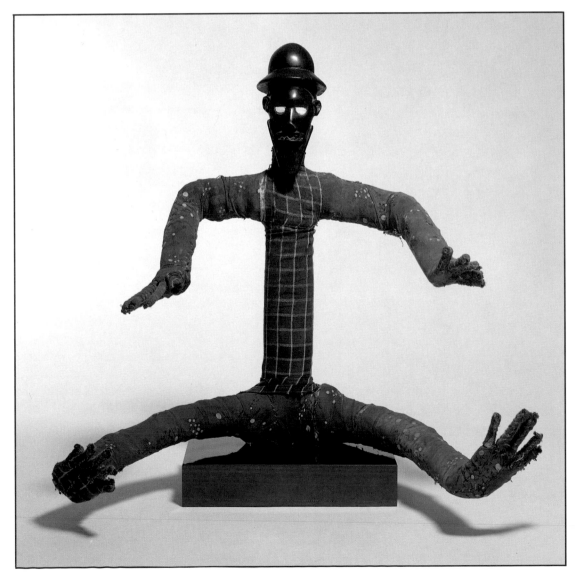

FIG. 177. A Bembe funerary effigy includes two kinds of imported red cloth, a representation of a pith helmet, and eyes made from pieces of imported porcelain. H. 20 in.

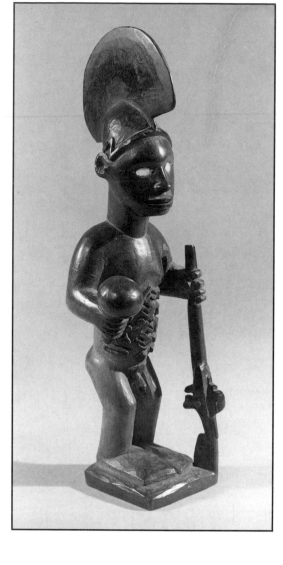

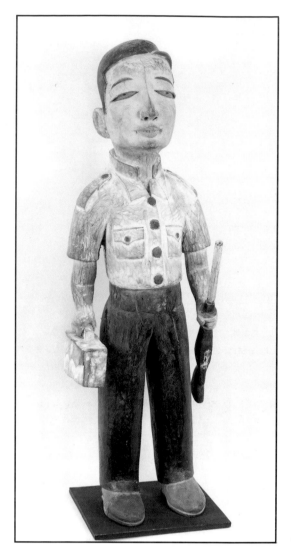

FIG. 178. The Bembe, once part of the Kongo Kingdom, have been in touch with European strangers and their artifacts since the late fifteenth century. Many outside ideas have been assimilated. H. 10 in.

FIG. 179 (*far right*). A Makonde figure, probably of a European, holds a gun and a small case. Its local use is not known. H. 14 in.

backdrops for statuary and for dignitaries seated in state.

Imported cloth (or fabric woven locally of imported thread) was sometimes preferred for ritual use over indigenous cloth. The Bembe funerary effigy's body, covered with plaid and print cloths, is surmounted by the quintessential status symbol of the colonial era—the pith helmet (fig. 177). Made only for funerary rites of venerable or influential persons, such effigies contain disinterred bones of the deceased. The bones are wrapped in imported cloth that is specifically red, considered the color of life and festivity. Some of these figures, at least, were kept as commemorations after the second burial celebration was completed (Widman 1967, 58–59).

Firearms are even more widely portrayed in the arts, probably because they were assimilated into local arsenals as early as the sixteenth century. They occur in all media, from tiny goldweights to life-size cement sculptures. Virtually all traditions of figurative art on the continent include European

weapons (figs. 178, 179), which of course have been locally copied and modified for several centuries. As indicated in chapter 6, firearms, like swords and spears, have both practical and purely symbolic roles. In the latter instances, guns, along with other imported items such as pipes, walking sticks or staffs, umbrellas, and hand-held mirrors, structurally alter the person carrying the object. His or her reach is spatially extended, conferring greater stature and thus prestige, among many other possible messages.

"Message" is indeed a key word for one class of objects inspired by European silver-headed canes. These were given to legitimize messengers and later fostered the creation of sculptured linguist staffs for Akan chiefs (figs. 29, 123). Although imported canes were emblems of credence in the eighteenth century, it was not until the late nineteenth century that the idea was transformed and "Akanized" into the staffs with gold-leafed carvings (referring to proverbs) that became part of chiefly regalia. Linguist staffs, now so firmly imbedded in Akan culture as to be

called "traditional" by many, remind us that all art forms are *historical*. Strangers were the impetus for some even when the resulting forms, like linguist staffs, owe their primary artistic character to the creativity of Akan patrons and artists.[14]

Assimilated far longer, smoking pipes occur on all social levels. Tobacco was introduced from America or Brazil to West Africa by the late sixteenth century. The most striking pipes are long-stemmed Akan or Cameroon Grassfields versions for chiefs. Figure 180 shows a bearded, uniformed German soldier with a bolt-action rifle on his shoulder. This pipe, made shortly after the turn of the twentieth century, probably belonged to a wealthy man or a royal, for it is too large for an ordinary farmer.

Chairs have been imported, as well as locally made, from Renaissance times onward. They create structural alterations of the body analogous to those created by hand-held objects. Chairs too are made and used differently in Africa than in Europe. Most are smaller than the originals. Several are sumptuously adorned with brass, silver, or small carvings (fig. 19), more so than their

European prototypes. Chokwe examples are occasionally carved out of a single piece of wood, though most are pieced together. African chairs frequently have slanted backs, signaling that they are sat upon as stools rather than leaned back on, as chairs are in Europe or America.

Countless other once-foreign objects can be added to those mentioned. Bells, ships, locks, keys, forts, clocks, and flags express different but related notions of power, control, or ownership. Along with various weapons and adapted uniforms, these are commonly seen items in coastal Ghana—for example, as insignia of the Fante military companies known as Asafo. Some Asafo flags are radically aggrandized compared with their models, reaching three hundred feet in length. On the other hand, both ships and forts (or castles), also present as sources of imagery for several centuries, are miniaturized in Akan hands; they serve as motifs and metaphors rather than as useful or practical vessels or buildings. Both ships and forts appear as actual shrines (or components thereof) that belong to Asafo companies and on their flags (figs. 1, 181).

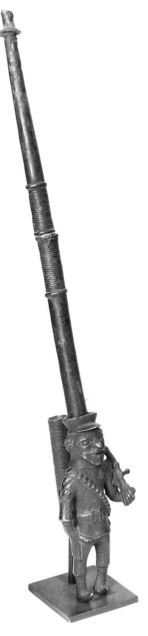

FIG. 180. A Cameroon pipe, probably made in Bamum, depicting a German soldier in an early-twentieth-century uniform. H. 18 in.

FIG. 181. Fante military companies have transformed many European artifacts, such as flags and ships, into their own symbols of prestige and military power. 43¹/₂ x 72 in.

FIG. 182. Fon royals of Dahomey commissioned numerous silver objects for prestige displays. Occasionally, similar pieces, like this rider on a lion, were presented to Europeans. H. 7½ in.

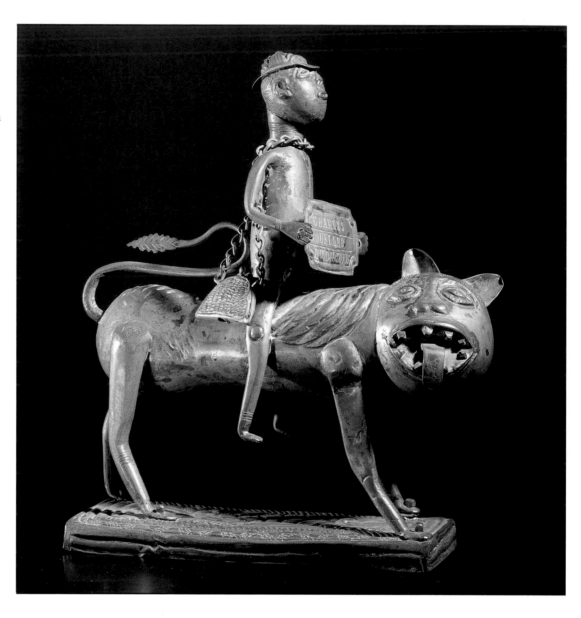

Assimilated Motifs. Guns, pipes, cannons, chairs, hats, bottles, bicycles, ships, Christian crosses, and many other imported objects are also treated as motifs in sculpture, textiles, and painting. Many in turn are metaphors or symbols evoking ideas, important people, proverbs, or powers. Thus locks and keys stand for chiefly control among the Akan; bunches of keys displayed in processions represent controlling strength, recalling the Akwamu state, whose superior military power and intelligence enabled its warriors to capture the keys to Christiansborg Castle in 1693.

Bunches of keys may also refer to those with the power to lock up (and therefore control) a state's vast wealth. Miniature goldweight sculptures catalogue a truly encyclopedic list of European imports, from boats to bugles, bowlers to buttons. Hundreds of tiny imported objects, or pieces of them, were also incorporated into goldweight sets (Garrard 1983). Dozens of other motifs have also been incorporated into Akan and Ewe relief, sculpture, casting, weaving, and appliqué over the past few centuries. Many motifs, like Akan keys and goldweight subjects, are specific to the art of a certain region, but a

few, such as crowns and pith helmets, are widely dispersed, at least in West Africa.

European heraldic compositions appear, though partly transformed, in the arts of several West African courts and sometimes in popular arts as well. Unicorn, griffin, some elephant, and most if not all lion imagery is adapted from European prototypes, often coats of arms. Ross (1982a) has argued convincingly that nearly all lions in Akan arts are inspired by nineteenth-century imports. The same is probably true in Dahomean art as well (fig. 182). King Glele (reigned 1858–89) took the lion as his personal symbol, although as a silver rider on a lion—a presentation piece for a departing Frenchman—suggests, the animal also appears in nonroyal contexts. Apparently much appreciated by the Fon people of Dahomey, the outsider is being "lionized" in a most literal fashion by this gift, which is self-documenting by virtue of the sign held by the rider that includes the name of the man being honored.

Borrowed Artists and Technologies. If it is a truism that technological innovations, like other imports, become so well absorbed into a culture that they are no longer recognized as foreign, the same process when applied to artists themselves seems less obvious. Yet recognizing the importation of both artists and new technologies is a critical key to African art history. Entire genres, including some famous ones, have resulted from the assimilation of artists, particularly in expansionist situations. The arts of Asante, Bamum, and Dahomey as they were known from the last decades of the nineteenth century to the early twentieth owe a great deal to forcible (at first) work for conquerors. Thus in the early eighteenth century when the Asante Confederacy was consolidated under Osei Tutu, goldworking was done by Denkyira and Akim goldsmiths in Kumasi, where Asante craftsmen learned the trade. Bamum warfare in the nineteenth century brought metalsmiths and bead embroiderers to Fumban, the capital, as King Mbuembue

expanded Bamum political and artistic hegemony (figs. 159, 175; Geary 1988a, 107). Similarly, the Dahomey court came to "own" craftsmen such as appliqué tailors and metalsmiths, originally strangers brought into the palace structure at Abomey. So, as Geary (1988a, 112) has cogently argued for Bamum, the creation, display, and use of works of art provide "a charter in aesthetic terms of the conquest and absorption of numerous chiefdoms."

The incorporation of written texts and labels in works of art—a feature of Muslim-made (or derived) artifacts (textiles, shirts, amulets) for several hundred years—gained impetus in the twentieth century as more Africans became literate. Words are powerful, whether oral or written, and writing expresses prestige, and often authority, in addition to its other messages. Literate priests and artists are therefore quick to make their command of reading and writing apparent, as indicated in an Asante shrine that contains numerous books and other imported status symbols (fig. 176). Written words are featured in many arts, especially those of this century, including Fante flags and military monuments, Asante drums, and several masquerades in Nigeria.

Some artistic specializations, of course, depended on Europe more or less directly. As we have seen, many materials were imported: most beads, appliqué cloth, sheet silver, copper, brass, iron, and tin, among other things. European tools and manufacturing processes were adapted too. Carpentry and the piecing together of sculptural forms (rather than carving from a single piece of wood or unitary casting) are techniques learned from outsiders that account for certain chairs (fig. 19), Kalabari ancestral screens (fig. 107), large Dahomean wood and iron sculptures, and other works. Many craftsmen who were strangers—carpenters, shipwrights, tailors, blacksmiths—lived in the floating "trading factories" that lay off West African communities for months at a time over a period of several centuries (c. 1650–1900).

FIG. 183. The Kalabari, by virtue of several centuries of trading contact with Europeans, have created many forms of dress that rework outside materials and styles.

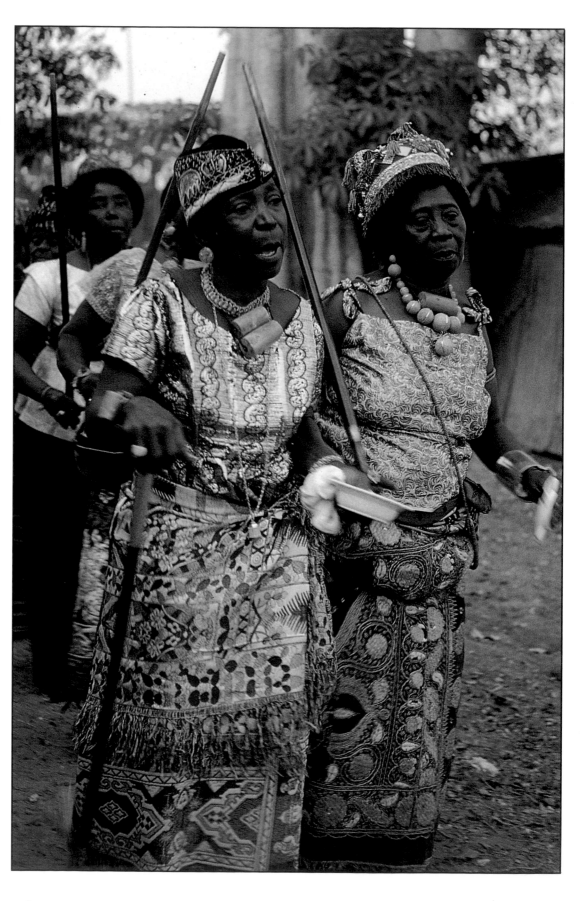

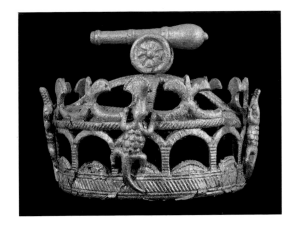

FIG. 185. White men are often satirized in the secular puppet performances of Mali. Here, a man holds a pith helmet and smokes a cigarette.

The Changing Arts of Dress. Africans clearly channel much artistic energy into dress, and equally clearly, their ensembles often owe much to the impact of materials, forms, and styles assimilated from the outside. Few abrupt changes in dress appear to have resulted from the formalization of European rule that grew out of the arrogant partitioning of Africa at the Berlin Conference of 1884–85. Rather, throughout the late nineteenth century and the first decades of the twentieth, the European presence became ever more pervasive. By 1920 or 1930 in most of West and Central Africa, white men were quite familiar to many local people. Many artifacts, particularly items of European clothing, had long since been selectively imported, copied, and transformed for local use. Sewn, tailored garments gained popularity over a two- or three-century period. These were made by professional tailors, who learned their trade from outsiders.

Although a history of clothing and dress has yet to be written for any specific culture or region, much less for all of West or Central Africa, some observations on these complex matters are in order.[15] Change was gradual everywhere, but it was more marked, with imports more fully absorbed, in some coastal societies. By 1850 or 1870, for example, modified aspects of European dress were no longer exotic and had become well-entrenched norms among the Fante and Kalabari (fig. 183). In keeping with adap-

tations in the whole realm of material culture, selection, transformation, and reinterpretation were far more common than wholesale adoption. Or if one item, such as a pith helmet, was adopted, it was not necessarily accompanied by other parts of its foreign ensemble. At times the new artifact (or its modified copy) became emblematic, a signal element. Headwear was especially well suited to this purpose, for it had long been symbolically and artistically important to many African peoples. Portable and highly visible, hats and other headgear dramatize the head, so striking differences in appearance can result from relatively modest expenditure.

Great quantities of headwear of nearly every description have been exported to the continent for centuries, especially to coastal West Africa. Royal crowns and pith helmets, however, appear as dominant artistic motifs. Crowns occur as mask motifs, and actual versions—carved, painted, beaded (Yoruba), knit (Bamum), or gold-leafed (Akan)—are worn by some leaders (fig. 184). Wherever crowns have been adopted, such as in West Africa from the Mende areas in the west to the Cross River region in the east, they retain their noble associations. Pith helmets are more broadly dispersed in Africa (fig. 177), probably because they were worn by European outsiders of every social rank. Yet in many cases African wearers of these hats are declaring status, wealth, and power.

FIG. 186. King Njoya of Bamum, a kingdom in the Cameroon Grass-fields region, and his wife. They are wearing locally made royal garments that blend European styles and materials with those of Bamum invention.

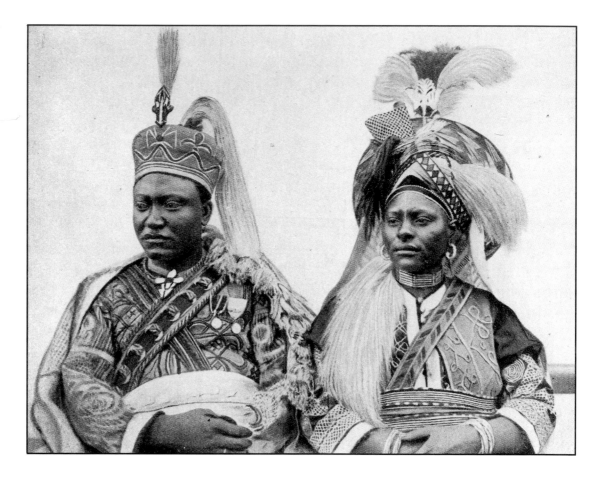

Pith helmets are signal elements too in recognizing the stranger in masquerades and puppet theater, probably because of the high visibility of the motif (fig. 185). Whites and colonial officers, of course, represent only a fraction of masked strangers. Nearly every culture that gives much emphasis to masquerades includes at least one character who is a stranger. The alien is the drama-tized "other," from the idealized and beauti-ful, but untouchable, Fulani maiden in Dogon masking to the mocked, barely toler-ated Hausa cattle traders among the Yoruba. More often than not, it seems, Af-rican strangers are lampooned by other Af-ricans, just as whites are.

Widespread minor changes of dress were accompanied in some areas by the adoption of whole ensembles, especially in the dec-ades around 1900 as colonial rule was estab-lished. Uniforms were imposed by Euro-peans on small but powerful groups in local populations (for example, police and court messengers [fig. 61]), yet the voluntary adop-tion of foreign clothing ensembles was also important (fig. 186). Quite often such cloth-ing was altered and amplified by local inven-tion, as in Fumban, the capital of the Bamum Kingdom, during the reign of the innovative King Njoya (Geary 1988b).[16] Un-der Njoya, German dress was adopted in several versions beginning in 1902, some with wholesale local embellishments, but was abruptly abandoned in favor of Muslim dress by 1910. Njoya himself, surely enor-mously fond of both dressing up and posing for the camera, wears about twelve variants of foreign outfits (European, Hausa, or Fu-lani) in photographs taken between 1902 and 1914 (fig. 186; see Geary 1988b). If no other known African leader was quite as foppish as Njoya, many embraced aspects of outsiders' dress, which was also popular among the people at large.

Ambiguity in Culture Contact

The ambiguity of the African encounter with Europe is manifest in African art. On the one hand, Europe imposed many forms and ideas on African peoples; on the other, Africans made many of their own choices, accepting some offerings, rejecting others. Outright imperialism is rarely to be seen in the arts except in a negative form, when a tradition has disappeared under outside pressure. But modifying influences are many and far-reaching. Change may be instigated from the outside, but change itself is African. This can be seen in an Mbundu cyclist (fig. 187), who probably represents a thin-nosed European but may be a spirit carved in his image. The rider's rifle, hat, flag, and clothing are of course imports, but they are not impositions. For the most part—at least in the visual arts—Africans have exercised creative choice, transforming, "Africaniz-ing," what has been made available from the outside. An aspect of this process may also be the control of outsiders by making images of them. Potentially malevolent spir-its were surely confined and put to positive use in this manner. Particularly in their early encounters with whites, Africans as-cribed to them extraordinary, even super-natural, powers. For centuries, artists and patrons have thus recognized the ambigu-ous, sometimes even contradictory, contri-butions of the stranger to African life.

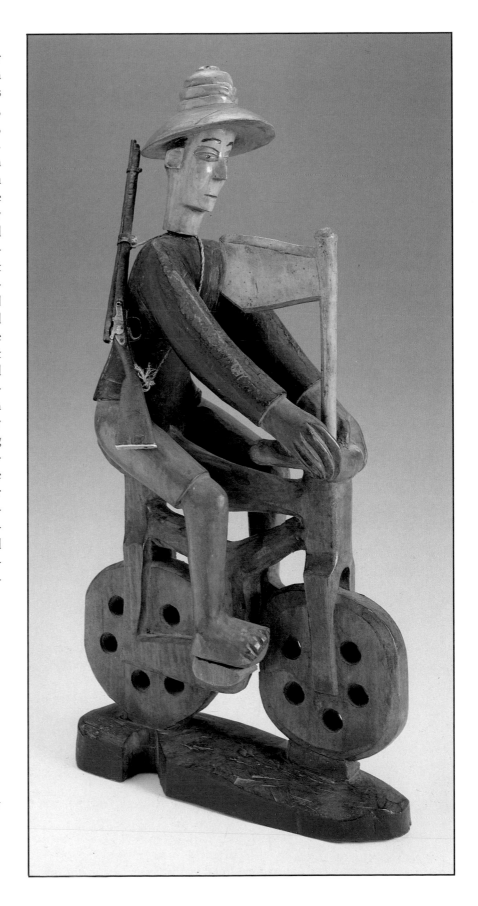

FIG. 187. This cyclist, wearing a detachable pith helmet and rifle, probably represents a white man and certainly illustrates the impact of strangers on several aspects of African art and life. H. 19¹⁄₈ in.

9 Change and Continuity
The Icons in Twentieth-Century Art

Forms and ideologies in African art have undergone accelerated change during the twentieth century. Yet there is also continuity with the past; the five icons under discussion here are still important subjects. Art—and these icons—remain vital to the quality of life.

Trends of the last three or four generations are illustrated in the contrast between two images of couples: a nineteenth- or early-twentieth-century Dogon housepost from Mali with a male and female in high relief (fig. 188) and a 1970s painting of an Ivorian couple eating dinner with a white man (stranger) in a city restaurant (fig. 189). The housepost helps to hold up the roof of a men's house, *togu na,* called a "house of words," in which the wisdom of the ancestors should prevail. To this end, men will pour libations of millet beer, inviting super-

natural participation in discussion and decision making. The urban restaurant, of course, is a contemporary, secular environment in which vital people like those depicted in the wall painting enjoy food and drink, including the European-style bottled beer advertized nearby. The carved, monochromatic Dogon couple, in contrast, seem abstract and remote from the immediacies of life.

The differences between these two renderings of couples—in materials, forms, meanings, and contexts—are much more evident than the similarities, and these contrasts imply several questions. What has happened to African visual art in one hundred years? How did the couple icon migrate from an agricultural village to an open-air restaurant in a modern city? How did artists move from the stiff, schematic relief to the lively "photographic" illusion? How did artistic ideology change from repeated "ancestral," seemingly timeless conventions to unique portraits of urbane-looking people we might recognize? Answers are far from simple.

The visual arts of the twentieth century reflect an overarching movement toward secularity. Always diverse in content and context, recent arts are if anything still more pluralistic in supporting economic and social structures. The political dimensions of art are shifting to embrace national and international perspectives rather than local ones. Christian and syncretist churches recognize the power of visual forms but tend to exploit art less than did earlier indigenous religions. Islam tolerates artistic production in some areas but more often inhibits or proscribes it. Indigenous local spiritual institutions continue to lose ground. Within and contributing to these temporal emphases are several discernible artistic trends: a shift away from schematic renderings and styles to more varied and realistic ones; changes in form and content from replication to innovation and the unique work of art; increased emotional expression; a growing emphasis on anecdotal or narrative rep-

FIG. 188. An older type of Dogon *togu na* post. The simplified, schematic images probably represent Nommo, primordial beings. H. 75 in.

FIG. 189. A painting on a restaurant wall of an African couple with a European exemplifies the recent trend away from spiritually oriented sculpture and toward entirely secular art, which is often two-dimensional.

resentation, as well as on self-conscious personal style; and a change in context from the conservative village to the progressive, international city. All the developments, it must be stressed, are gradual, discontinuous, and in progress; they are tendencies and directions rather than finished transactions. In some places, earlier and later forms and uses coexist.[1]

From Schematic to Realistic Renderings

One important twentieth-century stylistic trend is from earlier conventionalized modes to more naturalistic and even realistic formal expression. Aspects of this shift can be seen in the contrast between a late-nineteenth- or early-twentieth-century wooden Baule couple (fig. 190) and an Ibibio cement couple (fig. 191) executed in the 1970s. The Baule male and female shrine

figures are generalized renderings of unseen nature spirits. They are idealized as human beings—neither young nor old, unblemished—and are made according to collective Baule standards of excellence for sculpture. Though Baule style is more naturalistic than many, it is nevertheless conventionalized. The carver's models were previous sculptures or his conceptual or memory image of how nature spirits should look. The Ibibio artist S. J. Akpan, in contrast, modeled detailed cement portraits of a specific couple, using a photograph of the people as a guide. The images are tangibly realistic; they are personal and immediate, down to the man's caught-in-action arm positions and the woman's penetrating gaze. Life-size and created as a grave memorial for the deceased couple, the figures are based on the artist's perception of the way these middle-aged people actually looked. Akpan also

FIG. 190. Older shrine figures, like these Baule examples, are more difficult to date than images showing time-specific European artifacts or using imported materials. H. 14½ in. (male) and 17 in. (female).

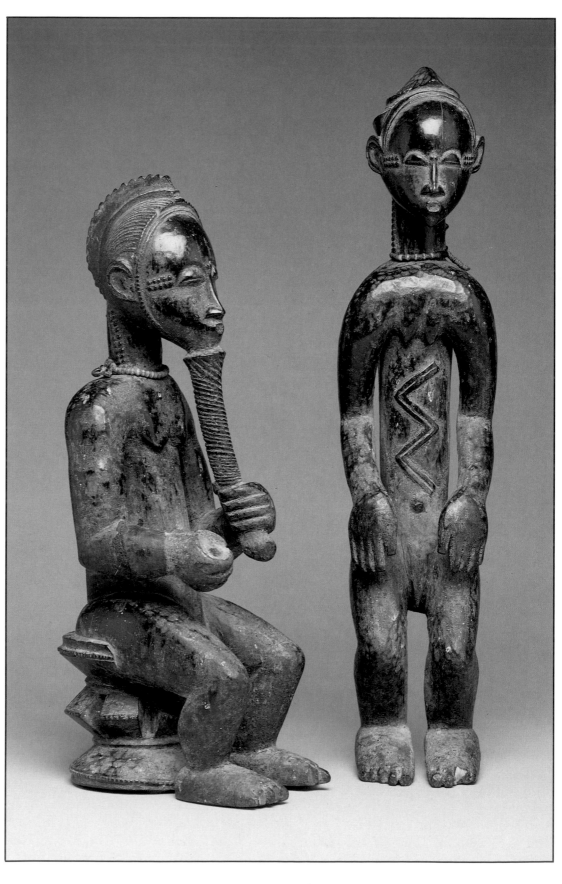

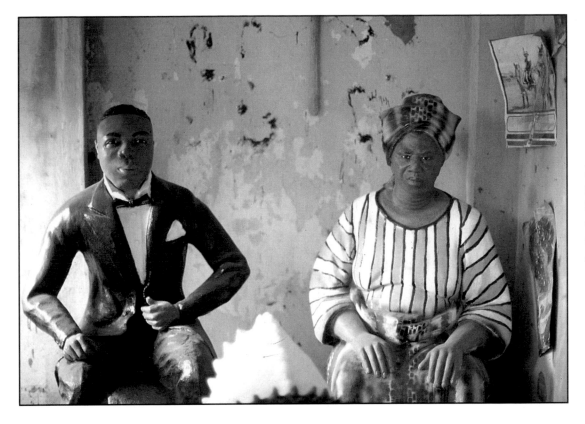

used subtly modulated oil paints to reinforce the descriptive realism. New materials have been introduced along with unfamiliar styles.

Portraits as naturalistic as the Ibibio couple do not occur in African art until about the middle of this century. The conventions of the Baule couple are much more typical of nearly all imagery until the last few decades, although there are of course exceptions.[2] Earlier formal qualities stem partly from the fact that most African sculpture has been created to embody or channel impersonal powers. The "natural" powers of bush spirits, as focused in the Baule shrine images, exist everywhere in nature. Even ancestral representations, as we have seen, have normally been generic; they do not refer to personal traits or individualized sources of spirit energy. The secular Ibibio sculptures, however, commemorate recognizable local people in what Nigerians call "cement photographs."[3] Their clothing is modern, imported, and stylish, contrasting markedly with the unclothed Baule couple (whose only "dress" was probably layered sacrificial offerings). The cement sculptures extol the virtues, and even apparently the personalities, of the memorialized couple at a time when houses of mud or clay with thatched roofs are considered old-fashioned, almost uncouth. The sculptures were created to show the peoples' stature in life, as well as the generosity and loyalty of their children and extended family, who paid for the monument. The relative formality of the couple's position, however—frontal and essentially symmetrical—reflects continuing concerns with canonic modes of self-presentation. Thus formality may persist even as naturalism and personalization increase.

Formal qualities of the Baule and Ibibio pairs—pose, proportions, dress, realism, and so forth—contribute to a sense of relative timelessness for the Baule and temporal specificity for the Ibibio, as if the former is one in a long-established series and the latter is an innovation. The iconic quality of the Baule couple, as well as their place in a bush-spirit shrine, suggests that they took part in an often-repeated ritual by which people maintained order in their world. The Ibibio couple, however, have a momentary, even transient, quality that is paradoxical in view of the durable cement in which they are rendered.

A small delicate ivory couple from Loango (Kongo) falls conceptually between the Baule and Ibibio pairs (fig. 192). An early tourist carving, the couple appear to be Europeans who are embracing. Their pose is relatively informal, even personal, but their facial features are conventionalized. The painstakingly rendered clothing suggests a date of about 1850 to 1875.

FIG. 192. Ivory carvings from Loango were made as export or tourist art before 1900. This example appears to represent a European couple. H. 3 in.

FIG. 193. This recent *togu na* post features anecdotal, quasi-realistic scenes in low relief. It is painted with European enamel pigments.

FIG. 194 (*far right*). An old-style *togu na* post with an explicit symbol of androgyny. It probably represents "two in one" Nommo spirits in primordial times, before the separation of the sexes.

From Replication to Innovation

While it is a truism that all art changes, colonialism and other twentieth-century phenomena (for example, greater mobility, faster communication, literacy, print media) have had the effect of increasing rates and types of change. One aspect of African art in the twentieth century, therefore, is a trend away from apparent replication and toward innovation. This may be observed again in the tradition of posts created for Dogon men's houses, *togu na* (figs. 188, 193, 194). A survey of nineteenth- and twentieth-century houses shows an overwhelming emphasis on highly conventionalized male and especially female figures (Spini and Spini 1977). These are immortal ancestors—the Nommo of creation myths—eternal sources of wisdom that men congregating in these houses must draw upon in guiding present society toward the future. The remarkable compression of salient male and female sexual characteristics into a single economical bisexual image is repeated on several posts, as if an archetype; the symbol reminds us of the extent to which African art expresses ideas and ideals, often those arising from long-repeated myths (fig. 194). We do not know when this seemingly timeless post was carved, but it was still in use in the spring of

1989. Old posts like this one, however, are threatened today by the increasing traffic in antiquities.[4]

A *togu na* renovated in 1986, like others done even more recently, shows several sorts of innovation in the content and form of post carving (fig. 193). Many of these developments reveal increasingly rapid, cross-cultural forms of communication. Subjects depicted have expanded to embrace Islam and topical contemporary scenes and objects that include airplanes, trucks, urban architecture, and European dress. Posts have writing in Arabic and French, as well as dates and numbers. Carved figures wear Western clothing and have animated poses. Polychrome paints, sometimes imported oils, are being used. The 1986 renovation involved a competition among sculptors; Amasom Pujugo carved the prizewinning post. Two modern couples are shown on it. The female half of one drives a plow pulled by an ox that is being attacked by an elephant, which, in turn, is being killed by the woman's equestrian husband. A soldier seems to watch these activities while seated in a chair. This is an apocryphal scene, perhaps a narrative one. The second group, on the upper right part of the same post, shows

a man begging his wife to return home (Huet 1988, 36). These complex, topical renderings show off Pujugo's virtuosity.

Twentieth-century artistic innovations are many: materials and techniques, types and styles of images, and vastly expanded subject matter. Compare, for example, several versions of the woman-and-child icon: a classic Owo Yoruba ivory carving (fig. 195), an Igbo terra-cotta (fig. 196), a Senegalese glass painting (fig. 197), and a Bamana puppet from Mali (fig. 198). The Owo Yoruba and Igbo figures are in replicated styles, time-honored carving or modeling techniques, and revered materials in use for centuries. Ivory mother-and-child carvings from Owo are rare, but we may suppose wooden examples, so prevalent in Yoruba art in the last one hundred years, were numerous. The Igbo terra-cotta is one of many woman-and-child figures known from this fairly remote area. Its date is uncertain (possibly early twentieth century); its forms were apparently not affected by modernizing trends elsewhere in Igboland. The Owo ivory is perhaps a sixteenth-century work, thought by some to have been carved by an Owo artist for the court of Benin and used, possibly, in a shrine of the queen mother or king. The impassive facial expression of both the Owo and Igbo women and their seemingly distant emotional relationships with their children, moreover, are pre-twentieth-century formal characteristics, as might be expected.

Both the Bamana puppet and the Senegalese glass painting represent increasingly secular orientations in the lives of art, and each genre has embraced topical, innovative subjects, such as President Musa Traore's motorcade (fig. 119). Daytime puppet theater is purely for entertainment, and glass paintings decorate homes, not shrines. The planar form of this and other puppets continues an earlier style. Jointed limbs that allow movement by the pulling of strings and puppet clothing (often imported or at least industrially made cloth), however, are innovative features. Portable, two-

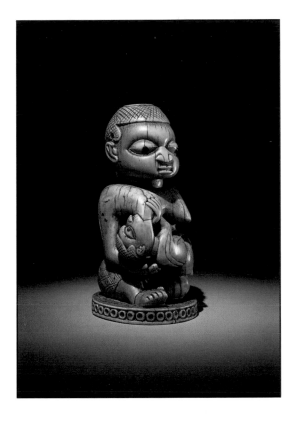

FIG. 195. A rare Owo Yoruba ivory, perhaps dating to the late sixteenth or early seventeenth century. The manner in which the child "ingests" its mother's breast can be taken as the extent to which African mothers give to their children. H. 5³/4 in.

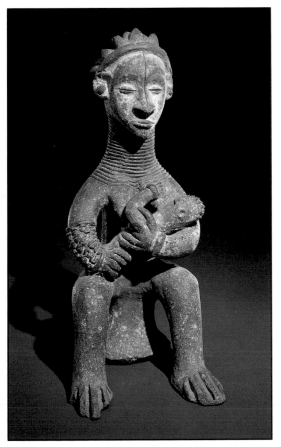

FIG. 196. A terra-cotta woman-and-child image of the sort used in medicine shrines and by diviners in northeastern Igboland, Nigeria. H. 13¹/4 in.

FIG. 197. Glass paintings are popular today in many countries. African versions were first made in Senegal in the 1930s. 14^{15}/16 x 18^7/8 in.

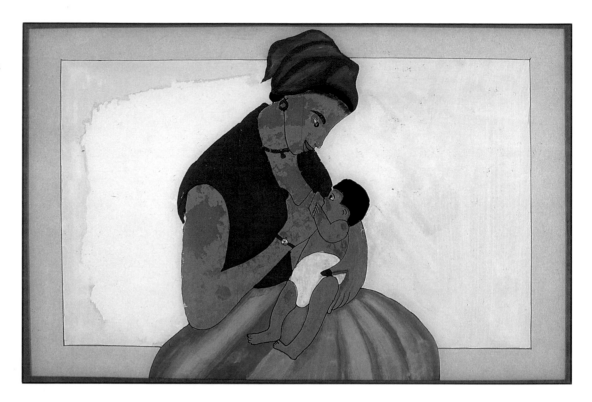

FIG. 198. Animated mothers with children are part of most puppet theater in rural Mali. H. 24 in.

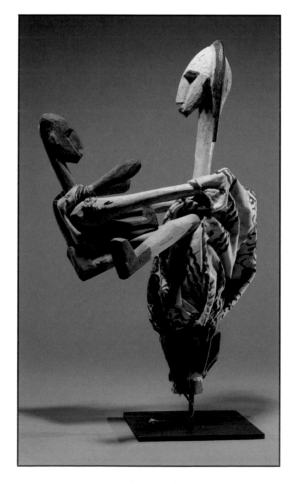

dimensional renderings of self-consciously framed subjects are quite new to Africa, just as the glass itself and the colored pigments are imports. Mother-and-child imagery continues, although innovative styles, materials, and uses inform many recent versions of the icon.

Heightened Emotional Expression

In the past two or three decades, new emotionally intense, psychologically complex content has entered the world of African art. Although moments of this sort have occurred in the past,[5] expressionless facial features, as in the Owo ivory, are far more characteristic. The modern trend is observable in the Ibibio cement couple (fig. 191), in Shilakoe's etching of a South African family group (fig. 25), and in the glass painting just discussed (fig. 197). Consider, for example, the close mother-child bond evoked in the glass painting in contrast to the emotional distance of the Owo ivory. Emotional expression in sculpture is difficult in economical, conventionalized styles. It is more easily achieved in highly detailed, naturalistic ren-

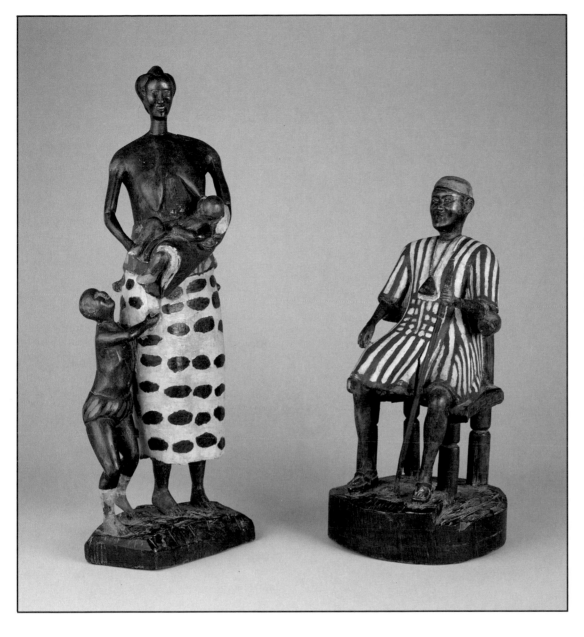

FIG. 199. This family group, attributed to the Limba of Sierra Leone, is most unusual in the extent to which poses and faces are emotionally expressive. H. 25¼ in. (female) and 20 in. (male).

derings, such as the Limba group in figure 199.

The Limba family group is carved in an unusual style. The sculptures evince a strong artistic personality, the sure yet idiosyncratic hand of a person familiar, at least in passing, with European art. We sense the confidence of an experienced artist alongside naive qualities that suggest he may have been self-taught. The figures have expressive postures and faces. The body of the older standing child spirals in contrapposto as he lifts one foot higher than the other—rare in African sculpture and quite clear evidence of outside influence. All three children have distinct, dynamic poses (one child is hidden behind the mother). The five people have alert, individualized facial expressions and personalities. While we are not aware of any narrative intent, the group has an immediate emotional presence. Like the Ibibio cou-

ple (fig. 191) and the Abidjan painted trio (fig. 189), the Limba group has a time-specific and momentary quality.

Sculptors and painters who carefully observe expression in both faces and body positions of living people and translate these observations into representational form are rare in the history of African art. Most examples are recent and clearly derive from the illusionistic sculptural and two-dimensional styles of Europe and America. Photographic imagery, now widespread on the African continent, has also contributed to this trend toward emotional intensity. The expressive, lively faces in the detailed illusionistic restaurant painting that opened this chapter (fig. 189) would probably not have been possible without the influence of photography, despite the fact that most African photographs are rather formal portraits.

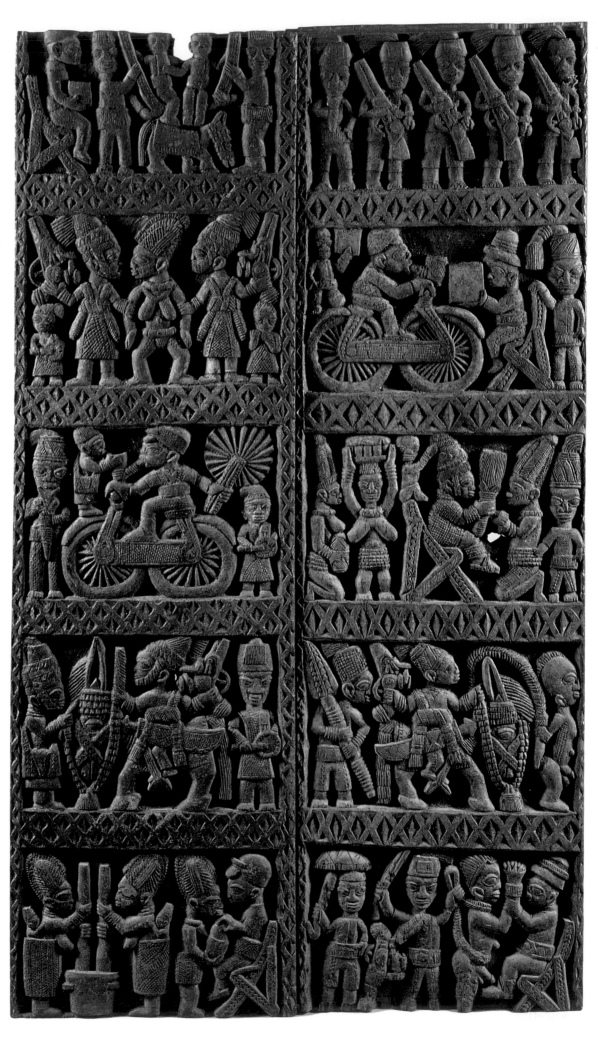

FIG. 200. Yoruba doors for palaces or shrines carved by the artist Areogun (or his workshop) show anecdotal or episodic scenes from royal and everyday life. H. 71½ in.

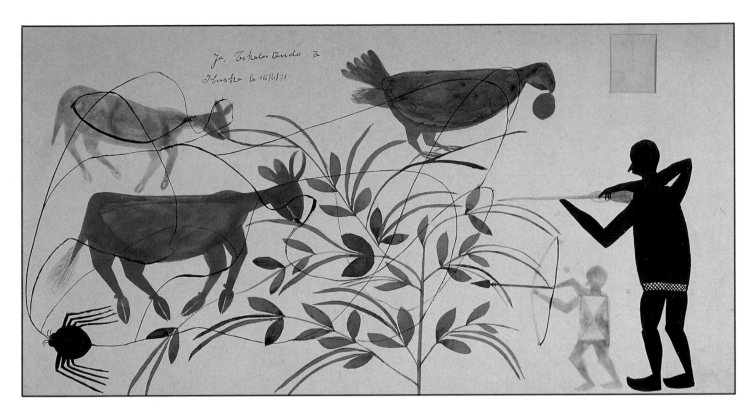

FIG. 201. In this 1931 work, the watercolorist Djilatendo shows two hunters in a fanciful landscape. 14¹/₂ x 28¹/₄ in.

Episodic or Narrative Representation

Many recent paintings and sculptures exemplify the shift toward both seemingly time-specific, episodic representations and those that tell a story. Neither are absent from earlier arts, but they are not common.

An early-twentieth-century Yoruba door (fig. 200) is composed of descriptive vignettes of royal and everyday life. Two women (with children) pound food in a mortar; a woman kneels before a king; several men brandish weapons; riders—of bicycles as well as horses—interact with other people; and soldiers present their prisoners to superiors. Four of the five icons—all but the couple—are present in the vivid scenes of the ten panels. European clothing, chairs, weaponry, and bicycles are very much in evidence and certainly part of the short stories told on these doors.

Other episodic, sometimes anecdotal works appeared as early as the 1920s and 1930s in both Zaire and Senegal in entirely two-dimensional, portable form. These works represent a new direction in African art of recent times. Two-dimensional art itself, of course, is not new; Africa's earliest surviving works are ancient rock paintings and engravings. Using European materials, Djilatendo and Lubaki made their first watercolors in what was the Belgian Congo, and Gora M'Bengue executed his first glass paintings in Dakar, Senegal. Djilatendo sometimes worked with texts of local folk-tales, which he designed into his compositions of multiple animals. He observed life around him—men on bicycles or seated at tables, for example. He also painted fanciful subjects, such as whimsical landscapes populated with animals, spiders, and hunters (fig. 201). M'Bengue and other glass artists paint a variety of brightly colored topical, bourgeois subjects, as well as occasional historical scenes and illustrations of folklore (figs. 44, 145, 197). Neither the Yoruba doors nor the 1930s paintings on paper and glass are continuous narratives—like the drama of Chukwuma and Rose, the signboard by Middle Art (fig. 27)—but they do have a pictorial quality; they tell at least part of a story.

In a work painted to advertise his own skills, Middle Art annotated the tragic love story of Chukwuma and Rose. In the first scene, on the left, the couple embraces, promising faithfulness. Then Chukwuma appears alone, lamenting all the money he spent courting Rose; having sold his property, he no longer can afford to send his two brothers to school. He has no recourse but suicide, shown in the upper right, while Rose, below, has already found a new friend. Simple and melodramatic, Middle Art's cartoonlike story in sequential images and word blocks seems to derive partly from chapbooks—novellas and didactic tracts about modern life—written and sold mainly in the prominent market town of Onitsha,

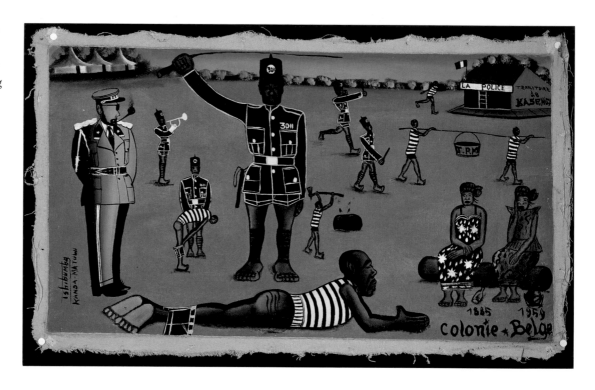

FIG. 202. Popular painting in Zaire illustrates many legacies of the colonial era, from painting styles and materials to the depiction of an oppressive prison environment. Like most modern works, this is signed. The artist is Tshibumba. 15¼ x 26¾ in.

Nigeria. The painting shares with many of these a fresh, naive, pidgin-English quality of compelling directness. Middle Art, like most modern Onitsha artists and writers, is self-taught. Like much folk art, his sign has a disarming clarity of vision, an incisive and simple message. This is certainly a narrative, as are the scenes on Pujugo's prizewinning *togu na* post (fig. 193).

Another urban, quasi-narrative tradition is represented by the Colonie Belge genre, which has flourished in Zaire (Shaba province) for about twenty-five years (fig. 202).[6] Tshibumba's scene of a uniformed prison guard poised to whip a prisoner, with an anonymous white administrator casually smoking a pipe nearby, is typical of these remembrances of colonial and postcolonial life, which include the trauma of forced labor, imprisonment, and brutality under an oppressive regime. The central scene of flogging dominates seven smaller scenes of people shown frontally or in profile. Women are crying, men carry water (normally women's work), clothes are removed, men are chased and flogged. These expressions of humiliation and grief refer to the pre-

independence period, yet they have remained part of contemporary Zairian workers' experience throughout the more recent era under President Mobutu. Social, political, and economic conditions have not greatly improved since independence.

The creation and marketing of this Shaba painting and others of its genre articulate additional messages. The painters work to a small margin of profit, rapidly turning out near replicas of several popular themes rather than a succession of original works. (This is also true in the tradition of glass painting; both recall earlier forms of replication in sculpture.) The selling of these paintings is a dimension of urban petty trade; customers buy a painting "because there is an empty wall in their living room, because they like what they see, or because they want to spend, finally, a buck on something that is not absolutely necessary for survival" (Szombati-Fabian and Fabian 1976, 17). The paintings adorn domestic rooms and semi-public gathering places in workers' camps, squatters' towns, and residential zones outside higher-class areas. Life is hard in these crowded urban environments.

Fig. 203. This Baule
carving of the foreign
water spirit Mami Wata
derives from a color lith-
ograph that has been
widely circulated on the
African continent since
about 1900. H. 14½ in.

Stress on Personal Style

In recent decades various trends have com-
bined to place increasingly greater stress on
the individuality and self-expression of Afri-
can artists. This is not to say that pre-1900
art is anonymous, for many individual
hands can be identified even if the artists'
names rarely survive. Generally, however,
personal expression seems to have been lit-
tle emphasized in earlier African art and
thought, just as individualism in the society
as a whole was quite often downplayed in
favor of the collective strength of a lineage
or group. Though we obviously lack insight
into the personal motivations and relative
self-consciousness of artists who are long
dead, the surviving art forms themselves, as
well as data on the place of artists in soci-
eties, suggest greater selflessness and ano-
nymity than is observable today. Only
recently, for example, have Dogon carvers
of *togu na* posts been remembered by name.
Blacksmiths of the Western Sudan have
produced thousands of sculptures, but the
groups commissioning them apparently
have not memorialized artists' personalities
by transmitting their names through time in
oral traditions.[7] Today many artists in Mali
and elsewhere either sign their work or seek
to be remembered in other ways as individ-
uals. These developments stem in part from
the influence of Europe and America, where
the uniqueness of each artist's hand has
long been important.

From Village Parochialism to Urban Internationalism

A tendency in visual art that is explicit in
the fashioning of the icon of the stranger—
especially European outsiders—is the shift
from provincial village traditions to those of
an international, often urban character.
This trend began in the nineteenth century
and even before, but it has gained momen-
tum in the last few decades, especially since
World War II. Two Baule carvings made for
personal shrines about 1950 to 1960 are good
examples of this increasingly international
perspective (figs. 203, 204). The female figure

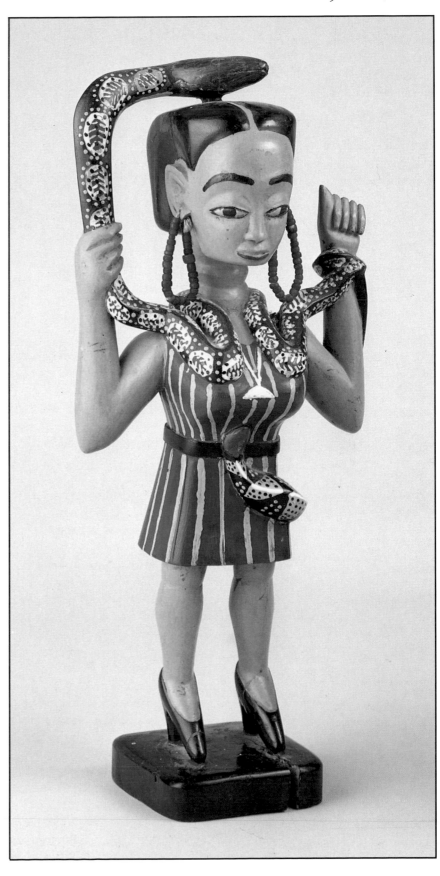

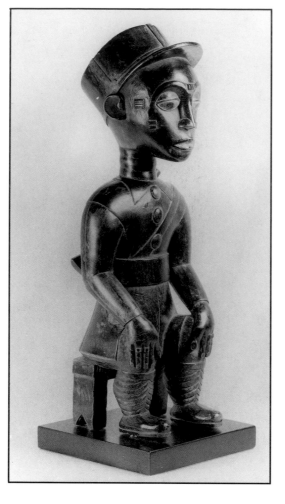

Fig. 204. A Baule veteran in a European-style uniform, prestigious attire for a "spirit lover" figure. Such an image was commissioned by a woman after consulting with a diviner. H. 12⅝ in.

represents Mami Wata, a foreign water spirit who first appeared in West Africa about 1900 in the form of a color lithograph from Germany (of an apparently East Indian "snake charmer").[8] The Mami Wata cult is now widely distributed in Africa; it can be found in several dozen cultures from Senegal to Tanzania. This Baule carving, however, was probably made as a "spirit lover" for a Baule man.

Mami Wata's iconography has been updated from the original lithograph to reflect the novel, glamorous French fashions that had invaded the Baule world by the 1950s: high-heeled shoes, short skirts, modish hairstyles, and colorful jewelry. Notably, the carving is painted with European oils. Indeed, Mami Wata epitomizes modern ideas about glittering female dress, worldliness, and affluence. Her cults are found in villages and cities alike, but her Western clothing (like the uniform of the veteran in figure 204), had by about 1960 to 1970 become symbolic of progressive urban living for increasing numbers of people.

By the mid-1960s, when most of the modern countries of sub-Saharan Africa had gained independence, it was the township

or city, not the quiet village of one's parents and ancestors, that was coming to set the ideological tone for upwardly mobile youth. Especially for younger generations with some school education, cities had become vibrant, rich centers of commercial and cultural activity. Education and business opportunities appeared to provide access to money and an exciting life. Greater literacy in this period also signaled the increasing use of writing in art. Newspapers and photographs gained stature and influence. Hotels, bars, and highlife music were plentiful. Records or tapes, television, stylish wardrobes, motorbikes, and even cars were accessible to hardworking (or lucky) people. These stimulations contrasted with the perceived duller life of the village, marked by the daily routine of farming and submission to the conservative rules of elders.

The uniformed Baule soldier, also a "spirit lover" (fig. 204), reinforces these points. He represents a veteran (*ancien combattant*), pensioned, wise, and proud by virtue of his worldly experiences. Smartly dressed, this image represented to many Baule in the 1950s an ideal of sophisticated manhood. This sort of spirit lover would undoubtedly have been seen as threatening to its female owner's real husband (Philip Ravenhill, pers. com., Feb. 1989).[9]

In many respects, the veteran and Mami Wata are similar. Both are symptomatic of shifting social and economic values. Each represents the importance of invoking the wider world to achieve success. She is an actual outsider, a water spirit from across the seas. With light skin and luxuriant straight black hair, she is considered very beautiful. She is attractive in part because she is outside the kinship system (and its constraints), detached from normal social bonds, as the veteran may be as well. It is this very freedom in social relationships that makes the city so attractive to many younger people. The veteran is the native who has been abroad, if perhaps only to another African country; as one who has seen the world and is probably literate, he represents

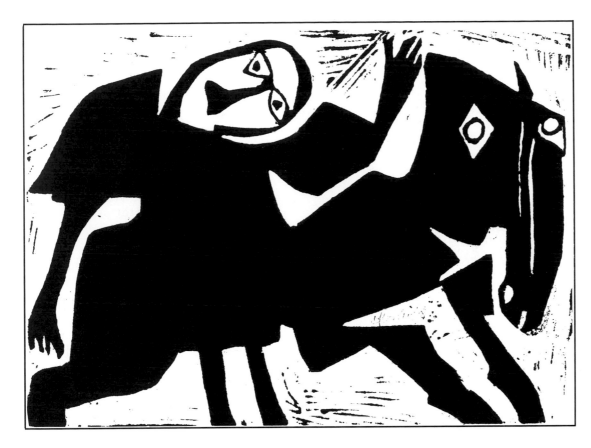

Fig. 205. A linoleum block print by the artist Hezbon Owiti of Kenya strongly recalls turn-of-the-century prints made by German expressionist artists who were influenced by African sculpture. 8³/4 x 11⁷/8 in.

increasing numbers of people who are not content with the slower pace of village life.

Modern graphics, murals, signs, and other two-dimensional works also exemplify the trend in recent decades toward internationalism. Contemporary artists who happen to be African compete with others from every part of the world. They share styles, materials, and techniques, although their individual hands and especially their subject matter can at times be recognized as African. Many are college teachers—some were trained abroad—who are self-conscious about personal style, creative output, and public recognition. Most live in cities or academic environments that have a European (or American) atmosphere. They are psychologically distant from village sculptors (male) and painters (female) working in conservative styles. Sokari Douglas Camp, for example, is a Nigerian woman who makes sculpture in welded metal. She draws on her native Kalabari experiences and art traditions, yet she works mostly in England. She exhibits internationally, as have the three printmakers represented here: Hezbon Owiti of Kenya (fig. 205), Bruce Onobrakpeya of Nigeria (fig. 206), and Cyprian Shilakoe of South Africa (fig. 25).

Hezbon Owiti's black-and-white linocut (fig. 205) shows a close, perhaps ironic resemblance to German expressionist woodcuts by such artists as Pechstein and Schmidt-Rotluff. The latter two, active in the early 1900s, were partly inspired by the geometric clarity, flat planes, and simplified, exaggerated conventions of some African sculpture. Owiti's rider—called Good-bye—has therefore come full circle in a little more than half a century. Owiti and other artists, of course, have had access to the whole history of world art in books and museums; they are literate and have traveled widely.

Bruce Onobrakpeya's etching (fig. 206) depicts a group of people accompanying a corpse, carried on a bicycle, back to the village for burial. Here, a modernized rider icon is central in a seminarrative, pictorial work that reinforces a traditional value: the importance of returning a deceased person to his natal community. Onobrakpeya is a versatile, innovative painter and printmaker. He developed his own "deep etching" technique, of which figure 206 is an example. Such high-relief prints are almost sculptural. His work also embraces a great variety of subjects, from his native Urhobo mythology and village life to Christian, nature, and humanistic themes.

Unlike village artists of the past century—or indeed modern glass painters and Shaba artists—recent artists emphasize the uniqueness of each new work, although European-style replication in print-making is accept-

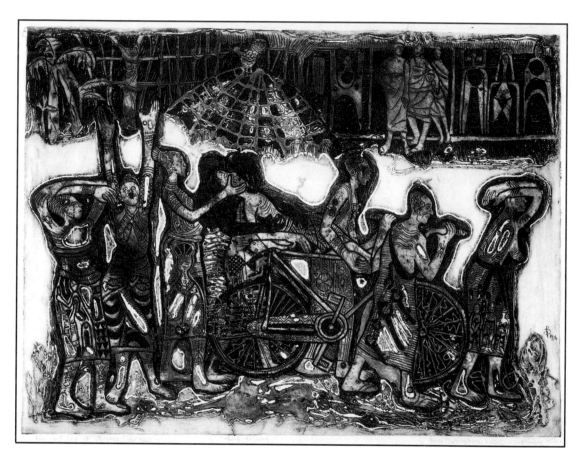

able. Modern, international artistic trends in many media are notable in all African countries; the few examples shown here only hint at the richness of contemporary African art.[10]

Changing Environments, Persisting Icons

In his name and in his art, the Ibibio cement sculptor Sunday Jack Akpan has assimilated some of what the outside world has offered modern Nigeria. His studio sign reads, "Natural Authentic Sculptor." His business card says, "Undertakes Construction of Images, Statues, Tombstones of all Kinds, Pottery Products [formally women's work], Painting of Houses in the Most Modern Ways, Decoration of House Furniture, and General Arts." His home is "painted pink, yellow, blue, white, and green, and 'Hallelujah' is written three times across the front" (Nicklin and Salmons 1977, 32). Akpan's

naturalistic funerary monuments are very popular today, as the environment for ancestral remembrance has expanded to reflect new attitudes and artifacts, new colors and styles. More choices are available in art, as in the rest of life.

Akpan's cement couple (fig. 191) fulfills a continuing, even timeless, need in Africa: the veneration of ancestors. Elsewhere, shrines to nature deities also embrace cement sculpture, just as masquerades incorporate industrially made cloth and plastic. Many ancient values persist even as new ones evolve beside them and threaten to crowd them out. The five icons we have been looking at serve all these masters—the old, the new, the evolving—in part because the images partake of and represent eternal ideas. In African art these icons will endure—and change in outward aspects—as long as humankind continues to revere its ancient and still important truths.

Appendix
List of Illustrations

A diamond (♦) next to a figure number indicates that the artwork appeared in the exhibition *Icons: Ideals and Power in the Art of Africa*, held at the National Museum of African Art from October 25, 1989, to September 3, 1990.

FRONTISPIECE
Asafo *posuban* of Company No. 2
Fante group, Akan peoples, Gomoa Degu (Legu), Ghana
Photograph by Herbert M. Cole, 1974

FIG. 1
Asafo *posuban* of Company No. 2
Fante group, Akan peoples, Gomoa Degu (Legu), Ghana
Built by Kojo Abban, 1936, and renovated by Kwame Munko
Photograph by Doran H. Ross, 1974

♦ FIG. 2
Male and female figures
Kongo peoples, Congo and Zaire, c. 1900
Wood
H. of male 12¹/₂ in. (32 cm); H. of female 12³/₄ in. (32.5 cm)
Marc Leo Felix
Photograph by Dick Beaulieux

♦ FIG. 3
Equestrian figure
Akan peoples, Ghana and Côte d'Ivoire, 18th–19th century
Cast copper alloy
H. 2⁷/₈ in. (7.5 cm)
The Bonnefoy Collection, New York
Photograph by Eastern Studios, New York

♦ FIG. 4
Display sculpture
Igbo peoples, Nigeria, c. 1935
Wood, paint
H. 59 in. (150 cm)
The Trustees of the British Museum, 1954.Af23.522

♦ FIG. 5
Female equestrian figure
Akan peoples, Ghana and Côte d'Ivoire, 18th–19th century
Cast copper alloy
H. 3¹/₄ in. (8 cm)
The Bonnefoy Collection, New York
Photograph by Eastern Studios, New York

♦ FIG. 6
Weight: Woman and child
Akan peoples, Ghana and Côte d'Ivoire, 18th–19th century
Cast copper alloy
H. 1¹⁵/₁₆ in. (4.9 cm)
R. and L. Phillips
Photograph by Prudence Cuming

♦ FIG. 7
Weight: Man with long-barreled gun
Akan peoples, Ghana and Côte d'Ivoire, 18th–19th century
Cast copper alloy
H. 3⁵/₁₆ in. (8.4 cm)
R. and L. Phillips
Photograph by Prudence Cuming

FIG. 8
Shrine to river god Tano
Asante group, Akan peoples, near Kumasi, Ghana
Photograph by Herbert M. Cole, 1975

♦ FIG. 9
Seated woman and child
Asante group, Akan peoples, Ghana, late 19th–early 20th century
Wood, pigment, glass beads, fiber
H. 22¹/₄ in. (57 cm)

Mr. and Mrs. Arnold J. Alderman
Photograph courtesy of Sotheby's

♦ FIG. 10
Vessel in the form of a woman and child
Yombe group, Kongo peoples, Congo and Zaire, possibly 19th century
Wood, metal
H. 9¹/₈ in. (23.2 cm)
The Detroit Institute of Arts, bequest of Robert H. Tannahill, 70.129

♦ FIG. 11
Mortar in the form of a woman and child
Kugni group, Kongo peoples, Congo, 18th–19th century
Wood and metal
H. 6⁷/₈ in. (17.5 cm)
Saul and Marsha Stanoff
Photograph by Richard Todd

FIG. 12
Door frame
Baham Kingdom, Bamileke peoples, Grassfields region, Cameroon, early 20th century
Wood
H. of section on left 104 in. (264.2 cm); H. of section on right 100³/₄ in. (256 cm)
Murray and Barbara Frum Collection
Photograph by James A. Chambers

FIG. 13
Obemne, twelfth king (*fon*) of Baham, in front of door frame (see fig. 12)
Baham Kingdom, Bamileke peoples, Grassfields region, Cameroon
Photograph by Father Frank Christol, 1925

FIG. 14
Mbari house to the earth
 goddess Ala
Artist: Nnaji of Umuhu
 Inyeogugu
Owerri group, Igbo peoples,
 Ndiama Obube Ulakwo,
 Nigeria
Built in 1959
Photograph by Herbert M.
 Cole, 1966

FIG. 15
Rock painting of a family
Sefar, Tassili-n-Ajjer, Algeria
Photograph by Douglas
 Mazonowicz, 1972

FIG. 16
Ijele masquerader
Igbo peoples, Achalla, Nigeria
Photograph by Elizabeth
 Evanoff, 1983

FIG. 17
Chief being carried in
 palanquin
Fante group, Akan peoples,
 Abaasa, Ghana
Photograph by Herbert M.
 Cole, 1974

FIG. 18
Man seated on a dog (*nkisi*)
Kongo peoples, Congo and
 Zaire, 19th–early 20th
 century
Wood, glass, paint
H. 13 in. (33 cm)
The Metropolitan Museum of
 Art, The Michael C.
 Rockefeller Memorial
 Collection, Purchase,
 Nelson A. Rockefeller Gift,
 1966, 1978.412.531

◆ FIG. 19
Chief's chair
Chokwe peoples, Zaire and
 Angola, 19th century
Wood, antelope hide
H. 23 in. (59 cm)
Musée national des Arts
 africains et océaniens, Paris,
 MAAO/MNAN 83.4.1

FIG. 20
Egungun masqueraders:
 European couple
Artist: Kilani
Yoruba peoples, Ilogbo,
 Nigeria
Photograph by Marilyn
 Houlberg, 1982

◆ FIG. 21
Spoon: Man riding antelope
Bembe group, Kongo peoples,
 Congo, 19th–20th century
Wood
H. 5¼ in. (13 cm)
Gaston T. de Havenon

FIG. 22
Equestrian figure
Yoruba peoples, Nigeria, 19th
 century
Ivory
H. 2³/16 in. (5.5 cm)
Michael Graham-Stewart
 Collection, London
Photograph by Jan
 Woroniecki

FIG. 23
Medicine shrine called
 onyeogude, "savior"
Igbo peoples, Amagu Izzi,
 Nigeria
Photograph by Herbert M.
 Cole, 1982

FIG. 24
Shrine figure (*okega*)
Igala peoples, possibly Ibaji
 area, Nigeria, early 20th
 century
Wood, metal, accumulative
 materials, blue powder,
 kaolin
H. 24½ in. (62.2 cm)
National Museum of African
 Art, gift of Orrel Belle
 Holcombe in memory of
 Bryce Holcombe, 87-6-1
Photograph by Jeffrey
 Ploskonka

◆ FIG. 25
The Family
Artist: Cyprian Shilakoe
 (1946–72)
South Africa, 1969
Etching
13 x 14½ in. (33 x 37 cm)
M. Wolford/Mbari Art
Photograph by Jeffrey
 Ploskonka

FIG. 26
Grave sculpture
Ibibio peoples, near Ikot
 Ekpene, Nigeria
Photograph by Herbert M.
 Cole, 1966

FIG. 27
*The Story of Chukwuma and
 Rose*
Artist: Middle Art (Augustine
 Okoye)
Nigeria, c. 1971
Oil on plywood
27³/16 x 41³/4 in. (69 x 106 cm)
Iwalewa-Haus, African Studies
 Center, Bayreuth
 University, no. 14109
Photograph by Jörg Schulze

◆ FIG. 28
Staff top: Woman seated on a
 leopard
Kongo peoples, Cabinda,
 17th–18th century
Ivory
H. 7½ in. (19 cm)
The Bonnefoy Collection,
 New York
Photograph by Eastern
 Studios, New York

◆ FIG. 29
Linguist staff: Rooster and hen
Asante group, Akan peoples,
 Ghana, 20th century
Wood, gold leaf
H. of full staff 66³/4 in.
 (170 cm)
The Richard and Barbara
 Faletti Collection
Photograph by Paul Markow

◆ FIG. 30
The Tree
Artist: Asiru Olatunde
 (b. 1915)
Yoruba peoples, Nigeria, 1963
Aluminum repoussé
H. 54³/4 x 34¹/4 in. (139.2 x
 87 cm)
M. Wolford/Mbari Art
Photograph by Jeffrey
 Ploskonka

FIG. 31
Rock engravings of a couple
Tassili-n-Ajjer, Algeria
Photograph by Thomas K.
 Seligman, 1980

FIG. 32
Shrine to Udo and Ogwugwu
 with priest, Okonkno Eze
 N'Iru
Igbo peoples, Oba Uke,
 Nigeria
Photograph by Herbert M.
 Cole, 1983

FIG. 33
Egungun masquerader:
 Woman and child
Yoruba peoples, Nigeria
Photograph by Michel Huet,
 before 1978

FIG. 34
Figures of deities convened for
 annual festival
Igbo peoples, Oreri, Nigeria
Photograph by Herbert M.
 Cole, 1966

FIG. 35
Fon chief
Abomey, Dahomey Kingdom,
 Benin
Photograph by M. T. G.
 Thiévin, 1931, courtesy of
 the Melville J. and Frances
 S. Herskovits Collection,
 Eliot Elisofon Photographic
 Archives, National Museum
 of African Art

FIG. 36
Festival for Fante chief's
 installation
Saltpond, Ghana
Photograph by Doran H.
 Ross, 1979

◆ FIG. 37
Equestrian figure
Edo peoples, Benin Kingdom,
 Nigeria, 17th–18th century
Cast copper alloy
H. 18¹/4 in. (46.4 cm)
The Board of Trustees of the
 National Museums and
 Galleries on Merseyside,
 Liverpool, England,
 1978.226.1

◆ FIG. 38
Rider with shield
Mali, 11th–15th century
Cast copper alloy
H. 1¹/2 in. (4 cm)
Mr. and Mrs. Arnold Syrop
Photograph by Jerry L.
 Thompson

◆ FIG. 39
Female and male figures
Mali, 10th–15th century
Cast copper alloy
H. of female 3¹/2 in. (9 cm); H.
 of male 3 in. (8 cm)
Mr. and Mrs. Arnold Syrop
Photograph by Jerry L.
 Thompson

◆ FIG. 40
Male and female figures
Wurkun peoples, Nigeria,
 19th–20th century
Wood
H. of figure on left 17¹/2 in.
 (44.5 cm); H. of figure on
 right 15¹/2 in. (39.4 cm)
Collection of Count Baudouin
 de Grunne, Belgium
Photograph by Roger
 Asselberghs

FIG. 41
Weight: Man with gun
Akan peoples, Ghana and
 Côte d'Ivoire, 18th–19th
 century
Cast copper alloy
H. 2³/8 in. (6 cm)
The Bonnefoy Collection,
 New York
Photograph by Eastern
 Studios, New York

◆ FIG. 42
Kneeling man with gun
Dan peoples, Liberia and Côte
 d'Ivoire, 20th century
Cast copper alloy
H. 8 in. (20.4 cm)
Ernst and Anne Winizki
Photograph by Ernst Winizki

◆ FIG. 43
Weight: Chief holding knife
 and head
Asante group, Akan peoples,
 Ghana, 18th–19th century
Cast copper alloy
H. 2 in. (5.1 cm)
Leloup, Inc.
Photograph by Noel Allum

◆ FIG. 44
Les Amoureux
Artist: Gora M'Bengue
Gorée Island, Senegal, 1983
Glass, India ink, paint
13 x 18⁷/8 in. (33 x 48 cm)
Collection of M. and Mme.
 Renaudeau
Photograph by Renaudeau

◆ FIG. 45
Woman and child
Pende peoples, Zaire, 20th
 century
Wood
H. 24¹/2 in. (62 cm)
Pace Primitive Art
Photograph by David Allison

◆ Fig. 46
Heddle pulley
Dogon peoples, Mali,
 19th–20th century
Wood
H. 8¹/₂ in. (22 cm)
Marc and Denyse Ginzberg
Photograph by Luigi Pelletieri

Fig. 47
Equestrian puppet
Bamana peoples, Mali, 20th
 century
Wood, cloth
H. 13³/₄ in. (35 cm)
Dr. and Mrs. Raoul Bezou
Photograph by Pierre de
 La Barre

◆ Fig. 48
Plaque: Multiple figures
Edo peoples, Benin Kingdom,
 Nigeria, mid-16th–17th
 century
Cast copper alloy
H. 18 in. (46 cm)
National Museum of African
 Art, purchased with funds
 provided by the
 Smithsonian Collections
 Acquisition Program, 1982,
 82-5-3
Photograph by Jeffrey
 Ploskonka

Fig. 49
Drawing of a rock art image of
 a forceful male
Pedra Quinhengo, Angola
Drawing by Jo Moore, after
 Carlos Ervedosa 1980, 272

◆ Fig. 50
Rider
Possibly Tiv peoples, Nigeria,
 19th–20th century
Cast copper alloy
H. 6 in. (15.2 cm)
Leloup, Inc.
Photograph by Noel Allum

◆ Fig. 51
Woman and child
Lulua peoples, Zaire,
 18th–19th century
Wood, red powder (tukula),
 white powder (pembe)
H. 12 in. (31 cm)
Collection Timmermans-
 Haems
Photograph by Hughes Dubois

◆ Fig. 52
Janus figure
Igbo peoples, Nigeria, early
 20th century
Terra-cotta, pigments
H. 12 in. (31 cm)
Private collection
Photograph by Richard Todd

◆ Fig. 53
Staff top: Equestrian figure
Bamana peoples, Mali,
 19th–20th century
Iron
H. 9¹/₂ in. (24.2 cm)
National Museum of African
 Art, gift of Joseph H.
 Hirshhorn to the
 Smithsonian Institution in
 1966, NMAfA 85-19-1
Photograph by Jeffrey
 Ploskonka

Fig. 54
Olokun shrine in
 Ighiohen-Aiyivieruemwoya
Edo peoples, Benin, Nigeria
Photograph by Phyllis
 Galembo, 1985

Fig. 55
Meeting room of the prime
 minister of Oguta
Igbo peoples, Oguta, Nigeria
Photograph by Herbert M.
 Cole, 1983

◆ Fig. 56
Woman with child and
 supporting figures
Yoruba peoples, Ikerre, Ondo
 State, Nigeria, c. 1920
Cloth, basketry, multicolored
 beads, fiber
H. 41³/₄ in. (106 cm)
The Trustees of the British
 Museum, 1924.136

Fig. 57
Couple
Tabwa peoples, Zaire,
 19th–early 20th century
Wood
H. of male 18¹/₂ in. (47 cm); H.
 of female 18¹/₄ in. (46.4 cm)
The Metropolitan Museum of
 Art, The Michael C.
 Rockefeller Memorial
 Collection, gift of Nelson A.
 Rockefeller, 1969,
 1978.412.592, 1978.412.591

◆ Fig. 58
Female figure; rider
Mali, 11th–15th century
Cast copper alloy
H. of female 3⁵/₁₆ in. (8.4 cm);
 H. of male 3¹/₂ in. (9 cm)
Mr. and Mrs. Arnold Syrop
Photograph by Jerry L.
 Thompson

◆ Fig. 59
Weight: Couple on tripod
 chair
Akan peoples, Ghana and
 Côte d'Ivoire, 17th–18th
 century
Cast copper alloy
H. 2¹/₄ in. (6 cm)
R. and L. Phillips
Photograph by Prudence
 Cuming

◆ Fig. 60
Stool with male and female
 figures
Zimba peoples, Zaire, 19th
 century
Wood
H. 15 in. (38.1 cm)
Leloup, Inc.
Photograph by Noel Allum

◆ FIG. 103
Hunter with antelope
Lower Niger Bronze Industry
 (dates unknown), Nigeria
Cast copper alloy
H. 14 in. (36 cm)
The Trustees of the British
 Museum, 1952.Af11.1

FIG. 104
Hunters wearing mud-cloth,
 or *bokolanfini*, shirts
Bamana peoples, Beledougou,
 Mali
Photograph by Pascal James
 Imperato, 1969

◆ FIG. 105
Archer
Inland Niger Delta region,
 Mali, 11th–15th century
Terra-cotta, pigment
H. 24³/₈ in. (62 cm)
National Museum of African
 Art, museum purchase,
 86-12-1
Photograph by Jeffrey
 Ploskonka

FIG. 106
Ancestor altar in the palace of
 the king of Benin
Edo peoples, Benin City,
 Benin Kingdom, Nigeria
Photograph by Eliot Elisofon,
 1970, courtesy of the Eliot
 Elisofon Photographic
 Archives, National Museum
 of African Art

FIG. 107
Ancestral shrine of
 Amachree I
Kalabari group, Ijo peoples,
 Buguma, Nigeria
Photograph by Edward
 Roland Chadwick, c. 1925,
 courtesy of the Trustees of
 the British Museum

◆ FIG. 108
Male figure (*ikenga*)
Igbo peoples, Nigeria,
 19th–20th century
Wood
H. 21¹/₂ in. (55 cm)
Collection of Emily A.
 Wingert
Photograph by Jeffrey
 Ploskonka

◆ FIG. 109
Shrine figure (*okega*)
Igala peoples, Nigeria,
 19th–20th century
Wood, pigments
H. 68³/₄ in. (175 cm)
The Trustees of the British
 Museum, 1949.Af46.192

◆ FIG. 110
Male figure
Artist: Bvu Kum
Esu (formerly Bafum-Katse)
 Kingdom, Grassfields
 region, Cameroon, early
 20th century
Wood, hair, ivory, bone, bead,
 cloth, camwood
H. with base 45¹/₂ in. (116 cm)
Ruth and Paul Tishman
 African Art Collection,
 Walt Disney Co.

◆ FIG. 111
Male figure
Fon peoples, Benin, 19th–20th
 century
Wood, pigment
H. 8³/₄ in. (22.2 cm)
Ruth and Paul Tishman
 African Art Collection,
 Walt Disney Co.

FIG. 112
Engraving of a hunter
Chokwe peoples, Angola
Engraving in Capello and
 Ivens 1881

◆ FIG. 113
Male figure of the hero
 Chibunda Ilunga
Chokwe peoples, Zaire and
 Angola, 19th century
Wood
H. 15⁵/₁₆ in. (38.9 cm)
J. Kerchache
Photograph by Igor
 Delmas-Shango Productions

FIG. 114
Male figure of the hero
 Chibunda Ilunga
Chokwe peoples, Zaire and
 Angola, 19th century
Wood
H. 15¹/₄ in. (39 cm)
Staatliche Museen
 Preussischer Kulturbesitz,
 Museum für Völkerkunde,
 Berlin, III C 1255
Photograph by Eliot Elisofon,
 1969, courtesy of the Eliot
 Elisofon Photographic
 Archives, National Museum
 of African Art

◆ FIG. 115
Male figure with lance
Bamana peoples, Mali,
 radiocarbon dated to
 A.D. 1280–1415
Wood
H. 35³/₈ in. (89.9 cm)
The Metropolitan Museum of
 Art, gift of the Kronos
 Collections in honor of
 Martin Lerner, 1983,
 1983.600

FIG. 116
Woman and child
Bamana peoples, Mali,
 radiocarbon dated to
 A.D. 1280–1415
Wood
H. 48⁵/₈ in. (123.5 cm)
The Metropolitan Museum of
 Art, The Michael C.
 Rockefeller Memorial
 Collection, bequest of
 Nelson A. Rockefeller, 1979,
 1979.206.121

◆ FIG. 134
Man riding motor scooter
Yoruba peoples, Nigeria,
 20th century
Wood
H. 22¹/₂ in. (57.2 cm)
Mr. and Mrs. Bram Goldsmith
Photograph by Gene Ogami

FIG. 135
Government employee Dr. U.
 Zerbini being wheeled about
 in his "Congo chair"
Bomba, Congo Free State
 (Zaire), 1908
Photograph courtesy of the
 National Anthropological
 Archives, Smithsonian
 Institution

FIG. 136
Bearded white man being
 carried by two Africans
Kongo peoples, Congo and
 Zaire, early 20th century
Wood
H. 11⁵/₈ in. (29.5 cm)
James Willis Gallery

FIG. 137a
Drawing of a rock engraving
 of a rider
Possibly Mammanet, Air,
 Niger
Drawing by Jo Moore, after
 Striedter 1984, fig. 186

FIG. 137b
Drawing of a rock painting of
 a rider
Tihoun-Beddednin, Central
 Ahaggar, Algeria
Drawing by Jo Moore, after
 Trost 1981, fig. 338

FIG. 137c
Drawing of a rock painting of
 a rider
Tikemtin, Atakor, Central
 Ahaggar, Algeria
Drawing by Jo Moore, after
 Trost 1981, fig. 450

FIG. 137d
Drawing of a rock painting of
 a rider
Mpongweni, Underberg
 district, Natal, South Africa
Drawing by Jo Moore, after
 Johnson 1979, fig. 3

FIG. 138
Fly-whisk handle: Rider
Igbo-Ukwu, Nigeria, 10th
 century A.D.
Cast copper alloy
H. 6³/₁₆ in. (15.7 cm)
National Museum, Lagos,
 Nigeria, IR359
Photograph by Dirk Bakke

◆ FIG. 139
Equestrian figure
Inland Niger Delta region,
 Mali, 11th–15th century
Terra-cotta
H. 27¹/₂ in. (70 cm)
Private collection
Photograph by Richard Todd

◆ FIG. 140
Equestrian figure
Dogon peoples, Mali,
 18th–19th century
Wood
H. 36 in. (92 cm)
The Mnuchin Foundation
Photograph by Ivan Dalla
 Tana

◆ FIG. 141
Rings
Dogon peoples, Mali, 19th
 century
Cast copper alloy
H. of ring on left 2¹/₂ in. (6.3
 cm); H. of ring on right
 2¹¹/₁₆ in. (6.9 cm)
Jean Willy Mestach
Photograph by Speltdoorn et
 Fils

◆ FIG. 142
Ring with rider
Mali, 11th–15th century
Cast copper alloy
H. 1³/₄ in. (5 cm)
Mr. and Mrs. Arnold Syrop
Photograph by Jerry L.
 Thompson

◆ FIG. 143
Equestrian figure
Inland Niger Delta region,
 Mali, 11th–15th century
Cast copper alloy
H. 6¹/₄ in. (16 cm)
Charles and Kent Davis
Photograph by Pierre de
 La Barre

◆ FIG. 144
Rider
Dogon peoples, Mali,
 19th century
Iron
H. 4¹/₂ in. (12 cm)
Mr. and Mrs. Arnold Syrop
Photograph by Jerry L.
 Thompson

◆ FIG. 145
Untitled
Artist: Djiby Seck, Senegal
Painted in Mali, 1987
Glass, paint
12³/₄ x 19 in. (32.5 x 48.2 cm)
Private collection
Photograph by Jeffrey
 Ploskonka

◆ FIG. 146
Equestrian figure
Senufo peoples, Côte d'Ivoire
 and Mali, 19th–20th century
Wood
H. 12¹/₂ in. (32 cm)
The Trustees of the British
 Museum, 1948.Af2.4

FIG. 147
Drawing of an Asante chief
 equipped for war
Asante group, Akan peoples,
 Ghana
Drawing by Joseph Dupuis, in
 Dupuis [1824] 1966, facing
 page 223

◆ Fig. 161
Portuguese soldier
Edo peoples, Benin Kingdom,
 Nigeria, 18th–19th century
Cast copper alloy
H. 17 in. (43.2 cm)
The Trustees of the British
 Museum, 1944.Af4.7

Fig. 162
Rock painting of a human
 figure
Sefar, Tassili-n-Ajjer, Algeria
Photograph by Thomas K.
 Seligman, 1984

◆ Fig. 163
Couple
Guro peoples, Côte d'Ivoire,
 20th century
Wood, paint
H. 18 in. (46 cm)
Joseph and Margaret
 Knopfelmacher
Photograph by Manu
 Sassoonian

◆ Fig. 164
Soldier
Ewe peoples, Ghana, 20th
 century
Wood, paint
H. 28³/4 in. (73 cm)
Collection Dürckheim,
 Entraching, West Germany
Photograph by George Meister

◆ Fig. 165
Staff for champion cultivator
Gurunsi peoples, Burkina
 Faso, 19th–20th century
Wood, paint
H. of full staff 59 in. (150 cm)
Mr. and Mrs. Bram Goldsmith
Photograph by Gene Ogami

Fig. 166
Male figure
Inland Niger Delta region,
 Mali, 14th–16th century
Terra-cotta
H. 18³/4 in. (48 cm)
Private collection
Photograph by Ken Cohen

◆ Fig. 167
Pendant: European and horse
Edo peoples, Benin Kingdom,
 Nigeria, 18th–19th century
Cast copper alloy
H. 8 in. (20.3 cm)
National Museum of African
 Art, gift of Joseph H.
 Hirshhorn to the
 Smithsonian Institution in
 1966, NMAfA 85-19-9
Photograph by Jeffrey
 Ploskonka

◆ Fig. 168
Saltcellar
Sapi-Portuguese, Sierra Leone,
 c. 1490–1530
Ivory
H. 13¹/4 in. (33.7 cm)
Allen Memorial Art Museum,
 Oberlin College, Oberlin,
 Ohio, gift of Gustave
 Schindler, 1956
Photograph by Jeffrey
 Ploskonka

Fig. 169
Figure of St. Anthony of
 Padua
Kongo peoples, Zaire, date
 unknown
Wood
H. 20 in. (51 cm)
Staatliche Museen
 Preussischer Kulturbesitz,
 Museum für Völkerkunde,
 Berlin, III C 44072
Photograph by W.
 Schneider-Schütz

◆ Fig. 170
Crucifix (nkangi or nkangi
 kiditu)
Kongo peoples, Congo and
 Zaire, probably 16th–17th
 century
Cast copper alloy
H. 10⁵/8 in. (27 cm)
Dr. Ernst Anspach
Photograph by Malcolm
 Varon

◆ Fig. 171
Power figure (nkisi)
Kongo peoples, Congo and
 Zaire, 18th–19th century
Wood, nails, mirror, horn,
 embedded substances
H. 12¹/2 in. (31.7 cm)
Dr. Ernst Anspach
Photograph by Ken Cohen

◆ Fig. 172
Staff top
Vili group, Kongo peoples,
 Congo, 19th century
Ivory, mirror, embedded
 substances
H. 5¹/4 in. (13.4 cm)
National Museum of African
 Art, museum purchase,
 86-2-1
Photograph by Jeffrey
 Ploskonka

◆ Fig. 173
Gong in the form of a woman
 and child
Kongo peoples, Congo and
 Zaire, 19th century
Wood
H. 9³/4 in. (25 cm)
John and Nicole Dintenfass
Photograph by Lynton
 Gardiner

◆ Fig. 174
Male figure (ntadi)
Yombe group, Kongo peoples,
 Congo and Zaire, 19th
 century
Steatite
H. 21¹/2 in. (55 cm)
The Detroit Institute of Arts,
 gift of Frederick K. Stearns,
 90.S11462

Notes

CHAPTER 1
Introduction: *Icons, Ideals, and Powers*

1. In the early stages, this book was called *Archetypes*. This title was abandoned when it became clear that instead of having singular or universal meanings beyond superficial ones, each theme and icon has rich constellations of local interpretations. The word *icon*, as used in the title, suggests some of the timeless character of much of the imagery but avoids the psychological stereotyping (as in the writing of C. G. Jung and others) implied by the word *archetype*.

2. Animals such as leopards and elephants may also be called icons, yet our purview is confined to those of human (or humanoid) subject. Images of maidens, and perhaps older men and tricksters, are among the other human themes that achieve iconic stature in Africa.

3. The proverbs were kindly supplied by Peggy Appiah (pers. com., June 1987).

4. The notion of Asafo companies "fighting with art" in the modern era is developed by Ross (1979) in a monograph of that title.

5. See Danto et al. 1988 for an exploration of various historical and contemporary points of view toward African art.

6. See Geary 1988b for a thorough examination of the interrelationship of European and African biases and sensibilities in the creation of early photographic images in Cameroon.

7. Although a successor to King Obemne may well have sold these portals legitimately, outsiders and Africans themselves have stolen many objects. With troubling irony, we see that the arts of Africa now rival the Elgin marbles as they stand by one another, at least figuratively, in the British Museum and elsewhere.

Both the African and American contexts of works of art, and the important questions they pose for writing, study, and museum display, are embraced by still broader historical and cultural processes that extend backward in time and outward to the boundaries of society. Although this is not the occasion to discuss these broader social and moral issues, many of them have been analyzed with great sophistication in Clifford 1988, Fabian 1983, and Stocking 1985.

8. This section on *ijele* is strongly indebted to the brilliant analysis of Henderson and Umunna 1988.

CHAPTER 2
Useful Images: *The Life of Art in Africa*

1. Nsemi Isaki, the author of this passage, wrote in Kikongo for the missionary-ethnographer Karl Laman.

2. The motifs are background features in this genre of Chokwe sculpture. Neither the couple nor the woman and child is essential to the design, use, or significance of the chair. The motifs are appropriate, however, to chiefly alliances between lineages through marriage and to the continuity of both leadership and the chief's kin group. As is evident here, the icons are sometimes peripheral to the meaning of a work of art. At other times, the icons are in the foreground or dominant.

3. This discussion and the model were generated by an important essay by the late Arnold Rubin, *African Accumulative Sculpture: Power and Display* (1974). Because this model is being applied to cross-cultural comparisons, the relative placements of various works are approximate and to some extent arbitrary.

4. Here, as elsewhere in this book, the multiplicity of present and past realities makes it difficult to write in a single tense. In the 1980s, Ebira masks still undergo such transformations, as did Dan spirit masks in the 1970s (Fischer and Himmelheber 1984). The process recorded by Harley in the 1940s for Liberian masks may no longer occur (Harley [1950] 1975). To maintain the use of only one tense would result in inaccuracies, so an effort is made throughout to use tenses that are correct as of the time of writing.

5. Kasfir (1988b, 4) makes a similar point about the shifting domains of masquerades, although her conceptual poles are "ritual" and "play" (which roughly correspond to my "spiritual power" and "public display").

6. What is fascinating but difficult or impossible to determine is why one society chooses to create anthropomorphic deities or ancestor symbols and another does not.

7. Applying methods pioneered by Thompson (1974), de Grunne (1987, 1988) has done fieldwork in Mali among the Soninke and other groups on the meanings of postures and gestures in everyday and ritual life. This work, in turn, enables him to interpret meanings for some of the ancient terra-cottas and bronzes.

8. Pastoral and seminomadic peoples of Africa have created relatively little figural art and therefore have not been included in this study.

9. Because of these disparities, it is difficult to make general statements about shrine arts. Shrines can be effective without any carvings or other objects we would call art.

CHAPTER 3
Iconic Conventions: *The Ideology of Form*

1. I do not distinguish between "art" and "craft" in Africa. I believe there are extraordinary pots, baskets, and textiles—often referred to as crafts—that are fine works of art. Many sculptures and paintings—rapidly produced copies or other weak, heartless works, for example—are poor art, if art at all.

2. Studies of style are very complex in Africa. The origins, ethnic identities, boundaries, and cross-influences of styles in various materials are difficult subjects, complicated by imprecise dating for most works. Since my focus is iconography and cross-cultural comparison, however, considerations of ethnic style are given little emphasis here. See Kasfir 1984 for a revealing analysis of the problems in style studies.

3. The face is not a physiognomic likeness of any one person, so other arguments are advanced to make this attribution. Nevadomsky (n.d.), in a forthcoming paper, argues to my satisfaction that this person is King Esigie, acknowledging the many divergent opinions of the horseman's identity over the years.

4. Other traditions incorporating informal postures include Fon ancestral altars (*asen*), the small sculptures on Chokwe chair rungs, and Woyo pot lids, as well as scenes on the superstructures of some Yoruba, Edo, and Igbo masks.

5. Paintings (and imported prints) of Mami Wata are exceptions. See chapter 9.

6. Marcel Griaule and his school have been criticized for their failure to explain the disparity between the appearances of sculpture and myth and the realities of everyday Dogon life.

7. Despite these prevailing trends, some leaders have been innovators. Certain Benin and Dahomean kings added forms and iconography to their respective court repertoires (Ben-Amos 1980; Adams 1980). King Njoya of Bamum was also an especially creative innovator (Geary 1988a, 1988b).

8. See Vogel 1980, 19, and Cole 1982a, 178.

9. Doran Ross (pers. com., Dec. 1988) points out that because there are so many exceptions to this tendency, this discussion may be in the realm of inaccurate cliché. I acknowledge exceptions but believe proportions to be derived from these beliefs in many instances.

10. Among the peoples who subscribe to the "ringed neck convention" are the Mende, Temne (fig. 88), Bidjogo, Dogon (fig. 64), Dan, Baule (fig. 203), Krinjabo, Agni, Asante, Fante (fig. 85), Igbo (fig. 52), Luba, Hemba, and Songye.

11. Apart from the shapes of many Asante and other Akan heads in sculpture, relatively little firm evidence attests to the widespread molding of infants' heads (Doran Ross, pers. com., Dec. 1988).

12. Not all aspects of style, however, can be linked with known local or cross-cultural preferences as in the cited examples. Indeed, style is an elusive phenomenon in the art of Africa. So many factors contributing to its formation are lost to us because most available examples date from the late-nineteenth or twentieth century.

13. This opposition between the association of women with soft materials and containers and the association of men with hard sharp instruments has been observed before by myself and others. See Cole 1982a; Cole and Aniakor 1984, 6, 223; and M. Drewal 1989, 300 (manuscript kindly supplied by the author).

14. My Igbo fieldwork reveals this distinction. Henry Drewal (pers. com., 1988) corroborates similar ideas among the Yoruba.

15. Variations on this mythic motif occur at least among the Dogon (Griaule [1938] 1963, 91), Guere/We (Adams 1986, 101), Senufo (Glaze 1981, 91), Baule (Vogel 1977, 96), Kuba (Torday and Joyce 1910, 250), and Igbo (Cole and Aniakor 1984, 186).

16. Although I do not know the full distribution of creation myths that have god modeling the original people from clay, it probably occurs more than just among the Fon (Mercier 1954, 222), Edo (Ben-Amos 1986, 63), and Igbo (Cole 1982a, 218).

Two as One: *The Male and Female Couple*

1. An impressionistic survey of Zairian art, principally from Felix 1987, reveals ancestor figures among at least the Tabwa, Hemba, Shankadi, Lwalwa, and Junga.

2. Lost-wax casting is especially appropriate for the creation of primordial couples. Because the mold is broken, each figure, like each human being, is unique. *Edan* casting rituals are discussed in Williams 1964. For more data on Ogboni, see H. Drewal 1989 and Witte 1988, and for *mbari*, see Cole 1982a.

3. See Henderson and Umunna 1988 for a fuller discussion of the spiritual and mystical dimensions of termite hills in Igbo life.

4. The female figure has no name in Igbo apart from being called his wife. Conceptually, Ala, Earth, is the wife of Thunder, the sky god.

5. Ottenberg (1975) found almost the exact same statements being made in Okumpka masked skit performances among the Afikpo Igbo. Women were criticized for attempting to be too modern. Some of their adventures and trading activities were seen as threats to men, who wanted them to stay at home.

6. This riddle has received numerous interpretations. Ogboni members wear three cowries strung on the left wrist and send three cowries as a message to indicate unanimity (H. Drewal 1989; Witte 1988).

7. Several peoples in Zaire believe in primordial couples: Ngbaka, Ngbandi, Rungu, Zela, Ngala, Hemba, Bemba, and Banja (Felix 1987).

8. Ezra (1988, 21) has recently pointed out that little solid field information confirms connections between mythical persons and sculptured ones. Nor is much known about the precise contexts of use of the Dogon figures.

9. Dogon figures may have breasts but no primary sexual characteristics; I call these androgynous. There are many, too, that have both explicit male genitalia and breasts; I call these bisexual.

10. Although there is a remarkable similarity between these Igbo-Ukwu male and female figures and biblical illustrations of Adam and Eve, there is no possibility of a historical connection. For the myth, see Cole and Aniakor 1984, 15.

11. An issue of *African Arts* (February 1982, vol. 15, no. 2) included several papers on sexual imagery in Akan goldweights, Fon brasses, Yaka masks, Igbo *mbari* houses, and a contemporary pipe from the Malawi artist Berlings Kaunda. Expressly erotic Fon and Akan images all seem to have been made in response to the European market.

12. Female chiefs are known in several areas, however, and many exceptions modify the general statement about male dominance.

D'Azevedo has noted this difference in status in West African societies that have ostensibly balanced male and female associations, such as the Senufo and their Poro and Sandogo associations.

> Though it is quite obvious that the traditional associations of women in these cultures provide them with instruments of social power somewhat more effective than in many other societies, their status is nevertheless subsidiary and auxiliary to that of the politically omnipotent organization of men. The ideology of male superiority pervades the cultures and their social arrangements. (1987, 10)

13. Margaret Drewal (1989) makes an elaborate, sophisticated case for sexual equality among the Yoruba. I am grateful for the opportunity of having read "Gender Play" (chapter 9) from her forthcoming book.

14. See Roberts 1986, Fernandez 1977, Cole and Aniakor 1984, Glaze 1981, Vogel 1980, and DeMott 1982.

15. This discussion of Tabwa dualistic thought obviously owes a great debt to Roberts' work, which I hope I have not violated or distorted.

16. Correspondence between a spirit's name and its behavior is often slight. The spirit characters Kingfisher, Pot of Evil Medicine, and Egret, for example, reveal few if any behavioral traits that would enable an onlooker to guess their names.

17. I am indebted to Philip Ravenhill's published work and personal communications in writing this section.

18. Unless field information is available—which it rarely is—we cannot be certain that these couples are considered married. The fact that they are executed and "live" as a couple, however, may render institutionalized marriage moot or unimportant.

19. This attribution is made on the basis of the pigtail-like extensions, with small sculptured vials attached, that hang from the backs of the heads of both adult figures. These are common attributes of Eshu cult images, and the small figure in front of the horseman has also been documented on another Eshu equestrian (Henry and Margaret Drewal, pers. com., June 1989).

20. See M. Drewal 1989 for a discussion of the Yoruba female as container and the male as contained.

21. See Hyde 1983 for an explanation of how the most important gifts increase, in principle, as they are passed along.

Chapter 5
Maternity and Abundance:
The Woman and Child

1. Eberhard Fischer (pers. com., Jan. 1986) mentioned a ritual occasion among the Dan when a grown man was nursed—or pretended to be—by a woman.

2. See Cole and Ross 1977 for a fuller discussion of Akan terra-cottas and their uses and meanings.

3. The marriageable maiden is another important icon in African art, thought, and life. Her image occurs in many contexts, especially in masquerades, among many African peoples.

4. Initiation schooling was, and is, broad and varied. Marriage and birth are stressed in this text, but young women learned many skills needed for domestic and economic pursuits and for general participation in adult life, such as agriculture, trade, craft production, singing, and dancing.

5. Excision of the clitoris is given various explanations, including the reduction of women's sexual aggressiveness and the removal of those body parts that "make women like men" (d'Azevedo 1987, 9).

6. In one study, conducted in 1970, women between the ages of forty and forty-nine had given birth to an average of 8.5 children each. Of these children, an average of 3.9 survived (MacCormack 1982a, 118). Frequent infant deaths helped establish the phenomenon of the changeling, the child believed "born to die," perhaps just as it began to be cherished by its parents. A changeling appears in this world only briefly, often several times, dying and being reborn, plaguing its parents with its mysterious actions, and causing much anguish and economic hardship to avert death. It is costly to consult diviners repeatedly, purchase herbal medicines, and take all the necessary precautions to avoid an infant's death. Still the remedies may not work.

7. Personal communications (Jan. 1989) from Judith Timyan and Philip Ravenhill contributed much to my discussions of spirit lovers in this chapter and in chapter 8.

8. See Cole 1982a, fig. 8, for the *mbari* image and de Grunne 1987, fig. 12, for a Djenné terracotta with four children.

9. Ojo 1978, from which I draw for this discussion of Epa, gives vernacular names and some vernacular song texts, along with more extensive information on the mother-and-child dimensions of this masquerade.

10. In some societies—among the Igbo, for example—twins and other multiple-birth children were not appreciated and were allowed to die.

11. Many twins are of opposite sex, but since these are obviously siblings, they have been excluded from the "couple" theme as discussed here. Exceptions occur among the Dogon, Senufo, and other peoples when twins are also considered deities or impersonal spirits.

12. Diviners and other religious specialists deal with bush spirits, considered troublesome, disease conferring, ugly, and otherwise unpleasant, among the Akan, Baule, Lobi, Senufo, Voltaic, and other West African peoples. These same spirits, when appropriately appeased, can reverse their negative effects.

13. I am again grateful to Margaret Drewal for permission to quote from her important doctoral dissertation.

14. Lobi and related women keep amulets and other secret personal objects in small "shrine baskets" (Cole and Ross 1977, 62). Gurunsi and related women own nested sets of calabashes, one of which contains charms and other personal items; men are forbidden access to these personal items (Cole and Ross 1977, 96, note 3). Dogon granaries, according to the Dogon sage Ogotemmêli, symbolize women; each contains one pot that is a womb and, within it, another that is a fetus (Griaule 1965, 39). I have elsewhere interpreted the round plates incorporated within the walls of *mbari* houses as female symbols (Cole 1982a, 220). Luba bowls, often held by females as implied extensions of their wombs, suggest analogous symbolism.

CHAPTER 6
Hunters, Warriors, and Heroes:
The Forceful Male

1. In style, however, the hunter does not accord with other Benin works, so its ultimate place of origin remains unknown (W. B. Fagg 1963, 99).

2. *Ikenga*-related images are found among the Igala, Ijo, Edo, Urhobo, Isoko, Ishan, and probably a few other smaller language groups in southern Nigeria. See Vogel 1974.

3. See Geary 1981a, 12. In an important paper, Geary (1986, 6–7) questions Harter's designation of this Esu figure as a "king." Based on her own fieldwork in the lower Fungom area, which includes Esu, Geary calls this person an "outstanding individual" or a "big man." Nineteenth-century chieftaincy in this area was weak, and there was no tradition of carving commemorations of chiefs.

4. Other Akan priest figures hold a ritual sword in the right hand and an egg in the left. Among other things, the egg symbolizes fertility, abundance, and power. This iconography appears to be a visual pun, with slightly different meanings, on the knife and head.

5. As Willis, de Heusch's translator, notes, this important question confounds scholars as eminent as historian Vansina and ethnologist de Heusch (de Heusch 1982). For this book, the distinction matters little.

6. According to the thesis being developed here, the word *traditional* is not an appropriate designation, since it tends to freeze earlier works in a nontemporal limbo. Chapter 8 will further discuss why such a word is misleading.

7. Bastin (1978) and Vansina (1984) certainly rely on mythology to elucidate this image. Bastin discusses a series of freestanding representations of this culture hero, as well as other manifestations of him in sculptures owned and used by chiefs and in masks.

8. Sorcery, like witchcraft, is often misunderstood. Contrary to Western stereotypes, sorcery is by no means a wholly negative force. As McNaughton (1988, 11–16) explains it, sorcery is neutral. It is a manipulation of power that the Bamana use daily, as exemplified by protective amulets. Sorcery can also be extraordinary, as when leaders need power to meet crises, solve problems, and deal with enemies. The character of sorcery, for good or ill, depends largely on the intentions of the person using it. See also Nevadomsky 1988 for an interpretation of analogous positive- and negative-valued "medicines" in Edo life.

9. This discussion of Dan masks relies heavily on Fischer and Himmelheber 1984, 8–9, 59–62.

10. Elizabeth Cameron of the art history department at UCLA is undertaking research on this topic as this book goes to press.

11. Neolithic stone axes are associated with gods of thunder and lightening among many West African peoples, who keep them in shrines.

12. See McNaughton 1988, to which this discussion is indebted.

13. Suzanne Blier (pers. com., Jan. 1989) provided information on the possible use of this figure in the Age cult. Her extensive study of Fon arts is forthcoming.

14. This notion is a variation on a theme first elucidated by Arnold Rubin (1974).

Chapter 7
Riders of Power: *The Mounted Leader*

1. Camels facilitated trade over the extensive trans-Saharan network of routes from the first millennium A.D.

2. "Human-on-human" riders were also included in an earlier treatment of this subject (Cole 1983b). They are omitted here because they unduly expand the concept.

3. Given the obvious relationship between this ring and Desplagnes' data, cited by Ezra herself in discussing an iron quadruped (probably a horse), Ezra's caveats seem overly cautious.

4. Although I am not postulating a definite historical relationship between early archaeological copper alloy horsemen from the Inland Niger Delta (c. 1000–1650) and later Akan goldweight equestrians (c. 1600–1900), this possibility is worth careful examination before it is ruled out. Surely the horses brought into what is now Ghana came from the north, as did both casting technology and weighing systems.

5. Igbo informants insisted that they do not know what gods and spirits really look like, because at best people merely glimpse them, often at times of crisis or in what today are referred to as "near-death experiences." Several people said "he who sees a god is a dead man," surely an adage about the insubstantiality and invisibility of spirit power.

6. Henry Drewal (pers. com., Dec. 1988) acknowledges that Yoruba carvers stockpile low-cost, high-demand items, such as *ibeji*, but he does not know of an instance when an artist has done so for divination cups.

7. For riders of lions and leopards in Fante shrine carvings, see Ross and Garrard 1983.

8. Asante, Fante, Fon, Yoruba, Edo, Cameroon, Chokwe, Luba, Songe, Zimba, Hemba, and numerous other peoples, especially from Zaire, use caryatid human or animal stools.

9. For a full analysis of the headdress, see especially Geary 1988a, as well as Geary 1981a, 1983.

Chapter 8
Ambiguous Aliens: *The Stranger in African Art History*

1. "True" is used because all spirits, particularly bush spirits, could arguably be defined as strangers of a sort. To include all spirits and deities within the category of strangers, however, would substantially alter the usual definition of strangers as both Westerners and Africans think of them.

2. Philip Ravenhill (pers. com., March 1989) also informs me that the Zu (or Zuzu) cult was itself an "outsider," introduced by diviners from neighboring Wan peoples.

3. In an important early study, Lips ([1937] 1966), mistakenly identifies many images of persons wearing European dress as caricatures of foreign intruders. An excellent reassessment of Lips' excesses and the complexity of the so-called colon corpus is Norris 1983, which, however, does not incorporate the insights of Ravenhill 1980. I have benefited greatly from conversations with Dr. Norris and Dr. Ravenhill, as well as from their published work.

A recent publication, Werewere-Liking 1987, regrettably perpetuates many earlier misunderstandings. The book illustrates numerous recent colon figures made to look as though they have been used and are therefore old.

4. See, for example, Förster 1987 for a discussion of the history of brasscasting and other metalwork in the Western Sudan.

5. See Huard 1960, which reproduces drawings of dozens of weapon-bearing people from many Saharan sites. Although many of the weapons shown would appear to be iron, this determination is very hard to make with certainty.

6. See Prussin 1986, 105, for a discussion of the precarious unity and communication network, based substantially on trade, that characterized each of these medieval polities.

7. For the Mossi version of this history or myth, see Roy 1987. The Nupe also have a variant, analogous tradition (Nadel 1942, 78–79). Information on this staff was kindly provided by Christopher Roy (pers. com., Jan. 1989).

8. Some Benin castings of leopards are vessels with the animals' nostrils serving as spouts. They are partly derived from European aquamaniles. Wooden stools constructed with four legs

are probably also copies of European artifacts (Ben-Amos 1980, 14).

9. Bassani and Fagg 1988 provides a comprehensive analysis of all known Afro-Portuguese ivories and a catalogue raisonné. Kongo artists, mainly from Loango, also carved much ivory for the European trade, principally in the nineteenth century.

10. Bassani and Fagg (1988, 75) state that the finial of this piece has been restored and that "one scholar asserts that the group on the lid is a replacement." These assertions have not yet been verified by scientific examination.

11. See Hilton 1985 and Thornton 1983 for sophisticated discussions of the nature of Kongo assimilations and interpretations of Christianity, which are more complex than discussed here. The Kongo-Christian interactions in religion and the arts deserve a major study.

12. DeCarava (n.d.) reviewed the literature (up to about 1970) at the suggestion of Douglas Fraser, one of several scholars (including Nuoffer, Olbrechts, and Maesen) who believed that Kongo art had been affected by European influence. She concluded—at least for the woman-and-child icon—that the evidence does not favor any substantial outside impact.

13. Decoration with mirrors and plates occurs in Igbo diviners' houses, and plates (or fragments of them) embellish *mbari* houses, some Yoruba and Ewe shrines, and Dagomba houses, among other surfaces.

14. See Cole and Ross 1977, 161; McLeod 1979a; and Ross 1982b.

15. The inevitable risk is oversimplifying complex processes and phenomena that reach to the core of African society.

16. Geary's detailed studies of Bamum dress, as seen through the lenses of German photographers, are fine sources on this topic, as well as appropriate cautions on the complexity of the subject.

CHAPTER 9
Change and Continuity: *The Icons in Twentieth-Century Art*

1. These arts are sometimes referred to as "transitional." Yet this is a word, like "traditional," that begs questions. All art is transitional, of course, between earlier and later forms.

2. The most striking exceptions are the tenth- to fifteenth-century hollow copper alloy heads from Ife, Nigeria, which, though idealized and somewhat conventionalized, are highly naturalistic and are probably portraits.

3. Damas Nicolas, who works near Abidjan, is another artist in an increasing number who work in highly naturalistic styles.

4. Dogon villagers have even resorted to defacing the carvings on *togu na* posts to make certain that the posts remain in place and outside the international market for African art.

5. Among the sculptures of ancient Ife and Owo, for example, are a few that depict age and apparently expressions of emotion, as in the furrowed brow of an Owo terra-cotta image (see Eyo and Willett 1980, cat. no. 63).

6. This large corpus of popular paintings from the Shaba province in Zaire has been studied extensively by Szombati-Fabian and Fabian (1976). They identify three principal categories: Things Ancestral, Things Past, and Things Present. The Colonie Belge genre belongs to Things Past. My discussion of this Tshibumba painting owes much to their work, which is far too profound and sophisticated for brief explication here.

7. It is possible that certain artists achieved local fame in Dogon country and that some individuals were remembered by name, even though scholars who have recorded Dogon arts have not (until very recently) acknowledged artists' prominence or asked questions about artistic individuality.

8. See H. Drewal 1988a and 1988b for the most extensive discussions to date of this fascinating deity. Much of my discussion derives from Drewal's work, although I have sporadically studied the Mami Wata cult among the Igbo since 1966.

9. See Ravenhill 1980 for full discussions of shifting aesthetic preferences among the Baule and the meanings of Baule figures carved with Western dress.

10. See the periodical *African Arts* for numerous articles on the recent arts of Africa. See also Jean Kennedy's forthcoming survey of contemporary arts, *New Currents, Ancient Rivers: African Artists in a Generation of Change* (Washington, D.C.: Smithsonian Institution Press).

Bibliography

Achebe, Chinua
1984 "The Igbo World and Its Art." In *Igbo Arts: Community and Cosmos*, by Herbert M. Cole and Chike C. Aniakor. Los Angeles: UCLA Museum of Cultural History.

Adams, Monni
1980 "Fon Appliqué Cloths." *African Arts* 13 (2): 28–41, 87–88.
1986 "Women and Masks among the Western Wè of Ivory Coast." *African Arts* 19 (2): 46–55, 90.

Ajayi, J. F. Ade, and Michael Crowder
1985 *Historical Atlas of Africa.* Cambridge: Cambridge University Press.

Akinjogbin, I. A.
1967 *Dahomey and Its Neighbours, 1708–1818.* Cambridge: Cambridge University Press.

Alldridge, T. J.
1901 *The Sherbro and Its Hinterland.* London: Macmillan.

Antwerpasche Propagandawekan
1937 *Tentoonstelling van Kongo-Kunst.* Antwerp: Antwerpasche Propagandawekan.

Arnoldi, Mary Jo
1983 *Puppet Theatre in the Segu Region in Mali.* Ann Arbor, Mich.: University Microfilms International.

Association française d'action artistique
1985 *Sculptures en ciment du Nigeria de S. J. Akpan et A. O. Akpan.* Paris: Association française d'action artistique.

Badinter, Elisabeth
1981 *Mother Love: Myth and Reality; Motherhood in Modern History.* New York: Macmillan.

Balandier, Georges
1968 *Daily Life in the Kingdom of the Kongo from the Sixteenth to the Eighteenth Century.* Translated by Helen Weaver. New York: Pantheon Books.

Bamberger, Joan
1974 "The Myth of Matriarchy: Why Men Rule in Primitive Society." In *Woman, Culture, and Society*, edited by Michelle Zimbalist Rosaldo and Louise Lamphere. Stanford: Stanford University Press.

Barley, Nigel
1988 *Foreheads of the Dead: An Anthropological View of Kalabari Ancestral Screens.* Washington, D.C.: Smithsonian Institution Press for the National Museum of African Art.

Barnes, Sandra T., and Paula Ben-Amos
1983 "Benin, Oyo and Dahomey: Warfare, State Building and the Sacralization of Iron in West African History." *Expedition* (Philadelphia) 25 (2): 5–14.

Bassani, Ezio
1977 "Kongo Nail Fetishes from the Chiloango River Area." *African Arts* 10 (3): 36–40, 88.
1979 "Sono from Guinea Bissau." *African Arts* 12 (4): 44–47, 91.

Bassani, Ezio, and William B. Fagg
1988 *Africa and the Renaissance: Art in Ivory.* New York: Center for African Art.

Bastin, Marie-Louise
1969 "Arts of the Angolan Peoples: 3. Songo." *African Arts* 2 (3): 51–57, 77–78.
1978 *Statuettes tshokwe du héros civilisateur "tshibinda ilunga."* Arnouville, France: Arts d'Afrique noire.
1982 *La sculpture tshokwe.* Translated by J. B. Donne. Meudon, France: Chaffin.
1984 *Introduction aux arts d'Afrique noire.* Arnouville, France: Arts d'Afrique noire.

Bay, Edna G.
1985 *Asen: Iron Altars of the Fon People of Benin.* Atlanta: Emory University Museum of Art and Archaeology.

Beckwith, Carol, and Marion Van Offelen
1983 *Nomads of Niger.* New York: Abrams.

Ben-Amos, Paula
1980 *The Art of Benin.* London: Thames and Hudson.
1986 "Artistic Creativity in Benin Kingdom." *African Arts* 19 (3): 60–63, 83–84.

Berjonneau, Gérald, Jean-Louis Sonnery, and Fondation Dapper
1987 *Rediscovered Masterpieces of African Art.* Boulogne, France: Art 135.

Berns, Marla C., and Barbara R. Hudson
1986 *The Essential Gourd: Art and History in Northeastern Nigeria.* Los Angeles: UCLA Museum of Cultural History.

Besmer, Fremont E.
1983 *Horses, Musicians and Gods: The Hausa Cult of Possession-Trance*. South Hadley, Mass.: Bergin and Garvey.

Biebuyck, Daniel
1969 *Tradition and Creativity in Tribal Art*. Berkeley and Los Angeles: University of California Press.
1973 *Lega Culture*. Berkeley and Los Angeles: University of California Press.
1981 *Statuary from the Pre-Bembe Hunters*. Tervuren, Belgium: Royal Museum of Central Africa.
1985 *The Arts of Zaire*. Vol. 1, *Southwestern Zaire*. Berkeley and Los Angeles: University of California Press.
1986 *The Arts of Zaire*. Vol. 2, *Eastern Zaire*. Berkeley and Los Angeles: University of California Press.

Bird, Charles S., and Martha Kendall
1980 "The Mande Hero: Text and Context." In *Explorations in African Systems of Thought*, edited by Ivan Karp and Charles S. Bird. Bloomington: Indiana University Press.

Blackburn, Julia
1979 *The White Men*. London: Orbis.

Boahen, A. Adu
1971 "The Coming of the Europeans." In *The Horizon History of Africa*, edited by Alvin Josephy. New York: American Heritage.

Borgatti, Jean
1980 *Levels of Reality: Portraiture in African Art*. African Studies Center Working Papers, no. 36. Boston: African Studies Center, Boston University.

Bosman, William
[1705] 1967 *A New and Accurate Description of the Coast of Guinea*. Reprint. London: Frank Cass.

Boston, John S.
1977 *Ikenga Figures among the North-West Igbo and the Igala*. London: Ethnographica.

Bourdier, Jean-Paul, and Trinh T. Minh-ha
1985 *African Spaces: Designs for Living in Upper Volta*. New York: Africana.

Bourgeois, Arthur P.
1982 "Yaka Masks and Sexual Imagery." *African Arts* 15 (2): 47–50, 87.
1984 *Art of the Yaka and Suku*. Meudon, France: Chaffin.

Bradbury, R. E.
1973 *Benin Studies*. London: Oxford University Press for the International African Institute.

Brain, Robert, and Adam Pollock
1971 *Bangwa Funerary Sculpture*. Toronto: University of Toronto Press.

Bravmann, René A.
1973 *Open Frontiers: The Mobility of Art in Black Africa*. Seattle: University of Washington Press for the Henry Art Gallery.
1974 *Islam and Tribal Art in West Africa*. Cambridge: Cambridge University Press.
1983 *African Islam*. Washington, D.C.: Smithsonian Institution Press; London: Ethnographica.

Brett, Guy
1986 *Through Our Own Eyes: Popular Art and Modern History*. London: New Society Publishers.

Brincard, Marie-Thérèse, ed.
1982 *The Art of Metal in Africa*. New York: African-American Institute.

Capello, Hermenegildo Carlos de Brito, and Roberto Ivens
1881 *De Benguella ás Terras de Iácca: Descripção de uma Viagem na Africa Central e Occidental*. 2 vols. Lisbon: Imprensa Nacional.

Catchpole, Brian, and I. A. Akinjogbin
1983 *A History of West Africa in Maps and Diagrams*. London: Collins.

Chernoff, John Miller
1979 *African Rhythm and African Sensibility*. Chicago: University of Chicago Press.

Clifford, James
1988 *The Predicament of Culture: Twentieth-Century Ethnography, Literature, and Art*. Cambridge: Harvard University Press.

Cole, Herbert M.
1982a *Mbari: Art and Life among the Owerri Igbo*. Bloomington: Indiana University Press.

1982b "Sexual Imagery in Igbo Mbari Houses." *African Arts* 14 (2): 51-56, 87.

1983a *Male and Female: The Couple in African Sculpture*. Los Angeles: Los Angeles County Museum of Art.

1983b *Riders of Power in African Sculpture*. Los Angeles: Los Angeles County Museum of Art.

1985 *Mother and Child in African Sculpture*. Los Angeles: Los Angeles County Museum of Art.

1988 "The Survival and Impact of Igbo Mbari." *African Arts* 21 (2): 54-65, 96.

Cole, Herbert M., and Chike C. Aniakor

1984 *Igbo Arts: Community and Cosmos*. Los Angeles: UCLA Museum of Cultural History.

Cole, Herbert M., and Doran H. Ross

1977 *The Arts of Ghana*. Los Angeles: UCLA Museum of Cultural History.

Cornet, Joseph

1971 *Art of Africa: Treasures from the Congo*. Translated by Barbara Thompson. London: Phaidon.

1975 *Art from Zaire/L'art du Zaire: 100 Masterworks from the Institute of the National Museums of Zaire (IMNZ)*. New York: African-American Institute.

1982 *Art Royal Kuba*. Milan: Sipiel.

Crédit Communal de Belgique

1971 *Art africain—Art moderne*. Brussels: Crédit Communal de Belgique, Centre Cultural.

1977 *Arts premiers d'Afrique noire*. Brussels: Crédit Communal de Belgique, Centre Cultural.

Danto, Arthur, R. M. Gramly, Mary Lou Hultgren, Enid Schildkrout, and Jeanne Zeidler

1988 *Art/Artifact: African Art in Anthropology Collections*. New York: Center for African Art.

d'Azevedo, Warren L.

1973a "Sources of Gola Artistry." In *The Traditional Artist in African Societies*, edited by Warren L. d'Azevedo. Bloomington: Indiana University Press.

1973b "Mask Makers and Myth in Western Liberia." In *Primitive Art and Society*, edited by Anthony Forge. London: Oxford University Press for the Wenner-Gren Foundation for Anthropological Research.

1987 "Gola Womanhood and the Limits of Masculine Omnipotence." Paper presented at the annual meeting of the African Studies Association, Denver, Nov. 20, 1987.

DeCarava, Sherry Forsythe

n.d. [c. 1973] "Female and Child Figures in Lower Congo Art: The Question of European Influence." Master's thesis, Columbia University.

de Grunne, Bernard

1980 *Terres cuites anciennes de l'ouest africain/ Ancient Terracottas from West Africa*. Louvain-la-Neuve, Belgium: Institut supérieur d'archéologie et d'histoire de l'art.

1987 "From Prime Objects to Masterpieces." In *Rediscovered Masterpieces of African Art*, by Gérald Berjonneau, Jean-Louis Sonnery, and Fondation Dapper. Boulogne, France: Art 135.

1988 "Ancient Sculpture of the Inland Niger Delta and Its Influence on Dogon Art." *African Arts* 21 (4): 50-55, 92.

de Heusch, Luc

1982 *The Drunken King, or, The Origin of the State*. Translated by Roy Willis. Bloomington: Indiana University Press.

DeMause, Lloyd, ed.

1974 *The History of Childhood*. New York: Psychohistory Press.

DeMott, Barbara

1982 *Dogon Masks: A Structural Study of Form and Meaning*. Ann Arbor, Mich.: UMI Research Press.

de Oliveira, Ernesto Veiga

1985 *Escultura africana em Portugal*. Lisbon: Instituto de Investigação Cientifica Tropical, Museu de Etnologia.

Desplagnes, Louis

1907 *Le plateau central Nigérien: Une mission archéologique et ethnographique au Soudan français*. Paris: Larose.

Dieterlin, Germaine
1957 "The Mande Creation Myth." *Africa* 17
 (2): 124–38.
Douglas, Mary
1975 *Implicit Meanings: Essays in Anthropology.*
 London: Routledge and Kegan Paul.
Drewal, Henry J.
1977 *Traditional Art of the Nigerian Peoples:
 The Milton D. Ratner Family Collection.*
 Washington, D.C.: Museum of African
 Art.
1978 "Art and the Perception of Women in
 Yoruba Culture." *Cahiers d'études
 africaines* 68 (XVII-4): 545–67.
1984 "Art, History, and the Individual: A
 New Perspective for the Study of African
 Visual Traditions." In *Iowa Studies in
 African Art*, vol. 1, edited by Christopher
 D. Roy. Iowa City: School of Art and
 Art History, University of Iowa.
1988a "Mermaids, Mirrors, and Snake
 Charmers: Igbo Mami Wata Shrines."
 African Arts 21 (2): 38–45, 96.
1988b "Performing the Other: Mami Wata
 Worship in West Africa." *The Drama
 Review* 32 (2): 160–85.
1989 "Meaning in Oshugbo Art among Ijebu
 Yoruba." In *Man Does Not Go Naked:
 Textilien und Handwerk aus Afrikanischen
 und Anderen Landen*, edited by B.
 Engelbrecht and R. Gardi. Bäsler
 Beiträge zur Ethnologie, vol. 29. Basel.
Drewal, Henry J., and Margaret T. Drewal
1983 *Gelede: Art and Feminine Power among the
 Yoruba.* Bloomington: Indiana
 University Press.
Drewal, Margaret Thompson
1989 "Performers, Play, and Agency: Yoruba
 Ritual Process." Ph.D. diss., New York
 University.
Drewal, Margaret Thompson, and Henry
John Drewal
1983 "An Ifa Diviner's Shrine in Ijebuland."
 African Arts 16 (2): 60–67, 99–100.
Duerden, Dennis
1968 *African Art.* London: Hamlyn.
Dupuis, Joseph
[1824] 1966 *Journal of a Residence in Ashantee.*
 Reprint. London: Frank Cass.

Egharevba, Jacob
1960 *A Short History of Benin.* 3d ed. (1st ed.
 published in 1934). Ibadan, Nigeria:
 Ibadan University Press.
Elisofon, Eliot
[1958] 1978 *The Sculpture of Africa.* Reprint.
 New York: Hacker.
Ervedosa, Carlos
1980 *Arqueologia Angolana.* Lisbon: Ediçẽs 70.
Eyo, Ekpo, and Frank Willett
1980 *Treasures of Ancient Nigeria.* New York:
 Knopf in association with The Detroit
 Institute of Arts.
Ezra, Kate
1984 *African Ivories.* New York: Metropolitan
 Museum of Art.
1986 *A Human Ideal in African Art: Bamana
 Figurative Sculpture.* Washington, D.C.:
 Smithsonian Institution Press for the
 National Museum of African Art.
1988 *Art of the Dogon: Selections from the Lester
 Wunderman Collection.* New York:
 Metropolitan Museum of Art.

Fabian, Johannes
1983 *Time and the Other: How Anthropology
 Makes Its Objects.* New York: Columbia
 University Press.
Fage, J. D.
1969 *A History of West Africa.* 4th ed. London:
 Cambridge University Press.
Fagg, Bernard
1977 *Nok Terracottas.* Lagos: Ethnographica
 for the National Museum.
Fagg, William B.
1963 *Nigerian Images: The Splendor of African
 Sculpture.* New York: Praeger.
1964 *Afrique: Cent tribus, cent chefs-d'oeuvre.*
 Paris: Congrés pour la Liberté de la
 Culture.
1969 *African Sculpture.* Washington, D.C.:
 International Exhibitions Foundation.
1970 *Divine Kingship in Africa.* London:
 British Museum.
1981 *African Majesty: From Grassland and
 Forest.* Toronto: Art Gallery of Ontario.
Fagg, William, and John Pemberton
1982 *Yoruba Sculpture of West Africa.* Edited by
 Bryce Holcombe. New York: Knopf.

Feest, Christian
1980 *The Art of War.* London: Thames and Hudson.

Felix, Marc Leo
1987 *100 Peoples of Zaire and Their Sculpture: The Handbook.* Brussels: Zaire Basin Art History Research Foundation.

Fernandez, James
1973 "The Exposition and Imposition of Order: Artistic Expression in Fang Culture." In *The Traditional Artist in African Societies,* edited by Warren L. d'Azevedo. Bloomington: Indiana University Press.
1977 *Fang Architectonics.* Working Papers in the Traditional Arts, no. 1. Philadelphia: Institute for the Study of Human Issues.

Finnegan, Ruth
1970 *Oral Literature in Africa.* London: Clarendon Press.

Fischer, Eberhard
1978 "Dan Forest Spirits: Masks in Dan Villages." *African Arts* 11 (2): 16–23, 94.

Fischer, Eberhard, and Hans Himmelheber
1984 *The Arts of the Dan in West Africa.* Translated by Anne Buddle. Zurich: Museum Rietberg.

Fischer, Eberhard, and Lorenz Homberger
1985 *Die Kunst der Guro, Elfenbeinküste.* Zurich: Museum Rietberg.

Fisher, Humphrey J.
1972–73 "'He Swalloweth the Ground with Fierceness and Rage': The Horse in the Central Sudan." Parts 1, 2. *Journal of African History* 13 (3): 367–88; 14 (3): 355–79.

Flam, Jack D.
1970 "Some Aspects of Style Symbolism in Sudanese Sculpture." *Journal de la société des africanistes* 40 (2): 137–50.
1971 "The Symbolic Structure of Baluba Caryatid Stools." *African Arts* 4 (2): 54–59, 80.

Fondation pour la recherche en endocrinologie sexuelle et l'étude de la reproduction humaine
1977 *La maternité dans les arts premiers/Het Moederschap in de Primitieve Kunsten.* Brussels: Fondation pour la recherche en endocrinologie sexuelle et l'étude de la reproduction humaine.

Forman, Werner, Bedrich Forman, and Philip Dark
1960 *Benin Art.* London: Hamlyn.

Förster, Till
1987 *Glänzend wie Gold: Gelbguss bei den Senufo, Elfenbeinküste.* Berlin: Reimer.

Förster, Till, and Lorenz Homberger
1988 *Die Kunst der Senufo.* Zurich: Museum Rietberg.

Foss, Susan Moore
1979 "She Who Sits as King." *African Arts* 12 (2): 44–50, 90–91.

Fraser, Douglas, and Herbert M. Cole, eds.
1972 *African Art and Leadership.* Madison: University of Wisconsin Press.

Freeman, Thomas Birch
[c. 1843] 1968 *Journal of Various Visits to the Kingdoms of Ashanti, Aku, and Dahomi in Western Africa.* Reprint. London: Frank Cass.

Freyer, Bryna
1987 *Royal Benin Art in the Collection of the National Museum of African Art.* Washington, D.C.: Smithsonian Institution Press for the National Museum of African Art.

Fry, Jacqueline, ed.
1978 *Vingt-cinq sculptures africaines/Twenty-Five African Sculptures.* Ottawa: National Gallery of Canada.

Garrard, Timothy F.
1980 *Akan Weights and the Gold Trade.* London: Longman.
1983 "Akan Pseudo-Weights of European Origin." In *Akan Transformations: Problems in Ghanaian Art History,* edited by Doran H. Ross and Timothy F. Garrard. Museum of Cultural History Monograph no. 21. Los Angeles: UCLA Museum of Cultural History.

Geary, Christraud M.
1981a *The Idiom of War in the Bamum Court Arts.* African Studies Center Working Papers, no. 51. Boston: African Studies Center, Boston University.
1981b "Bamum Thrones and Stools." *African Arts* 14 (4): 32–43, 87.

1983 *Things of the Palace: A Catalogue of the Bamum Palace Museum in Foumban (Cameroon)*. Studien zur Kulturkunde, no. 60. Translated by Kathleen M. Holman. Wiesbaden: Steiner Verlag.

1986 "Portraiture in the Cameroon Grassfields: A Critical Overview." Paper presented at the 7th Triennial Symposium on African Art, Los Angeles.

1988a "Messages and Meaning of African Court Arts: Warrior Figures from the Bamum Kingdom." *Art Journal* 47 (2): 103–13.

1988b *Images from Bamum: German Colonial Photography at the Court of King Njoya, Cameroon, West Africa, 1902–1915.* Washington, D.C.: Smithsonian Institution Press for the National Museum of African Art.

Geary, Christraud M., and Adamou Ndam Njoya

1985 *Mandou Yénou: Photographies du pays Bamoum, royaume ouest-africain, 1902–1915.* Munich: Trickster Verlag.

Gebauer, Paul

1979 *Art of Cameroon.* Portland, Oreg.: Portland Art Museum in association with the Metropolitan Museum of Art.

Geluwe, Huguette Van

1978 "'Phemba' Mother and Child." In *Vingt-cinq sculptures africaines/Twenty-Five African Sculptures*, edited by Jacqueline Fry. Ottawa: National Gallery of Canada.

Gennep, Arnold van

[1908] 1960 *The Rites of Passage.* Translated by Monika B. Visedom and Gabrielle L. Caffee. Chicago: University of Chicago Press.

Gillon, Werner

1984 *A Short History of African Art.* New York: Facts on File.

Glaze, Anita J.

1975 "Woman Power and Art in a Senufo Village." *African Arts* 8 (3): 24–29, 64–68, 90–91.

1981 *Art and Death in a Senufo Village.* Bloomington: Indiana University Press.

1986 "Dialectics of Gender in Senufo Masquerades." *African Arts* 19 (3): 30–39, 82.

n.d. [c. 1983] "The Children of Poro: A Reexamination of the Rhythm Pounder in Senufo Art, Its Form and Meaning." *Connaissance des arts tribaux bulletin* (20).

Goldwater, Robert

1960 *Bambara Sculpture from the Western Sudan.* New York: University Publishers for the Museum of Primitive Art.

1964 *Senufo Sculpture in West Africa.* Greenwich, Conn.: New York Graphic Society for the Museum of Primitive Art.

Gray, Richard, and David Birmingham, eds.

1970 *Pre-Colonial Trade: Essays on Trade in Central and Eastern Africa before 1900.* London: Oxford University Press.

Griaule, Marcel

[1938] 1963 *Masques dogons.* 2d ed. Paris: Institut d'ethnologie.

1965 *Conversations with Ogotemmêli: An Introduction to Dogon Religious Ideas.* London: Oxford University Press for the International African Institute.

Griaule, Marcel, and Germaine Dieterlen

1965 *Le renard pâle.* Paris: Travaux et mémoires de l'institut d'ethnologie.

Hambly, Wilfrid D.

1930 "Use of Tobacco in Africa." In *Tobacco and Its Use in Africa*, by Berthold Laufer, Wilfrid D. Hambly, and Ralph Linton. Field Museum of Natural History, Department of Anthropology Leaflet no. 29. Chicago.

Harley, George W.

[1950] 1975 *Masks as Agents of Social Control.* Reprint. Millwood, New York: Kraus.

Harter, Pierre

1971 "Le crâne humain en Afrique." *Arts d'Afrique noire* 2:4–11.

1980 "Rôle culturel et social de la mère dans l'ouest camerounais." In *Cameroun: Arts et cultures des peuples de l'ouest.* Geneva: Musée d'ethnographie Genève.

1986 *Art anciens du Cameroun.* Arnouville, France: Arts d'Afrique noire.

Henderson, Richard N., and Ifekandu Umunna

1988 "Leadership Symbolism in Onitsha Igbo Crowns and Ijele." *African Arts* 21 (2): 28–37, 94.

Herbert, Eugenia W.
1984 *Red Gold of Africa: Copper in Precolonial History and Culture.* Madison: University of Wisconsin Press.

Herskovits, Melville J.
1938 *Dahomey: An Ancient West African Kingdom.* 2 vols. New York: J. J. Augustin.

Hertz, Robert
[1907-9] 1960 *Death and the Right Hand.* Translated by Rodney Needham and Claudia Needham. New York: Free Press of Glencoe.

Hilton, Anne
1985 *The Kingdom of Kongo.* Oxford: Clarendon Press.

Holý, Ladislav
1967 *Masks and Figures from Eastern and Southern Africa.* Translated by Till Gottheiner. London: Hamlyn.

Horton, Robin
1965 *Kalabari Sculpture.* Lagos: Department of Antiquities.

Huard, Paul
1960 "Contribution à l'étude du cheval, du fer et du chameau au Sahara oriental." *Bulletin de l'I.F.A.N.* ser. B, 22 (1, 2): 134-78.

Huet, Jean-Christophe
1988 "The *Togu Na* of Tenyu Ireli." *African Arts* 21 (4): 34-36, 91.

Huet, Michel
1978 *The Dance, Art and Ritual of Africa.* New York: Pantheon.

Hyde, Lewis
1983 *The Gift: Imagination and the Erotic Life of Property.* New York: Random House, Vintage Trade Books.

Imperato, Pascal James
1970 "The Dance of the Tyi Wara." *African Arts* 4 (1): 8-13, 71-80.
1978 *Dogon Cliff Dwellers: The Art of Mali's Mountain People.* New York: L. Kahan Gallery.

Johnson, R. Townley
1979 *Major Rock Paintings of Southern Africa.* Edited by Tim Maggs. Bloomington: Indiana University Press.

Jones, G. I.
1984 *The Art of Eastern Nigeria.* Cambridge: Cambridge University Press.

Kaplan, Flora S., ed.
1981 *Images of Power: Art of the Royal Court of Benin.* New York: New York University Press.

Karpinski, Peter
1984 "A Benin Bronze Horseman at the Merseyside County Museum." *African Arts* 17 (2): 54-62, 88-89.

Kasfir, Sidney L.
1984 "One Tribe, One Style? Paradigms in the Historiography of African Art." *History in Africa* 11:163-93.
1988a "Celebrating Male Aggression: The Idoma *Oglinye* Masquerade." In *West African Masks and Cultural Systems,* edited by Sidney L. Kasfir. Tervuren: Musée royal de l'Afrique centrale.

Kasfir, Sidney L., ed.
1988b *West African Masks and Cultural Systems.* Tervuren: Musée royal de l'Afrique centrale.

Kauenhoven-Janzen, Reinhild
1981 "Chokwe Thrones." *African Arts* 14 (3): 69-74, 92.

Kecskési, Maria
1986 *African Masterpieces and Selected Works from Munich: the Staatliches Museum für Völkerkunde.* Translation of *Kunst aus dem Alten Afrika.* New York: Center for African Art.

Lajoux, Jean-Dominique
1963 *The Rock Paintings of Tassili.* London: Thames and Hudson.

Laman, Karl
1957 *The Kongo.* Vol. 2. Uppsala: Studia Ethnographica Upsalienia.

Lamp, Frederick
1986 "The Art of the Baga: A Preliminary Inquiry." *African Arts* 19 (2): 64-67, 92.

Laude, Jean
1973 *African Art of the Dogon.* New York: Brooklyn Museum in association with Viking Press, Studio Book.

Law, Robin

1980 *The Horse in West Africa.* London: Oxford University Press.

1986 "Dahomey and the Slave Trade: Reflections on the Historiography of the Rise of Dahomey." *Journal of African History* 27:237–67.

Lecoq, Raymond

1953 *Les bamileke.* Paris: Editions africaines.

Leiris, Michel, and Jacqueline Delange

1968 *African Art.* Translated by Michael Ross. New York: Golden Press.

Leuzinger, Elsy

1963 *Afrikanische Skulpturen/African Sculpture: A Descriptive Catalogue.* Translated by Ann E. Keep. Zurich: Atlantis.

1967 *Africa: The Art of the Negro Peoples.* Translated by Ann E. Keep. 2d ed. New York: Crown.

1972 *The Art of Black Africa.* London: Studio Vista.

1977 *The Art of Black Africa.* New York: Rizzoli.

Levine, Robert A.

1983 "Fertility and Child Development: An Anthropological Approach." In *Child Development and International Development: Research-Policy Interfaces,* edited by Daniel A. Wagner. San Francisco: Jossey-Bass.

Levtzion, Nehemia

[1973] 1980 *Ancient Ghana and Mali.* London: Methuen. Reprint. New York: Africana.

Liking, Werewere

1987 *Statues colons.* Paris: NEA-ARHIS.

Lips, Julius E.

[1937] 1966 *The Savage Hits Back.* Translated by Vincent Benson. New Haven, Conn.: Yale University Press. Reprint. New Hyde Park, New York: University Books.

Lopes, Duarte, and Filippo Pigafetta

[1881] 1970 *A Report of the Kingdom of Congo and of the Surrounding Countries, Drawn Out of the Writings and Discourses of the Portuguese Duarte Lopez, by Filippo Pigafetta* [1591]. Translated by Margarite Hutchinson. Reprint. London: Frank Cass.

MacCormack, Carol P.

1982a "Health, Fertility and Birth in Moyamba District, Sierra Leone." In *Ethnography of Fertility and Birth,* edited by Carol P. MacCormack. London: Academic Press.

MacCormack, Carol P., ed.

1982b *Ethnography of Fertility and Birth.* London: Academic Press.

MacCormack, Carol P., and Marilyn Strathern, eds.

1980 *Nature, Culture and Gender.* Cambridge: Cambridge University Press.

MacGaffey, Wyatt

1977 "Fetishism Revisited: Kongo *Nkisi* in Sociological Perspective." *Africa* 47 (2): 172–84.

McLeod, Malcolm D.

1979a "Asante Spokesmen's Staffs: Their Probable Origin and Development." In *Akan-Asante Studies.* British Museum Occasional Papers, no. 3. London.

1979b "A Note on an Asante Royal Chair of Iberian Origin." In *Akan-Asante Studies.* British Museum Occasional Papers, no. 3. London.

1979c "Three Important Royal Kuduo." In *Akan-Asante Studies.* British Museum Occasional Papers, no. 3. London.

1980 *Treasures of African Art.* New York: Abbeville Press.

1981 *The Asante.* London: British Museum Publications.

1985 *Ethnic Sculpture.* London: British Museum Publications.

McNaughton, Patrick R.

1988 *The Mande Blacksmiths: Knowledge, Power, and Art in West Africa.* Bloomington: Indiana University Press.

Maesen, Albert

1981 "Statuaire et culte de fécondité chez les luluwa du Kasai (Zaire)." *Quaderni poro,* no. 3 (June–July): 49–58.

Mair, Lucy

[1953] 1969 *African Marriage and Social Change.* Reprint. London: Frank Cass.

1977 *Marriage.* London: The Scholar Press.

Marks, Sheila, and Richard Rathbone

1983 "The History of the Family in Africa: Introduction." *Journal of African History* 24 (2): 145–61.

Maurer, Evan M., and Allen F. Roberts
1985 *Tabwa: The Rising of a New Moon; A Century of Tabwa Art.* Ann Arbor, Mich.: University of Michigan Museum of Art.

Mercier, P.
1954 "The Fon of Dohomey." In *African Worlds: Studies in the Cosmological Ideals and Social Values of African Peoples*, edited by Daryll Forde. London: Oxford University Press for the International African Institute.

Metcalf, George
1987 "A Microcosm of Why Africans Sold Slaves: Akan Consumption Patterns in the 1700s." *Journal of African History* 28:377–94.

Meyer, Piet
1981 *Kunst und Religion der Lobi.* Zurich: Museum Rietberg.

Meyerhoff, Barbara
1982 "Rites of Passage: Process and Paradox." In *Celebration: Studies in Festivity and Ritual*, edited by Victor Turner. Washington, D.C.: Smithsonian Institution Press.

Mollien, G. T.
1820 *Travels in the Interior of Africa, to the Sources of the Senegal and Gambia.* London: H. Colburn.

Mount, Marshall Ward
1973 *African Art: The Years Since 1920.* Bloomington: Indiana University Press.

Murdock, George P.
1959 *Africa: Its Peoples and Their Culture History.* New York: McGraw-Hill.

Nadel, Siegfried Frederick
1942 *A Black Byzantium: The Kingdom of Nupe in Nigeria.* London: Oxford University Press for the International Institute of African Languages and Cultures.

Nevadomsky, Joseph
1986 "The Benin Horseman as the Ata of Idah." *African Arts* 19 (4): 40–47, 85.
1988 "*Kemwin-Kemwin*: The Apothecary Shop in Benin City." *African Arts* 22 (1): 72–83, 100.
n.d. "The Costume and Weapons of the Benin Brass Horseman." *African Arts.* Forthcoming.

Neyt, François
1977 *La grande statuaire hemba du Zaire.* Louvain-la-Neuve, Belgium: Institut supérieur d'archéologie et d'histoire de l'art.
1981 *Arts traditionnels et histoire du Zaire/ Traditional Arts and History of Zaire.* Brussels: Société d'arts primitifs.

Neyt, François, and Louis de Strycker
1975 *Approche des arts Hemba.* Villiers-le-Bel, France: Arts d'Afrique noire.

Nicklin, Keith, and Jill Salmons
1977 "S. J. Akpan of Nigeria." *African Arts* 11 (1): 30–34.

Nketia, J. H. Kwabena
1969 *Funeral Dirges of the Akan People.* New York: Negro Universities Press.

Norris, Edward Graham
1983 "Colon in Kontext." In *Colon: Das schwarze Bild vom weissen Mann*, edited by Jens Jahn. Munich: Rogner and Bernhard.

Northern, Tamara
1984 *The Art of Cameroon.* Washington, D.C.: Smithsonian Institution Traveling Exhibition Service.

Nunley, John
1987 *Moving with the Face of the Devil: Art and Politics in Urban West Africa.* Urbana: University of Illinois Press.

Oelmann, Albin
1979 "Nduen Fobara: Ancestral Memorial Screens from New Calabar." *African Arts* 12 (2): 36–43, 90.

Ojo, J. R. O.
1978 "The Symbolism and Significance of Epa-Type Masquerade Headpieces." *Man* n.s. 13 (3): 455–70.

Olbrechts, Frans M.
1946 *Plasteik van Kongo.* Antwerp: Uitgeversmij. N.V. Standaard-Boekhandel.

Opoku, Kofi Asare
1982 "The World View of the Akan." *Tarikh* 7 (2): 61–73.

Ottenberg, Simon
1975 *Masked Rituals of Afikpo: The Context of an African Art.* Seattle: University of Washington Press.

Perani, Judith
1980 "Patronage and Nupe Craft Industries."
 African Arts 13 (3): 71–75, 92.

Phillips, Ruth B.
1978 "Masking in Mende Sande Society
 Initiation Rituals." *Africa* 48 (3): 265–77.

Picton, John
1987 "Masks and Identities in Ebira Culture."
 Paper presented at seminar, Concepts of
 the Body/Self in Africa. School of
 Oriental and African Studies, University
 of London.

Preston, George Nelson
1985 *Sets, Series and Ensembles in African Art.*
 Introduction by Susan Vogel and
 catalogue by Polly Nooter. New York:
 Abrams for the Center for African Art.

Prussin, Labelle
1986 *Hatumere: Islamic Design in West Africa.*
 Berkeley and Los Angeles: University of
 California Press.

Rattray, Robert S.
1923 *Ashanti.* Oxford: Clarendon Press.

Ravenhill, Philip L.
1980 *Baule Statuary Art: Meaning and
 Modernization.* Philadelphia: Institute for
 the Study of Human Issues.
1988 "An African Triptych: On the
 Interpretation of Three Parts and the
 Whole." *Art Journal* 47 (2): 88–94.

Roberts, Allen F.
1986 "Duality in Tabwa Art." *African Arts* 19
 (4): 26–35, 86–87.

Roosens, Eugeen
1967 *Images africaines de la mère et l'enfant.*
 Louvain, Belgium: Editions Nauwelaerts.

Rosaldo, Michelle Zimbalist
1974 "Woman, Culture, and Society: A
 Theoretical Overview." In *Woman,
 Culture, and Society,* edited by Michelle
 Zimbalist Rosaldo and Louise Lamphere.
 Stanford: Stanford University Press.

Ross, Doran H.
1977 "The Iconography of Asante Sword
 Ornaments." *African Arts* 11 (1): 16–25,
 90–91.
1979 *Fighting with Art: Appliquéd Flags of the
 Fante Asafo.* Los Angeles: UCLA
 Museum of Cultural History.
1980 "Cement Lions and Cloth Elephants:
 Popular Arts of the Fante Asafo." In
 *5000 Years of Popular Culture: Popular
 Culture before Printing,* edited by Fred E.
 H. Schroeder. Bowling Green, Ohio:
 Bowling Green University Popular Press.
1982a "The Heraldic Lion in Akan Art: A
 Study of Motif Assimilation."
 Metropolitan Museum Journal 16:165–80.
1982b "The Verbal Art of Akan Linguist
 Staffs." *African Arts* 16 (1): 56–67.
1984 The Art of Osei Bonsu." *African Arts* 17
 (2): 28–40, 90.

Ross, Doran H., and Timothy F. Garrard, eds.
1983 *Akan Transformations: Problems in
 Ghanaian Art History.* Museum of
 Cultural History Monograph no. 21. Los
 Angeles: UCLA Museum of Cultural
 History.

Roy, Christopher D.
1987 *Art of the Upper Volta Rivers.* Meudon,
 France: Chaffin.

Rubin, Arnold G.
1974 *African Accumulative Sculpture: Power and
 Display.* New York: Pace Gallery.

Ryder, A. F. C.
1969 *Benin and the Europeans, 1485–1897.*
 London: Longmans.

Salmons, Jill
1977 "Mammy Wata." *African Arts* 10 (3): 8–15,
 87–88.
1985 "Martial Arts of the Annang." *African
 Arts* 19 (1): 57–62, 87–88.

Shack, William A., and Elliott P. Skinner, eds.
1979 *Strangers in African Societies.* Berkeley
 and Los Angeles: University of
 California Press.

Shaw, Thurstan
1970 *Igbo-Ukwu: An Account of Archaeological
 Discoveries in Eastern Nigeria.* 2 vols.
 Evanston: Northwestern University
 Press.
1978 *Nigeria: Its Archaeology and Early History.*
 London: Thames and Hudson.

Shelton, Austin J.
1969 "Igbo Child-Raising, Eldership, and
 Dependence: Further Notes for
 Gerontologists and Others." *The
 Gerontologist* 8 (4): 236–41.

Sieber, Roy
1961　*Sculpture of Northern Nigeria*. New York: Museum of Primitive Art.
1980　*African Furniture and Household Objects*. Bloomington: Indiana University Press.

Sieber, Roy, and Roslyn Adele Walker
1987　*African Art and the Cycle of Life*. Washington, D.C.: Smithsonian Institution Press for the National Museum of African Art.

Silverman, Raymond A.
1983　"Akan Kuduo: Form and Function." In *Akan Transformations: Problems in Ghanaian Art History*, edited by Doran H. Ross and Timothy F. Garrard. Museum of Cultural History Monograph no. 21. Los Angeles: UCLA Museum of Cultural History.

Siroto, Leon
1968　"Face of the Bwiti." *African Arts* 1 (3): 22–89, 96.
1976　*African Spirit Images and Identities*. New York: Pace Editions.
1979　"Witchcraft Belief in the Explanation of Traditional African Iconography." In *The Visual Arts: Plastic and Graphic*, edited by Justine Cordwell. New York: Mouton.

Smith, Robert
1967　"Yoruba Armament." *Journal of African History* 8 (1): 87–106.

Söderberg, Bertil
1966　"Antelope Horn Whistles with Sculptures from the Lower Congo." *Ethnos* 31:5–33.

Spini, Tito, and Sandro Spini
1977　*Togu Na: The African Dogon, "House of Men, House of Words."* Translated by Verna Kaye-Ciappina. New York: Rizzoli.

Stocking, George W., Jr., ed.
1985　*Objects and Others: Essays on Museums and Material Culture*. History of Anthropology, vol. 3. Madison: University of Wisconsin Press.

Stössel, Arnulf
1984　*Afrikanische Keramik: Traditionelle Handwerkskunst Südlich der Sahara*. Munich: Hirmer.

Striedter, Karl Heinz
1984　*Felsbilder der Sahara*. Munich: Prestel-Verlag.

Szombati-Fabian, Ilona, and Johannes Fabian
1976　"Art, History, and Society: Popular Painting in Zaire." *Studies in the Anthropology of Visual Communication* 3:1–21.

Thompson, Robert Farris
1973　"Yoruba Artistic Criticism." In *The Traditional Artist in African Societies*, edited by Warren L. d'Azevedo. Bloomington: Indiana University Press.
1974　*African Art in Motion*. Washington, D.C.: National Gallery of Art.
1978　"The Grand Detroit N'Kondi." *Bulletin of the Detroit Institute of Arts* 56 (4): 207–21.

Thompson, Robert Farris, and Joseph Cornet
1981　*The Four Moments of the Sun: Kongo Art in Two Worlds*. Washington; D.C.: National Gallery of Art.

Thornton, John K.
1983　*The Kingdom of Kongo: Civil War and Transition, 1641–1718*. Madison: University of Wisconsin Press.

Tonkin, Elizabeth
1979　"Masks and Powers." *Man* n.s. 14 (2): 237–48.

Torday, Emil, and Thomas A. Joyce
1910　*Notes ethnographies sur les peuples communément appelés bakuba, ainsi que sur les peuplades apparentées, les bushongo*. Brussels: Ministère des Colonies.

Trimingham, J. Spencer
1965　*Islam in the Sudan*. New York: Barnes and Noble.

Trost, Franz
1981　*Die Felsbilder des Zentralen Ahaggar (Algerische Sahara)*. Graz: Akademische Druck- und Verlagsanstalt.

Tunis, Irwin L.
1979　"Cast Benin Equestrian Statuary." *Baessler Archiv* n.f. 27:389–417.

Turner, Victor W.

1957 *Schism and Continuity in an African Society: A Study of Ndembu Village Life.* Manchester, England: Manchester University Press for the Institute for African Studies, University of Zambia.

1967 *The Forest of Symbols: Aspects of Ndembu Ritual.* Ithaca: Cornell University Press.

1969 *The Ritual Process.* Chicago: Aldine.

Vansina, Jan

1972 "*Ndop*: Royal Statues among the Kuba." In *African Art and Leadership*, edited by Douglas Fraser and Herbert M. Cole. Madison: University of Wisconsin Press.

1984 *Art History in Africa.* London: Longman.

Verly, Robert

1955 "La statuaire de pierre du Bas-Congo (Bamboma-Mussurongo)." *Zaire* 9 (3): 451–528.

Vogel, Susan M.

1974 *Gods of Fortune: The Cult of the Hand in Nigeria.* New York: Museum of Primitive Art.

1977 *Baule Art as the Expression of a World View.* Ann Arbor, Mich.: University Microfilms International.

1980 *Beauty in the Eyes of the Baule: Aesthetics and Cultural Values.* Philadelphia: Institute for the Study of Human Issues.

1985 *African Aesthetics: The Carlo Monzino Collection.* Venice: Abbazia di S. Gregorio.

Vogel, Susan, ed.

1981 *For Spirits and Kings: African Art from the Paul and Ruth Tishman Collection.* New York: Metropolitan Museum of Art.

Vogel, Susan, and Francine N'Diaye

1985 *African Masterpieces from the Musée de l'Homme.* New York: Center for African Art and Abrams.

Walker Art Center

1967 *Art of the Congo.* Minneapolis: Walker Art Center.

Walker, Roslyn Adele

1976 *African Women/African Art.* New York: African-American Institute.

Wannyn, Robert L.

1961 *L'art ancien du métal au Bas Congo.* Champles par Wavre, Belgium: Editions du vieux planquesaule.

Widman, Ragnar

1967 *The Niombo Cult among the Babwende.* Statens Etnografiska Museum Monograph Series, no 11. Stockholm.

Willett, Frank

1967 *Ife in the History of West African Sculpture.* New York: McGraw-Hill.

[1971] 1985 *African Art: An Introduction.* New York: Praeger. Reprint. New York: Thames and Hudson.

Williams, Denis

1964 "The Iconology of the Yoruba *Edan Ogboni*." *Africa* 34 (2): 139–66.

Witte, Hans

1988 *Earth and the Ancestors: Ogboni Iconography.* Amsterdam: Gallery Balolu.

Zahan, Dominique

1974 *The Bambara.* Leiden: Brill.

1979 *The Religion, Spirituality, and Thought of Traditional Africa.* Chicago: University of Chicago Press.

Zuesse, Evan M.

1979 *Ritual Cosmos: The Sanctification of Life in African Religions.* Athens: Ohio University Press.

Lenders to the Exhibition

Affrica Collection
Mr. and Mrs. Arnold J. Alderman
Allen Memorial Art Museum, Oberlin
 College, Oberlin, Ohio
Dr. Ernst Anspach
The Collection of Nancy and Richard
 Bloch
The Collection of Victor Bol, Brussels
The Bonnefoy Collection, New York
Mr. and Mrs. William W. Brill
The Trustees of the British Museum
M. Cohen
Charles and Kent Davis
The Collection of Count Baudouin
 de Grunne, Brussels
Gaston T. de Havenon
Collection Carol Dekoninck, Antwerp
Département de l'Afrique Noire,
 Laboratoire d'Ethnologie du Muséum
 National d'Histoire Naturelle (Musée de
 l'Homme), Paris
The Detroit Institute of Arts
Geraldine and Morton Dimondstein
Drs. John and Nicole Dintenfass
Collection Dürckheim, Entraching,
 West Germany
The Richard and Barbara Faletti Collection
Drs. Thomas and Vaughana Feary
Marc Leo Felix, Brussels
Beverley and Gerson Geltner
Marc and Denyse Ginzberg
Rainer and Monika Goedl, Assenhaussen,
 Upper Bavaria, West Germany
Mr. and Mrs. Joseph M. Goldenberg
Mr. and Mrs. Bram Goldsmith
H. K. Gallerie, St. Gallen, Switzerland
The Jay and Clayre Haft Collection
Iwalewa-House, African Studies Center,
 Bayreuth University
The Robert Jacobs Collection
J. Kerchache

Joseph and Margaret Knopfelmacher
Dr. and Mrs. Robert Kuhn
The Collection of Amy and Elliot Lawrence
Leloup, Inc.
Mr. and Mrs. J. Thomas Lewis
Marc Lippman, M.D., and Dr. Abby
 Lippman
G. Luttik
Drs. Daniel and Marian Malcolm
Jean Willy Mestach
The Metropolitan Museum of Art
The Mnuchin Foundation
Musée national des Arts africains et
 océaniens, Paris
The Board of Trustees of the National
 Museums and Galleries on Merseyside,
 Liverpool, England
Ruth and Richard Newman
Robert and Nancy Nooter
Pace Primitive Art
Dr. and Mrs. Max Pailet
R. and L. Phillips, London
The Collection of M. and Mme. Renaudeau
Doris and Merrell Rief
Michael and Rosemary Roth
Robert Rubin
The Seattle Art Museum, Katherine White
 Collection
Mr. and Mrs. Edwin Silver
Saul and Marsha Stanoff
Mr. and Mrs. Arnold Syrop
Collection Timmermans-Haems
Paul and Ruth Tishman African Art
 Collection, Walt Disney Co.
UCLA Fowler Museum of Cultural History
James Willis Gallery
Emily A. Wingert
Ernst and Anne Winizki
M. Wolford/Mbari Art
Collection H. and M. Zimmer
Anonymous lenders